PERI T0105231

PERFUME

A
CENTURY
of
SCENTS

LIZZIE OSTROM

PEGASUS BOOKS
NEW YORK LONDON

PERFUME

Pegasus Books Ltd
148 W 37 Street, 13th Floor
New York, NY 10018

First Pegasus Books hardcover edition December 2016

ISBN: 978-1-68177-246-2

10 9 8 7 6 5 4 3 2 1

Printed in the United States of America
Distributed by W. W. Norton & Company, Inc.

For Dan

Contents

A Century of Scents
An Introduction

SCENT IS THE SILENT AND invisible companion that marches through our history. Sprayed or dabbed on in the mornings as we blink out the sleep in our eyes, and more emphatically in the evenings when it is time to be noticed as we play, it comes with us as we go about our lives. Some scents cling, koala-like, to their owners for decades, till death do them part. Others are not so fortunate, getting a few years, or months, before the next one knocks them over the head and steals their place. Some become fossilised into a certain life-stage: my first perfume; college; travel; living in that damp flat that got burgled; that weird six months we don't talk about.

Scent has radiated from the collars of politicians as they stand on the steps triumphant, and when they leave, hounded and broken. It has been dabbed on by performers getting into character for their next role. And it has been present – even playing a supporting or confidence-boosting role – in negotiations, tussles, crimes, parties, productions and seductions, in instances both infamous and prosaic. Scent, depending on who is wearing it and why, can mean power, emancipation, beauty, perversion, belonging or escape. It can stand for a movement, a tribe, a sub-culture. It can represent tradition or, as with patchouli oil in the 1960s, its rejection. Even after a person's death, scent offers a resurrection of sorts: we cannot speak to our loved one again, but we can smell their perfume on their clothes, almost as if they have only just taken off a favourite jumper.

I

When it comes to the initial sales pitch, this most puffed-up of products, often commanding eye-watering prices, is certainly boastful about its potential. It needs to be. After all, this is alcohol with added bits. It's one of the most indulgent pleasures and, in an age of sanitation and disinfectants when we rarely need to cover a stink, sits so far up Maslow's hierarchy of needs that the angels in heaven just saw a bottle shoot over their heads. When we are sold perfume, we are accustomed to also being sold the idea of a life we will never have. Of course sex – whether in a penthouse overlooking the Eiffel Tower or in a floral meadow carefully cleaned of cow dung – is a part of this. But with models lying draped across a lawn, chaise longue, bed or cliff-top, it also sells a mind-altering languor, a mood that is carefree, untroubled and peaceful. In enticing us towards this state, there is a fuzziness in perfume, a nonsense logic all too familiar from screen commercials with their bizarre moodscapes. To pastiche: 'She knew his essence. It was theirs. Their moment.'

When it roams into la-la territory, perfume risks becoming the next emperor's new clothes, more snake-oil even than bottled mineral water. Music is the pulse of an era, a portent of unrest, of revolution. Fashion demonstrates ideas about self-expression and acceptability. But perfume? A bit trivial, isn't it? What could it possibly have to say?

We are told that olfaction is the magic key to unlocking memory, and sometimes we do have a vivid picture connected to a particular smell. If we are lucky, it might be from an idyllic moment in childhood, when we had our own treehouse and hosted a tea party for the squirrels; if we are unlucky, it could be the classroom at school where we got thumped. But more often when we smell something not quite familiar, catching a whiff off another person's coat, it is as though we have been kidnapped and taken to a remote landscape. Blindfolded, disoriented, we sense something of the place but are unable to distinguish exactly where we are. There is that frustrating feeling of recognising a smell, of knowing we know it, but being completely flummoxed as to its identity. After a friend tells us 'that's Paco Rabanne' and puts us out of our misery, there is that moment of relief.

The Rubik's Cube is solved! All is well with the world. When fragrance more often than not renders us dumb, how are we supposed to start articulating its important role in our history?

Nearly all of us, though, are expert readers of scent. We may not be able to decipher individual notes or name the perfumer, but we are good at making judgements in order to place what we smell. These responses are personal to us, and they can feel unshakeable: 'That smells young. This one smells like my grandma. That one over there smells vintage. This bottle is cheap. That one's expensive. That one's for hippies. That's for one-night stands.' If we were to cluster together these archetypes – the trashy broad, the femme fatale, the old crone – we would be in the latest David Lynch project.

It is in understanding how we respond to scent, collectively and as individuals, that we can begin to tell the story of the role this invisible reference point has played in the twentieth century. A perfume that was the height of daring fifty years ago and which stood for everything risqué now moves towards frumpiness as the people we associate with that sort of smell advance from being Gigis to grannies. It is a similar phenomenon to our assessment of Christian names as contemporary or old-fashioned, or to rewatching television programmes made ten years ago, which, once so crisp and fresh, now look fuzzy and dated.

Scent reflects what is appealing and exciting in an era, and our focus – the turbulent twentieth century – was crucial in forming fragrance as we know it today. It was the century in which we decided to spray scent on our skin as opposed to our handkerchiefs. It saw certain smells become gender-specific, defined, and understood as being suitably 'masculine' or 'feminine'. And it was a century of escalating chemical innovation. Instead of a limited palette of natural materials and fragrance types, perfumers found at their disposal hundreds of new molecules to play with. This led to an explosion of novel smells and odour effects, such as the aroma chemical Calone – also known as Watermelon ketone – which in the 1990s gave rise to all those marine scents promising snorkel dives amid the seaweed. We may not know

the names of these materials, but we know their smell once nestled in a composition.

What of the scent wearers? As with so many consumer goods in the last century, we saw fine fragrance burst out from being the exclusive bedfellow of the elite and leisured classes, transformed from an objet d'art to a mass-market proposition. Newly affordable, perfume became available to millions more people, who were enticed by ever more sophisticated marketing, by the inflation of celebrity culture, and by the centre of influence moving from Europe – particularly France – to the United States.

But really, when we speak of the twentieth century, we speak of our own nostalgia. An archaeological dig through the scents of the past one hundred years offers the opportunity for us to rake over the ones we wore and perhaps still enjoy, the ones our mothers and fathers and friends have worn, and the ones we wanted to wear but never dared. When we reach further back, to the people who are just out of our remembered history – our great-grandparents and their forbears – scent offers an enticing lens through which to imagine their world, as if by smelling the same perfume we might also breathe the same oxygen.

A warning: some of the scents included in this tour are now lost, particularly those from the start of the century. There are also those from more recent decades that flopped and were quickly swept off the shelves. Many of my choices that are still manufactured today have been reformulated – whether discreetly or dramatically – so they can keep in step with the market's notion of what is commercial and current, or on account of regulatory pressures, or because ingredients once readily available are now harder or more expensive to obtain. Today's version of a 1920s perfume may represent the same intention as the original, and will continue to offer pleasure under the same name, but some might consider it a new scent entirely.

You might also be wondering what is the point of including perfumes here that have gone the way of the dodo. We may remake old ballgowns from a sepia photo, but we cannot so easily replicate a scent

that has fallen into obscurity. The liquid in the bottle is, of course, not the whole story, so we can still enjoy discovering a fragrance after it has been laid to rest. Even with perfumes that are ready and waiting for us in the aisles, we need more than just a description of the smell. For just as we buy books because of their covers, we also buy and enjoy scents because of their names, straplines or cover stars, sometimes falling in love with the contents even before we've actually sprayed it on our skin.

This is why, in our century of scent through one hundred perfumes – ten for every decade – each scent speaks to us in a different voice. There are those which are the ultimate example of their maker's craft, seamlessly structured and unfolding beautifully, layers peeling back to reveal more beneath and achieving that rare accolade of 'classic'. These appear alongside 'the ones that got away', prized in their time but now alluringly obscure: Black Satin, Hypnotique, White Shoulders. There are perfumes that have made their way into these pages for pertinently expressing something about the era in which they were created, encapsulating to perfection a lifestyle craze, a preoccupation, a culture, through the fragrance itself or through the bottle (the twentieth century saw flasks shaped like pipes, the Statue of Liberty and, more unfortunately, grenades).

Be ready to encounter, and let us not beat around the bush here, a fair few fragrances with dubious reputations in terms of artistry – fragrances that might be said to barely qualify as 'perfumes' (Mennen's Skin Bracer, anyone?). These are the scents that, through a combination of sheer persistence, marketing genius and hitting the zeitgeist, went global. They fizzed around networks and neighbourhoods, were instantly recognised on the streets and could be found under Christmas trees throughout the land. And this is the thing: a scent is as much about the people who wear it as the people who make it. Sometimes the stories of those who got hold of a scent and made it theirs are more engrossing than the concept behind its creation. It might be the tale of one individual or the collective shared narratives of the masses: the millions of American women in the 1950s who bathed in Youth Dew

before an evening out with their husbands, the hordes of teenage boys with a can of Lynx, the generation of men for whom an evening of clubbing began with a splash of Joop!

Sometimes all you want is a beautifully cooked steak as a proper treat; at other times only a hot bacon sarnie from your local cafe will hit the spot. In the same way, our century of scents brings together the rarefied and the regular joes. This is not a book about the best (only a small percentage of people would, in a blind sniffing, be able to identify the finest); it is about the beloved. The strangest. The most outrageous. The scents we groan about because we remember thinking we were so attractive in them.

In our tour we will travel to belle époque Paris and her court perfumers, once the darlings of the French aristocracy and now re-inventing themselves for the modern world of the bourgeoisie. We will meet the visionaries and mavericks of the 1920s who packaged up perfumes that sold back to the Bright Young Things their thrilling, illicit behaviour in olfactory form. In 1940s America we will discover how the Second World War led to failed attempts to turn the Florida marshlands into the new south of France, where jasmine would grow as far as the eye could see. Later we will open the bathroom cabinet of 1950s 'Executive Man', for whom an interest in fragrance had to go hand-in-hand with a brutal stinging and a'slapping of the cheeks, and we will get to know his baby-boom daughters of prosperity, demand-ing new perfumes for their sweet sixteenth. 1980s corporate power perfumes will naturally come out to play, along with their reactionary successors of the following decade, the office-appropriate fragrance equivalent of the white shirt and black trousers.

Every scent has something to say. Each is bounded by its decade but also reverberates into others. As we march through the century, many of the old guard continue to walk with us, blossoming in later life or finally finding their metier years after launch. Thus when we speak of the scents of, say, the 1990s – of L'Eau d'Issey and Thierry Mugler's Angel – we speak of scents still with us, with narratives that have some way to go; whether they will sprint or limp towards the

finish line, and the moment of their withdrawal from the shelves, is still to be discovered.

Even scents that are unfamiliar may be recognisable in the role they played during their time. For me, The Body Shop's White Musk was the coming-of-age fragrance; for someone fifteen years older, that might have been Aqua Manda by Goya, and fifteen years before that, Ma Griffe by Carven. And that's just in the United Kingdom – other perfumes referenced in these pages will resonate with readers elsewhere in the world. Whether we're scent fiends or casual users, we can all look back and consider what we've worn and when: the smells that evoke a particular person we were dating or hanging out with; the ones that went with a scene we were once part of. The story of the twentieth century through perfume is also the story of our own personal century of scent.

Read, reminisce and keep those nostrils keen...there is a lot of perfume coming up.

Yours,
Lizzie Ostrom

The Bountiful Belle Époque
1900–1909

WE BEGIN WITH A NEW century, one so sparkling in its remoteness to us that it can come across as curiously without odour, just out of range of our nostrils. How can we get its perfumes to come into focus, especially when so few of them still exist for us to discover? Did people even *use* perfume back then or were they gripped by a prudishness about scent?

To set the scene, we are going to take a journey to London Bridge, where in 1908 the English fragrance firm of Gosnell's had mounted an audacious spectacle to attract the gaze of busy passers-by crossing the river or rushing to make the train home from work. Flying high in the sky was a hot-air balloon shaped like a perfume bottle, specifically Gosnell's famous Cherry Blossom, which was celebrating its twentieth successful year. From its hovering basket, thousands of flyers were flung over people's heads, and probably into the River Thames. The stunt, equivalent to those aeroplanes that expel coloured smoke spelling out 'Marry me, Sheila!', was risky, not least because the unconventional shape meant the balloon would rise or fall suddenly, much to the concern of the pilot. Over in Paris, another balloon was entertaining French consumers, who also favoured the wares of English companies.

It seems like a modern idea even now, and in fact so much that appears to be new and exciting in perfume was already being tried out in the nineteenth and early twentieth centuries, before scent became

9

defined more narrowly as a liquid we spray on our wrists. To offer a flavour: in Victorian England, the well-known perfumery firm of Eugène Rimmel had employed all sorts of whimsical marketing strategies. There had been perfume fountains available for hire at balls and parties, their delightful waters spilling out to fragrance the air (how long until a twenty-first-century version, perhaps installed at a fancy new cocktail bar, is heralded as a novelty?). At the 1867 Paris Exhibition, Rimmel arranged for the construction of a cottage housing a scent distiller for live demonstration, and floral clocks that revealed different flowers according to the time of day. What they couldn't do with paper wasn't worth knowing: perfumed programmes, fans and almanacs, and Valentine's cards with greetings such as 'May we row in the same boat? I'll have you now!' You could even buy a Rimmel perfume bottle with a handy opera glass at one end. Meanwhile, a competitor – Piesse & Lubin of 2 New Bond Street – were busy promoting 'The Fountain Finger Ring' which, disguised as a piece of ornamental jewellery, would spurt out jets of scent at a ball or concert.

Though Rimmel's ingenious practices were old hat even by 1900, they help to convey just how pervasive scented goods were during this period. They could be bought as finished products but were also made at home as a hobby. A feature in a December 1903 edition of the *Chicago Daily Tribune* described a mania among sewing-bee clubs for making scented Christmas sachets, which could come in oriental-themed designs (Japanese doll heads, or 'Chinamen') and be filled with sandalwood-perfumed beads. Another common practice was to line the walls of wardrobes with cotton, sprinkle over a sachet of perfumed powder, and cover it with cheesecloth to encourage the slow, subtle permeation of fragrance into clothes.

Neither was perfume 'for the rich'. The names that have survived in the annals are the brands of prestige and glinting luxury, of Lalique bottles and rustling printed tissue paper, the likes of Houbigant, Guerlain, Coty and Caron, and rightly so, given their artistic achievements. But no less important were the much less glamorous providers of perfume such as Sears, Colgate and the California Perfume Company,

who brought fragrant wares to millions through their catalogues and door-to-door sales forces, but which by virtue of being mass market and generic became obscure.

As we will see, in the bountiful belle époque perfumes were talked about extensively. Brand names were understood, loved and disparaged in the way we might adore and mock our own notorious perfumes. But because such references often came not in literary but in popular fiction – as obscure now as Sears' offerings – they are hard to find. The incidental reference to a Le Trèfle Incarnat in a romance story is easy to miss and difficult to contextualise when nobody alive remembers the scent, let alone understands truly what it meant to the people of that generation. The reconstruction of these contexts is attempted here, but with an inevitable loss of nuance.

What we can more readily understand is the story backstage, which is much better documented. It is a story of technological innovation and the triumph of chemistry. Following the discovery of how to isolate specific molecules from raw materials, and how then to synthesise them, the first perfumes still available today to incorporate early synthetic molecules coumarin (named after coumarou, French for the tonka bean) and vanillin were Fougère Royale by Houbigant in 1882 and Jicky by Guerlain in 1889. Their launches were the starting gun, the transition from purely natural fragrances, lovely in their own way but limited, to what we know as 'modern' perfumery. A few years after these early pioneers, at the turn of the twentieth century, firms realised that they could now re-create prohibitively expensive perfumes at a fraction of the price if they worked in some of the new materials in their palette. Perfume lovers of 1900 would never have guessed that the arrival of so many violet scents was to do with recently discovered aroma compounds called ionones; it was a trade story, not relevant to the customer and with the potential to interfere with their notion of what perfume was. While other inventions – telephones, gramophones, cars – excited, delighted and disturbed with their phantom-like powers to convey information and people, perfume sat outside the technological discourse because the chemicals

so effectively mimicked the real thing that they were camouflaged in plain view.

That this changing face of the industry was not yet registering with the public is clear from a 1906 article in American *Vogue* about the rose harvest in Grasse in southern France. The writer saw it as an Arcadian experience, a pastoral idyll in which 'hundreds of women and children, in their picturesque national costumes, gather the blossoms of the flowers, merrily chatting and singing at their poetical task'. The journalist then equated each flower to a fairy or elf containing a spirit which might be captured and trapped in a bottle for the consumer's delight – a firefly of fragrance. Of course harvests continue to this day – rose petals are subjected to solvent extraction to produce absolute – and these sorts of 'romancing the perfume' articles are still written, as the idea is so compelling. But in this first decade of the century, the old style of floral perfumery – of stephanotis, heliotrope and verbena – was about to make room for some altogether more exciting fragrances. And they would cause a stir without their fans being any the wiser about the industrial manufacturing facilities whence their ingredients emerged.

Le Parfum Idéal

BY HOUBIGANT, 1900

THE QUEEN-BEE PERFUME

AT THE END OF THE nineteenth century a tribe of über-stylish young women called the Gibson Girls came to represent fin-de-siècle good living. The lightly satirical pen-and-ink creation of American artist Charles Dana Gibson, the Gibson Girls captured the vivacity of a new generation, freer than their predecessors to lark about and break gentlemen's hearts. Gibson Girls were proto pin-ups with Barbie-doll figures, boasting tiny waists and arms, and improbably enormous boobs. Their shape was supposedly down to their sporty pursuits but really came enhanced by the fashionable swan-bill corsets of the time. And that Edwardian hair! Their top buns were so bouffant, they could have stored a packed lunch in there.

The Gibson Girls appeared so effortlessly cool, one might have thought they would be up for a friendly game on the tennis court, but look closely and they invariably bore a dismissive, too-good-for-thou expression. In other words, they were rich bitches. The best of the cartoons showed the girls in packs, torturing their male admirers with a 'Who, me?' smile, or prodding a Tom-Thumb-scale man with a pin. There is a wonderful example called 'Love in a Garden', in which one

13

girl, impeccable in pressed whites, instructs five lovelorn specimens to tidy up her lawn. One is staring at her gormlessly, not noticing his mower is crushing some terracotta pots. Another duo are too enamoured to realise they just planted a tree upside-down.

The Gibson Girls soon moved from their newssheet beginnings to become a merchandise phenomenon, their faces popping up on porcelain plates, tablecloths and ashtrays. If she could be deployed to sell a colander, imagine the power a Gibson Girl would bring to a bottle of fragrance. That scent was Le Parfum Idéal.

This 'Perfect Perfume' came from Houbigant, a French house with an enviable aristocratic heritage dating back to 1775. Rumour, or sales copy, had it that when Marie Antoinette attempted to flee the Jacobins in peasant clothing, she was detected, and captured, because of the wafts of Houbigant fragrance coming from her person. Houbigant had survived the revolution and were now patronised by the Tsar and Tsarina, and most of the Russian nobility, whose grace and favour were critical to the success of the industry. With such illustrious customers, the pressure to produce something special must have been intense.

Le Parfum Idéal was one of the first major launches of the twentieth century. It had actually been created a few years earlier but had its unveiling at the 1900 Exposition Universelle in Paris as *the* fragrance for the new era. As the biggest ever global trade fair – with eighteen dazzling sections, show-villages for each country, and the Eiffel Tower as its main entrance – the Exposition Universelle attracted millions of visitors, swelling the population of the capital by 7 per cent. Alongside the first public demonstration of escalators and magical, electrical light displays, there was a substantial focus on the emergent art nouveau movement in arts and crafts. All the perfumers who mattered had jostled to showcase their wares in themed pavilions commissioned from the most fashionable architects available, including Hector Guimard, who had just unveiled his new Métro designs. There were arbours, frescos and fountains galore, all intended to make the displays of perfume bottles a bit more thrilling, especially given that down the road visitors could watch the first ever film recording with sound.

Le Parfum Idéal was Houbigant's crowning glory. Its cut-glass bottle, designed by Baccarat in their signature decanter style, was housed in an ornate box patterned with oriental-rug motifs. It was finished off with a glinting golden label on which could be seen a Gibson Girl in profile, sniffing a flower and looking delighted. This fictional, generic ideal of beauty had become the face of a product, as vivid a brand ambassador as a real celebrity. As *Vogue*'s beauty writer reminisced years later, in the 1930s: 'The very thought of that golden lady on the label makes us break into nostalgic memories of the day when a bottle of "Idéal" occupied the place of honour on the dressing table of our mama.'

The perfume itself also evoked an ideal; it smelt of the perfect flower – not one particular variety, but a bouquet. 'Millefleurs' fragrances had been a common conceit through the nineteenth century, but relied upon the available glut of natural materials. Le Parfum Idéal, in a celebration of technology, stood above the others by the inclusion of some of the exciting new synthetic ingredients on the market. And, for the wearer, Le Parfum Idéal offered a certain opacity. It was difficult to deconstruct the scent and pinpoint exactly what it was, and that was the point. This was fragrance as artistry and mystery, something far beyond what the wearer could create for themselves from a Victorian recipe, and therefore most deserving of its outrageous price tag. That shining Gibson Girl seal was the flourish to complete the sales pitch, an irresistible suggestion to women that they too could use scent to prolong their charms – the queen bee once more.

Le Trèfle Incarnat

BY L.T. PIVER, 1900

THE ARTIFICIAL PERFUME

'NATURAL VERSUS SYNTHETIC' IS A perennial argument in fragrance. It is fairly common to hear people say that they like only natural or organic perfumes, not 'those nasty chemicals' you get nowadays.

Three distinct concerns are at play here. The first relates to a preference for simplicity, for the reassurance of the one-note Verbena Cologne and its clean lemon-balm tang, instead of the muddle of a more complex list of ingredients.

The second comes from the joy of having a perfume that smells like a carbon copy of its counterpart in nature, whether that be the tea rose or the mandarin. Conversely, it is certainly true that some perfumes smell 'chemical' and nose-tingling, which does not necessarily mean they are more contrived than others, but that their aroma is interpreted as 'fake' rather than 'natural' because it is too redolent of cleaning products, cheap toilet sprays and other functional nasties which we might not like to associate with fine fragrance.

The third concern relates to synthetic materials and taps into equivalent anxieties in skincare, fabrics and food – that natural is authentic and gentle, whereas synthetic is harsh, toxic and irritating.

Truth be told, everything is a chemical, and in any case the situation is becoming even more nuanced; these days natural materials sometimes have parts of their molecular composition removed, taking potential allergens with them.

Back in 1900, most people didn't have a clue about synthetic molecules, even as they bought bottles containing coumarin or ionones. These new materials had only been incorporated into perfumery for fifteen or so years, and customers would never have dreamed that their fragrances contained anything other than extracts of flowers, fruits and woods. When Le Trèfle Incarnat ('The Crimson Clover') was launched at the Paris Exposition Universelle of 1900 (having been created in 1896), only the trade discussed its composition, but they did so keenly as they were very impressed by its invention. For L.T. Piver's creation was absolutely the child of scientific progress, and it was bold of the perfume house to embrace these new possibilities rather than remain in the conservative past.

The base, a fougère (fern) – itself an imagined smell (not many ferns have an aroma) – was introduced using the brand-new isolate material called Amyl Salicylate to give a spicy, mowed-lawn scent. With an aroma that blended hay, bergamot and herbaceous lavender, Le Trèfle Incarnat, helped along by its lucky motif of the clover, became a smash. It offered a novel smell that was exciting but reassuringly couched in the language of the great outdoors – the grand Edwardian tradition of picnics in the meadows. Imagine, as a woman, having been stuck with the same scents for years, only to be suddenly offered a new choice; it must have been like an original dress style arriving out of the blue. Within just a few years the name 'Le Trèfle Incarnat' entered common parlance, as though it had always been there. It had slipped into the canon beautifully.

Le Trèfle Incarnat was not, however, without controversy – tprecisely because it was so distinctive. In morally uptight circles it was viewed as deeply suspect. Its synthetic ingredients may have passed under the radar, but its not-quite-placeable smell, coupled with its popularity among good-time girls, gave the fragrance a reputation

as being 'artificial'. In Berta Ruck's popular novel of 1915, *Miss Million's Maid*, a life-swap romp about a maid and her mistress, this unease is particularly well expressed by the more chaste of the two women, Beatrice, who is trying to rein in the newly discovered frivolity of her former servant, Million. As she follows Million into a frenetic restaurant, Beatrice is hit with 'a waft of warmer air' which carries a clash of aromas: 'of coffee, of cigarettes, of hot food, and of those perfumes of which you catch a whiff if you pass down the Burlington Arcade'. Discerned in the melange is lilac, opoponax, 'Russian violet' and Phulnana – a famous perfume of the firm of Grossmith – together with the 'most penetrating, most unmistakable of all the scents; the trèfle incarnat'. Bitingly, Beatrice notes that, actually, a *true* lady should need hardly any perfume to maintain her visage.

Several other popular English novels also incorporated the scent, especially to evoke the seedy vibes of Piccadilly nightlife. In Compton Mackenzie's 1912 work *Carnival*, about a dancing girl in London, the down-at-heel venue that is the Orient Palace of Varieties reeks of it: 'Above all the frangipani and patchouli and opoponax and trèfle incarnat steals the rank odor of goats.'

And in *Diamonds Cut Paste*, an otherwise forgettable 1909 tale from husband-and-wife team Egerton and Agnes Castle, Le Trèfle Incarnat is described as a pollutant taking possession of a room and 'overpowering the breath of the wholesome flowers'. One upstanding woman remarks to her acquaintance, 'You don't know Trèfle Incarnat? It shows what high-class moral circles you frequent. My dear, it's just the kind of thing that catches you by the throat at certain hotels and restaurants – it just floats down the river on Sunday afternoons.'

Floating down the river in a boat for some naughtiness? Where do we sign up?

Climax

BY SEARS, C. 1900

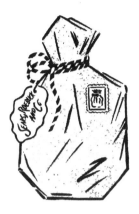

THE MAIL-ORDER PERFUME

IT IS NATURAL TO ASSUME, given that nearly all the famous and sur-
viving fragrances of the early twentieth century came from luxurious
French houses, that perfume circa 1900 was a rich person's game,
neither affordable for nor desired by the hard-working man or woman.

But no. The mass market in 'fancy goods' was thriving, particularly
in America. It is just that, because the products were rather run-of-the-
mill, they have been all but forgotten. It is quite astonishing to think
that in the early twentieth century the firm of Colgate sold hundreds
of varieties of toilet water (and we complain that there are too many
perfume launches today). Richard Hudnut, the first major cosmetics
manufacturer in the US, had been selling scents to the middle classes
since 1880 in pharmacies and general stores, his offerings including
Queen Anne Cologne and Violet Sec. There was also the well-known
Frederick Stearns & Co. from Detroit and the California Perfume
Company, later to become Avon.

The retailer that arguably did more than anyone to popularise
perfume at the beginning of the twentieth century was Sears (later
Sears, Roebuck). Richard Sears launched his mail-order catalogue in

Chicago in 1888 at the perfect moment. New railroad infrastructure now connected the huge terrain that was North America, turning the national distribution of goods, formerly a logistical nightmare, into an entrepreneur's dream. Initially he offered watches by mail with the promise to bring quality goods to all parts of the Union, a money-back guarantee and, from 1896, free rural delivery. Very quickly he developed his business into a twice-yearly publication selling much more than timepieces. Sears expanded into spices, utensils, clothes, baths, farm machinery, curtains, even house-building kits. It was more a case of what wasn't in the catalogue than what was, which meant that Sears acted as a huge leveller. The company were able to convey the same commodities to customers no matter where they lived. From East Coast to West Coast, families were ordering the season's fashionable dress materials or the newest patterned wallpaper, sold to them through textured sample inserts. Or indeed, procuring Sears' Tea Rose perfume.

Sears' success was as much down to their tone as their product range. Instead of an army of sales agents, each with their own style of selling (as was the case with the California Perfume Company), the Sears catalogue spoke with a single unifying voice. It was passionately on the side of the consumer, bringing them the keenest prices possible and importing directly, with no superfluous middle-men. Sears demonstrated their dedicated fervour through a reckless use of shouty upper case: 'THERE IS NOT A TOWN IN THE UNITED STATES WHERE WE HAVE NOT SOLD GOODS... DISTANCE CUTS NO FIGURE.' They even employed an illustration of Lady Justice blindfolded, to bring credence to the 'Policy of Our House', as though the catalogue was actually a redraft of the Bill of Rights.

Crucially, Sears the shopkeeper was figuratively blind. Customers too embarrassed to buy particular products in a local store, where the town gossip might be listening in, could be assured that Sears' service was anonymous and discreet. This, arguably, meant that any woman who did not want to be seen to be interested in perfumes and beauty products could secretly indulge her private fantasies and order as

many as she desired from the pages of the latest catalogue. The pagination of early editions bears this out: in 1897, for example, the perfumes appeared next to the blush-inducing, hush-hush contraceptive aids. Two years later they were to be found next to cosmetic preparations such as the Secret de Ninon freckle treatment and arsenic complexion wafers. And in 1900, they were given their own 'department' within the catalogue, earning additional column inches as demand boomed.

So familiar must readers have been with the kinds of perfumes on offer that Sears often listed a few varieties, such as New Mown Hay and Lilac Blossom, followed by an 'etc. etc.', as though saying, 'You know the drill.' Prices started at just 25 cents for a small bottle ($7 in today's money), but Sears' offerings were 'the usuals', no different from what Hudnut or Colgate were peddling. Yet Sears made the most of their standard range by offering a bewildering hierarchy of enticing packaging grades to create a point of difference. Instead of eau de toilette versus parfum, it was 'Triple Extract' in the simple, pourer bottle, through to 'Seroco' (which sounded Italianate, but was an acronym derived from Sears, Roebuck and Company), the priciest and most prestigious. In the middle sat the 'Climax' option. Was this why the perfumes were next to the sex aids? Was Sears' Climax Ylang Ylang an elixir of love, an aphrodisiac? Well, potentially, and we have to see this titillating language as another instance of Sears deploying hyperbole to stir excitement among readers. However, on perusing the catalogue more closely, it soon becomes clear that the word 'Climax' was applied all too freely to products in and outside the bedroom. There were bamboo rods called Climax. There were buggies called Climax. And, yes, there was a loo roll variety called Climax.

Perfume was becoming bog standard, and for that we have to thank Sears.

Mouchoir de Monsieur

BY GUERLAIN, 1904

THE FLÂNEUR'S PERFUME

WITH MY IMPECCABLE FRENCH, I used to assume that Mouchoir de Monsieur translated into English as 'Mister Moustache', which would be a fabulous name for a cologne, and which is offered now to enterprising readers wishing to launch a new brand. The correct nomenclature is, instead, 'Gentleman's Handkerchief', which spawns its own flights of fancy, as though our man is going to throw down his square in the warm-up to a duel, or might wave it in a lady's face to seduce her. Where he might keep said hanky about his person is not for us to speculate.

The name, alas, is actually quite prosaic: many liquid perfumes of the nineteenth century were handkerchief scents. For Regency men and their successors, perfume was normally destined to be dabbed onto a piece of material which could then be brought close to the nose in circumstances of noxious airs and pollutions (that, or lots of men were still clutching their childhood blankies).

Of course, the fragrance was pleasurable in its own right, not just a high-class version of Dettol. By the early 1800s, the perfumed hanky was a ubiquitous accessory among gentlemen concerned with

immaculate self-presentation, and was occasionally mocked by social commentators. One satirical cartoon of around 1819 shows a beanpole of a dandy in distress who has dropped his perfumed kerchief onto the pavement. Because of his ridiculously tight clothing, he struggles to bend over and retrieve it, contorting his body so that he is almost doing the splits, and becoming the laughing stock of bystanders.

Mouchoir de Monsieur was produced in 1904, in the twilight of the handkerchief era. Rather than promising an exciting new concept, Guerlain were making a nod to the English fragrance tradition, creating their own French version of a classic whilst referencing their earlier output, Jicky. By the belle époque, that leisurely class of men about town – Guerlain's ideal customer – were more commonly identified as flâneurs, which translates as 'strollers' (if you're feeling kind) or 'loafers' (if you're not). They had a hard life, seeking out the passing pleasures of the boulevards, wandering into a show, then a café, then witnessing some street scenes that they would keenly convey to the world in their journals and letters. Flâneurs strove to maintain their separateness from the raw life they observed before them, so as to more fully experience that strange feeling of alienation. Mouchoir de Monsieur made an ideal accomplice on these dawdlings around Paris. Like Le Trèfle Incarnat, it was based on the fougère fragrance, that approximation of what a fern might smell like, created through a balance of creamy-smelling coumarin and campherous lavender. Yet it also had a typical animalic dirtiness beneath ('animalic' scents being derived from animals, or plant materials like the musky ambrette seed, which have animalic characteristics). In forging a connection with the filth of urban living, as with other fragrances of its era, Mouchoir de Monsieur parallels the flâneur's dalliance with the experiences of the masses, while always reminding the wearer that they had pots of money and could escape to their nice rooms any time they pleased.

L'Origan

BY COTY, 1905

THE BEAUTY-HALL PERFUME

BUILDINGS THE SIZE OF A city block. Mannequins, dressed in the latest finery and furs, beckoning passers-by from behind gleaming glass. Space, mirrors, steel. Afternoon tea accompanied by string quartets. Cooking demonstrations. Fashion shows and tableaux vivants of exotic Eastern scenes. More, more, more.

By the first years of the twentieth century, retail was riding high on the coat-tails of department stores, which were mushrooming in major cities and turning shopping into a leisure activity, to the vexation of traditional small-scale shopkeepers. With products now zoned by category, perfumes were given dedicated, roomy sanctums of their own. One of the most famous of the grand emporiums – Selfridges in London – strategically placed perfumes on the ground floor in 1910, where they remain to this day, capitalising on the way a good smell can lure customers inside. In Zola's novel of 1883, *Au Bonheur des Dames* (*The Ladies' Paradise*), store manager Octave Mouret cleverly has a fountain of violet-scented water installed on the shop floor to coincide with his linen sale, in an early example of scent marketing.

François Coty, a pugnacious entrepreneur from Corsica with a

keen nose, was the man who established the blueprint for perfume brands in the department-store era. His interest was first piqued at the 1900 Paris Exposition, where, gazing at the latest glassware designs from Lalique and Baccarat, he understood the appeal and power of a beautifully tailored bottle. He also spotted the opportunity to craft olfactory effects from a much wider range of scents by playing with some of the whizzy new synthetic materials and bases made by the larger manufacturers. Coty's intuition was about to make him a lot of money – the equivalent of billions of pounds – and turn him into one of the richest and most high-profile men in France. With a chemist in tow and serious pitching skills, he managed to get Lalique on board to create his flacons and one of the big chemical companies to help him with his formulations. Then there was his wife Marie, who was put to work designing the finishing touches and trimmings. Coty succeeded where others had failed because of his ability to create scale, to turn his precious jewels into products that could be replicated and shipped worldwide. The opening of his own vast manufacturing plant, known as la Cité des Parfums, was the sign that an empire had been made.

Legend has it that, in order to get an audience with the management at the prestigious Les Grands Magasins du Louvre, Coty staged his own theatrical intervention, smashing a bottle of La Rose Jacqueminot on the shop floor, whereupon women came over like bees to honey, demanding to know what it was and how they could get hold of it. Some accounts say that Coty planted the women on the shop floor or that he fabricated the whole tale. Others say that his wife, who had a floristry concession in the shop, dropped the bottle by accident or on his behalf. Maybe this story has become so over-baked because it helps us to point to a moment in which modernity 'happened', as opposed to the slow, indefinable transition that really brought it about. Even if true, Coty's origin story doesn't really tally with the brand's early trade in America. One of the first retailers to promote their perfumes was Schramm's prescription drugstore in Salt Lake City in 1905, which was as far from the glitzy department-store world as it was possible to get.

La Rose Jacqueminot itself was a triumph; a rich, resonant take on the scent of rose – paired with violet – that must have played as if coming out of a shiny new gramophone. The house of Coty quickly made a reputation for themselves worldwide and were soon being listed alongside products from much more established houses such as Roger & Gallet and Houbigant.

Coty's all-star line-up, his perfumes of 1905 to 1925, have a deserved reputation as the jazz standards with which, according to perfume historian Denyse Beaulieu, other perfumers could riff to produce their own great works, notably Jacques Guerlain. Coty's Chypre enabled Guerlain to create Mitsouko; his Emeraude of 1921 was the bedrock on which Shalimar was built, and L'Origan became the godmother of L'Heure Bleue, also by Guerlain.

L'Origan pretty much began the category of the 'floral oriental', a binge of polleny orange flower, nutmeg, cloves, vanilla and incense. A laden, prima donna of a scent, it speaks of night-time bewitchment and assignations in the back of a carriage. Once out on the market, Coty's perfume just kept on selling: by 1919 it was making the equivalent of $6.7 million per year. And L'Origan was such a hallmark because, as well as being available as an extract and eau de toilette, it was used to fragrance numerous other products, becoming the smell of the pursuit of beauty itself. In particular L'Origan went into an early deodorant powder – the aroma of dusted armpits – and, later on, Coty's famous Air Spun face powder, bought by millions more women to keep the pesky midday shine away. Which raises the question: if we were to encounter L'Origan today, in its original glory, would it smell of powder through our reading of the fragrance on its own terms – dusty and soft – or because, well, face powder smells just like L'Origan?

Shem-el-Nessim

BY GROSSMITH, 1906

THE ARABIAN NIGHTS PERFUME

OPEN UP A WOMEN'S MAGAZINE during the belle époque and, somewhere in the classified section, readers would find a small, enticing advert for the predecessors of L'Origan: 'oriental' perfumes. This was a term so overused that it was deployed to flog half the goods in the shops. You think department stores today go crazy with their merchandising? Try 'Gardens of Allah' fashion shows for size, or floors transformed into ancient Eastern temples.

In the late nineteenth and early twentieth centuries, 'oriental' described pretty much any scent that promised to make you swoon with its intensity, typically incorporating rich, ambrosial materials. With their mysterious, dense formulae, they were sometimes touted as being for 'complex' women (as opposed to 'fastidious' women, who would get on better with a single-note floral). They were often employed in one's living quarters to produce an intangible sweetness that could not quite be traced and so were also bought as silk sachets to be hidden in upholstery or dropped into the bottom of a vase, no doubt to be forgotten.

'Many women love sweetness not because they think it is the

proper thing, but because they cannot help it,' declared an American *Vogue* perfume editorial in 1899, positioning oriental scents as utterly compulsive purchases for the fairer sex. Indeed, the many brands that sold them routinely depicted the sniffer lounging on a couch and being transported into a reverie, as though drugged. English firm Grossmith's Shem-el-Nessim, named after the Ancient Egyptian fertility festival, was 'a dream of a fragrance, exquisitely suggestive of oriental luxury'. Its artwork showed an androgynous genie girl slumbering as a cloud of perfume or a dream-bubble floated above her head. There is something decadent in this suggestion of being spirited off to magical places, of women wasting away in stifling clothing in their drawing rooms, at risk from the opiate-like fug of these scents.

One antagonist of the indolent perfume lover was Bernarr Macfadden, American founder of the Physical Culture movement. Terrifying in his fervour, Bernarr launched an early exercise-equipment shop by London's Fleet Street. He also produced *Physical Culture*, a magazine espousing the views of his mini-empire, which eventually changed its name to the more appealing *Beauty and Health*. To modern eyes, the contents look none too inviting. Along with photo stories of toddlers lifting weights, the publication exhorted readers to abandon their corsets (all well and good), and to stop playing the piano (not so good), which was never going to get them a husband. Women who allowed their muscles to waste through unhealthful pursuits were to be pitied. Why? Because they would not have enough strength to enjoy 'sexual vigor', as practised – of course – by married couples, leading to the propagation, in the words of the magazine, of 'a master race'.

For devotees of Physical Culture, fragrances, even light ones, were de trop. Along with cosmetics, even the lightest scent was associated with women who, according to Macfadden in one of his tracts, were:

crooked-backed, stooping, too fat unless too lean, with their breast bones caved in ... faces painted besides. What a damaging confession that they need to paint? Yet how awfully they look without, and even with. And they use cologne in addition, thus telling us all

within smelling distance that they lack that balmy perfume which is coincident with normal health.

Shem-el-Nessim, launched in 1906, will not have gone down well with the *Physical Culture* gang for it is a gloriously marzipan-esque scent which gives the feeling of golden shimmer falling softly on the skin. This is no outdoors number, belonging firmly in a locked room, far from prying eyes, in which one may 'laze about' while pouring endless glasses of sweet sherry. Thankfully, after decades in the wilderness, Grossmith staged a recent revival and introduced once again – with some modifications – their heritage fragrances, so that Shem-el-Nessim may be enjoyed with nary a dumb-bell (nor Mr Benarr Macfadden) around to spoil the experience.

Après l'Ondée

BY GUERLAIN, 1906

THE PURPLE PERFUME

THE SMELL OF PARMA VIOLETS is contentious. Those who have grown up in an era of party bags may remember going home, sick from too much time on the bouncy castle, and expectantly reaching inside, between the slice of cake and balloons, for a pack of Love Hearts, only to pull out a tube of violet Swizzels. A truly disheartening moment.

Parma violets are impossibly nostalgic and so weighted with associations of old dressing tables and grandmas in rocking chairs that it is almost impossible to smell them afresh. If only we could, violets would seem wondrous and otherworldly, for there is nothing like them.

In the Edwardian period, you couldn't move without being assaulted by the scent of violets; anyone who detested it would have found the era trying. It really was a moment of floral asphyxiation. Every fragrance house had a new violet scent in the works at any one time. There was a hard commercial rationale behind this proliferation: whereas natural violet was increasingly scarce and costly, synthetic versions were suddenly very cheap to produce and would fly off the shelves with a tidy profit. This was down to the recent discovery of

chemical compounds that bore a remarkable similarity to real violet – ionones. The very first in the new wave of synthetic violet scents had been Roger & Gallet's Vera Violetta in 1892. By 1910 there were dozens of them.

As well as dabbing oneself with a violet perfume, one could ingest violet cream chocolate thanks to Charbonnel et Walker or a small tot of violet liqueur, the latest craze from France. Face powder was scented with the flowers. Homes throughout the land would have them potted on tables, and when it came to a Valentine's bouquet, there was only one flower to use. Violet was a very fashionable name for new babies; even clothes were looking suspiciously purple all of a sudden.

Most of the dozens of violet perfumes of this period would have smelt near identical, but one of the best, for sale to this day, put the violets in relief with other materials, to create something more imaginative. It was called Après l'Ondée, 'After the Rain Shower', to suggest a scene in which the garden flowers are still dripping and there's a freshness in the air. Alongside the violets is a chilled spiciness from anise (think sambuca) and an uplift from bergamot, a play of light and shade. We can imagine an Edwardian beauty desperate to host her garden party after it has been pouring, making everyone go outside even though hems are going to get dirty and it will be freezing. This is the fun in Après l'Ondée. When violets had otherwise got into a dead-end rut, Guerlain understood how to elicit purple prose from the wearer, prompting a sense of reverie and contemplation. Most importantly, the perfume house knew that there would be a crucial question for any perfume enthusiast: 'I wonder what inspired the name?'

Pompeia

BY L.T. PIVER, 1907

THE HOODOO PERFUME

A PERFUME CALLED POMPEIA IS a tantalising proposition, suggesting the aroma inside an excavated amphora, trapped under ash for two thousand years but containing precious preserved elixirs. There is something covetable in the idea that with a dab of this on the décolletage one might suddenly receive a glimpse of an ancient civilisation and the past life of a wealthy woman who tragically died in the eruption.

Our own era's obsession with Pompeii pales in comparison with the furore that preceded the launch of this early-twentieth-century scent. By then, the city was already a well-trodden tourist destination and something of a cliché (though the erotic murals had been spirited away from public gaze), and Edward Bulwer-Lytton's 1830s romp *The Last Days of Pompeii* was about to be made into no fewer than three films. These followed an infamous stage production of the 1870s, which was its own natural disaster: some of the acrobats fell onto audience members from on high, and the volcano broke.

So, was this new scent re-created from a pot of fragranced oil discovered intact by archaeologists in a buried villa? Sadly, no. Many of the containers once thought to have held perfume more likely had

fish sauce inside. The 1907 Pompeia was actually a patchouli and rose cologne that combined some of the same materials used in L.T. Piver's earlier hit, Le Trèfle Incarnat. It may have featured a picture of a Roman lady on the bottle, but that was as close as it got to the world's most famous ruin.

However, L.T. Piver do feature in a beguiling archaeological dig of their own. As one of France's premier fragrance houses, their products were much in demand throughout the Western world – an essential export of Parisian haute luxe. Remarkably, they had a hundred retail outlets, including a substantial presence in the United States. New Orleans, with its French heritage and position as a wealthy port city, was in receipt of many of their luxury goods. But one consignment never reached its destination: in 1865, the steamer *SS Republic* foundered in the Atlantic en route from New York to New Orleans. Nearly a century and a half later, a marine excavation dive found on board fifty stoneware cosmetics pots bearing the Piver branding, destined for the belles of the town.

In a moment of serendipity, the popularity of continental perfumes such as Pompeia in the southern states of America coincided with something from another world entirely: the emergence of New Orleans hoodoo and Haitian voodoo. These parallel strands of folk magic emerged from African American culture in the Mississippi Delta by way of slave routes from West Africa. Hoodoo originally offered its followers a means of feeling that they could control their luck and success. High-stakes gambling dens became a natural home for hoodoo spells and lucky charms. Many of these required the making of a concoction that could be sprinkled prior to a game for some lucky mojo, the carrier for spiritual appeals to unseen gods. One recipe for a homemade version invites readers to boil a cat alive, after which they are instructed to grind the shoulder bone into 'Black Cat Dust'. This might then be stirred into a bottle of Jockey Club, a fashionable fragrance of the nineteenth century and, later, a favourite of JFK's.

Like Jockey Club, Pompeia, because of its local availability, became one of the principal 'spiritual colognes' of hoodoo. By the middle of

the twentieth century L.T. Piver had suffered a decline in fortunes and change in ownership and Pompeia then became available from botanic magic stores in a cheaper reformulation of the original as well as in 'lotion' form. It is still in use today. One hoodoo manual proclaims Pompeia to be the preferred perfume of Damballah, Sky God and Creator of Life, and suggests offering him an egg washed in Pompeia Lotion and placed on top of a pile of flour. Guidance on drawing a 'psychic power bath' involves infusing the water with devil's shoestring (vernacular for a species of the honeysuckle family) and Pompeia. To this day, the lotion is sold on eBay for thirty dollars, as part of a hoodoo kit, in a plain bottle (though the Roman lady remains on the label). The original 1907 Piver scent packages, including beautiful talc boxes in high belle époque style, are collectors' items, the perfect place to keep expensive jewellery.

Fragrance is one of the most tightly controlled luxury commodities. Brand owners rule with an iron grip to keep the right sort of customer buying their offerings in the right sort of stores. But sometimes a perfume breaks free into a new realm in a way its creators could never possibly have conceived. There is something delicious about a scent that began life referencing one culture being appropriated by another altogether.

American Ideal

BY CALIFORNIA PERFUME COMPANY, 1907

THE HOME-GROWN PERFUME

YOU MAY BE FORGIVEN FOR thinking that American Ideal has a remarkably similar name to Houbigant's Le Parfum Idéal from a few years prior. You would be correct, for there is something of the Old World versus the New World here.

The California Perfume Company is one of the globe's most famous brands in its post-1939 identity: Avon. The firm was set up in 1886 by David H. McConnell, a bookselling executive who decided to start manufacturing perfumes and cosmetics when he realised that beauty aids were becoming more acceptable and saw the commercial potential in nudging customers to try a bit of rouge. While other fragrance ventures were focusing on exposure in the new department stores, McConnell, like Sears, had a different mechanism for getting into the hearts and wallets of modern American consumers. At the Union Publishing Company he had built up an army of sales agents, initially recruited to flog books and now on hand to do the same for skin creams and toilet waters. They were, by and large, female, educated and driven to earn, and they knew how to sell to other women. They were recruited via classified ads in the local newspapers seeking

'canvassers' and 'active' types, for this was a job of relentless roaming, knocking on doors, and, in all likelihood, being a busybody.

What this sales army brought – with reps as far afield as Atlanta, San Francisco, Dallas and Kansas – was ready penetration across thousands of miles. This was a national movement, and in order to win trust it needed to sell national products.

American Ideal was the California Perfume Company's standard-bearer for home-grown perfumes. Despite being founded on the East Coast, McConnell's business was named after California as a positioning exercise, the 'land of sunshine and flowers', where the finest fragrance materials could be cultivated. The catalogue, known as the *C.P. Book*, went so far as to say: 'California does not produce as many flowers as France, but it is claimed by some that the flowers which it does produce are larger and more beautiful and have more delicate odors.' It was a bit of an 'I'm the king of the castle' moment, and one in the eye for the continent. Even though the California Perfume Company offered a trilogy of French perfumes, these were French in tradition only, not in manufacture. Indeed the *C.P. Book* made great efforts to explain the cost of duty on imported goods, and the economic rationale for purchasing products made in America.

Was American Ideal a blatant copy of Le Parfum Idéal? It is impossible to know, at least in terms of the formulation of the scent. The name was certainly in the zeitgeist, and the bottle bore a similar image of a beautiful girl in profile, just like Houbigant's version. What we do know is that the California Perfume Company used their fragrance as a point of difference, promising it to be 'more concentrated and lasting than any other perfume ever made in this or any foreign country'. Just one drop was said to be enough for perfuming a handkerchief or dress for a week, allegedly because a procedure called 'loading' took place, whatever that was supposed to mean.

We have here a strange combination of transparency and duplicity. On the one hand, McConnell's team offered in their customer literature an incredibly detailed, almost trade-focused run-down on how the fragrance materials were extracted, including charts and tables

that detailed the relative yield per acre, weight and value of various flowers. They talked about their in-house perfumers and their efficient supply chain, which meant high-quality products at lower cost. Admirable stuff. But at the same time, the *C.P. Book* put about the notion that chemical perfumery was inferior to natural and had no place in their business. Yet it would have been almost impossible, even with their economies of scale, for their violet fragrances to retail for fifty cents a bottle had they used only natural violet extract – a prohibitively expensive material. Their New Mown Hay fragrance, too, would probably not have been viable without the addition of synthetics such as coumarin to give the toasted, grassy quality required.

The California Perfume Company started something important: they made fragrance an everyday treat for millions of women. Their aggrandisement of American perfumes might have come across as a little too earnest, but it helped to inspire the next generation of young American women to seek out their fragrance fix from a city across the ocean: Paris.

Peau d'Espagne

THE WANTON PERFUME

PEAU D'ESPAGNE – 'SPANISH SKIN' or 'Spanish Leather' – was already an old-school genre of fragrance when L.T. Piver released their bottled version in 1908 in a return to their origins: the company was founded as a perfumed glove shop in 1769. Curing leather in fragrant waxes had been a central activity of the fragrance industry in Renaissance Florence, so that to many people leather *was* perfume. By the Victorian period, recipes for Peau d'Espagne were in ready circulation, the idea being that households could get hold of the ingredients and make their own mix, in which they would soak strips of leather for a couple of days. These oddments would then be stored flat in drawers to impart their scent to writing paper.

As the belle époque good times progressed, fewer people were blending their own perfumes; they had other things to do for entertainment and the perfume industry was becoming slick at pushing the finished, ready-to-wear products. There were different varieties of Peau d'Espagne liquid fragrances from across the West – from France, Germany, Italy, Russia and the United States.

According to London-based perfumer Septimus Piesse's formula-

tion in his 1857 *The Art of Perfumery and Methods of Obtaining the Odors of Plants*, Peau d'Espagne contained a classic blend of flowers such as neroli and rose, spices (clove and cinnamon), and fresh herbs such as verbena and bergamot. Beneath it all came the murmerings of the animalic materials of musk and civet. The writer and father of auto-eroticism Havelock Ellis remarked that 'it is said by some, probably with a certain degree of truth, that Peau d'Espagne is of all perfumes that which most nearly approaches the odor of a woman's skin'. He doesn't sound that convinced, and if you ever did encounter a woman who naturally smelt of this stuff, you would suggest she find a doctor.

Peau d'Espagne's association with the flesh came, as with Le Trèfle Incarnat, more from its ubiquity. As a generic fragrance type rather than one branded product, the name proliferated as slightly different versions came out from each house, increasingly affordable and widely available. Once it became associated with the riff-raff, however, it was on its way out of fashionable society. Peau d'Espagne soon became a smell that everyone recognised, and which attached itself to insalubrious settings. In James Joyce's *Ulysses*, Molly dismisses it as a lowly scent ('there was no decent perfume to be got in that Gibraltar only that cheap peau dEspagne that faded and left a stink on you'), and across the Atlantic, Peau d'Espagne features in O. Henry's *Strictly Business*, a short-story collection from 1910 of the everyday lives of New Yorkers. In a Lower East Side beer hall, frequented by dockers drinking 'mud honey', there pervades 'the familiar blended odors of soaked lemon peel, flat beer, and peau d'Espagne'. Glamour itself!

Nice girls, we know, wore violet perfumes, but naughty girls, who might end up in trouble, were the ones who wore Peau d'Espagne, peroxided their hair and put belladonna drops in their eyes to make their pupils dilate. Now that connection, and its fragrance, has been all but erased, which is a shame, as it sounds like a very good perfume to have in your toolkit for precisely those reasons. Still, there may be a handful of people alive who, if presented with the aroma, would give you a wink, knowing exactly what it was all about.

The Theatrical Teens
1910–1919

'HYSTERICAL' IS HOW WE MIGHT describe some of the ways in which perfume was used in the years 1910 to 1919. As it became more acceptable to be taking pleasure in fragrance, and to be seen doing so, there arrived all the frenzied activity that comes with a brand-new hobby. Scent was a toy to be played with, its limits tested, and even though most experimentation came from a bohemian minority, such practices were reported in the press as the latest daring jaunts, with a tone that was half scornful, half delighted and intrigued.

One bizarre example came in 1912, when the *New York Times* reported goings-on among smart Parisian ladies looking for 'novel sensation':

Instead of using morphia, cocaine or caffeine, they now employ as a stimulant hypodermic injections of otto of rose and violet and cherry-blossom perfumes. An actress was the first to try the new practice. She declared that forty-eight hours after the injection of the perfume known as 'new mown hay', her skin was saturated with the aroma.

The journalist noticeably omitted a 'do not try this at home' warning, although it is probable, or at least to be hoped, that injecting scent was practised only by the crazed. What stands out is the notion of perfume as an active agent, not just in its seeping through the skin

from the inside out, but in supplying a drug-like hit and thus realising the dreamy stoner imagery cultivated by oriental fragrances in previous decades.

An actress, we're told, was the first to try the new syringing practice, and actresses in general were at the vanguard of olfactory experimentation. In those heady days, fragrance was often considered to be as much a bedfellow of the arts – especially the stage – as it was a commercial enterprise. Diaghilev's Ballets Russes was one of the most culturally significant and notorious companies of the decade, particularly for the pagan shocker that was 1913's *The Rite of Spring*. This new ballet was infamous for its erotic, violent, ritualised choreography of a girl dancing herself to death, cloaked in exotic and otherworldly costumes designed by Léon Bakst and all set to the frenzied, nerve-activating strings of Igor Stravinsky's score. Perfume was a part of the *Gesamtkunstwerk* – this 'total' work of art – and was rumoured to have been sprayed on the stage curtains in order to fragrance the air and get performers into the right mindset. The company had a long-standing association with scent; according to expert Davinia Caddy, the dancers and their ballets inspired several new perfumes during the decade, including Prince Igor, and Un Air Embaumé, both from Rigaud. One critical review of 1915 from the French publication *Comœdia illustré* even described the Ballets Russes' very Russianness as 'a perfume of a particular piquancy'.

They were not the only troupe using their noses. In 1915, the *Washington Herald* reported the goings-on at the Elliott Theater New York, which was staging a play called *Experience*. Each actress was playing an embodied emotion, including Passion and Slander. However, the managers believed that they were performing somewhat 'lackadaisically' and decided to call in an authority on perfumes, Professor Gilbert Roodhouse, to prepare a special fragrance for each of them, designed to correlate with and draw out their emotion. 'If you pick the right one,' relayed the reporter, once more linking scent with drugs, 'your actress will behave like a "doped" race horse at a half-mile track.' Inside every dressing room was a metallic tank with a pump spray

attached, and just before the performance the actresses would take a 'jag', their maids spraying them with their scent for three minutes. Three whole minutes.

Eleanor Christie, playing Intoxication, was prescribed ambergris, the whale emission, and reported success. 'It is as though she has drunk five quarts of champagne, yet she still retains full control of all her senses,' noted the journalist. Frances Richards, as Slander, found that a lemon perfume 'makes her hate everyone when she is on stage'. Florence Short, or Passion, was given frankincense and myrrh, which Professor Roodhouse said was Cleopatra's perfume; he explained that 'she has to drink two glasses of ice water in order to counteract the effects every night when she is through with her scene where she tempts Youth'.

In this decade, live performers were put to work endorsing not just fragrance as a concept but specific brands, an early take on celebrity perfumes, including, as we shall see, Poinsettia from the English firm of Atkinson. We will encounter, too, fragrances inspired by the literary arts, particularly those released by one of the most influential creatives of the decade, the fashion designer Paul Poiret. He also, alongside Bakst, created stage costumes for the Ballets Russes and positioned himself in the eye of the high-art blizzard to offer exquisite, esoteric scents to his well-to-do customers.

The bigger picture, however, shows that fine fragrance was beginning to seep beyond its traditional home among royalty and the aristocracy. Two events accelerated this change. The first was the Russian Revolution, which in one swoop obliterated the Russian royal family, who had been crucial patrons of the industry. The fortunes of one scent, The Empress's Favourite Bouquet, offer the most stark example: originally a bespoke commission, it was transformed and given a new, post-revolutionary identity as Red Moscow, a famous Soviet scent from a state-run perfumery. In tandem, the exile of White Russians to Paris and other parts of Europe brought a wave of perfumery talent (and opportunists) who would come to light up the scene in the 1920s.

The second event was the cataclysmic First World War. It altered forever the alliances, power structures and economies of Europe and, understandably, also closed down much (though not all) of the fragrance industry for a good half decade. The scent production that did continue risked taking on a propagandist edge, as if the very choice of one's cologne could reveal whose side you were really on.

As France was brought low, in America interest was starting to build for the finer things in life, not just scent purveyed by good old Sears, Roebuck, but the proper stuff. American soldiers stationed in Europe were coming home to their girlfriends and mothers with those fancy European perfumes they could still get their hands on, including 1916's N'Aimez Que Moi from Caron: 'Forget Me Not'. In America, it was less a case of remembering, more of finding anew these aromatic delights. When the war was over there was going to be an awful lot of demand, especially from a new generation of women eager for emancipation and excited to find out how perfume might help them express themselves and their aspirations.

Special Nº 127

THE SOCIETY PERFUME

BACK IN THE EARLY NINETEENTH century there was a tremendously fashionable court periodical 'addressed particularly to ladies' called *La Belle Assemblée*, most remembered now for its illustrations of the latest looks, which provide an important record of Regency style. As one of the age's lifestyle bibles, *La Belle Assemblée* persuaded a few perfumers to tout their goods on its pages. Which they did, loudly. Take one advertisement for the lavender water of New Bond Street firm Gattie and Pierce, which featured the illustrated faces of as many royal customers as could be fitted in: His Grace the Duke of Marlborough, the Countess of Darnley, the Countess of Liverpool, and Her Grace the Duchess of Devonshire. As if coming from their very mouths was the declaration: 'Where delicacy of flavour and fragrance of perfume are admired among the ladies, the Treble Distilled Lavender Water stands first to claim the distinction.'

Fragrance companies have long benefitted from their royal connections, and they continue to exploit them. It is an interwoven history going back centuries and not surprising given that for many years the nobility were the only social group able to afford fine perfumes. Much

45

of Guerlain's business in the nineteenth century came from networking within the Russian court, and scents became named after their original clients, such as their Bouquet de la Duchesse de Bedford of 1840 and Bouquet de l'Impératrice of 1853. Over in England, Piesse & Lubin had in the same era been flogging the socialite Baroness Rothschild's Bouquet, and, blatantly, Buckingham Palace Perfume.

There are a few firms whose names instantly invoke the image of a coat of arms and one of them is Floris. Like Penhaligon's and Atkinsons, Floris belong to that cluster of British heritage brands that began by selling grooming aids such as bear's grease and hairbrushes, only later gathering a reputation for their scented waters and colognes. Floris were founded in 1730 by a Minorcan, Juan Famenias Floris, and received their first royal warrant a century later, not for perfumes but for combs. 'By Appointment To' was a critical asset to such houses, helping to legitimise fragrance: if it was good enough for HRH then it was good enough for the rest of us. One of the most productive of royal warrants was enjoyed by the perfumery firm of Gosnell's, which had a close association with Princess Alexandra of Denmark and used it to sell their bottles of Cherry Blossom. Their marketing collateral, such as scented bookmarks, featured not just the royal connection but the image of a young nun with the strapline 'Nun Nicer'. This was a double whammy of prestige and piety (although not too pious: the nun's lips look suspiciously pink, as though she's got a pot of rouge hidden under her wimple).

The trouble was that Alexandra adored perfume so much that royal warrants were being issued left, right and centre. By the early twentieth century, everyone seemed to have them. French firm Houbigant tried to 'claim' her when they boasted that Alexandra's bespoke perfume was their Cœur de Jeannette of 1900.

What Floris did with their Special N°127 was clever, if not unique. The perfume was created originally in 1890 for a Russian called Grand Duke Orloff. Prestigious customers enjoyed the VIP treatment of having their own formulation made up, which would be entered into the ledger book so that another bottle could be mixed when next

required. Each customer had a number. Orloff's was 127. After he died, the fragrance was put on general sale, offering customers the chance to smell as distinguished as a duke but with the understated, terribly British notion of having a numbered bottle, to avoid being too blatant and vulgar. Floris were about to start exporting to the United States, so perhaps they were also anticipating the appeal such noble associations would hold for those keen to be introduced to Old World sensibilities.

Special N° 127 is what you might call a cologne with oomph, a well-crafted herbaceous citrus with a geranium zing that does not necessarily smell distinctive but does smell dapper. The smell, when accompanied by its story, evokes a gentleman at leisure: a morning in town, with a trip to the barber's, a new suit in the offing at Savile Row and the fine prospect of an afternoon at the club with the newspapers. For those of us without such a lifestyle, Special N° 127 can bring an alternative sense that all is well: on a sweltering, melting day, it is just the aroma to combat sweat and fluster.

Narcisse Noir

THE LAWSUIT PERFUME

Narcisse Noir is such a legendary perfume that rare is the person who sniffs in ignorance of her many tales. Even those entering a perfume shop oblivious to the scent's crackling layers of myth will soon spot the mad eyes of the sales manager breathlessly preparing their next disciple for the grand narrative: that this perfume is casually referenced in Noël Coward's play *The Vortex*; that the nuns in the 1949 film *Black Narcissus* went wildly lascivious when they smelt it; that Gloria Swanson purred its name in *Sunset Boulevard*.

By the time you get to smell the thing, this perfume has already taken on the status of a holy relic – to be in its presence is akin to approaching the finger of St Thomas in Santa Croce or the tooth of the Buddha at Kandy. The reaction then is either one of worshipful devotion, or deflation. Many venerate Narcisse Noir; few feel they can wear it or live up to its promises.

Where did this scent come from and how did it become the must-have accessory for the beau monde of the first half of the twentieth century?

Narcisse Noir was the first success of the fragrance house Caron,

founded by the self-taught Ernest Daltroff in 1904, who teamed up with his muse Félicie Wanpouille. Their earliest releases such as Radiant, Chantecler and Isadora did fine, but it took some alliteration and a devilishly suggestive name to push them into the big league (they will feature again over the course of these pages). Narcisse Noir is ostensibly named after the narcissus flower, but a black narcissus? There is no such thing. Like black roses, which have since been bred to satisfy curiosity, there is something tantalising in the idea of a virginal yellow daffodil gone to the dark side, a nocturnal, dusky version of her daylight cousin and, of course, bearing loaded associations of vanity through the story of Narcissus and the pool in Greek mythology. Even the linguistic root, 'narce', means to stupefy, after the flower's narcotic qualities.

Caron certainly did not dispel the suggestion that its eponymous flower might be real. But the perfume actually takes its dense white floral fragrance from orange flower and jasmine, together with musk and sandalwood; sometimes it smells intensely powdery, sometimes oleaginous, as though lubricating the skin on which it is worn.

Though Narcisse Noir is a perfume of the pre-war period, its influence snowballed in the 1920s, when the perfume industry was catering to the sorts of people one might indeed encounter in a Coward play. As drama critic George Jean Nathan put it in his 1926 collection of essays *The House of Satan*, such a tribe had 'elaborate intimacy with various Continental salons and watering-places, passing mention of tennis, cricket, bridge, mah jong, bezique, Russian music, Claridge's, the Embassy Club and Monte Carlo, numerous calls on our old French friend, *chic*, information as to the vogue in Paris parlor games'. Narcisse Noir, risky and elusive, slotted right in among the other exotic accoutrements of this in-crowd.

Having struck gold with Narcisse Noir, Caron knew that protecting the scent's hallowed name would be crucial for its long-term success. Unsurprisingly, in the late teens and 1920s a string of pretenders came along hoping to have a piece of the Narcissus dollar, with ever more creative twists on the concept. Narcisse de Chine by Victor Vivaudou,

Narcisse d'Or by A. Joncaire, Narcisse Royale by Colin de Paris, and Narcisse Blanc et Noir from Morny Frères were just a few.

When trademarks are so critical to the prospects of commercial success, it is not unheard of for perfume brands to behave litigiously. Caron lawyered up against several firms, including Du Moiret for their Moon-Glo Narcissus, and Henri Muraour & Cie for their Narcisse Bleu. The principal complaint, *Caron Corporation v. Conde, Limited*, made it to the New York Supreme Court and became a heavily cited case. Caron, holding the trademark for the complete phrase 'Narcisse Noir', argued that any use of the word 'narcisse' in fragrance from a competitor should be disallowed. The judge recorded their argument as being 'that the word "narcissus" is "suggestive", that it has been used by the plaintiff [Caron] in an "arbitrary and fanciful" sense, and that therefore the plaintiff is entitled to restrain the use of a similar word in a similar sense'. The judge, however, was having none of this and ruled that the 'narcisse' in this phrase was descriptive of a flower rather than 'suggestive' and therefore could be used by anybody.

Caron's strategy had backfired. They had launched 'Black Narcissus' as the bottled essence of this supposed species but were now trying to make out that the narcissus was known as *their* imaginative concept, nurtured by them over the preceding fifteen years (even though other companies had launched Narcisse fragrances before Narcisse Noir). The fictionalised floralcy did not stand up in court.

Caron need not have worried, for who today has heard of Narcisse de Chine or Moon-Glo Narcissus? Narcisse Noir won the fight for our hearts, Caron holds the story, and we live in thrall to its telling.

Poinsettia

BY J.E. ATKINSON, 1911

THE THEATRICAL PERFUME

AN OBSCURE SCENT, THIS ONE, but worthy of our attention as an early example of celebrity endorsement. We encountered the Gibson Girls in the first decade of our tale, and now it is time to meet the Gaiety Girls. Be assured that there are no plans to reference the Golden Girls in the 1980s chapter. Yet.

The Gaiety Girls were a phenomenon of the Edwardian world of light musical comedies. Their home was the Gaiety (latterly the 'New Gaiety') Theatre in London's West End, which specialised in tasteful entertainments full of fizz, fun and frivolity. Think Gilbert and Sullivan meets Cole Porter. Many productions, perhaps a few too many, included the word 'Girl' in the title (*The Earl and the Girl*, *The Sunshine Girl*, *After the Girl*, *The Girls of Gottenberg*) and followed the progress of modern women, usually with an occupation, finding love 'above their station' with plenty of hijinks along the way.

Every musical needs irresistible ensemble choreography, and this is where the Gaiety Girls came in. Gaiety Girls were resolutely *not* of low morals. They may have sung and danced, but this was not a tease act; it was more hand-waving in a line with a cut-out of a

beach behind. Those who made it into the roster did very well for themselves; in an echo of their onstage roles, many girls from non-titled, proletarian families received proposals from the aristocracy and became ladies. The ever so slightly creepy nickname of 'stage-door Johnnies' was given to those who hung about, desperate to make the acquaintance of a performer such as Miss Phyllis Dare.

The obsessive fervour with which the Gaiety Girls were pursued – whether by audiences, who were kept at a distance by the proscenium arch, or by the lords ingratiating themselves backstage – positively gushes out of the pages of *The Play Pictorial* magazine, which each week covered the minutiae of the latest musical entertainments. There were odes to the Gaiety Girls' enchanting beauty, which clearly compensated for a lacklustre script: 'What charms they possess and what charms they reveal!... What care for a plot when such visions of delight are about? Plot, indeed – be hanged...!' Never mind that sometimes the girls' exact identity was 'so difficult to guess, even with the aid of the programme', for their 'appearance on the scene' afforded 'a continual feast for the eye'.

Included in this ogling was an obsession with dress. The Gaiety Girls, naturally, were appealing to photographers, especially when clad in their elaborate themed costumes. Their outfits were described in great detail, which sometimes took up as much space as the main critical review. Take this exhaustive inventory of performer Gabrielle Ray:

A very pretty crêpe de chine mantle, with wide sailor collar at back, cut into points from which hung long tassels, and a chic little coral pink swathed cap. In the juggling duet, she slips off her coat and quick changes into a spangled purple skirt, beautifully embroidered in tulips of all colours. The skirt is elaborately lined with pink gauged chiffon.

Given that the Gaiety Girls were fashion icons to be pored over and emulated, it is no surprise that a fragrance house realised that if readers were desperate to keep up with what Gabrielle Ray looked like,

they might also be keen to know what she smelt like.

In 1911 Ray, Phyllis Dare, Connie Ediss and Olive May were all ravishing in *Peggy*, one of the most popular plays of the pre-war years. With exquisite timing, the Bond Street firm Atkinson released a new scent called Poinsettia, after the crimson Christmassy flowers, and signed the four ladies in an early example of a formalised perfume ambassadorship. Competitor Gosnell had done something similar with their Cherry Blossom fragrance by linking it with Marie Roze and her title role in *Manon*. The French firm Bourjois also enjoyed success with their own tribute to the character Manon Lescaut (there must have been something in the tragic story of this fallen woman that inspired emulation).

As an utterly obscure perfume named after an odourless specimen, a description of Poinsettia's aroma is as lacking as a decent Gaiety script. Our only inkling of its smell comes from the adverts placed by Atkinson's in the London press, which bore the faces of all four young stars in *Peggy*, advising that this perfume had been 'specially created' for them, and that they had 'obtained large supplies'. A first-person quote from Olive May (her unfortunate surname, Meatyard, was understandably not part of her public identity) enthused, 'I am surprised that a perfume of such rare charm and delicacy can be obtained at such a price. Poinsettia is unobtrusive but sweetly all-pervading.' Note how women can enjoy perfume so long as it is subtle enough, not *too much* – a proviso we encounter again and again in the twentieth century – and how much more reassuring this is coming from an acceptable woman of the stage.

While there was no direct reference to the play *Peggy*, readers would have known that this was the season's hot ticket. In the show, Olive May performed one number in which she lassoed a load of chorus boys while singing, 'the beating of a heart and the swish of a lasso are the only sounds one hears on the prairie'. Such swagger must have held an amazing allure for those women just beginning to break free of the propriety and shackles of the nineteenth century, so what tremendous power in her pronouncement that she favoured

Poinsettia! Customers ordering the perfume could even receive, in a special offer, a set of reproduction portraits of the actresses in red crayon, created by the artist Joseph A. Simpson.

Miss May didn't do too badly herself, at least by the sound of it. She quit the stage in 1912 to marry Lord Paget; after they divorced she married once again into the aristocracy to become the Countess of Drogheda. One might suspect that Poinsettia was *not* in her trousseau. This deal was a hard, commercial exchange, and who can blame Olive and friends (or their agents) for cashing in on a mania.

Nuit de Chine

BY PAUL POIRET, 1913

THE FANTASTICAL PERFUME

SOME PEOPLE DEDICATE THEMSELVES TO making life beautiful. With instinctual good taste, magpie tendencies and a flair for colour, they weave painfully exquisite tableaux, defining the look of an era. Paul Poiret was one such person. Closely aligned with the kaleidoscopic aesthetic of the Ballets Russes (and with liberating women from corsets through his draped tunics and pantaloons), Poiret sold fashions, home furnishings and perfumes to some of the world's wealthiest in the 1910s and 20s. The perfumes, however, have disappeared (aside from the very rare and usually empty bottles that surface and sell for thousands).

So ornate were Poiret's fragrances that they almost had the feel of museum pieces that needed to be kept in an alarmed case. Poiret, a keen traveller, was an insatiable collector of decorative objects and held a more nuanced view of the East than many other peddlers of the exotic. Not for him the generic 'oriental' scent; his were specific: Maharadja, Aladin and Sakya Mouni, the latter named after the Buddha. Nuit de Chine, one of his most renowned and made by Maurice Shaller, was poured into a snuff- or opium-type bottle with Bakelite ring handles, the outer box covered with beautiful woven silk. Sometimes the glassware would be

hand-painted by students from Poiret's own school of decorative arts, the École Martine. For the woman or man who had everything, Poiret's perfumes conveyed high luxury and a certain intellectual prowess. Nuit de Chine employed a natural creamy sandalwood and a lick of smoky incense to re-route a European fragrance into something convincingly Eastern, though when smelt today it is uncannily like a bottle of cola frothing with spice and lime (a quality shared by many orientals, including the 1950s perfume Youth Dew).

But there is unusual, and then there is esoteric. Nuit de Chine's flacon bore the ideogram for 'kono' in Mandarin. You have to give an A for effort to the beauty writer of a 1916 feature in *Vogue*, who tried desperately to communicate its meaning to her readers: 'The outline indicates a limited area, the land which a feudal lord could cover with the arms of his retainers. Within are lines denoting the residence of the lord, and the whole character signifies kingdom or country.'

Highfalutin fragrances such as these demanded some serious VIP marketing, and Poiret was master of the launch, excessive to a degree not witnessed again until the 1970s. He often tested out new ideas on his circle of friends, generating buzz before tweaking and releasing them for sale. In June 1911, Nuit Persane, which never made it to market with this name, was celebrated with a '1002 Nights' ball in his garden. Three hundred pals were invited, in fancy dress (they were told beforehand exactly which character they needed to be), for a night of excess, with Poiret lording it over them as a sultan. A report from a later gala gives an inkling of the Poiret beneficence:

He covered the whole garden with a silken canopy held up on poles fifty feet high. Chandeliers and flood lights illuminated the scene. To the music of harp and flute Greek maidens in filmy gauzes danced on the lawns while the host dealt out champagne and souvenirs with a lavish hand.

These souvenirs would of course have included a memento of the fantasy evening: a bottle of the celebrated perfume.

This sylvan account comes to us from Robert Forrest Wilson, a Pulitzer-prize-winning American journalist resident in Paris and the author of the travel guide *Paris on Parade*. Wilson loved covering the circus of the luxury industries and made sure he got access to the creative workshops of as many couturiers in the city as possible. Once inside, well, catty is an understatement.

In describing his interview at Poiret's atelier, Wilson relates his first encounter with the legend – a sign on his door that reads: 'Danger!!! Before knocking ask yourself three times – is it absolutely necessary to disturb HIM?' Upon entering with some trepidation (Wilson already knew Poiret's reputation for rages), there he was: 'Is this the face that launched a thousand ships – presumably all filled with American shoppers bound for Paris? It is a rotund little man before you with a bullet head... hair carefully brushed to conceal the bald areas in the scalp.'

Meow.

Poiret may not have been one of the beautiful people, but his name travelled before him. Strange, then, that he chose to call his perfume company after his daughter – Les Parfums de Rosine – which may have been an error. Not just because it was another brand for customers to get to know, but because Rosine would never become a figurehead with whom to identify, unlike fashion designers of the 1920s and 30s, from Chanel to Lelong, who were stamped all over their own creations. Rosine was very much an enigma, and the same *Vogue* writer who had explained so well the kono ideogram attempted to convey the mystery:

Is she fairy, goddess, or vestal? Our minds, intensely curious, seek to understand this incredible being, who flits along paths flaming with roses and across fields marvelously white with narcissus to steal the secret of their fragrance and bring us back their perfumes, powerful, and intoxicating to the verge of ecstasy.

Rosine was imagined as a lady-adventurer type who had sniffed the fragrant wonders of the world in Baghdad, China and India and was now, having allegedly studied ancient manuscripts for the recipes,

resurrecting them for the purchaser's delight. The backstory was as fantastical as the perfumes, but it may as well have been the truth. For the American readership, newly excited by the world of Paris fashion but learning about this faraway place via print magazines, had no idea who was a person, who was a trademark and who a fiction.

The real Rosine died of Spanish flu shortly after that article was published. Still, her father continued the line throughout the war, as we will see with Le Fruit Défendu, and into the 1920s. But Les Parfums de Rosine would not endure. It was too much, too beautiful, too costly. The vision was a craftsmanship that would struggle to translate into a sustainable and commercially successful business, ready for the demands of mass-production. What is more, the arresting beauty of the material – the bottles, boxes, labels and trimming – eclipsed that of the unseen: the smell of his perfumes. Poiret was, in his formulations and ideas, too far ahead of his time, although, thankfully, one of his perfumers, Henri Alméras, was just getting started and would soon move over to the house of Jean Patou.

In a (very controlled) interview with *Theatre Magazine* in 1922, Poiret spoke beautifully of inspiration:

> I sleep on the grass, and I smell the verdure, the foliage around me, why is it that people always make perfumes from flowers? Why not from these things as well? Surely they are as stirring, as thrilling... these scents of the damp earth and the leaves, the pine trees, the salt marshes, as those of flowers... I have made a perfume even from the plants that grow deep in the sea...

Mossy perfumes were nothing new, but something salty, something redolent of seaweed? Such things would only edge into popularity well into the twentieth century.

The rest of Poiret's story is no surprise. He went bust in 1929 and had to sell his leftover clothing stock as rags. Swept out of the picture by a new generation of designers, his style too ornate and Aladdinesque, Poiret ended his days as a street painter and died in poverty.

Ess Viotto

BY BRONNLEY, 1913

THE WORKING WOMAN'S PERFUME

AN ADMISSION: ESS VIOTTO IS not technically a perfume. Nor – despite appearances – is it an intentional anagram, though its letters do rearrange to give 'Vote Tis So'. These days it might be utterly obscure, but the name Ess Viotto once described an emerald-green bottle of wildly popular scented hand-drops brought to Britain by the soap-making firm of Bronnley and quickly plugged by the *Sunday Times* as a 'universal requirement' for women.

We are all familiar with hand cream and with that accessory of OCD moments, the anti-bacterial hand gel. Ess Viotto had a very particular set of functions, obscure today, to 'slippen' the hands while rendering them fragrant with violets.

For women, of course, the condition of the hands was, in 1913, still telling of social class. Rough, chapped mitts were a clear indication of a life of toil, while soft, slender fingers spoke reassuringly of leisure and suggested that the lady in question had no need to get involved with cleaning dishes, putting laundry through the mangle or plucking weeds. Gloves, worn daily, could mask the truth in most social scenarios, but at some point a suitor was going to want to kiss a hand,

and then the cat would be out of the bag. Think of that moment in *Gone with the Wind* when a beleaguered Scarlett O'Hara, forced to pick cotton in the middle of the Civil War, dresses up in old curtains to ask Rhett Butler for money. She almost gets away with it, until he holds her hands and realises they're as coarse as pumice stone.

Ess Viotto existed, in effect, to soothe the self-conscious by offering an invisible sheath to the skin:

> Are your hands White, Soft and Beautiful, as White and Soft as those of a Baby? If not you can have them so – hands that give a delicate touch, the very essence of refinement – hands that are the envy of every lady you know – and the trouble at arriving at this very acme of perfection – very little.

If we look at the year of its release, 1913, we can see why Ess Viotto was such a well-received product. The Great War was about to begin and with it the turmoil and transformation on the home front that would see millions of young women enfolded into employment, standing in for men now enlisted into the armed forces, whether in administrative, office-based positions or in industrial labour and manufacturing.

Even wealthy women not requiring a paid job might have found themselves left with more of the household chores, right down to chopping the onions, as their maids were diverted to munitions work. On an individual level, it must have been quite a peculiar experience to move from a life of Riley to experiencing all the physical aches and pains of hard graft, as well as the evidence this left on the body. The beauty industry has always been brilliant at turning insecurities into commercial opportunities. Ess Viotto grasped this immediately and responded to (or fuelled) such worries in their advertising campaigns: 'Women who have been working since war began... have been concerned with preserving the smoothness and fine feeling of their hands.'

Ess Viotto's preservative effects lay as much in its fragrance as its skincare benefits. Violet scents, we know, were understood to be

dainty, ladylike and youthful. Here, they provided a trompe l'œil in smell form: the illusion of leisure. The woman of the 1910s could, when out and about, drop on some Ess Viotto and instantly turn her hands into delicately scented objects of beauty rather than rough instruments of labour.

Be gone the smell of grease, garlic and grind, or at least the fear of it. Enter the bucolic, delightful odour of flowers, as though emanating from your very hands, smelling of those golden days of peace and pleasure.

English Lavender

BY YARDLEY, 1799 AND 1913

THE PATRIOTIC PERFUME

Ess Viotto's violet scent was not the only example of a fragrance applied to wartime purpose. In 1915, *The Sketch*, that high-society weekly which a few years prior had been carrying advertisements for Atkinson's Poinsettia, waxed lyrical on the evocative power of fragrance:

> There are some typically English things which bring our much-loved home before our eyes even if our people are in the desert, on the mountain top, in the trenches, or watching and waiting in the big ships. One of them is the scent of English violets, which reproduce in brain-waves the charm of English lanes in springtime.

While neither violets, nor roses for that matter, particularly 'belong' to England as opposed to any other country, amid the trauma of the First World War – with British men flung to the other side of the world in the name of duty – scents like that of violets were heralded as nostalgic gateways back home. Another such aromatic, declared *The Sketch*, was 'English lavender, which conjures up the autumn and late summer joys of our land'. So violet for the year's beginnings, and

lavender for its harvest. Today, a tiny proportion of British fields are dedicated to the cultivation of lavender; but go back a hundred and fifty years and parts of the country, namely a corridor south of London towards Mitcham, and Hitchin in Hertfordshire, were famed for their lavender fields, the English equivalent of Grasse's jasmine. The scene was idyllic, as described in a Victorian edition of *The Farmer's Magazine*:

> In a ride by rail from West Croydon to Sutton, and on both sides, commencing at Waddon, as far as the eye can reach are long narrow strips and occasionally broad expanses of lavender. After a thunderstorm, refreshened by the rain, the colour is deepened and intensified, and the perfume crosses the pathway of the train. When the sun is shining with unusual brightness, anyone standing in the midst of those fields may see the sky reflecting back the colours from the earth, the blue tints exchanged to lavender.

If thinking of lavender and thinking of England, the quintessential lavender brand must be Yardley of London, even though the firm have long sourced much of their essential-oil harvest from overseas. This entry is a (modest) cheat, because Yardley actually began selling lavender soap and waters in the eighteenth century. But in 1913 they relaunched their most famous scent in a new bottle and in the same year appropriated as their trademark Francis Wheatley's cottage-box pastoral painting *Flower-Sellers Group*, replacing the basket of primroses with lavender sheaves. They also had a smart new shop in Bond Street to convert their long-accrued heritage into twentieth-century chic.

Throughout both world wars, when means were reduced and supplies tight, Yardley coolly carried on, offering itself to the beleaguered public as an accessible treat. An extra narrative clouded the first conflict, however, one that we will call 'the cologne wars'. This rather different contretemps was, in truth, fought on a very small battleground indeed, namely the pages of our old friend *The Sketch*. To give some context, when the Great War was finally over, this publication seemed most excited about the fact that fancy-dress balls might now

resume in London.

Turn the pages of *The Sketch* throughout the war years and you would find, in the classified section, plenty of adverts for 4711 Cologne by German company Mäurer & Wirtz, its esteemed heritage dating back to 1799. Alongside Yardley's English Lavender, this was the other perennial of pharmacy cabinets. Particularly at Christmas time, 4711 identified itself with the wartime mood, and aggressive promotions suggested that readers could buy the cologne to relax during times of anxiety or revive themselves from strain. They might also give a bottle to a wounded soldier, especially as this was the one perfume a man might allow himself to wear (according to the brand). But look out, 4711: Yardley was taking up just as much advertising space, both for their lavender water and for their own, home-grown cologne. For let us not forget: Germany and England were at war, and therefore, to purchase German goods was not to be countenanced. *The Sketch* may have been happy to take Mäurer & Wirtz's advertising money, but they were not about to endorse them editorially:

We had considered, and we continue to consider, Eau de Cologne indispensable. What we have parted with, and for ever, is its German connection. There was never any reason why we should have had it; for Yardley's Eau de Cologne has been made here in our own London town for a century, and is incomparably finer in quality than what came to us from Hunland.

That even fragrances were involved in a consumerist jingoism must tell us something about the strength of feeling coursing through society at the time. 'Buy Yardley' was a cry of support for the nation, while a purchase of 4711 was portrayed as a minor betrayal. But forget Yardley's Eau de Cologne. If we were going to get patriotic, the real fragrance to back should have been their lavender. That, after all, is the smell of England's green and pleasant land, and to this day it is still there in the shops, right next to the 4711, hopefully as the best of friends rather than sworn enemies.

Le Bouquet Préféré de l'Impératrice

BY BROCARD & CO., 1913

THE REVOLUTIONISED PERFUME

THIS PERFUME IS FAMOUS, NOT for what it was in 1913, but for what it is understood to have become in 1925. The word is *understood*, because the exact story is somewhat obscure – perhaps even given a little make-over after the event. Le Bouquet Préféré de l'Impératrice ('The Empress's Favourite Bouquet') came from the firm of Henri Brocard, one of the two major perfumeries of nineteenth-century Russia, both of them founded by Frenchmen. The other was Rallet & Co., which was considered to be more upmarket, if only because Brocard, alongside their perfumes, were known for making mass-market soaps, which, sweetly, came with free cross-stitch patterns. Brocard eventually became Europe's biggest soap maker.

The Empress's Favourite Bouquet was, as with so many fragrances of this period (not least Floris'), made for an individual: Maria Feodorovna, wife of Emperor Alexander III and mother to Nicholas II, last tsar of Russia, who'd also had The Czarina's Bouquet created for her by Houbigant.

Has anyone alive today ever sniffed the original fragrance, or got some hidden away in an attic? It is unlikely: just a few years later

came the Russian Revolution, and it was *au revoir* to French perfumes and the perfumers who made them. Ernest Beaux, Rallet's perfumer, decamped to Paris, where he was taken under the wing of Chanel and went on to create N°5.

The firm of Brocard was soon taken over by the state and nationalised first as State Soap Factory N°5 and then as Novaya Zarya ('New Dawn'), while Rallet was renamed 'Freedom'. Any references to empresses were obviously anathema, so the story goes that the essential backbone of Brocard's original perfume was retained, then reworked to allow for synthetic materials and changes in supply, to emerge rebranded in 1925 for a new Russia as Krasnaya Moskva. This translates as 'Red Moscow' or 'Beautiful Moscow'; in Russia the colour red equates with beauty. An updated design identity was adopted, one which worked from the modernist art deco palette and incorporated rousing Kremlin imagery.

As the century and the Cold War advanced, the fragrance industries in East and West ran as distinctly separate machines – Red Moscow versus Chanel N°5 – but having shared a heritage they had much more in common than appearances might allow. Red Moscow is a classic fragrance, certainly not far from an old school Guerlain or Grossmith. It is peppery with carnation and has a frontal zing and spritz from aldehydes, a group of chemical compounds first used in the early twentieth century that give fragrances lift-off – and often a nose-tingling soapiness.

Red Moscow is of huge cultural importance because so many millions wore it when choice was restricted, and foreign perfumes, of course, were not available. In the diary of Elena Skrjabina, a woman living in Russia during the Second World War, there is a moment in which she describes trying to open a cafe in a building formerly used as a perfume shop. Despite being long vacant, the air smells so fragrant that Elena wonders, 'What would happen if all our cakes and pastries were to take on the aroma of "Red Moscow"?' So ubiquitous was this particular make, it became a synecdoche for perfume itself.

There were other fragrances to come from New Dawn. Particularly

in the 1930s, releases came thick and fast, intended to give the impression of bounty, the provision of beauty to all women in the nation. Giving perfumes as a gift even came under the Soviet definition of *kulturnost* or 'cultured behaviour', including to aunts and teachers on International Women's Day.

Some releases during this period were specialist indeed, particularly commemorative perfumes which had an industrial or military sensibility. One was called Belomorkanal, after the construction of the White Sea Canal, and another souvenir from 1941 was presented in a bottle shaped like a tank, complete with gun turrets. Among the most talked about Soviet-era perfumes from New Dawn, certainly in the West, was Experimental Project Apollo-Soyuz, or EPAS for short, named after a rare joint effort in the space race between the USSR and the USA. Mirroring the wider détente, the fragrance was provided by New Dawn in Russia, while the packaging was manufactured by the American firm Revlon. When an American academic of Soviet affairs was asked to try it, he said it was 'characteristically Russian, sweet and cloying'.

His comments, almost anthropomorphising this seemingly inferior product into a cultural stereotype, reflect the also-ran status of Soviet perfumes, which seemingly lacked the subtlety, the costlier ingredients and the artistry of their French counterparts: cheap trash. Such derision was not helped by the fact that one of New Dawn's men's colognes, the famous Troinoi ('Triple'), which was based on a historic Napoleonic cologne, garnered an unofficial use as surrogate booze for down-and-outs. It was as likely to be available at street kiosks as in pharmacies, and tales exist of DIY attempts to crystallise the aromatics to avoid getting poisoned.

Today, New Dawn and their Red Moscow are enjoying a renaissance among magpies of kitsch and those curious to experience Soviet nostalgia second-hand. The empress's former perfume now sells for a few pounds online, undoubtedly not what it once was in terms of packaging or formulation, but most definitely worth a sniff (if not a sip).

Le Fruit Défendu

BY PARFUMS DE ROSINE, C. 1914

THE BEST-NAMED PERFUME

IN THE PERFUME CHRISTENING ANNALS, Le Fruit Défendu, 'The Forbidden Fruit', has to be up there in the top five. Paul Poiret and his Parfums de Rosine, aided by the great perfumer Henri Alméras, plundered the founding myth of Abrahamic religions, Adam and Eve in the Garden of Eden, and endowed that fateful apple (though it may well have been a pomegranate) with a fragrance. This was no Braeburn facsimile, however, more like a Dutch still life of glazed fruits in a shadowy room, smelling of golden, stringy caramel, with the added boozy peach syrup of a Bellini.

The perfume, housed in a glass apple (years ahead of Nina Ricci's version in the 1940s), arguably exemplifies the moment at which fragrance really worked out what it was selling, aside from the scent itself – that stirring feeling that something significant or interesting might be about to happen. Caron's Narcisse Noir had hinted at the possibilities, but it was Poiret who saw that symbolic nomenclature could turn us into frenzied followers, transforming our desire to own a perfume into desperation. The deeply entrenched symbolism of the apple – promising fertility, eternal youth, sin, knowledge – made

sales copy redundant; the narrative was ready made and had been with women since the bedtime stories of their childhood.

Le Fruit Défendu, remarkably, was released during the First World War, when the fragrance industry in France might have come to a juddering halt. While this was the case in the Second World War, in 1914 many fragrances were made on a tiny artisanal scale, just a few hundred flasks, operating outside of the industrial supply chain. Even though the industry slowed down, it carried on in a limited form, catering to the metropolitan rich. So appealing was the idea of this forbidden fruit that according to curators at Paris' Osmothèque perfume archive, some Parisian women accrued quite a reputation wearing it. At a time when their husbands, lovers and brothers were being sacrificed on the front lines, there they were gallivanting around town wearing *this* shocker and applying it towards goodness knows what scheme. To some it seemed as though Eve was back; she had abandoned Adam and was going out with the serpent in her handbag..

There is of course that other fairy-tale myth conjured by this fragrance, that of the Brothers Grimm's Sneewittchen – Snow White. When Le Fruit Défendu was exported to America towards the end of the First World War, a century after the tale was originally published, the story had just been adapted into a quite sinister silent feature film, which etched itself indelibly on the mind of a young Walt Disney. Juxtaposing Rosine's perfume against this cultural moment, which saw a young Snow White gifted a poisonous apple by a jealous Queen, we can understand the true deliciousness of this fragrance as a form of fantasy role-play. The wearer could be both the willing victim of this dripping juice, desperate to be seduced by the illicit, or they could be the Queen, dabbing on the scent to preserve her beauty and exert her power over somebody meeker and more suggestible.

Chypre

BY COTY, 1917

THE CLASSICAL PERFUME

COTY'S CHYPRE IS ANOTHER RELEASE dating from the Great War – according to the perfume house itself and received understanding. But for such a famous perfume, Chypre isn't half mired in fog. The year attributed to this entry is a fiction. What seems to have happened, according to pharmacy advertisements of the time, is that as early as 1909 Chypre (perhaps the same blend as the one for which Coty is known; perhaps not) was introduced to outlets in the United States. It then seems to have disappeared around 1913, only to pop up again towards the end of the decade. It could, therefore, be argued that Chypre really belongs to the previous decade of our century of scents. It is a tricky one, and one of the perils of trying to date a fragrance with exactitude, but, for now, here it stays.

Chypre was a much less tempestuous scent than the likes of Le Fruit Défendu or Narcisse Noir; in its 'greenness' it was cooler and self-possessed. No tantrums here. The generic term 'chypre' was already a long-standing convention within fragrance, drawing on an ancient tradition of perfume-making on the Mediterranean island of Cyprus ('Chypre' in French). This gateway between East and West was

famous for aromatics such as the beautifully sticky labdanum, a dark resin taken from the leaves and twigs of the rock rose, so gummy it would stick to the beards of grazing goats. Over time the name chypre became almost a stamp of approval, as well as a loosely identifiable style. Powdered chypres containing moss, with animalics such as musk or ambergris, were fashionable alongside vanilla and mille fleurs in the eighteenth century, favoured for being incredibly long-lasting.

What Coty did was to take the core assets of the chypre, which had been underexploited, and gave it a revamp, one so successful that this perfume is now seen as the first of its kind. It is always annoying when a perfume gets discontinued, and especially so for Chypre, because it was a reference point for so many other twentieth-century fragrances.

Coty had already given rose a glossy facelift through Le Rose Jacqueminot, got everyone excited again about amber with Ambre Antique, and taken orientals to new heights with L'Origan. Now they offered a bewitching fragrance at once floral, mossy and balsamic, with a moreish bergamot opening: herbal, citric and dry. Coty themselves described the scent as 'amber froth emanating at certain hours from the woods and the forests'. Chypre, with its now distinctive trio of bergamot, labdanum and oakmoss, was like a patch of *garrigue*, wild Mediterranean scrubland, given a onceover with the topiary shears to become the last word in chic. They could have really gone for it with the sell – Cyprus was after all the birthplace of Aphrodite, so there was plenty of material for an overblown representation. But restraint prevailed. There was a hint of the classical association in the subdued sage-green paper covering the perfume box, which depicted Coty's signature motif of classical nude figures crouching over fragrant embers and wafting the vapours towards their faces. Coty did not tend to appropriate other contemporary cultural reference points (unlike Guerlain), but this perfume occupies the same realm as Isadora Duncan dancing barefoot in a Grecian robe (designed by Paul Poiret), or Nijinsky's faun in the Ballets Russes' *L'après-midi d'un faune*, having a wonderful time in the forest frolicking with the nymphs.

Mitsouko

BY GUERLAIN, 1919

THE OBLIQUE PERFUME

'MITSOUKO' IS THE ROUGH TRANSLITERATION of a Japanese female name, and the heroine of a romantic novel, *La bataille*, which is said to have inspired Guerlain's perfume of 1919 – literary references and a penchant for the orient being things Guerlain had in common with Les Parfums de Rosine and Grossmith.

A chypre with peachiness, built on the foundation of Coty's own Chypre, Mitsouko is one of those legendary perfumes which inspires devotion and allegiance, perhaps because it is known for being difficult, revealing its hand slowly, if ever. A quality made even more complicated by the fact that the eau de toilette, eau de parfum and parfum versions are so utterly different.

For this reason, Mitsouko is a heartening scent to wear when alone, or rather, when not wanting to feel lonely. Mitsouko has such presence and personality, it is a little like having talk radio on in the room, providing the consolation of company even if nobody's there – a characteristic, perhaps, of any great perfume. Indeed Mitsouko does, to this wearer at least, seem as though she is communicating, and with something different to say at each sniff. The fragrance starts with a

mossy scratchiness, like a sore throat in smell form, which over the hours becomes its own lozenge-remedy of soothing, honeyed fruits. Patience is amply rewarded; Mitsouko's dying hours are so beautiful that some might wish there was a pause button. Others might not: every perfume has its haters, and that is just fine.

In old Kyoto there were once scent clocks, used by geishas to tell the time. These clocks comprised a carefully calibrated stick of incense that each hour transitioned into a different fragrance, so that the time of day could be understood by a sniff. Mitsouko does not dramatically change into a new perfume each hour, but it does follow the unravelling day through its impressive progression. Find some at the counter, spray it on, go home, and every hour, on the hour, breath it in deeply and share Mitsouko's story.

The Roaring Twenties
1920–1929

TAKE A LOAF OF SUGAR, soak it in perfume, eat it and your eyes will shine more brightly. This little ritual, *almost* tempting, was a minor craze among schoolgirls in 1924, one of those things that catches on suddenly only to be declared dead the following year. Eating perfume was in the 1920s a specialist pursuit, but the schoolgirl's communion wasn't so far off the money.

In the early years of the decade, the fragrance industry, particularly in the United States, was in a precarious position. Demand for perfume and fragrant goods had rocketed throughout the Great War, during which time toiletries had become important for maintaining sanitation and were promoted as part of military training. Women who'd been brought into employment also found themselves with disposable income, which they were able to spend on cosmetic comforts. When the conflict ended, the trade was ready for a bonanza, as predicted by industry rag *The American Perfumer and Essential Oil Review* in 1921:

> Once a woman has become accustomed to the use of perfumes and toilet preparations she remains a permanent user of these necessities of modern life. Financial vicissitudes may compel her to economize in the use of aids to her comfort and beauty, but they will rarely, if ever, compel her to do without them.

Their hunch was correct: between 1913 and 1929, fragrance sales tripled – an astonishing feat in just sixteen years. But the sellers weren't rubbing their hands with glee; at least, not just yet. The problem was the Volstead Act of 1919, which established Prohibition, making alcohol not just political enemy number one but a tax nightmare, bringing an almighty headache for related industries. Fragrance representatives entered into a perilous, though ultimately successful, lobbying campaign to persuade America's Congress that, as denatured alcohol was unsuitable for drinking, it should be entitled to a tax remission, and permits should be issued to allow manufacture. One of their arguments was that fragrance was one of the most profitable games going, a sure-fire way to boost consumer spending and help promote post-war economic recovery. Desperate to present the industry as squeaky clean, veteran perfumers met at the Waldorf Astoria. They were visited there by government officials, who were well aware that some attendees were diverting perfume materials into bootleg channels, for a profit of up to 300 per cent. The warning was given that anyone found engaging in this illegal trade would be rooted out and dealt with.

This wasn't the only way in which scent danced with the illicit. In the 1920s it became a symbol of female emancipation for young women experimenting with new behaviours, codes and clothes. No longer content with dabbing it on handkerchiefs, or stuffing powders into sachets, the new generation were as likely to inhale perfume by dipping cigarettes into a few drops of scent before lighting up. Some came in bottles that looked just like hip flasks and which could store bootleg gin later down the line. Fur coats were doused with specially designed fragrances. Drinking, puffing, dancing, sweating, kissing, shagging and scenting: they were all bundled together in one intoxicating maelstrom. Racy scents were all part of the breathtaking show, engorged by a level of attention that hasn't been seen since. A cabaret act at the Paramount New York, for example, featured a giant perfume bottle onstage that, as described by *Variety* in March 1927, turned about, 'revealing at its top the face and figure of Dorothy Neville while the

rest of the fifteen feet of height is covered by her wide skirts'. Around this spectacle emerged a troupe of dancing girls from within smaller silvered bottles.

As shops' shelves became laden with smart presentation boxes and tinkling bottles, it was no longer enough for the aspiring fashionable woman to simply enjoy perfume in general; it had to be the *right* perfume. Stefan Zweig's novella *The Post Office Girl*, set during the 1920s, concerns a young woman called Christine, whose middle-class Austrian family had been brought low by the war. Invited by her rich aunt to spend a few weeks in a swanky Alpine resort, she convinces the gadflies around her that she is a moneyed and eligible young heiress, and attracts the attention of a number of suitors. Some of the other girls are jealous, especially one called Carla, who starts to become suspicious of Christine's background. Carla's curiosity is piqued because Christine doesn't know much about polo or fast cars and isn't 'familiar with common perfumes like Coty and Houbigant'. Christine's game is soon up; she betrays herself partly by not being in the loop about fashionable scents. Indeed, so recognised and desirable was the Coty brand by the 1920s that $20,000 worth of stock was robbed from one of their delivery lorries at gunpoint. The thief said to the driver, in typical twenties gangster fashion, 'Stay here and don't make any noise or it's curtains for you.' Meanwhile, over on the border between Tijuana and Mexicali, out-of-work Tinseltown actresses were making ends meet by getting into a perfume-smuggling racket.

One of the joys – and confusions – of 1920s perfume was keeping up with the zeitgeist amid the sheer abundance of exciting new things to smell and novelty concepts that rushed to join the party. Perfumes were increasingly sold as part of a whole lifestyle, along with dresses, coats, hats and gloves; they were purveyed by couture houses inspired by the precedent of Paul Poiret but doing things their own way: Jean Patou, Coco Chanel, Edward Molyneaux, Jeanne Lanvin. Out tumbled the scents, so many of them that, as women became stunned by the choice, a secondary product blossomed: the perfume 'diagnosis' experience. This offered customers their own, sometimes equally

puzzling journey of discovery, to find their perfect perfume match.

The big sell was fast maturing into a slow seduction. This was especially relevant when established ways of presenting a product as ephemeral as perfume were beginning to look tired, as a feature called 'The Psychology of Trademarks' instructed the trade:

> You cannot illustrate the products you sell. They are not suscep-tible to illustration and a description of the illusive odour itself evolves into a collection of euphonious adjectives and literary pyrotechnics which have been in use since the River Nile perme-ated the atmosphere of Egypt with its first odoriferous effluvia of decayed matter.

Forget trying to describe a smell. Forget pictures of flowers and fairies. The best way of shifting stock was to stir the emotions in the same manner that the poetic voice of a 'fake lecturer upon astrol-ogy' would enrapture the 'naturally musical' woman, even if he were talking gibberish. Perfume was becoming melody over lyrics, and that pertains to this day.

Habanita

BY MOLINARD, 1921

THE SMOKING PERFUME

PICTURE A TORTOISE, A LARGE one. Sizeable enough that a woman can ride on its back without her feet touching the floor. And now imagine the woman, who wears a raunchy, skin-tight black dress, is cracking a leather whip to hurry her animal taxi along.

This is not a scene from a minority-interest adult movie but a 1920s advert for Murad Turkish cigarettes. Fantastical and more than a little wacky in its *Alice-in-Wonderland*-esque styling, even this was trumped in weirdness by a promotion for the Abdulla cigarette brand, which decided to associate itself with celebrity female swimmers of the day such as Gertrude Ederle, Queen of the Waves, first of the sisterhood to cross the Channel:

> We only know ABDULLA's best, so cheered and braced and propped her –
> She'd still be swimming – but by chance the shores of Calais stopped her.

This poem (of sorts) appears alongside an image of a lady swimmer, who achieves the unlikely act of holding onto her fag as she does the front crawl.

It was a long way from 1908, when New York State had instigated a ban on women smoking in public places, making the practice even more furtive than before. Within a mere twelve years, cigarettes had become the must-do habit of the burgeoning jazz age, particularly among flappers and fashionable young women. Cigarettes as a product weren't new, but they were newly discovered as a permissible way of ingesting nicotine. Formerly perceived as suspiciously effeminate compared with pipes and cigars, and shunned by the machos for their association with another sort of small apparatus, they had been taken up during the Great War by soldiers in need of a fix to steady their nerves. And they were much more portable, convenient and affordable than the more fiddly alternatives. Female suffrage, having aligned itself with the Everyman military culture and war effort, quickly seized on cigarette smoking as a symbol of emancipation. Once Eleanor Roosevelt and other celebrities were pictured puffing away in public rather than hiding their vice in a drawing room, the race was on for the industry to get as many women as possible lighting up, aided by the irresistible and artful glamour of the cigarette holder.

And it was an industry that had more than a few affinities with perfume. Not just in the ancient use of burned incense coiling up to the sky, but in the challenge to marketeers to translate these two products – intangible and all in the experience – into an imaginative visual language. And so we see that the aesthetic of those rather bonkers cigarette adverts is pretty much interchangeable with early fragrance promotions: the lure of the East, and the suggestion that one could be whisked away to a land of fantasy through the unfurling smoke or evaporation of alcohol. There was the fetishism of the beautifully illustrated cartons housing the sticks or flacons within – perfume boxes were even promoted as being ideal for storing cigarettes once brought home, and smart Bakelite party compacts invited women to pop their travel perfume bottle next to their smokes. Finally there were the cigarettes themselves, which could be bought ready-fragranced in aromas of rose, violet or amber. There was even a DIY option: packs of tiny disposable wands that could be slotted into the neck of a favourite

perfume bottle and then dabbed onto the cigarette paper.

Habanita, from the French firm of Molinard, was one perfume that would cement this association. It was not the first tobacco-scented fragrance (Caron had come out with Tabac Blond in 1919), but what is unusual about this one, still on the market today and the sole survivor of its type, is that it was initially designed to fragrance cigarettes rather than the person.

In its 'Little Havana' naming, there was perhaps a hint that the aromas of Habanita would help upgrade a cigarette into something even more special, redolent of the aroma of a fine Cuban cigar, to be smoked while the mind wandered to Pleasure Island with its hot nights, 'Son' music and seamy beaches. The fragrance of Habanita was less a facsimile of tobacco leaf and more to complement the functional scent of the cigarette itself, adding some pizazz and mystery around the edges. So there was clove and carnation for warmth, vanilla for smoothness, and leather to give an incense-like kick. Little wafts of peach and ylang-ylang then danced about to leave a teasing wake.

Habanita persists even though its original application has been decommissioned and it is now a regular skin perfume. It speaks to us because it is suggestive of using fragrance as part of a considered daily ritual, the territorial marking of our possessions, and because it offers us a retrospective sense of naughtiness. Smoking in the 1920s is frequently posited as having been a shocking phenomenon, when actually it became part of daily life so quickly that there was little at all outrageous about the practice. Today, with cigarettes in exile once more, Habanita offers a cheat of the fantasy, flapper lifestyle of which tobacco was a part. Thankfully, the only thing to become addicted to is the smell.

N°5

BY CHANEL, 1921

THE PERFUME

Coming up with something original to say about Chanel N°5 is a bit like trying to say something original about *Hamlet*. So dissected is N°5 that somebody's probably already written that first sentence. It is one of the few perfumes about which a dedicated book has been written. It would be the one they would send out to space. The perfume worn by the first woman resettled on Mars. Discovered buried by a forager in a neo-Iron Age society, centuries after apocalyptic war.

At parties, when the subject of one's line of work comes up, new acquaintances will frequently roll up their sleeves with a daring look in their eye and a challenge: 'Guess what perfume I'm wearing. If you can't get this one you're in trouble.' At which point their wrists – or, worse, their necks – are brought up to my face, a bit too close for comfort. Little do they know, ha ha, that by suggesting it should be obvious, the cat is out of the bag. No sniffing need occur. It will be N°5. Except that time it was White Linen, and wasn't that embarrassing.

Some perfumes are particular in who they attract, in that their wearer's style somehow mirrors the personality of their fragrance, though it is always a delight when someone goes for the totally

unexpected. A whey-protein-chugging body builder in the candy rose that is Paris would be wonderful. However, you can never tell who is going to be a N°5 wearer; all sorts will instigate the guessing game, and there is little to connect them in their sartorial tastes. And though this is said of many perfumes, N°5 really does smell a little different on everyone, if only because it is so widely adopted as for us to be able to make comparisons. So broad is its range that it is the Everywoman's choice, becoming whatever is required of it.

N°5 has the precision of well-cut clothes and that special appeal which comes from a clean, bare room free of the knick-knacks that would otherwise give away its age. Its versatility may well be connected to its abstraction. Even though it features a basket of very familiar materials topped with those famous crisp, aliphatic aldehydes – lemon, bergamot, rose, ylang-ylang, jasmine, musk, vetiver and sandalwood – it is one of the most difficult to deconstruct into its constituent parts and is more easily compared to other indulgent products like champagne and bubble bath, or to wealth, expense and gold. Guerlain's Shalimar, another of the greats from the 1920s, which perhaps wrongly does not get its own chapter here, comes with baggage that affects its representation: its Taj Mahal love story and the conventions of oriental fragrances. But Chanel is its own little bubble, free to go hither and thither, to break free from its vintage 1921 birthday and redefine itself for the tenor of the times. It's unstoppable, almost like The Thing in the way it can blend in with a new host environment. Even the bottle for the parfum, which has been modified in tiny ways over the years, always looks fresh.

Let's look at some of the creative strategies Chanel has implemented over the decades to sell their most successful fragrance. The terrain is as varied as the perfume's customers, but we can always be sure the talent will be the best in show. Among models there has been Suzy Parker in a white ballgown, the virginal debutante delight; and Jean Shrimpton, diaphanous in pink chiffon; then, totally conversely, Catherine Deneuve, photographed by Helmut Newton in an androgynous black suit. N°5's screen adverts have in the past four

decades taken a tour through many popular metiers, whether in Luc Besson's colour-saturated early 1990s gothic fairy tale with Estella Warren as Red Riding Hood and an *Edward Scissorhands*-type soundtrack (think choir singing plaintively), or the whimsy of Baz Luhrmann's *Moulin Rouge* spectacular. Oh, and that one of Brad Pitt in black-and-white-documentary style. Ridley Scott, enjoying a particularly long relationship with the house from the 1970s to the 1990s, shot a series straplined 'Share the Fantasy', which comprised dreamlike, surreal pieces, all of them featuring the portentous shadow of a plane passing overhead: a symbol of modernity and of humanity overcoming the law of gravity. It doesn't seem to matter that this is a perfume. Because N°5 is a cultural icon, it can get away with all manner of affectations.

N°5 is such an impressive chameleon that it is tempting to think of it as a creation of marketeers with an unusually fast grip, or at least as having been chiselled into a legend as the century advanced, rather than having found instant success. After all, plenty of brands with a heritage claim that their original product was revolutionary, and accordingly polish the past until it twinkles. N° 5, remarkably, leaves a trail of fascination that goes right back to the start. On launch it quickly eclipsed one of its contemporaries, Molyneux's Le Numéro Cinq, and by the 1930s was already being referred to as a classic, the unbeatable standard in fragrance. Others were quick to copy, and in the mid-century, Coty's L'Aimant from 1927 – very similar though not identical – was known informally as a cheaper option that the wearer could pass off as N°5.

Whether or not Chanel's perfume was entirely original (the perfumer Ernest Beaux may have come up with precursory ideas while still in Russia at Rallet & Co., but the revolution interrupted his work, thus making N°5's frothy, sparkling finish seem utterly original when he worked on it later in Paris), and whether or not you even like it, it cannot be denied that even in 1921 this perfume was perceived as something new. Against the embellished, expansive Rosine perfumes from Paul Poiret, whose style Gabrielle Chanel detested and was reacting against, this, Chanel's first, was a lean, mean, adaptable machine.

Nuit de Noël

BY CARON, 1922

THE FESTIVE PERFUME

Grab your partner one an' all, keep on dancing 'round the hall
Then there's no one to fall, don't you dare to strut
If your partner don't act fair, don't worry there's some more over there
Seekin' a chance everywhere at the Christmas Ball
'AT THE CHRISTMAS BALL', 1925

THIS IS A FAVOURITE, SO expect some gushing. It must be stated right away that Caron's 1922 triumph, 'Christmas Night', does not smell of mince pies, plum pudding or those orange pomanders with bits of clove stuck in them. Think instead of armfuls of spongy moss, from Caron's favourite Mousse de Saxe base, and roses so heavy they'd land with a thud.

Nobody will judge the wearer for applying Nuit de Noël while snuggled under the duvet to watch *Elf* for the tenth time. However, this intoxicating fragrance is best used for revelling until the candles burn out; and there had better be a champagne tower at this do. The clue is in the bottle, a glossy onyx black, decorated with an art deco headband and shaped like a hip flask, the quintessential Prohibition-era flapper

accessory. The vial could be hidden away in its tasselled, jade-green shagreen box, stashed in an evening pouch and brought out for a bit of witchery late into the night.

Nuit de Noël epitomised razzle-dazzle and perfume's new-found confidence – a special scent made in tribute to just one day of the year. As the party girl's choice, Nuit de Noël mixed in the world of 1920s revelry: 'New York Heeds the Call of Fancy Dress', proclaimed American *Vogue* the same year as the perfume came out, dizzily announcing that 'This winter, New Yorkers have been trying to prove how one can live on twenty-four hours a day – excluding sleep!' Parties, whether the fashionable Beaux Arts Ball – borrowed from France – or London's Chelsea Arts Club New Year's ball, were in another stratosphere entirely, taking on ever more elaborate themes (all creative successors of those 1002 Nights affairs given by Paul Poiret).

At these charity fundraisers, outfits needed advance planning if they were to have a chance of appearing on the society pages. Attendees would take note of the latest costumes for stage and opera by designers such as Georges Lepape and Dolly Tree and then reproduce them, or if flush would order from stores like Harrods in London, which had a vast fancy-dress department. Popular costumes included Pierrot and other Harlequin and clown themes, Peter Pan, gypsies, swashbucklers, Joan of Arc and Alice in Wonderland. That was the tame stuff. At one party a woman came dressed as Vienna's Stephansdom Cathedral, and for the Empire Balls guests were invited to represent one of the colonies. Sneaky tricks were part of the convention: heiress Nancy Cunard once invited the performer Irene Castle as a tactic to try and get her to do a free show. Irene was one step ahead and, foreseeing that the lights would go down, dressed all in black so she'd vanish into the surroundings.

Nuit de Noël can still be as much a part of ringing in Christmas as carols and mince pies. For those dreary moments after four hours in front of the television, fractious games of Monopoly and too many wedges of chocolate orange, it brings back a relieving frisson of anticipation and will have you ready for round two: New Year's Eve.

Bain de Champagne

BY CARON, 1923

THE PROHIBITION PERFUME

CHAMPAGNE BELONGS IN THE BODY, not outside the body. Bathing in the stuff sits at the 'do not attempt' end of the ostentation spectrum. Let us leave aside the cost for one moment. Think instead of the very particular stickiness as the warm, flattening soup starts to coat your hair, and the need for multiple trips to the glass-recycling centre afterwards. Short of a body scrub made from caviar, this is the most ridiculous way to burn through £6,000, the carefully calculated cost of filling a bathtub with non-vintage champagne. The custom is revived now and then by luxury hotels desperate for press coverage, but how many people, really, actually want to do it?

But still, what a tantalising fantasy of decadence, this champagne-bathing. Famous enthusiasts, allegedly, included Marilyn Monroe, and King Edward VII, who in the 1890s would fill the famous Sphinx bathtub in Paris' La Chabanais brothel for the benefit of himself and his merry band of prostitutes. Edward was a big man, so, if he planned on getting in the tub, that will have helped reduce the volume of champagne required.

In Prohibition-era America, matters really got steamy, given that

champagne was illegal and all. One infamous proponent was the Broadway producer Earl Carroll, who in 1926 was investigated by Prohibition agents after a particularly colourful party held on the stage of his theatre. Carroll insisted to them that 'any man, even a minister, might have attended with his wife... There was a bath tub... but there was nothing but gingerale in it, and nobody took a bath in the gingerale.' This didn't wash with the authorities, and the following year Carroll and his wife went on trial for perjury. Things did not go well after witness statements were produced to counter his version of events, as reported in the court documents for *Carroll v. United States*:

> A Miss Hawley came from the wings, dressed in a chemise. The plaintiff in error held a cloak in front of her while she slipped from the chemise and got into the bathtub, whereupon the plaintiff in error announced that 'the line forms to the right; come up, gentlemen'. About fifteen or twenty men lined up at the side of the bathtub, and as they passed by took glasses and filled them with the contents.

With this sensational story all over the press and Carroll frog-marched to prison for a year, it is no wonder that champagne fever exploded the thermometers in the 1920s. Belle époque marketing had set the mood, with its imagery of girls rocketing into the air straddling a cork, and now Americans visiting France desperate for a legal drink and a cabaret show had it hardwired into their brains that this particular choice of fizz was the epitome of La Belle Vie, the ideal accessory to wit and wisdom. 'Three be the things I shall never attain: envy, content, and sufficient champagne,' said writer Dorothy Parker, and who didn't want to be in her club?

As the crowning symbol of Paris' luxury industries, the froth needed to flow big time to keep the merry-go-round well oiled. This could be a mercenary business. Writer Robert Forrest Wilson (who encountered Paul Poiret in an earlier chapter) was scathing about the tourist trap that was 1920s Montmartre, now filled with Yanks (of

which he was one) watching what he thought to be mediocre dance shows at the Folies Bergère, performed by the likes of Josephine Baker in her famous banana costume. In this ersatz nightclub world (which today we dream of as being the real Paris, even as earlier writers harked back to the good old days of the nineteenth century), the protocol was thus: 'Mirrors and lights to dazzle them, jazz to excite them, hot and smoky air to make them thirsty – and they will buy plenty of champagne.' Lone male guests would be preyed upon mercilessly by prostitutes in collusion with the waiters. One glance from the man and she would take it as an invitation to sit with him. Moments later a bottle and two glasses would appear from nowhere, the champagne having been chilled as much as possible to hide its inferior quality (despite the high price tag). Several bottles later, we can all guess what happened.

The perfume house of Caron were completely in tune with the times, just as they had been with Tabac Blond a few years earlier. Seeing that champagne was so tied up with illicit behaviour, they brought out a bath preparation called Bain de Champagne, which they marketed in America as well as in Europe; perfume legend says it was sprayed around Harlem's Cotton Club. Sadly, it did not froth, as bubble bath was only just coming to the market. Bain de Champagne compensated for this by coming in a little wine bottle with foil over the top to offer a fun facsimile of pouring in the real thing, and a smell that reinterpreted the fun of champagne rather than attempting a replication. This product has one of the most girly, giggly fragrances ever produced, with all the vanilla of cake batter from benzoin resin and the smoky honey of opoponax, also known as sweet myrrh. We give thanks that this cruel world can have created something so frivolous yet happy-making. Picture pink marabou mules and you are there. It is tickly feathers and sherbet fountains, pampered princesses and a life of leisure. Royal Bain de Caron, as it is now known (for champagne wanted its name back) comes today in eau de toilette for – it has migrated from being used in the bath to a post-soak rub-down, though unofficially is still best in water. The antithesis of the pine and rosemary camp, Royal

Bain de Caron is useless at providing the psychological effect of soothing muscles and tight joints. Instead, it requests of its users a detailed equipage: an abundance of scented candles, an ostrich-feather dressing gown for afters, and a coupé glass full of the good stuff (ginger ale, of course); this is not about getting clean, but about getting ready to dance on a tabletop. Even the Prohibition police could not complain.

Le Dandy

BY D'ORSAY, 1923

THE GENDER-BENDING PERFUME

We are not fairly matched. If I were to wound him in the face it would not matter, but if he were to wound me, ça serait vraiment dommage!

COUNT D'ORSAY

THOSE WHO CIRCULATED IN THE high-living set of the jazz age would have been familiar with the figure of a 'goat'. This was not the pampered pet of some naughty debutante, brought out to play at a party, but slang, according to *The Deb's Dictionary*, for 'a perfumed pest with a silky beard, a silly voice, no morals and two legs or four as the case may be'.

Run from such chaps as fast as you can was the message, also unfairly implying that profuse use of perfume among young men should be considered an early-warning signal of both a silky sleaziness and ambiguous sexuality.

Men and scent began to run into difficulties in the 1920s. A hundred years prior, men had been much more heavy handed in the application of fragrance than women (think of all those handkerchiefs). Yet as certain smells became associated with, and appropriate for, a particular

gender, perfumes were now finishing their transition from 'his and hers' to 'his or hers' and, finally, to 'hers not his'.

Fashion designers, in the twenties the most important sellers of luxury scent, were too busy fawning over their female clientele, and perfume was increasingly positioned as a womanly beauty accessory, part of the ammunition of glamour. Sure, men with panache could pull off something intended for the ladies; the legendary jazz musician Leslie 'Hutch' Hutchinson, who fathered children with six different women, was an abundant user of Chanel N°5, which one variety performer associated with the smell of his dressing room. But anything too noticeable began to be seen as suspiciously effeminate, the preserve of gender-bending aristocrats.

Stephen Tennant was the peach of the scene. Born to a Scottish peer, and a family who owned vast swathes of land, Stephen never really needed to work – he was his own project and became 'the last professional beauty', according to aristocratic writer Osbert Sitwell – though he did spend a long time on an unfinished novel and was an inspiration for the character of Sebastian Flyte in Evelyn Waugh's *Brideshead Revisited*. Stephen's world, peopled by the likes of Noël Coward and Cecil Beaton, was one of exquisite but excessive beauty, the kind that necessitated owning raw-silk underwear, leopard-print dressing gowns and belts made from exotic animal skins. He famously ran gold powder through his Marcel-waved hair and would turn up at parties wearing lipstick ('I want to have bee-stung lips like Mae Murray') and earrings. Stephen loved perfume and had no qualms about going for it with the atomiser, as a defiant play on his freedom to be whoever he wanted and to take pleasure in the ecstasies of the senses. When his Adonis looks faded and his lithe figure turned to fat he took to his bed, in a room heavy with fragrance, and stayed there for nearly twenty years, until his death in 1987. According to his great-nephew, he favoured the House of Worth, which, with two exceptions, from the 1960s onwards only made female scents, notably Dans La Nuit and Je Reviens.

If the male fragrance lover of the 1920s was a rich, vain, deviant

young man, it is no wonder that one of the most feted scents of the time was Le Dandy by d'Orsay. Even though Count d'Orsay (1801–1852) himself was long dead by the time Stephen was swanning about, his name was inscribed on the bottle and he remained a figure of fascination through the early twentieth century for having commanded the erotic attentions of other men. His figure was depicted on cigarette cards and his persona resurrected on radio in the 1920s for the 'Parisian Romances' series. Like Stephen he was born into a life of wealth, the son of a Napoleonic general. With no need to take up a trade, he was destined to be a clotheshorse and a muse, notably to Lord Byron, who liked to call him 'Cupidon'. As well as being an amateur artist, the Count, allegedly, was an 'alchemist of luxury'. He made perfumes. According, at least, to the syndicate of investors who, seventy years after d'Orsay's death, created the Compagnie Française des Parfums d'Orsay in his honour, going so far as to purchase a castle to add some verisimilitude. Then, after running into difficulties during the war, they sold the company to Jean-Louise Guerin, known as Madame Guerin, who revived the house once again.

Although Parfums d'Orsay had developed twenty fragrances prior to 1925, Le Dandy was their first famous launch. In its original version it was a typically 1920s floral aldehyde, right on the pulse of fashion, while its gentlemanly revived version of today, with its brandy punch and bosky autumn apples, invites us into a panelled library after dinner with a glass of Armagnac.

The ultimate irony? The scent was largely taken up not by gentlemen but by provocative female flappers or garçonnes wanting their own moment of gender subversion, a playful gesture only egged on by the figure of D'Orsay, who said of Le Dandy: 'Worthy of Him. Worthy of You.' Girls will be boys will be boys will be girls.

Gardenia

BY ISABEY, 1924

THE WOOZY PERFUME

GARDENIA PERFUMES ARE NOT USUALLY the more esoteric or intellectual on the shelves but exist for those times when we demand simply to smell gorgeous. In nature, their petals project a smell that that can be quite heady: luscious, loud and evocative of the tropics. It is moist, bananary, juicy, creamy and sweet like pear drops. Some perfumes need to be worn with dressy clothes and will wail if combined with a tracksuit. Gardenia scents mind more about whether the owner has shiny hair and flake-free lips. Maybe a diamond or twelve, too.

The 1920s into the 30s brought gardenia a bit of a moment as the flower became a dapper accessory for buttonholes (striking against a dark jacket), a finishing touch for evening-wear, a flourish for the weekend and a wreath for brides such as novelist and society girl Nancy Mitford. Its bloom being short-lived, the flower became a poignant metaphor for young women in the prime of their beauty: Mae Murray, silent-film actress and star of 1919's *The Delicious Little Devil*, was called 'the gardenia of the screen'.

In contrast to the fleeting joy of the natural flower, gardenia in perfume form offered the wearer perennial delight. Among the

launches were Chanel's Gardenia of 1925; later, in 1932, came the tantalisingly named Tuvaché Jungle Gardenia. Isabey's version from 1924 won gold at the famous International Exhibition of Decorative Arts in Paris in 1925 and had as its face the charming operetta singer Yvonne Printemps. They were a house specialising in 'fleur' fragrances, who entered the American market by pronouncing themselves the favourite of French nobility and Old World aristocracy, promising that though their scent was for sale on Fifth Avenue it was bottled and packaged back in Europe.

Gardenia perfumes were often marketed to the young deb or sophisticated newlywed, though their swoon-inducing qualities made the flower a neat literary leitmotif for a darker taste in sexual infatuation. Aldous Huxley's satirical novel of the Bright Young Things, *Point Counter Point*, which was a must-read of 1928, features this disturbing scent throughout. The unhappily entangled Walter is newly obsessed with his cruel second mistress, Lucy Tantamount, a character inspired by the infamous heiress Nancy Cunard, who was all kohl-rimmed eyes, purple lips and dozens of African bangles (with never a smile to camera). In the midst of their unhappy trysts (Lucy has no qualms about sinking her nails into her lover's flesh when he is being too meek), Walter finds himself repeatedly assaulted by her gardenia scent. It is described as 'enveloping', 'filling' and 'stifling', a noxious substance that invades his body. As Lucy's grip on him tightens, her perfume becomes her 'second ghostly personality' and he is forced to inhale it again and again. By the end of the novel this delightful flower has become a symbol of terror. Meanwhile, Lucy has started to resemble a succubus – a supernatural female demon. There is something ghastly in these descriptions, akin to the disturbing thrill of one of those early German Expressionist horror films, all sharp corners, shadows and oppressive flickerings. In Lucy is the heartlessness of another seductress, the robot Maria of Fritz Lang's *Metropolis* (1927), who mesmerises men into uncontrollable lust while dancing and gyrating like the Great Harlot of Babylon.

The final trick of gardenia perfumes is that, usually, they are faked. The natural material yields little to extraction, and it is through the

combining of other floral notes with synthetic ingredients, like the coconutty gamma-nonalactone, that gardenia can live in fragrance. The most beautiful perfumes can be like so many Marias: rounded into 3D life, burrowing their way into our hearts and making us forget they were concocted in a factory, sitting in huge aluminium canisters until the time comes for decantation.

Amour Amour • Que Sais-Je?
Adieu Sagesse

BY JEAN PATOU, 1925

THE HAIR-COLOUR PERFUMES

IN 1925 A *VOGUE* JOURNALIST was sent on a mission: to tour Manhattan's elite perfume salons, where a small band of entrepreneurs were capitalising on a new 'soothsaying' trend in fragrance sales. With so many new launches, choosing a scent was becoming far too bewildering. Moneyed perfume lovers were paralysed as to which they should buy to express the very essence of their personality – which was their holy grail, their 'one'? Fortune-telling, tea-leaf reading, seances and astrology were all the rage at the time, with crystal balls from Czechoslovakia installed in fashionable homes, so why not create a scent-divination experience? Take one washed-up minor royal from Europe, get hold of an Upper East Side room, stuff it with upholstery, throw in some chinoiserie and dim lighting, and Bob's your uncle: instant cash.

Vogue began its journey into scent-based soothsaying at Madison Avenue's Rouge et Noir. This was the atelier of Prince Matchabelli's fragrance house, where the man himself would produce the perfect bespoke perfume for his clients – analysing their stance, their inner being, their aura. One customer proclaimed he adored the smell of

97

borscht (beetroot soup) and, undeterred, the Prince talked vaguely of finding something analogous. He even promised distant correspondents that from a letter alone he might, through the art of graphology, determine their perfect scent.

With his slightly frightening 'cold-reading' style, Matchabelli had something of the Hercule Poirot about him:

> The most difficult woman always, the Prince thinks, is the young woman, little, simple, who says she likes flowers, but in her soul she is what you Americans call a 'vamp.' I would not trust her, no. Inside, she is not flowers. She has a terrible burning like acids. I find it hard to make a perfume for her.

No, a perfume made from hydrochloric acid probably would have been a bad idea.

The *Vogue* journalist moved on, to the studio of Ann Haviland and her myriad sampling blotters. These were thrust up to the nose: Ann's trick was to spot the gap between verbal response and facial expression – to be alert to the gleam in the eyes that told her which was the right smell. Suitably matched, her clients would leave clutching a bag stuffed with six or more products bearing their signature fragrance.

Then there was Madame Desti, who asked her visitors to parade across the room so she could get a good look at their clothes:

> For this one – this slim, fragile little woman with her figure of a young boy and her silver hair – she says it should be a flower odour, very light, very aloof. For this other – an older woman infinitely subtle, infinitely weary, something of the incense sort, for she is truly religious in essence, although she doesn't know it.

Finally, there was the dominion of the Princess Tourkestanoff, who magicked together scent mood wardrobes – three perfumes 'that will blend, so that she can have an infinite variety of perfumes'. Those

who were sad needed only the right aromatic to turn their desperate need for a Martini into a 'wistful twilit gaity'.

Though Prince Matchabelli kindly offered to lend his services to clients living hundreds of miles from New York, it was the fashion designer Jean Patou who first understood how to make this diagnostic process scalable, connecting an olfactory profile to a particular 'type'. Blondes had the choice of Amour Amour ('Love, Love'), brunettes were permitted Que Sais-Je? ('What Do I Know?') and redheads were offered Adieu Sagesse ('Goodbye Caution'), created by one of Paul Poiret's former perfumers, Henri Almeras. Each described the stage of a love affair, with no prizes for guessing that the first was a romantic floral, the second a fuzzy peach, and the last spicy and powdery to mark consummation, and possibly implosion.

Guerlain used the same idea in some of their 'Are You Her Type?' adverts, in which L'Heure Bleue was for blondes, Liu for redheads, and Mitsouko for brunettes. The concept was such a hit that Patou later released evening gowns bearing the same titles. His three perfumes smelt absolutely beautiful, and their names were coyly humorous, but the marketing conceit did start to cement olfactory families with particular 'looks' as a clue to their temperament and preference.

Writing of her passion for perfume in 1925, the famed opera singer Lucrezia Bori of the Metropolitan Opera House argued that 'strong, pungent scents have a depressing effect upon the golden-haired, while flower essences if used by brunettes often cause headaches'. With dispiriting misguidedness, Bori elided complexion with personality: the ditzy blonde versus the mysterious brunette. We must not forget that although hair dye was available in the twenties, safety fears about chemicals meant that henna was the only reliable hair-colouring product. It was not so easy to make a switch (though that would all be transformed with the popularity of peroxided stars in the 1930s). Unless particularly adventurous, women would be stuck with their genetic hair colour and all the traits that supposedly conferred. Such pernicious stereotyping pervades the industry to this day, if a little more undercover and implied, and remains so very tiresome indeed.

Tutankhamon Pharaoh Scent

BY AHMED SOLIMAN, 1925

THE EGYPTOMANIA PERFUME

THE WORLD OF THE ANCIENT Egyptians holds a perennial fascination for us. Its takeaways – mummies, hieroglyphs, kohl eye make-up, ass milk – are central to fantasy Sunday-afternoon activities that few of us ever properly follow through: 'This afternoon I'm going to bathe in ass milk, although I've only got semi-skimmed cow's, will that do?' Or, 'Today I'm going to watch Elizabeth Taylor in *Cleopatra* and copy her smoky eyes, except I forgot it's so long and I need to get an onion from the supermarket before it closes.'

Now and then, enthusiasm for this ancient world turns from hillock into mountain. It happened in the early nineteenth century, following Napoleon's exhaustive Egyptian Campaign. It kicked off again eighty years later with the unearthing of Deir el-Bahri's cache of royal mummies, and once more in 1922 when Howard Carter excavated Tutankhamen's tomb in the Valley of the Kings, together with the accompanying hoard of beautiful decorative objects.

For the economically buoyant 1920s, Egypt provided a ready-made aesthetic that architects and designers could incorporate into their new art deco style. In construction-boom America, city residents

must have been thrilled that their latest movie theatres resembled the interior of the Malkata – even the ticket booths were dolled up.

Unsurprisingly, with the Ancient Egyptians famed for progressing the use of perfume from the sphere of religious ritual to personal grooming and pleasure, the twenties also saw a renewed obsession with the cult of beauty. Like Helen of Troy, the queens of the Nile had once held men and nations in thrall because of their devastatingly beautiful visages. This level of grooming took work and a lot of helpers. One magazine feature from 1925 imagined for readers the lengthy regime of Princess Akhenaton. She would first be slathered with fragrant pastes of 'sandal' (sandalwood) or 'citronella', then:

> Nubian slaves lead the Queen to her bath, a marble-lined tank sunk in the floor and filled with the amber-toned water of the Nile. Her skin glistens with the glow of health as the slaves polish limbs whose grace and symmetry, poise and undulating movements are almost a lost art to the Western civilizations.

Perfume was thus destined to become part of this Egyptomania. A mysterious fragrance could epitomise the very essence of the Secret of the Sphinx, and with bottles so much more elaborate back then, new launches were ripe for some Nile-isation. Sadly, none of the many Egyptian scents have survived. Were they too focused on the packaging, overlooking the juice? Were they guilty of gimmickry, offering concepts that didn't translate into enduring loyalty? A perfume named Scarabée, such as L.T. Piver's of 1922 (a rapid relaunch following an original 1909 release), might be fun for a few months, but who wants a long-term relationship with a beetle? Likewise, seeing the head of the Pharaoh on one's dressing table must have become a little oppressive after a while.

But all these perfumes were just French houses playing at a theme. Those who wanted authenticity needed to go to Cairo, ideally on one of the new Egyptian-themed cruise-liners. They should take with them a copy of Clara E. Laughlin's economically titled travel guide: *So You're Going to the Mediterranean! And if I were going with you these are the*

things I'd invite you to do.

One of Laughlin's top tips was to visit the city's famous Palace of Perfumes, presided over by maestro Ahmed Soliman. Readers were advised that *all* the taxi drivers knew it and could drop them right into the Khan el-Khalili Bazaar, offering final directions on foot.

Devotees, if they managed to avoid being drawn away by an impostor or getting caught up in a carpet-buying ritual, would find themselves in Cairo's most chichi gift shop, which specialised in selling the beauty secrets of the Egyptians at fixed prices – no bargaining allowed. Alongside kohls and incenses (and scented amber cigarettes) were the perfumes. They were packaged in enamelled bottles shaped like obelisks with intricate depictions of the pharaohs, as though they had somehow been found in Tutankhamen's tomb. Ahmed himself was, according to the travel guide, descended from a long line of perfumers:

> From father to eldest son in each generation is handed down the precious parchment wherein are recorded the secrets of making the Attar of Roses, the Incense of Araby, the Lotus Flower perfume. And I'm sure that not only Cleopatra, but such lovely ladies as Hatshepsut and Nefertiti, of the sumptuous Eighteenth Dynasty, would have been ravished by a visit to Ahmed's temple.

Well, they *would* have been ravished as no doubt there were more perfumes there than they could ever have dreamed of. After the King Tut unveiling, Soliman must have thought all his birthdays had come at once. His range was exhaustive, and many explicitly referenced the Who's Who of the ancients: Tutankhamon Pharaoh Scent, Ramses IV and Queen Hatasu. We will overlook one of his other perfumes, titled Banana. That most of them came out in a rush in 1925 puts the authenticity of the papyrus recipe ledger into some uncertainty. But, finally, with these precious and expensive vials and a stick of kohl, a flapper could walk like an Egyptian, look like an Egyptian and smell like an Egyptian. And no doubt tell all her friends at home about Ahmed Soliman, Cairo's perfume king.

Huile de Chaldée

BY JEAN PATOU, 1927

THE SUMMER-HOLIDAY PERFUME

DEAUVILLE SOUNDS LIKE *THE* MOST exhausting place in which to see and be seen. St Tropez, Cannes, Portofino? They have nothing on 1920s Deauville. This pretty, timbered, seaside town on the Normandy coast, which had been popular with the great and the good for years, went berserk once society started having fun again after the Great War. The sunshine was unreliable, but that didn't stop thousands congregating there each summer and parading up and down the newly built promenade to set or inspect the latest fashions.

The lost generation of Americans in Paris loved it there, as it was only a couple of hours from the city; dancer Josephine Baker holidayed in the resort with her pet cheetah, Chiquita. The English adored it too, as it was perfectly placed for a just-exotic-enough escape, and we have the incongruous image of Winston Churchill posing for a photographer on the beach in his little swimming costume, looking really crotchety. The whole world, pretty much, was there, with guests able to peer at Argentinian polo players, steel magnates or Greek royalty in any one minute:

There is the woman who wears more bracelets on one fragile wrist than any other in Europe; here is the actress whose choice of clothes influences two continents; there is a group of high-class Hindoos, the men in European dress, the women in their native white fold-bordered muslins.

The arrival of someone really important such as King Alfonso XIII of Spain would set everyone fluttering, even more so when he was spotted eating a serving of shrimps with a glass of port.

So regimented was the hot-or-not list that 'everybody insists upon doing the same thing at the same time, which makes for a certain amount of overcrowding'. So reported Miranda, the almost jaded correspondent in *The Sketch*, who crafted a summer 'Deauville Diversions' column each week out of the seaspray of gossip. Lunch was best taken in the orchard of the Hôtel Normandy, after which some activity – golf, polo or tennis. The evening belonged to the 'orgy of expensiveness' that was the casino and the gala dinners, where the famous Dolly Sisters would dance, which quite perturbed the waiting staff, who couldn't work out which identical twin was which. This would often go on until late:

It is quite a common thing for this little band to remain together till six or seven in the morning, and meet the early bather when they wend their way home with the sun high in the heavens, and a terrible blinky morning-after-the-night-before feeling about being caught in evening dress.

We've all been there, Miranda.

Deauville's hub was the *plage*, where hot young things could battle for space in their newly revealing costumes, which got shorter in the leg and lower in the décolletage each year. Swimming was of course one of the chief delights, and for women given extra appeal through heroic Gertrude Ederle. Many who entered the waters at Deauville were papped, although they were generally more inviting of it than

Winston Churchill because they wanted to show off their choice of costume; Lady Diana Cooper was pictured in a very exciting patterned swimsuit, which instantly rendered plain ones passé.

The other key activity on the stretch known as the Potinière was sunbathing, which followed the trajectory of most activities that had suddenly become permissible after years of being frowned upon. 'Sunburning' attracted hordes of devotees, including Coco Chanel, who – as well as providing many of the women in Deauville with their resort outfits – led the way in making tanning fashionable, such was her own addiction to bronzing. Unfortunately, the northern coast of France was not entirely reliable in guaranteeing the correct degree of skin sizzle. Miranda noticed that fair women resorted to taking henna baths instead, 'with cheeks and lips painted a deep lacquer red that gives a most barbaric effect, almost reminiscent of the Russian Ballet'. Besides, some were catching on to the fact that real tanning might not be best for their skin come autumn; they were encouraged not only to fake it but to have their skin restored and bleached by Elizabeth Arden's special Après l'Été treatments.

If henna was the DIY, low-grade option for mimicking sunburn, Jean Patou, whose hair-colouring perfumes had launched earlier in the decade, sold something much better: Huile de Chaldée. Patou, a Normandy boy who scaled the fashion world after he returned from fighting on the Western Front, had a boutique in Deauville selling his wildly fashionable sports clothes to the legions of female golfers, tennis players and party-goers about town. Not dissimilar to Ambre Solaire, he began selling his sun *huile* as a tanning product with in-built sun-protection. It was russet brown and as well as colouring the legs was taken up as a foundation too. It is easy to see how it caught on. With hundreds of women packed onto the beach burning to a crisp, it surely only took one to complain about her peeling nose before another would quickly step in: 'Darling, don't worry. Look, I've got this new stuff you can use. Isn't it amusing. And it smells divine.' The hordes would be round in moments.

Chaldée really did smell as though made for frolics in the sand.

The overwhelming fragrance was of musk with opopanax, a warm, sweet, nuzzly aroma for the skin that works wonderfully with a lick of salt in the air, just as ice cream and candyfloss taste better by the seaside. The addictive smell of Huile de Chaldée even prompted Jean Patou to release a dedicated perfume version for any time of the year. But it also inspired other suntan products to copy its fragrance, which had rapidly become *the* scent of sunny holidays. Nearly a century on from the launch of Chaldée, we smell something like it every year, not in a luxury perfume but in our mass-market SPF lotions. When we squeeze the bottle and think of summer, what we are really thinking of is one little product from Jean Patou that got everyone associating the good times with the smell of vanilla, opopanax and orange blossom.

Zibeline

BY WEIL, 1928

THE FUR PERFUME

MINK, FOX AND ERMINE, HOW you have suffered for our vanity. It is quite astonishing to think that back in the 1920s two-thirds of women had a coat featuring some kind of fur. Many derived from one of the classic 'prestige' animals, but others came from sources more esoteric, such as the wombat or the racoon, the latter being the favoured skin for those long coats that drivers wrapped themselves in when going out in their unheated cars. Stoles and tippets were newly fashionable, and fox heads were dangling and swinging in the breeze as their wealthy owners marched down Bond Street.

The allure of fur is as much in its smell as its feel. There is a scene in *I Capture the Castle*, Dodie Smith's 1948 classic novel set in the thirties, in which sisters Rose and Cassandra must go to an up-market London department store to try and flog some moth-eaten coats they've inherited, far inferior to the sumptuous wares on display. As they make their way upstairs, Cassandra's nose is on the alert: 'There was a different scent in the fur department, heavier, and the furs themselves had an exciting smell.' Then there is that moment in C.S. Lewis' *The Lion, the Witch and the Wardrobe* when Lucy first stepped

into the wardrobe, got in 'among the coats and rubbed her face against them'.

If only Lucy had known about Guerlain's Bouquet de Faunes, launched in the 1920s. The name would have intrigued her, as a fan of mythological hybrids, and this one was an early fur perfume. Either that or something that Mr Tumnus might use to make his faun hair all curly. Fur perfumes, initially, were an early form of 'neutraliser', designed to mask the less appealing odours of must and murk. Over the years, however, they evolved into something to complement the garment being worn, and the various animals behind the skins became a neat conceit for developing a range of scent. Nevertheless, a fragrance applied directly onto fur still promised to endure for weeks on end, giving the wearer more value for money from their purchase.

The Parisian house of Weil, founded in true fairy-tale style by three brothers, were part of a small coterie of famous fur perfumers who followed that couturier trick of supplementing their clothing with this other, most profitable product; another to follow in the 1930s would be the renowned furrier Revillon Frères, who took a journey to the northern lights with their Latitude 50 perfume. Weil's most notable launch was Zibeline in 1928, created by Claude Fraysse and sold with the promise that it would not destroy precious fur. Zibeline, which means 'sable' in French (other perfumes were named Chinchilla, Hermine and Une Fleur pour la Fourrure) was a voluptuous oriental scent, 'as rich and husky as a torchsong', they said, and intended for the biggest of gala evenings out.

The most effective way today of invoking the civet wafts of Zibeline is to turn briefly to the vogue for exotic pets. Following in the footsteps of 'The Leopard Woman', from the eponymous 1920 adventure film, there came a flurry of performers, from Joan Blondell to Marian Nixon, who either dressed up as big cats or owned one. As we've seen, Josephine Baker took her pet leopard, Chiquita, on holiday to Deauville. Actress Marian Nixon was photographed in 1925 wearing a leopard-print coat while taking her leopard for a walk on the Hollywood streets; it appeared remarkably sanguine at the sight of one of

its brethren transformed into clothing. This safari chic juxtaposition – of wild beasts taken down to the beauty parlour – is one way we can conjure the smell of Zibeline, a perfume of savage glamour with its underlying animalic tang of natural civet derived from the perineal glands of those nocturnal mammals. Other fur perfumes featured the potent, leathery-smelling castoreum, extracted from the castor sacs of beavers. Fur fragrance strangely therefore served to disguise but also ultimately to enhance the smell of the animals transformed into the season's smartest of coats and hats.

The Threatening Thirties
1930–1939

YOU CAN DEPEND ON THE perfume industry to make light of the world's woes. No matter how bad things get, few obstacles can block the shimmer and glitz of a new fragrance. As the 1930s opened, the global economy was in meltdown and millions of families were on the brink of hardship. Buying fine fragrance was low down on most to-do lists. Yet right then, out of nowhere, just as it seemed that the whole business might have had its day, came the most expensive scent ever released: Joy, by Jean Patou.

Today, Joy has competition at the upper end of the spectrum, outdone by a fragrance with the modest asking price of just shy of a quarter of a million dollars, but in the thirties it was an outrageously daring proposition, containing the most costly essences of May rose and jasmine, and in extreme concentrations. Count up all the new fragrance releases in this decade, spurred on by the success of Joy, and you would never think that the Great Depression was doing its worst (though, to be fair, work on Joy would have commenced ahead of the crash). The rich were still there, still buying, and becoming more demanding of their perfumes. They needed smells that would amplify their lifestyle choices and echo the emotions brought on by the thrilling escapades and naughtiness taking place under the tables at exclusive nightclubs and casinos in the world's major cities. Per-fumes started bearing names such as Anticipation, Abandon, Audace and Challenge – little olfactory hurricanes creating an atmosphere of

daring around the wearer. There was even a fragrance from Revillon called Tornade ('Tornado'), which in 1937 took over a page in magazines such as America's *Time*, announcing itself as a divorcee's perfume for those 'just back from Reno'. This 'wicked essence of sophistication', readers were told, carried 'precious wood oils…imprisoned in an extract from the gland of sables'. Women were to apply it before they headed 'off to cocktails and may Allah protect you!' Perfume became so fashionable as a means of reinvention and recovery that the neurology department at Columbia University experimented with the administration of jasmine and tuberose perfumes, in conjunction with symphony music, to treat anxiety, hysteria and nightmares.

We are fortunate to have some thirties perfumes still with us, but many others have disappeared, including that intriguing divorcee's brew, and it is difficult even to guess at their scents through contemporary accounts. Writers of the time, particularly beauty editors at women's magazines, would often skid over the actual fragrance. In other matters of personal style they were in their element. They would dissect at length the gory details of beauty treatments at Elizabeth Arden's or Mrs Ingram's Tao Salon, including the special application of hormone creams and face harnesses. They would chronicle the exact shade of red in a new lipstick with a fervour that would make Pantone proud. With new perfumes, though, *Harper's Bazaar* would made such pronouncements as 'Marcel Rochas is doing one that is wonderfully smart, in an opaque white bottle banded with dark blue. Lipstick and powder to match.' That was it. Whether the perfume, once sprayed, opened up to a particular take on verbena, or whether a rose was candied or green, sweet or earthy, was not the point. These editors could see the limits of language in conveying a smell and knew that the writer's idea of a pretty fragrance was not necessarily the same as the reader's.

They also understood why customers were buying perfume in the first place. Scent enthusiasts cared less for the nuances of a composition and more for the impact a scent would have in society. Would it look good on the dressing table? Would it mark out the wearer as a

style leader? Most importantly, would the perfume be suitable for the maze of engagements and events awaiting those with plenty of cash still to splash?

Today, a 'signature scent' is one that best complements the wearer's personality and preferences, but in the 1930s this status was awarded to the most adaptable smells, those which would work in any given situation. And the life of the wealthy debutante featured some most serious situations. Her average day was one long, arduous circuit, from waking up at ten to do some light shopping, followed by lunch with mother, an afternoon manicure and then an evening ball. A perfume that would do the business during a round of golf as well as for an evening bash was the holy grail, and so the fragrance equivalent of the perfect pair of go-anywhere jeans was born.

The perfume house Yardley jumped on this 'all for one and one for all' sales strategy when promoting their classic lavender fragrance as a unique proposition: 'It is the one perfume which can be worn with perfect taste during daytime hours: the bridge party, the matinée, the many informal occasions – in the evening, too, when such an added refinement means so much to the charm of the moment.' They were not the only brand proclaiming they had 'it'. All the makers were working hard to attract the sports-playing, theatre-going, party-hosting posse. As a must-have decorative accessory, perfumes were being released in an endless parade, with more and more opportunities to covet and to own.

Once it had been brought safely home and was sitting proud in the bedroom like an Oscar statuette, what was a girl to do with her scent? Spray it all over, right, with a degree of abandon. Except that in the thirties, the etiquette on how to wear perfume was still being improvised. In 1936, the British weekly magazine *The Queen* was imploring its readers to get with the times and copy the Parisians by misting fragrance over the body – not just after dressing, but while still in lingerie – and even rubbing it into the eyebrows. They also helped readers to keep up with newly emerging fragrance trends:

Chypre, which used in former days to be associated with the fashionable demi-monde of France and Russia, with sequestered, silk-lined boudoirs and an artificial hot-house existence, is now being advocated for daytime wear by the women who go in for sports. Such a complete reversal!

With so many options, it is no wonder that commentators of the day such as Edith Sitwell started yearning for simpler times, when there had been only a few different scents from which to choose. Edith felt that the eighteenth century was a golden age of olfaction whose limited range of fragrances could more easily evoke a striking stock personality. In fact she become rather carried away in *Harper's Bazaar*, conjuring a whole montage:

We can see little masked ladies, looking out of moonlit windows and waiting for their forbidden pirate lovers, letting fall a few dark drops of this perfume on their hair and the curd-soft silks of their dresses; old and grumbling gentlemen sprinkling it upon their wigs in the brown and musty sunlight whose motes fall golden and sharp as ducats.

Just as Edith was away imagining her pirate escapades, the scents of the thirties hold much escapist nostalgia for us. Thankfully, some remain to be worn today. In putting them on, we are allowed to live a little of this alluring if disturbing decade, with zero effort. For in other sartorial matters, the period, frankly, was demanding. Those bias-cut silk dresses are glorious but merciless in displaying the tiniest pot-belly resulting from that recent pizza-eating session. The hairstyles are a nightmare and never stay in place. The showy Regency-style interiors are all black lacquer, ready to show up any greasy fingerprint or watermark. But the perfumes? Well, they are simply to be sprayed and enjoyed, whether you're garbed in evening gown or dressing gown.

Skin Bracer

BY MENNEN, 1930

THE SERGEANT-MAJOR PERFUME

BEFORE WE GET CARRIED AWAY by the glamour of the 1930s, we will begin with an inauspicious 'perfume' if ever there was one. Mennen Skin Bracer is one of those veteran aftershaves that has defied the laws of inflation, rising modestly from $1 in the 1940s to only $4 today. The fluid is a Chernobyl green and was designed to make the cheeks sting, to put the bite into a man's early-morning shave. It was meant to make wimpish fourteen-year-old boys spurt tears in front of the mirror on freezing November dawns as they slapped their cheeks with cologne in some puzzling masculine ritual. This rite-of-passage moment was parodied beautifully in the 1990 film *Home Alone*, when a young Kevin, sneaking his first morning with a Gillette blade, perforates the viewer's eardrums with his aftershave-induced scream.

With Mennen Skin Bracer the pain was part of it; it was good for you, in the way that having an officer bark at you to do yet another fifty push-ups was good for you. It showed that the product was manning you up and performing its duty to all fine gentlemen: 'Feel its ice-cool, stimulating tingle. Feel your face fairly sparkle with a crisp, clean sensation for hours. Have that extra assurance that comes with Skin

Bracer's fresh outdoor aroma!'

Advertisements like these appeared in non-sissy publications such as *Popular Mechanics* and *Field & Stream*. They appropriated pin-up iconography, with bikini-clad girls aplenty, and promoted the Bracer as an army favourite during the Second World War; the odd memoir from Korea even recalls soldiers polishing their boots with the stuff, which makes one wonder as to its precise formulation.

Although there are (many) other fragrances I might recommend above Mennen, it is a crucial inclusion for our annals; the 'he-man' smell, just like menthol mouthwash, that was a bestseller in America for years, a sometime rival to Old Spice's crown, and the product that made masculine scent not about beautiful smells but about efficacy: the minty tingling of overexcited capillaries that finished the alarm clock's work in the great morning wake-up.

Scandal

BY LANVIN, 1931

THE ANIMALIC PERFUME

SCANDAL COULD NOT BE MORE different from Mennen Skin Bracer. Calvin Klein's Obsession and other erotically tinged perfumes of the late twentieth century might proclaim themselves to smell sexual, but it's all a tease: when the breeze catches their skirts, they're caught wearing granny pants. Scandal, however – like its predecessor from Lanvin, the equally delightful Mon Péché ('My Sin') of 1924, and the fur perfumes of the period – is the real deal, and an interesting example of an attempt to equate transgression with a deep, barbaric aromatic profile.

This is a rich, fruity leather, influenced by the various Cuirs de Russie of the preceding years, including Chanel's of 1924, and is far throatier than the more tamed leather-inflected perfumes that would come to the fore in the 1950s, such as Jolie Madame. With a birch-tar odour helped along by clary sage and a molecule called isobutyl quinoline – which brought a furry, nutty smokiness over the rose and neroli – Scandal smells to me like the circus come to town, complete with a tussle of sweaty sequinned leotards and bits of lion hair. It certainly was not the *only* inky, animalic perfume around – the period

was riddled with them – but it was one of the most potent expressions of its class.

Coming from a couture house, Scandal was expensive stuff, but the fragrance industry wasn't entirely undemocratic, and water has to run downhill eventually. In the 1920s, enterprising agents in America had started importing fine French fragrances and rebottling them into tiny sample drams, often in the form of nips; these little Lucite shards looked a bit like drugs paraphernalia but contained a sample of fragrance to be snapped open for a single application. Dispensed in shops such as Woolworth and in vending machines, either in assortment packs or by brand, they offered a way for the growing number of fragrance lovers to afford perfume without spending a month's salary. Such practices, from the likes of Nips, Inc., a company which advertised itself as wholly independent of the luxury brands, weren't exactly official, and could undermine the hard-won prestige of a fragrance. Some turned a blind eye. But in 1938, Guerlain pursued Nips Inc., for rebottling Shalimar at below retail price. Only in 1947 was the court's judgment affirmed that the racket must cease.

In the meantime, this sampling trend meant that each day of the week could be coloured by a different, salacious mood: Monday for Indiscret, Tuesday for Tabu, Wednesday for My Sin and Thursday for Scandal. In the midst of a depression, this was a welcome innovation, a way for girls who had to work for a living to get a taste of the high life by wearing the risqué perfumes their idols in society enjoyed. Scandal, whether bought as a full bottle or tasted as a nip, brought the high drama of stage, screen and novel to the skin, without the nasty repercussions. This word, scandal, was a familiar, tantalising one. People had heard it frequently in the previous, corruption-ridden decade, but it was about to move over from politics into Hollywood, which hitherto had managed to cover up its own grubby business. A year after Scandal's release, in a notorious, endlessly discussed incident, the actress Peg Entwistle – struggling to make a career in the movies – threw herself off the 'H' of the Hollywood Sign, to her death, and wasn't found for two days.

Vol de Nuit

BY GUERLAIN, 1933

THE HIGH-ALTITUDE PERFUME

THE PERFUME AISLES AT DUTY FREE are the saviour of passengers with delayed flights. When the incoming plane's stuck somewhere over Malaga and £5 food and beverage vouchers are being handed out, some sit on wobbly stools at the terminal's oyster and champagne bar pretending to have a merry time while fending off nagging doubts about food poisoning. That's a mistake. Better to down a glass and then walk, mildly inebriated, around the perfume bottles for a trip down memory lane (giant Toblerone bar peeking out of hand-luggage) to review the entire Chanel back-catalogue in chronological order, applied to a forearm (the other is for lipstick swatches).

It is hit-and-miss as to whether this perfume will be in stock at the Guerlain duty-free counters, though you most likely will find it in larger French airports. If Vol de Nuit ('Night Flight') does sit somewhere on the shelf, take a sniff as this is *the* aviation-themed perfume – albeit referencing travel in the 1930s, which was another proposition entirely. Along with Caron's En Avion of 1929, Vol de Nuit is one of those art deco way-marker fragrances, commemorating gleaming new technology and the thrill of humankind propelling

itself into the skies. While En Avion is said to have been inspired by the chutzpah of female pilots such as Amelia Earhart, Vol de Nuit turned to the fictional world of Antoine de Saint-Exupéry's internationally bestselling novel of the same name, which tells of a pilot facing almost certain death as he takes off during a dangerous thunderstorm. The launch of Guerlain's perfume, hinting at an adrenaline rush, must have been a real event, coinciding as it did with the film adaptation starring Clark Gable and Helen Hayes.

On the nose, En Avion is more directly evocative of the experience of passenger flights of the 1930s, which soothed terror and risk with suede luxury. The spicy, dense perfume does suggest a tangle of fine leather upholstery, varnished wood and jet fuel, peeking through the slightly medicinal orange blossom. Vol de Nuit in contrast is often compared to other Guerlains, as though it sits in a gap and lacks a punchy enough personality of its own. Yet, in its complexity, you could spend an entire long-haul flight working out Vol de Nuit, as it steers from citrus to seaweed and to biting green galbanum before settling to a sweetly glowing amber. It flickers between shimmer and shade, a bit like one of those magic birthday candles that keeps on relighting despite having being blown out.

Perfumes like Vol de Nuit, which are so much tied to the pre-occupations of an era, help us wriggle ourselves into a mindset that is otherwise just out of reach. The smell itself is not necessarily a passport to being on an old aeroplane, but in pausing to take a sniff at it and to learn of its story, Vol de Nuit invites us to consider afresh the sensation of flying as being utterly strange and glamorous. A wonderful articulation of this came from Elizabeth Bowen, who in her novel *To The North* (1932) describes the landing of a London to Paris flight. Descending 'tipped' as though 'in indecision', and with a landscape beneath them that 'tilted and reeled', the passengers touch down with 'a whirr of arrival' – 'tipped like grain from a shovel, they all stepped, incredulous, out of the quivering plane.'

Tweed

BY LENTHÉRIC, 1933

THE OUTDOORS PERFUME

TWEED IS CUT FROM A different cloth to most other perfumes of the 1930s. In contrast to all those glamourpot scents – Passionnement, Indiscret, Shocking – Tweed is practical and hardy, the thing to wear for a drive with Toad of Toad Hall and a picnic hamper of trout pâté and oatcakes in the boot. Admittedly, the name is slightly rusty today, at risk of dowdiness through its association with flat caps and men in bashed-out jackets nursing a pint of bitter. Let us acknowledge that for women tweed is not the easiest fabric to make alluring. We may be hoping to channel Katharine Hepburn but more often will come out as the parish busybody trying to drum up support for a Neighbourhood Watch rota.

But there is unexpected delight in the house of Lenthéric's most famous fragrance. It walks us in the opposite direction of the cigarette-fuelled cocktail party and its silk and crêpe-de-chine gowns, way out of the city entirely and deep into a rugged landscape of mosses, rocky outcrops, dirt and a chill in the air. Tweed was a perfume in keeping with the likes of foreign correspondent Martha Gellhorn in her slacks and shirts. It suggested a certain practicality and efficiency while also

offering a sense of peaceful repose out in the elements; wear Tweed and you might convince yourself you had just returned from a long hill climb in the Highlands.

In working out what inspired this curious choice of launch, a hint comes from the interest in the 1930s in 'Scottish tradition' and the romance of the cloth weavers and distillers going about their lives in hostile, primitive conditions on the Outer Hebrides. *LIFE* magazine ran a photography feature on the Harris Tweed Company in 1939, boasting that tweed was smashing out of its daywear conventions and into evening attire. The reporter brought to life the olfactory qualities of the fabric – 'because pungent lichens and herb roots, peat smoke, fire and water are used in its manufacture, the legend prevails that a cow will be attracted to a genuine Harris Tweed by its smell and will lick the cloth' – and these qualities may well have inspired Lenthéric in their scent's composition (especially since they gave away free tweed bags with every purchase to solidify the connection). It's certainly a delicious-sounding smell, though it does raise the question: would a wearer of Tweed perfume be at risk of a malevolent herd approaching them, tongues hanging out?

Tweed, still for sale, needs a renaissance. In its last major campaign, in the 1980s, it was promoted by a model playing some kind of maiden aunt at a wedding, all perm, polyester pussy-bow blouse and dowdiness. Tweed does not belong in such a story; it belongs in the outdoors – as long as the cows stay well away.

Blue Grass

BY ELIZABETH ARDEN, 1934

THE EQUINE PERFUME

AFTER ALL THE JAZZ AGE'S drinking and carousing comes the detox, hosted at a trailblazing new 1930s health farm that featured a frightening number of colonic hoses. The resort in question was Maine Chance, the country house of beauty entrepreneur Elizabeth Arden, located in Mount Vernon, Maine. In 1933 she converted this piece of yellow clapboard Americana into the first ever 'destination spa', establishing the template on which hundreds of other terry-towelling-robe retreats have since modelled themselves.

Arden's red-door salons at high-status addresses such as Fifth Avenue and Bond Street were regular pitstops for the well-to-do as they went about their city lives, but Maine Chance was the big one for recharging the batteries each summer. The impetus for going was described by *Vogue* in 1933, who identified the wearying nature of 'Active Life', or 'the racket', as having 'reached such a nervous pitch in the last few years that few people can "take it" for long'. The magazine encouraged people in the know to share their little black books of rural retreats. They heard from Mrs Rupert Cochrane King about the pleasures of ranch life in Jackson Hole, Wyoming: 'You dress all day

in riding-clothes or the beloved blue jeans, changing when necessary to a clean shirt for the evening. There is riding, motoring, fishing, swimming, picnics, barbecues, rodeos.' Others favoured Arizona or the Hamptons, but Maine Chance was seen as the ultimate treat for getting away from it all. Four years later and by now highly renowned, it garnered a feature all of its own in the same magazine: 'In the midst of Sybaritic surroundings, you are trained as rigorously as any athlete.'

A stay at Maine Chance sounds both heavenly and hellish, a form of institutional relaxation suggestive of today's health destinations such as Austria's Mayr Clinic. Guests resided in cabins stuffed with Elizabeth Arden products and a timetable was issued each day to relieve them of the stress of decision making. It included massage, walking, swimming, badminton, horse riding and of course colonic irrigation. There was even a sun cabinet lined with cappa shells from the Philippines. The food, prepared by physician Benjamin Gayelord Hauser, encompassed nourishing broths in Thermos flasks, brought to guests on a cart that pursued them about the grounds. The disturbing part came with the wearing of skin-tightening frown plasters by day and face bandages by night.

The restorative effect of a week or two at Maine Chance was described in raptures: 'You see the lake gleaming down the hill. You feel that life begins at whatever age you are that minute.' And it is this halo effect, the invigoration that comes from being in the fresh air and wide-open spaces, that went into Blue Grass, a bestselling fragrance for well over thirty years. Arden might have been expected to channel the uptown New York beauty culture with her early perfumes (years later would come the releases Red Door and 5th Avenue, for example), but Elizabeth, perhaps counter-intuitively, went for Blue Grass in celebration of her beloved Kentucky and its equestrian culture. She was horse mad and later bought her own stables, winning the Kentucky Derby in 1947.

Her choice, by all accounts, was greeted warily by her team, who worried that the concept was too rural and folksy for the typical Arden customer. But Blue Grass, just like Lenthéric's Tweed and Worth's

Je Reviens, provided a nice foil to the more opulent fragrances of the time. It took the fashion for aldehydic florals and added in plenty of lavender and herbal tones to create a cool, lathered finish. Blue Grass was wild horses stomping the Kentucky plains by moonlight, with a breeze rushing through the grass. It was still a glamorous perfume, much as Mrs Rupert Cochrane King was still probably wearing lipstick with her jeans, but of a relaxed, buttoned-down kind. Blue Grass was and is scrubbed, pristine and rosy from the sauna. Over the years, however, it has also come to stand for the archetypal freshly soaped smell, as its olfactory profile has filtered down into more functional products. These days the same perfume can come across as sanitary and sterile where it once spoke of invigoration.

The link with washing was certainly there from the very beginning though; little tablets scented with Blue Grass were installed in the shower heads at Elizabeth Arden's Chicago salon to make the water even more refreshing. And in support of the argument that animals deserve to be treated like people, the Kentucky stables which housed all Arden's thoroughbreds were washed out with Blue Grass on her instruction. The horses, who enjoyed piped music and had Eight Hour Cream massaged into their sore hooves, were as well looked after as Maine Chance's pampered guests.

Fleurs de Rocaille

BY CARON, 1934

THE MATINÉE PERFUME

FLEURS DE ROCAILLE USED TO be one of Caron's most famous and well-regarded fragrances, but today it languishes next to the vampish Narcisse Noir as an icy aldehydic floral, positively carbonated and not at all as fashionable as it once was.

With a name meaning 'Rock Flowers', Fleurs de Rocaille was a refreshing, fun concept brought out at the height of the art deco period, suggestive of a clamber around the craggy grey rocks to find some tiny, bright, tinkling flowers. These are not luscious bouquets but soapy, frothy little things. Caron seem to have marketed the perfume specifically to young women, their advertisements focusing on a portrait of a girl with newly fashionable plucked-to-the-thickness-of-a-wire eyebrows.

For some reason, I have always connected Fleurs de Rocaille with the actress and dancer Ginger Rogers. As she swooshes around with Fred Astaire in the likes of *Top Hat*, her bright and breezy style, energy, and feather-light dresses seem much more in tune with this sort of fragrance than more hard-core perfumes such as Shocking, which we will meet soon. Fleurs de Rocaille is a matinée scent, not an evening

extravaganza. Though at $30 a bottle, close to $500 in today's currency and twice the price of other high-end fragrances of the time, the young things wearing Fleurs de Rocaille needed to have serious income to afford this 'Who, me?' perfume.

In 1940, Rogers was cast in the drama *Primrose Path*, produced by R.K.O. Pictures, one of the five big studios of Hollywood's golden era and behind all of Rogers' most successful releases with Fred Astaire. R.K.O. arranged a deal with Caron to place Fleurs de Rocaille bottles within this new story. Caron believed that this arrangement would show their fragrance in a beneficial light, but the movie was about prostitution, with Ginger's character trying to resist getting caught up in the trade practised by both her mother and grandmother. Caron, far from getting the classy positioning they had sought, found instead that one of their star perfumes was featured in circumstances 'depicting squalor, sordidness and depravity' with 'distinctly unpleasant people'. These complaints came from their unsuccessful attempts to get R.K.O. to remove the scene, even seeking a court injunction. To be honest, the film was so censored, with all references to prostitution cloaked in innuendo, that half the audience wouldn't have cottoned on anyway.

Fast-forward to 1992 and another film release: *Scent of a Woman*. In a moment known well by fragrance aficionados, Al Pacino's character, a blind ex-army officer, impresses a woman after smelling her perfume and, guessing correctly, names it out loud: Fleurs de Rocaille. It had taken fifty years, but Caron, finally, got the movie moment they had been waiting for.

Shocking

BY SCHIAPARELLI, 1937

THE TECHNICOLOR PERFUME

PERFUME IS OFTEN DESCRIBED IN terms of colour. Green fragrances are those that offer cooling, invigorating relief. Oriental perfumes are invariably imagined as an opulent purple – because naturally everyone in the East dresses like an emperor. And there are hesperidic colognes, taking on the jaunty yellow of lemon peel or noonday sunshine.

In the 1930s the connections between scent and colour were particularly pertinent. Thanks to Technicolor technology, cinema audiences were immersed more fully – not necessarily emotionally, but sensually – in the scenes that unfolded before them. The great outdoors looked more luscious and fertile than ever before, even the Munchkin village in *The Wizard of Oz* of 1939, which was constructed from glossy plastics. In these hyper-real worlds, characters seemed to pop out from the screen and into the auditorium, perhaps most memorably the evil Queen Grimhilde in Disney's *Snow White and the Seven Dwarfs*, who was all the more terrifying thanks to her matte red lipstick and purple cloak. Costumes looked as if you could reach out and touch them, not least Dorothy's glitter-gritted ruby slippers. Was there an olfactory analogue to this new brightness? A perfume that

could be as ritzy-glitzy as the Technicolor movies? If anyone was going to supply such a thing, it would have to be the Italian designer Elsa Schiaparelli, who birthed a colour of her very own, the crazed pink she named Shocking-pink.

Schiaparelli was renowned and feted in the 1930s for her use of wild pigments, making other designers, even Coco Chanel, seem old hat. Her bright yellow blooming trousers and violet fingerless mittens were typical of the way she cleverly deployed colour and shape in tandem so as to transform women into unfamiliar versions of themselves. The writer and filmmaker Jean Cocteau placed Elsa as some kind of maenad (those ecstatic female followers of Dionysus), and said about her:

Has she not the air of a young demon who tempts women, who leads the mad carnival in a burst of laughter? Her establishment in the Place Vendôme is a devil's laboratory. Women who go there fall into a trap, and come out masked, disguised, deformed or reformed.

This transformative effect extended to Schiaparelli's perfumes, most famously Shocking, which, alas, has been in and out of service more times than an exhausted diplomat. With this one, there is little room to interpret its smell as anything other than pink, for the colour is imprinted on our minds before we even uncap the bottle: through the artwork, the outer packaging and the copy. The fragrance's hit comes from a strange, funky combination of honey, civet and tarragon, and this is no ordinary honey but that made by a hive of oversized bees serving their queen in a mania. Not only was the smell bizarre, but Schiaparelli chose to house her precious liquid in a bottle designed by the Argentinian surrealist painter Leonor Fini and fashioned after Mae West's buxom torso. The bottle was then clothed with a corsage of Bakelite flowers. To spray on Shocking, the owner has to grope a pair of boobs.

By working on all the senses to create its flurry of fuchsia, Shocking was an immediate hit and 'the one to beat'. Sophisticated, irresistible

and daring, it outsold all other Schiaparelli perfumes and quickly spawned a variety of novelty editions, including a 'Spin and Win' roulette wheel of four miniature bottles for travel. One department store, Korricks of Arizona, summed up the craze when they put in their 1939 Christmas advertisements: 'If you aren't sure of her favorite you're safe if you pick Schiaparelli Shocking.'

Many perfumes come into our shops, and even though they may be innovative in the eyes of the industry, their boldness goes ignored or unrealised by us. Shocking, though, was one of those rare examples of a launch done so cohesively, in the service of a fragrance so unusual, that just as Technicolor made audiences' eyes pop at what could be done on film, Shocking made the perfume lover of the 1930s gawp anew at scent, and at just how bold, brash and exciting it could be.

Old Spice

BY SHULTON, 1937

THE EVERYMAN PERFUME

IF OLD SPICE WERE EVER discontinued, there would be the most fervent public outcry. Newspaper columnists would come over all nostalgic. The words 'end of an era' would be rolled out. Old Spice is one of our most recognised and beloved brands, the perfume brother to Birds Eye peas or Campbell's soup; we might not ever buy it, but we like to know it's there. Old Spice should perhaps be awarded protected status as the torch that is passed down through the generations from father to son at around the same time that they have that awkward chat about 'being careful'.

Maybe Old Spice's appeal comes from it being the smell of the Everyman. Whereas Brut, equally famous and to come in the 1960s, will put the hairs on your chest, Old Spice is more Jimmy Stewart in *It's a Wonderful Life*: familiar, unassuming and ever so slightly worn in. In spite of the ironic and much lauded 'The Man Your Man Could Smell Like' advertising campaigns of 2010 onwards, which positioned the product to appeal to younger men, will Old Spice ever stop being Dad in his plaid dressing gown and free hotel slippers?

It is precisely by being Mr Average – so steadfastly and proudly – that

Old Spice has kept its grip on the public imagination. The scent, now owned by Procter & Gamble, came from a typically American (and formidably successful) twentieth-century firm, Shulton, which was founded in the middle of the Great Depression by William Lightfoot Schultz as an emphatically home-grown brand. Schultz was incredibly clever: while American fragrances already existed as a counterpoint to the continental style, they had been weak on the messaging. Remember, for example, American Ideal of 1908 from the California Perfume Company, which had been vague in defining what the 'A' in America actually stood for. Shulton, though, came up with a credible, authentic landscape in which their new fragrance could operate: the nation's colonial history and specifically, the ships and naval culture that brought the Founding Fathers to its shores. In style, and with its tang of cinnamon, star anise and nutmeg, Old Spice is not hugely dissimilar to the Bay Rum scents (to come in the 1940s), but Schultz and colleagues charted a course through the seven seas comprehensive enough to build their own empire. Bay Rum describes a type of fragrance; Old Spice could only be Shulton's.

The foundations of this product are so sturdy because the colonial design inspiration was right there from the start. Shulton produced historically relevant shaving soaps in a mug and white porcelain bottles in the style of early dishware, probably to encourage gifting from wives to their husbands, especially around Father's Day. These accessories were so successful that Old Spice enjoyed special prestige as a collector's brand, and by the 1970s there was a remarkable range of memorabilia, enough to fuel a lifetime's knick-knack hunting. Anyone for some Old Spice binoculars, a ship's decanter filled with aftershave, a miniature cannon, a lantern, lifebelts or a boatswain's pipe? An entire role-play scenario could be created solely from these giveaways. Somewhere must live a man surrounded by Old Spice admirals' hats, demanding that the postman call him captain.

Colony
BY JEAN PATOU, 1938

THE VOYAGING PERFUME

DELIGHTFUL ARE THE PERFUMES THAT through their stories offer to transport us, even if by a circuitous route. Guerlain's Samsara draws the wearer into an Indian desert temple, while the smell of Giorgio Beverly Hills renders its subjects unconscious, after which it bundles them on a transatlantic flight of the mind to Rodeo Drive. One of the most transporting and exotic of all came out in the 1930s. Its name was Colony. The brainchild of Jean Patou, who has featured frequently in these pages, Colony was released to capture 'the hushed mystery of far-off isles' and, specifically, the French-governed tropics. The fragrance came in a pineapple-shaped bottle and was centred upon the alluring scent of this majestic fruit. Contrary to appearances, it was not sponsored by Del Monte, although they were certainly busy promoting their tinned produce during this decade, distributing recipes for pineapple coleslaw.

Colony has recently been reformulated and introduced back onto shelves after years of dormancy, cause for cheer because it is a stunning perfume: evocative of the beach, though with a certain sophistication. We are talking high-waisted swimsuits with a little belt, orchids in our

hair, twinkly painted toenails and a tiki bar nearby. As we have seen, Patou was a genius at translating fashionable lifestyle concepts into a sellable fragrance hook. His shop in Paris was designed to look like a cocktail bar, and for a few years he sold kits to allow his customers to make their own perfume at home, with various scented 'bitters' to modify the blends, and a neat little cocktail shaker. Patou even celebrated the advent of paid holidays in France with a perfume called Vacances, while 1935's Normandy, marking the maiden voyage of SS *Normandie*, was given to every lady who sailed first class.

Colony, too, was tapping into the craze for foreign travel. The wealthy were particularly excited by the prospect of experiencing the exotic, warm, yet culturally familiar French colonies, now finally accessible(ish) thanks to the availability of air travel. Europe had been 'done' and was perhaps not exciting enough for those with both money and the months of free time required for a decent immersion. In 1937, an illustrious magazine editor, Mrs James Rodney, reflected these desires in one of her taste-making articles:

It is the inevitable reaction to the English fog. Palm Beach, the West or East Indies, Nassau, Honolulu, India, for those whose time is of the enviable unlimited variety; Egypt, the Riviera, Portugal, North Africa, for others whose time is precious. And so I pretend it's to any of these far-distant enchantments I'm going.

Colony was just the perfume to take on one of these trips to enhance the enchantment, or to acquire afterwards as a reminder of good times. Or, for those who could only dream of Trinidad and Tobago, it could be a surrogate for the experience itself.

So far so good, but what about the oh-so-wrong original advert for the fragrance, which depicted a pair of eyes gleaming out of a dark jungle background?

Colony came out in 1938, when paternalistic views about 'natives' were rife. This was the age of the popular children's book series *Babar the Elephant* by Jean de Brunhoff. The Babar stories are delightful, but

they have a concerning undertone: Babar becomes king of the ele-phants only after he has brought back the civilising ways of the big city to his subjects. Mainstream cinema was similarly constructing the exotic foreigner as a flattened archetype. The actress Anna May Wong, hugely talented and the first Chinese woman to break into Hollywood, was always typecast in the Dragon Lady role – little wonder, given some of the cinematic conventions of the time. Peter Fleming, brother of the James Bond author, said this of 'orientals' in the pictures:

> You can credit them convincingly with the most extravagant of motives. You can shoot them, drown them, buffoon them, or throw them out of penthouses without anybody in the audience turning a hair. Their poisons and their passions, their loyalties and their lapsus linguae, will get you round practically any awkward corner in a scenario.

These views were played out on screen not only through a clutch of clichéd villains with their poisons and passions but also in more innocuous cinematic moments. Take the 1939 MGM musical *Honolulu*, in which the tap dancer Eleanor Powell goes to Hawaii, at the time a terribly exciting destination for visitors from mainland America. In one scene, the locals welcome her with an incredible dance routine. She smiles in thanks, then takes to the stage and out-dances them in an insanely advanced version of their own moves. Couldn't she just let them do their thing? Mind you, Honolulu was tourism as a show, lei flower garlands and all. Colony, in perfume form, likewise simulated the fun (and possibly the artifice) of being in exciting and faraway places, of seeing selectively and engaging lightly with the realities of the country, and having a whale of a time by the pool.

Alpona

BY CARON, 1939

THE SKI-RESORT PERFUME

EVEN AS WAR LOOMED CLOSER, Europe and the United States were in the middle of a sports craze which continues to this day, a craze that thrills some of the population but provokes bafflement or envy in everyone else. Skiing.

Ski resorts had only just put in rope pulleys, finally realising that people love flying down a mountain but do not generally relish the prospect of staggering back to the summit again and again with blue toes. No longer the preserve of the intrepid, skiing was now open to anyone with a bit of money, kit and bravado. 'Ski fashion' was massive, and alongside the predictable Tyrolean Maiden look there was now an exciting opportunity for designers, including Lelong, Schiaparelli and Patou, to take a more experimental line, dressing women in everyday trousers and exploring utilitarian chic. To us, however, some of the 1930s outfits seem to be verging on prisoner chic.

As skiing began generating big bucks, enjoyed by half a million Americans, canny entrepreneurs started to apply to mountainsides the philosophy that had made cruise ships into floating palaces. The European Alps were already colonised, but America offered vast

unpopulated mountain ranges in which to experiment with fine living, high-altitude style.

The most A-list resort was Sun Valley in Idaho, 'discovered' by the Austrian Count Felix Schaffgotsch, an idle banking heir and, it turned out, a devoted Nazi, who was tasked by a friend to find the ideal Alpine equivalent in North America. Sun Valley's Ketchum went from a quiet town of one hundred to a glitzy paradise that focused as much on dining, drinking and gambling as on the sport itself. The celebrity pack, led by Ernest Hemingway and including Clark Gable, Ingrid Bergman and Gary Cooper, soon flocked there for some winter fun. And the thing about ski resorts is that stars are somehow much more amenable to being photographed when they have ski poles in hand. Maybe they get less flustered in cold climates, or feel protected by their swaddling of thick ski wear, but they will agree to novelty poses and goofy line-ups unthinkable in any other location (this rule also applies to royal families). The hijinks and air of relaxation in Sun Valley, captured on camera, gave the place instant publicity.

Sun Valley even inspired a 1941 Hollywood musical – *Sun Valley Serenade* – which portrayed the resort as a utopian, pantheistic world in which scores of organised, co-operative people tear around on husky sleighs or march about in snow boots as if they are worker ants contributing to some great project. This is the trick of skiing. It seems industrious, and we forget it is about throwing yourself down a mountain for kicks.

With Jean Patou's Colony having been the poster perfume for the tropics, a scent was of course needed for its antithesis, the alpine setting. After all, what is a trend if you can't wear a fragrance to go with it? That perfume was Alpona by Caron. It was arguably the last great release before the outbreak of the Second World War, and it's a bittersweet confection. Alpona was a celebration of the French Alps, produced at the zenith of the decade's skiing fervour, and it built on an innovative coupling of florals with grapefruit to give the required icy high-peaks dazzle. It smells optimistic, if such a term can be used, yet the perfume's Jewish creator, Caron founder Ernest Daltroff, had just fled Paris for

the safety of the United States, leaving French operations under the watchful eye of Félice Wanpouille. Though European in name, Alpona was, unusually, launched alongside two other new Caron fragrances in a huge push at New York's World Fair of 1939–1940. This focus on the American customer hinted at the wider changes to come in the fragrance industry of the 1940s, and the migration of influence from Paris to the East Coast. Unlike their European counterparts, middle-class Americans would still be able to spend on luxury products in the years to come.

Alpona may suggest the sublimity of the summit, but the circumstances were the pits: Daltroff, weakened by the strain of his emigration, died soon after its launch (Count Felix, incidentally, was killed fighting for the Waffen-SS in Russia). Alpona was to be Daltroff's swan song, relatively unknown in comparison to his bestsellers Tabac Blond and Narcisse Noir, but a secret masterpiece at that.

The Insubordinate Forties
1940–1949

WHEN THERE IS A WORLD war on, with millions killed and wounded, perfume is the least of our worries. It seems churlish, even, to be covering in detail the fortunes of fragrance during so traumatic a time as 1939–1945. But here it is, if only because retrospection on the Great British home front has become so cemented on a small cluster of tropes – home-made Anderson shelters, black market bacon and the need to Dig for Victory – that by examining this little slipstream we might find something wider to say about the experiences of those living through the decade.

'Let us be practical', 'cherish' and 'treasure, to your last pinch' were among the snippets of advice given by Yardley to their customers in their wartime advertising, encouraging them to eke out their last few drops of perfume. It is quite strange to see a brand advising *against* buying, and attempting to temper demand. There is an impression, reading these, that some women were getting bolshy with the shopkeepers for running out. 'Please remember, the shortage is not his fault' was another stern reprimand and, in bold: 'There should be enough to go round if you will help by economising in their use.' Many perfume houses moved from being the naughty sister, egging you on to buy, to the ward matron, admonishing against excess and preaching restraint.

Most Parisian couture houses, whence so many perfumes originated, shut during the occupation; Lucien Lelong, famous for his 1930s

fragrances, was busy trying to convince the Nazis not to relocate the fashion industry wholesale to Berlin. Those who did manage to create something new in Europe, notably Rochas with Femme, later took on the status of legends for having kept artistry alive during the occupation, just as those perfumes released by Christian Dior and Nina Ricci after the war – Miss Dior and L'Air du Temps – became symbols of hope and regeneration.

Somehow the perfume industry did maintain a skeleton service, even if that meant selling off old stock when manufacturing was halted, or replacing natural materials, which were scarce and in any case impossible to ship, with synthetic alternatives, so that a perfume could be sourced entirely from within a laboratory. Much of this production took place in America, away from the war zones, where demand was high and the tax dollars from beauty purchases a welcome addition to the nation's coffers. Before the war, France had been the *ne plus ultra* of perfume, but now, with more scents bearing English names, the tide of influence was shifting. Many of these fragrances were prestigious and just as wearable as their European counterparts. But coming up from the rear, once the conflict was over, was a new cheeky brigade of perfumers keen to cash in on the gold rush and fill the gap in supply. We shall become further acquainted with two of them when we delve into the story behind Black Satin.

Amid all the scarcity, perfume in the 1940s began to play a more wistful tune, perhaps because scent is one of the most immediate ways in which the missing and the lost can leave their mark. As with the scent of Gardenia perfume left on a pillow in the song 'These Foolish Things', a smell can almost conjure a person's presence. Scent as sentimental memento had taken a chilling turn in *Rebecca*, Daphne du Maurier's bestselling psychological thriller of 1938, made into a Hitchcock film in 1940. Mrs de Winter, second wife of Maxim de Winter, is haunted by the feeling that her husband's first wife, Rebecca, now dead, has not quite disappeared. In a series of moments that build to a horrifying crescendo, she finds Rebecca's apricot-coloured nightdress creased as if just worn, and a handkerchief with Rebecca's lipstick marks, bearing

the scent of azaleas. Rebecca's scent follows her about, and housekeeper Mrs Danvers taunts her unwelcome new mistress with this, in one instance holding up a gown while remarking, 'The scent is still fresh, isn't it? You could almost imagine she had only just taken it off.' It is through her perfume that Rebecca nudges her way in between the new Mrs De Winter and Maxim, becoming a malevolent ghost: 'Her footsteps sounded in the corridors, her scent lingered on the stairs.'

We start to see, also, how an incongruent pairing between a person and their choice of scent can confuse and mislead. A benign version of this comes in 'Perfume', a short story of 1943 by the Australia-based journalist Eric Baume. A sub-lieutenant wounded in action is brought into a hospital, where he swoons in and out of consciousness and is temporarily blinded. During convalescence he enjoys visits from a woman called Augusta, keen to do what she can for the war effort. The soldier is utterly captivated by her scent, the fictional Presages from Monsieur Chambillard, which 'cut as softly as tempered steel into what could have been the fug of a sickbay: an invisible aureole in the atmosphere. His sleeping nostrils seemed to quiver, seeking it.'

Never have nostrils been so sexual.

Crucially, the sub-lieutenant cannot see Augusta, and falls in love with her on the basis of her scent, which he decides is certainly not the kind 'which sweeps from fat ladies in the front row of the stalls', and nor is it a 'nondescript aroma from miserly women'. He says, ominously, 'once a man understands perfume he can sense from it the girl he's going to marry'.

Augusta, however, knows that if he ever saw her, he would be horrified. Because she is indeed old, and matronly. Conscious that his eyesight will return, and pained by the thought of forcing him to confront the gap between his imagination and her appearance, she pretends to be a flighty young blonde, disappearing off into the night and leaving the following warning in a letter: 'Whenever you meet a girl with perfume, run like hell.'

'Perfume' was a minor story, but this was not a one-off thesis. By the end of the decade, noir, by now one of the triumphant genres in

fiction and film, had seized upon perfume as a symbol of identity, whether real or hidden. What do we tell other people about ourselves through our scent? How might we mislead them? And to what ends could we direct this power?

Chantilly

BY HOUBIGANT, 1941

THE ROMANCE PERFUME

HOUBIGANT'S CHANTILLY, A GIRLY CONCOCTION of rose, lilac and vanilla, is the sugared almond of perfumes. It is patisserie as sprayable liquid and offers admission to a world of sweetness and light. In this land there would be, each afternoon, raspberry tartlets, brûlées and other assortments waiting on a table with fine lace napkins to protect silk dresses from their buttery crumbs. From this vantage point, one might look on as swans and their cygnets play in the lake nearby.

This is where Jayne sat one day contemplating her impending spinsterhood, when she heard, unmistakably, the hooves of a steed flurrying towards her. As the animal whinnied and approached across the grounds, she noted with some excitement that it was a handsome horse, brown as mahogany and with kindness in his strong heart. Her eyes travelled upwards, and she beheld a similarly handsome gentleman in green breeches, looking flummoxed and entreating her. He seemed perturbed (he had been sent in haste to bear troubling news about Jayne's sister, Margaret), but he could recognise a fine figure of a lady when he saw her. Jayne, her heart fluttering quickly, stood up, curtseyed, and said to him...

This flight of fancy now concludes.

This is the thing with Chantilly. In its connections with lacework and softly-whipped cream, it is so romantic, in the Harlequin or Mills & Boon style, that one cannot smell the perfume or gaze on the powder-pink box with patterned trim without going a bit Bo Peep.

In its own way, Chantilly was radical in its conservatism. While other fragrance houses were selling full-bodied, seductive, naughty perfumes, Houbigant went for innocence; they re-referenced their aristocratic eighteenth-century heritage to produce a fragrance of courtly love originally for sale in 1898 and then re-released for the next generation. This scent was less *Les Liaisons dangereuses* and more Georgette Heyer. In the 1950s, the brand even circulated scented fans and a free publication to their department-store sellers called 'Speak Love with the Language of Fans', intended to support the old-fashioned definition of 'making love' as being all about glances and suggestion.

Never forgetting that Marie Antoinette had been one of their original patrons, Houbigant plundered a set of reference points that encompassed formal gardens, bowers, arches, fountains and statues and, most importantly, the prospect of suitors keen to woo. Their messages to the customer, saccharinely twee, included: 'Overture to romance', 'A fragrance never to be forgotten, intoxicating as a kiss!', 'Lovely perfume for a lovely lady', and 'Allurement for a lady'. Note that 'lady' cropped up very regularly, running the risk of sounding far too much like the flirtations of a caricatured Italian waiter: 'Preddy laydee, why you no give me no keeees? Paleeeeees don teeeese.'

Dri-Perfume

BY J.L. PRIESS, 1944

THE WAR-EFFORT PERFUME

In 1943, Chanel placed a notice in the reputable British press, including in *The Times* of London. Black-bordered and resembling a mourning announcement, it began with an apology regarding Chanel N° 5, which, 'owing to wartime conditions', was not currently available. Chanel assured readers that they were doing all in their power to transmit their famous scents through alternative products such as lipsticks and soaps and hoped that soon, in peacetime, they would be able to provide their perfumes once more.

Then came a warning: 'Any perfume offered to our clientele as Chanel is spurious and not a Chanel production unless the bottle is labelled with our name and address thereon, in conformity with the Board of Trade regulations.'

Thanks to the black market at home and the selling of dodgy goods to soldiers overseas, particularly at Mediterranean and North African ports, Chanel was the latest brand to be exploited by spivs and rip-off merchants taking advantage of the huge disruption to supply chains during the war. As with so many problems on the home front, it was an issue largely limited to Europe, part of the make-do story that

began with drawn-on stocking seams and ended with dresses made from curtains.

Across the Atlantic the situation was rather different – at least for the first few years of the war. Around the time of the Munich Agreement in 1938, when armed conflict was looking increasingly likely, canny agents representing French houses had ordered massive surpluses of finished perfumes as well as raw materials, according to a feature in the November 1942 edition of *Vogue*. In Q&A format, the magazine reassured its American readers that, even though the war had cut off the supply of ingredients, particularly the trophy notes of jasmine and rose, there was plenty still in stock and anyway the new perfume launches had been planned out years ago. Readers merely needed to use their perfume 'wisely' to avoid waste; 'be sure you like the tester-whiff of a fragrance, before you plunge for a whole bottle'. The usual advice.

The truth was rather more interesting. So important were cosmetic treats for morale, and, more importantly, for the United States' treasury, that the State Department initiated negotiations to try and circumvent blockades on the shipment of materials. These included not only essential oils from Grasse but ingredients imported from Asia, like citronella and lemongrass. For obvious reasons these attempts failed, not to mention that, during the occupation, land previously allocated to flower cultivation was fast being ploughed up to grow potatoes. A few 'success stories' made the rounds, but these had an air of fantasy about them, as with one story from the *New York Times*, which covered the fortunes of the perfume trade extensively during those years: 'A tale is told of vast supplies of jasmin extract stored at Casablanca – and Manhattan merchants await its gradual arrival by devious routes.'

Plan B? If perfume materials could not be brought to America, then America had to work out how to grow them on home soil or close by in Haiti or the Dominican Republic. With great enthusiasm, industry magnates began carrying out experiments. Swampland in Florida was converted for lemongrass cultivation, which conjures images of

alligators being shoved out of their watering holes to make way. Texas was posited as the best place to grow roses and experienced a few test rounds. But even if the land was suitable, there was one significant and depressing problem: the labour cost. It was far too expensive to pay people to pick the thousands upon thousands of blossoms required to make a kilo of absolute. God only knows what workers had been getting in France.

With stocks starting to slide and the supply of cosmetic alcohol halved, a contingency plan was required. America never ran out of liquid perfumes (concentrates and smaller-sized bottles were promoted over colognes), but to ease the pressure, brands started to introduce alternative formats. In a similar vein, they began to replace the metal casing for lipsticks with cardboard. One ingenious product was a rework of one of our earlier fragrances, Shocking. Solving the dual problem of shortages in perfume and hosiery nylon, Schiaparelli released 'Shocking Stocking', a tan-coloured lotion which provided the illusion of legwear while trumping the offerings from the likes of Rubinstein and Arden by scenting it with the brand's famous perfume. Lucien Lelong translated some of their most famous scents, including the appropriately named Tailspin, into emollient cream and solid colognes, while Prince Matchabelli had a bath oil which doubled as an eyelid perfume of all things.

The most prevalent revived format was the powdered perfume, which had been all the rage at the turn of the twentieth century. Now it was back, this time to be rubbed into the skin like a turbo-charged talc. Initially, powdered perfumes were called sachets, distinct from the kind you might leave in the knicker drawer, and included Gourielli's Something Blue, which was targeted at brides, the Jardinière Skin Sachet and Orloff's sachet bracelets. The latter had the scent dangling in a ball off a chain, but something funny must have been contained within them for they were found to be incredibly drying on the body and fleeting in fragrance – according, that is, to Orloff's rival, Priess of Chicago. As an alternative, Priess quickly released the Dri-Perfume, claiming that this was *not* a sachet but a superior powder, available

in the fragrances Creation, Allure and, less sensually, Tip Top. 'Super concentrated, non-evaporating', the Dri-Perfume was touted as the perfume of tomorrow – but it was a tomorrow that would only last a few days. The war ended months later, and powdered perfume started to disappear as alcohol restrictions were lifted. It is a shame because, these days, when alcohol-based fragrances are fast becoming more difficult to post or ship owing to security restictions, the novelty of their powdered allies would be most welcome.

Femme

BY ROCHAS, 1944

THE BACK-TO-THE-SOURCE PERFUME

ROCHAS' FEMME MARKS THE POINT at which the tornado of novelty that characterised 1920s and 1930s perfumes retreated to make way for a different style, necessitated of course by the restrictions of the Second World War. We depart the shores of Jean Patou and his intricate perfume cocktail bar kits, and of Schiaparelli's whimsy, and go back to basics. It is remarkable, having been caught up in the heady whirl of jazz age scents, that no company had until 1944 thought to name a perfume so simply: Femme. It is as though everyone had been cooking up pomegranate and gold-dust macaroons before remembering that there is such a thing as chocolate cake, which is actually all anybody ever really wants to order. Femme was, simply, a perfume for smelling wonderful.

That such a remarkable scent was developed in occupied France only adds to its allure. Femme was an early work from the legendary Edmond Roudnitska, who formulated many of the twentieth-century classics we know and love (flick forward to the 1960s and Eau Sauvage for one particular triumph). He was especially skilled in his way with fruity notes, gently nurturing the scent of melons and peaches to juicy

ripeness, never cloying.

In 1943, Roudnitska was based in an industrial part of occupied Paris somewhat lacking in glamour and hope. But, using a forgotten vat of Prunol base that smelt like pillowy Agen prunes, he managed to concoct a luscious, generously plummy perfume brought together in the style of great chypres such as Mitsouko. Femme was a bronzed elixir, particularly delightful if worn on one of the first chilly nights of autumn just as the leaves started to turn papery.

For two decades, so many of the perfumes we've discovered on this journey had invited women to shape-shift, to become someone else for a while or to explore a particular dimension of their femininity. Femme was created to smell like a woman, rather than make the woman dance to the whimsy of the perfume.

Did perfumes such as Femme mean the end of novelty? Of course not. But they did herald a simplification of the shelves and a certain sobriety in one's perfume range. The war had put the pantomime on pause – for a time.

White Shoulders

BY EVYAN, 1945

THE DIAPHANOUS PERFUME

The whiteness of the glazed observatory which crowns the massive roof contrasts sharply with the dark velvety greens of the canopy of oaks surrounding the place. The jasmine and other fragrant vines that drape the front perfume the grotto-like porch closed on the side by latticed shutters forming a delightfully cool and private outside sitting room.

BURNSIDE PLANTATION, LOUISIANA

THE SMELL OF THE MONEYED old Deep South is that of white flowers: Confederate jasmine, gardenia and wisteria, bowed around big old houses and giving off their sweet, bewitching aromas in the waxy heat.

This fragrant melange is associated with leisure and indolence because it peaks as thermostats soar, when one can be sure that anything involving physical or mental exertion is off. It is better to lope about and become intoxicated by the smell. Anybody wearing such a jasmine perfume is not likely to finish their current task any time soon; best let them meander slowly towards its completion.

As a material so crucial to perfumery, more common even than rose, why frame jasmine within the 1940s? Because it is time to pay

a visit to one of the most frenetic fictional perfume wearers of them all: Blanche DuBois, of Tennessee Williams' *A Streetcar Named Desire*. First played onstage in 1947 by Jessica Tandy, before Vivien Leigh took over on-screen in 1951, Blanche needs perfume like some of us need a cup of coffee. And it is jasmine perfume, of course, that is part of her compulsive toilette as she tries to accustom herself to living at her sister Stella's squalid, sweaty, New Orleans apartment.

When she is not steaming in the bathtub (fighting heat with heat) or powder-puffing her nose, Blanche is spraying on perfume, using cologne as a head tonic and trying to refresh the stuffy atmosphere and make it more pleasant. Together with Blanche's pretty clothes, jasmine perfume is all that remains from Belle Reve, the Arcadian country manor of her and Stella's youth, which Blanche has managed to lose in mysterious circumstances. Her collection of old perfume bottles (along with the clinking bottles of booze) offer a means to blur away harsh edges. Blanche, described by her playwright as 'mothlike', is obsessed with softness, shimmer and glow.

Blanche's jasmine perfume ('twenty-five dollars an ounce!'), sending out its jets of hypnotic, stupefying aroma, is part of her softening weaponry, just like the lantern she buys to subdue the glare of the bare bulb in the apartment and make her face appear younger. And it is Blanche's softness, her blurring of the truth, that obscures whether she is deranged, damaged, a trickster or all three. It is, like the soothing sounds of her name, in opposition to the hardness of her sister's brutal husband Stanley, with his quest for non-negotiable facts about Blanche's chequered history. It is in opposition, too, to the rock-hard abs of Mitch, her would-be suitor.

The Jasmine perfume of the 1940s that singled itself out as 'the best the world has to offer' was White Shoulders by Evyan. It was an American perfume for American women, with the luxury hallmarks expected from French perfumery and an equivalently high price-tag. This was a blended white floral, as cushioned as a cloud and one of the great 'going-out' perfumes of the twentieth century. Blanche, on the other hand, would in all likelihood have eked out the dregs of older

perfumes from the previous decade, such as Joy.

Truth be told, it is unlikely she could have afforded White Shoulders, though it describes a woman of Blanche's disposition. Its name speaks of immaculate, privileged beauty, the lady who can afford to wear gowns that reveal her perfectly cared for and cold-creamed décolletage. Early artwork depicted a woman gazing upon her White Shoulders products, her torso starting to dissolve just above her breasts, which is really quite unnerving. White shoulders, even when crowning a fine ballgown, cannot help but look fragile and delicate. The throat is on show, and the swanlike neck looks as though it might snap.

Black Satin

BY ANGELIQUE, 1946

THE PUBLICITY-STUNT PERFUME

ANGELIQUE. A SOFT, GENTLE KIND of a brand name. The sort of company we might imagine was cultivated by yet another aged Russian princess in exile who invited well-to-do women to pad around her exclusive salon for fragrant treats while drinking tea from a samovar.

Not a chance. Angelique, whose headquarters resided on Skunk Lane in Wilton, Connecticut, and whose manufacturing facility was nicknamed the 'Skunkworks', was the baby of two American execs, Charles N. Granville and N. Lee Swartout. They quit their tiring commuter-belt jobs and, together with their wives, created one of the most notorious consumer brands of the day. Despised and derided by much of the fragrance industry, Granville and Swartout were determined to blow apart the carefully cultivated mystique of the maisons des parfums.

Founded in 1946, Angelique leapt onto the scene like some court jester unleashing a flock of pigeons at a coronation banquet. Granville and Swartout, who had never worked directly in the fragrance industry, essentially thought this was an opportunity to make a quick fortune. How hard could it be, given the massive margins on each bottle? The duo realised that many American women were still saving perfume for

best, and so, with just one scent – Black Satin, for the 'worldly woman' – they embarked on a public relations campaign promoting abundant use from morning to night. Unfortunately, Granville and Swartout hit a problem: they hadn't spotted that another brand had already filed the trademark for Black Satin, and before they'd really got going they had to remortgage their homes (and ask their wives to put up some of their jewellery) to negotiate a $22,500 buyout of the name.

Once these teething problems were dealt with, Angelique stormed its way into the marketplace through a brilliant distribution strategy. This involved selling Black Satin at US Navy shops and posting stations in the Far East, to reach military men engaged in the post-war clear-up who wanted to bring back presents for their wives and girlfriends. The product range was ingenious, including solid perfumes shaped like lipstick bullets and a collaboration with make-up maven Hazel Bishop to design pin brooches concealing a wad of sponge pre-soaked in the fragrance. Demand was stimulated when Angelique scented all its bank cheques with Black Satin to provoke intrigue among female clerks who processed the payments.

These tricks were small fry compared with Granville and Swartout's wider publicity plans. America's towns and cities were about to be subjected to a very particular form of aerial bombardment. As *LIFE* magazine put it in a lengthy feature on the pair, 'they have attacked potential customers by spraying perfume wholesale into city streets; they have delivered it in the form of a gigantic Easter egg lowered from a helicopter'.

In 'Operation Odiferous', the duo got hold of a load of dry ice and took it up in a plane, claiming it was perfumed with Black Satin. The site of their perfumed assault was the local town of Bridgeport, Connecticut, which was already under a thick blanket of snow. Residents were not impressed. One fellow took his snow shovel and hit his wife on the head when she told him what was about to happen. When he was then held in the town jail and questioned, he 'refused to explain his act', just breathed 'kinda heavy'. He had, the reports noted, been shovelling out his driveway daily for twenty-two days already.

Imagine: thick winter for weeks, and then some bozos want to empty a load of scented ice onto your house.

On the day of the stunt the press were out in droves for an event that was all in the anticipation, not the execution. Very few people actually detected the fragrance or noticed the dry ice amid the snow, and proposals to reprise the stunt in other cities were abandoned after asthmatics complained about the possibility of an allergy attack.

This didn't stop the pranks, though. Next, for the launch of White Satin, Granville and Swartout hired twelve planes and a group of pin-ups christened the Bombadierettes. Each 'took command' of an aeroplane, this time dropping a perfumed cloud over Los Angeles, though, alas, the LA smog prevented the vapours from making it through. Undeterred, for the PR exposure was creating a frenzy of demand (sales had reached half a million dollars by 1949), Granville and Swartout moved on to machines that emitted perfumed bubbles, and cars that would make their way around Miami spraying Black Satin through the streets. Arguably, their low point came in the 1950s when they combined gallons of perfume with several tons of red dye (for Red Satin perfume) and poured the mixture into the Atlantic Ocean, supposedly so that the Gulf Stream could transport it to the United Kingdom in time for Christmas. We can only imagine how many fish died as a result of that little exercise.

Through this assortment of Willy Wonka escapades, the founders of Angelique did very nicely and Swartout left for the Virgin Islands on his earnings. But all was perhaps not what it seemed. Reports that the company had made a million in profits were thought to be dubious, and it was investigated for securities fraud. Black Satin was allegedly a beloved fragrance, bought on repeat by loyal customers, but was this really the case, or rather the genius puff of two hype monkeys who were masters of the emperor's new clothes? What is certain is that the stunts, eventually, ran dry and by 1970 Black Satin was being advertised for a dollar in the classifieds, alongside plastic trashcans. Granville and Swartout, 'fragrance entrepreneurs and meteorologists', were gone: poof, like a cloud burning off in a hot sky.

Oh!

BY CLAUDE MARSAN, C. 1946

THE FRENCH LOVER PERFUME

COMPARED WITH THE PRACTICE OF perfume bombing with Black Satin, the marketing strategies of a 1940s fragrance entrepreneur called Claude Marsan look modest.

Modest, yet much, much creepier.

Every now and then, a male pick-up artist arrives out of nowhere and, hungry for publicity, takes a group of journalists to a bar to demonstrate how he's managed to rack up a thousand bedpost notches in the last three years. This is accompanied by a series of high-energy lectures in convention centres just off arterial roads, during which Mr Pick-Up Artist leaps across the stage in leather trousers and cowboy boots in order to relay the secrets of his success.

Claude Marsan, a millworker turned perfume manufacturer based in Detroit, was the 1940s version of such a man.

It is not clear how Claude first inveigled his way into being a friend to all women and (in his own words) a 'luff ambassador'. As an exotic Frenchman travelling around America, he must have found it natural to position himself as 'shocked' and 'dismayed' at how useless husbands in the US were compared with his European compatriots.

With his profile on the rise, disgruntled wives wrote letters to him complaining of their useless men who were coming home drunk or making them listen to their awful jokes. In contrast, Claude suggested, French husbands were bringing flowers back every evening, performing love songs and treating their ladies to restaurant dinners. Claude started giving free public lectures to share with other women some of these real-life stories of woe, but this was said to have annoyed men so much that he had to go about incognito as 'the Unknown Frenchman' and carry a whistle in case of attack. What we do know – because he was happy to star in photoshoots – is that he wore a cream beret and, yes, had a bicycle. Bizarrely, he also wore a badge saying: 'I'm not bald yet, but may I please keep my beret on? Thank you, lady.'

As a perfume manufacturer, however, what a genius strategy this was – to be the confidante who tells the angry, weary woman that there is another way, that she can indeed turn her husband from a let-down of a Prince back into a Froggie, and that maybe she should try his new offering, Oh!, a perfume straight from the heart of this dashing, eligible Frenchman? Perhaps the plan was that the husbands themselves, feeling demoralised and useless, would proffer a bottle of the scent as a peace offering.

Was it called Oh! because this suggestion was so startlingly new? Or because at $23 an ounce (nearly $400 today) the kids were going to have to do without Christmas presents this year? To get women to spend such a sum, the complimentary lectures must have whipped attendees into a delirium. And, of course, that was their point.

Judging by subsequent events, we can in fact surmise that the 'Oh!' of his perfume more probably hinted at an orgasmic moan. For Claude's public appearances were very, very naughty.

In 1947, the city of Spokane, Washington, played host to Claude's demonstrations on the true art of love-making and marital kissing. All honest fun, except in a society still relatively prudish about public displays of affection. Claude's two-and-a-half-hour show comprised him snogging and groping a young model on stage and then encouraging attendees to have a go themselves. Perfume usually sells itself to us as

a precursor to the big seduction, so what a way to flip the order: get people turned on and *then* ask them if they'd like to buy a bottle.

The bravado backfired, eventually. In 1949, Claude was arrested by the vice squad in Los Angeles; he was there, allegedly, to instruct Hollywood actors in kissing on camera, but at the same time he was running a few shows on the side (by this point we get the impression that the perfume enterprise had slipped in priority for Claude). When he appeared in front of a female judge, Claude complained about the way she was looking at him and asked for a man instead. She was not impressed. Then, like some disgraced TV personality, he decided to entertain the court with a musical saw serenade. Claude ended up being sent to jail for ninety days. His offerings were deemed unsuitable for public consumption, and the judge in her verdict protested that 'portions of your performance were so lewd and obscene that... no doctor...would discuss such matters, even with married persons'.

After the verdict, Claude declared, 'I am aggrieved in my heart. A jury of women, those that I have a mission to save from the horrible effects of clumsy love-making, find me guilty.'

Oh! dear, Claude.

St Johns Bay Rum

BY WEST INDIES BAY COMPANY, 1946

THE ADVENTURER'S PERFUME

THERE IS A CERTAIN POINT in a man's life when he has to decide where he is going with his off-duty look. It tends to come around the age of forty, when clothing catalogues of the great outdoors come knocking – or slipping out of weekend newspapers. They feature brands that use terms like 'Harbour' and 'Yachtsman'. They specialise in selling brown deck shoes (no socks, please), chinos and fishermen's jumpers. Anchor motifs feature, heavily. This is the clothing for the fantasy of early retirement and endless years of messing about in boats. These catalogues bring the dream to life by seemingly scooping up all the older male models with salt and pepper hair and a grizzly look, who are then photographed with one hand tucked into their trousers and one foot up on the rigging, while they stare enquiringly at the horizon, shielding their eyes from the sun.

Harbour Man is a timeless, unvarying aesthetic which requires a timeless aroma: Bay Rum. Bay Rum did not, however, launch in the 1940s. It already had a long history in the Virgin Islands, where the leaves and berries of local West Indian bay trees would be crushed and macerated in rum, together with cloves, cinnamon and lime, to

produce a deliciously scented tonic for muscles and scalps. In the 1830s the delights of Bay Rum came to the attention of a Danish chemist called Albert Heinrich Riise, living on the island of St Thomas. He managed to refine the extraction and manufacturing process to create a desirable commodity, which took off during the nineteenth century, birthing a major industry on the Virgin Islands. Versions came from several illustrious American and English barber outfits, among them Caswell-Massey, Taylor of Old Bond Street and Geo F. Trumper. Unfortunately, Prohibition in the 1920s temporarily put a halt to exports, and the genuine product was undermined by synthetic domestic alternatives which were officially for hair-use, and unofficially for desperate guzzling (the jailhouse song 'Bay Rum Blues' gives a flavour of the mood). Having been in exile, after the Second World War Bay Rum made a rapid comeback; it had a quality that could not be manufactured: authenticity.

The beauty industry has always loved a 'nature's bounty' story, all the more if it can be framed as a local custom. We all know the formula for the typical narrative: 'For years the monks of St Unguento have prepared their hands for illuminating manuscripts by bathing them in the rare Maraioto olive oil from Umbria. Visitors to the monastery suddenly realised that the monks' skin was smoother than a new-born baby's, and now their secret is revealed to you in the form of L'Essencio ($300).'

Bay Rum, assembled not far from sandy beaches, using a small number of indigenous ingredients and shipped for gentlemen's pleasure, must have been such a refreshing proposition. It was practical and brawny compared to fancy European colognes, yet had more exoticism than Stateside makes such as Shulton's Old Spice (which, by the name, was possibly inspired by the Bay Rum ethos anyway). The fellow who staged the 1940s comeback was an American called John Webb, who moved to St Thomas and founded the West Indies Bay Company. He had the ingenious idea of wrapping the glass bottles in woven palm fronds – traditionally used by islanders to create fishtraps – which hammered home the islands-in-the-sun feel. Think Chianti

wine baskets, but more attractive. His St Johns brand of Bay Rum very quickly got national traction in the United States, and with Brooks Brothers a major retail partner, it did well with the preppy set. Several major consumer brands in the mid-century period were discovering persuasive new techniques centred around the protection of secret formulae – from Coca-Cola's closely guarded spice mix to the Colonel and his special spice rub – and Bay Rum's selling point also came from its time-honoured recipe and, as with fine spirits, the need to macerate and wait for the 'essences' to mature. There was, too, a fair sprinkling of piratical swagger, with pictures of cannons and Bay Rum held up as a form of bounty: a high-end aromatic grog, the treasure in the chest.

Bay Rum, just like chinos, is not going anywhere soon. It bears up against the more sophisticated competition, just about. Now and then, it will swing into fashion to become flavour of the month, but the trendy young things who order a bottle are not the long-term partners for such an aftershave. For by all the sea shanties in Christendom, Bay Rum simply demands the deck shoes.

Ma Griffe

BY CARVEN, 1946

THE PROTO-TEENAGE PERFUME

AERIAL PROMOTIONAL ACTIVITY WAS CLEARLY the thing in the 1940s. Vying with Angelique, the couture house Carven in France performed a classier version, attaching mini-bottles of their new fragrance, Ma Griffe, to parachutes and dropping them daintily over Paris. Their campaign has since become one of the legendary examples of buzz-building. It demonstrates a poker-faced conviction that the women of Paris would not just run around scooping up as many freebies as they could stuff in their handbags but would fall in love with this unusual new perfume, rushing to buy it as soon as their samples ran out.

Ma Griffe was also, like Rochas' Femme, confident in its name. The notion of a signature scent had been bandied about for a while, but Carven claimed it as their own: Griffe translates variously as 'Signature', 'Talon' or 'Scratch'; the French derives from the Latin 'gryphus' or 'griffin', the mythological beast that is part lion, part eagle. There is something territorial about the word, enabling the Ma Griffe fan to claim it as 'mine' or 'for me'.

Who was this 'me'? Who wore Ma Griffe? It was not the first fragrance to promote itself as being for the young (in the 1930s Fleurs

de Rocaille had been leaning towards a naïf audience, and Chanel was describing their Gardenia as 'youthful'), but Carven was the first house to truly back up their claims by having every aspect of their perfume scream 'new'. They set exactly the right tempo for those women on the express train of a liberated Fourth Republic France with its brisk economic growth. Ma Griffe was fresh green shoots in all respects. Created by Jean Carles, it used a newly available molecule called styrallyl acetate to refashion the scent of gardenia, taking it from candlelight to neon. No more floppy, luscious petals; instead, a leafy, metallic and feisty juice. Plenty of aldehydes helped Ma Griffe to burst forth, while the mossy base was warmed up from chilliness using cinnamon. Ma Griffe turns a 7 a.m. Monday morning wake-up in February into a shriekingly bright day.

Green was also the signature colour of Carven, which each season released a different dress in green and white stripes, stripes which made their way onto the Ma Griffe bottles in diagonal lines. Stand the Ma Griffe packaging next to other fragrances of the time and it appears ridiculously modern with its graphic, high-contrast look and a tennis-court hue so different to the usual hallmarks of luxury: golds, ambers and black. To make a comparison with typography, it is as if Ma Griffe were the first sans-serif perfume. It expressed perfectly the DNA of the new-kid-on-the-block fashion brand of Carven, which, quite astonishingly, had been founded by Carmen de Tommaso only a year prior to Ma Griffe's launch. Carmen had an architectural training and was spurred to design by her petiteness, which she found excluded her and many other women from the world of fashion and its tall willowy models. Carven clothes were structured with plenty of pin-tucks so as not to overwhelm daintier figures and championed a sporty, unfussy look, with day dresses in those green stripes, linen skirts, and summery playsuits in white cottons.

Just a year after the launch of Ma Griffe, another Parisian couture house, Balmain, came out with the galbanum-laden Vent Vert ('Green Wind'). It is difficult to know whether the two were worked on simultaneously, or whether Vent Vert was inspired by Ma Griffe

– or indeed vice versa. Balmain's perfume was created by Germaine Cellier, who seems to have sparred with Jean Carles. Both perfumers were formidable talents and both were based at the same company of Givaudan-Roure, so would have been introduced to new ideas and materials simultaneously, but rumour has it that Germaine's lab was kept well away from Jean's. The funny thing is that, despite the pair's mutual dislike, their respective perfumes were as siblings.

What Ma Griffe and Vent Vert seem to have been straining towards was a version of youthfulness which had not yet been fully articulated – that of the teenager. Teens had, since the early twentieth century, been identified and discussed through the lens of delinquency, but what was still being formalised was an understanding of teenage lifestyles and cultures: the things they were into. In America, 1944 had seen the launch of *Seventeen*, the first magazine created specifically for teenage girls, as opposed to the college-age readers of *Mademoiselle* in France. Films for teens, books for teens, drinks for teens, clothing for teens would all follow – whole new product lines for a new (and very lucrative) market. But perfume brands would not get on this particular bandwagon until the 1960s; possibly the industry was nervous of edging the closely protected 'grown-up glamour' of fragrance into more juvenile territory.

An early advertisement for Ma Griffe, announcing itself as 'un parfum jeune', featured an image not of a girl but of a mermaid. The new concept of youth, not yet made manifest, was expressed as a fantasy – a creature almost a woman, but not quite.

L'Air du Temps

BY NINA RICCI, 1948

THE MATERNAL PERFUME

As ATTESTED BY THE DIZZYING success of Ma Griffe, the French fragrance industry practically burst out of hibernation when the Second World War ended. A resumption of normal service was especially important given the huge inroads American brands and manufacturers had made over the past six years. Time to remind the world who was boss, while recognising that by far the most critical audience to please were Stateside women and therefore that some cross-cultural collaboration might be required.

One of the first big 'we're back' fragrance launches came in 1946 for Coty's Muse. The house had long been disassociated from its founder, François Coty, who'd died in 1934, having lost his fortune in a series of dodgy ventures, not only economic but also fascist. Coty had a new remit to make their fragrances available to an even greater number of women and in contrast to the high-end Lalique style of yore were going more mass-market: the affordable treat.

Muse was created in Paris but launched in New York at the Waldorf Astoria hotel, which had become the de facto base for anything to do with perfume. The event was huge, with around fifteen hundred

attendees invited to watch a spectacle that combined European and American influences. After music, lunch and an announcement in French with English translation, nine Greek muses, each dressed by a different fashion designer, serenely popped out from a faux-snow-covered temple and made their way through the audience. 'A tenth muse, called Osme, Greek for perfume, wore a floating gown of pale sea green and sun yellow combining jersey and marquisette. It was worn by Valentina...The new scent was wafted in the ballroom as Osme made her entrance.'

By enveloping the press in such a transporting experience, Coty was gently encouraging them to cover the product. This methodical, savvy approach to publicity would become the norm in a few decades' time, but in 1946 it was terribly exciting. Not that it guaranteed Muse long-lasting success – the perfume was discontinued in the sixties.

The two fragrances that trumped Coty with their post-war optimism were Miss Dior and Nina Ricci's L'Air du Temps. This is not necessarily because they smelt radically new to the untrained nose but because they were able to turn themselves into symbols. Miss Dior became the 'New Look' perfume owing to its association with the house's exciting new flared skirt shapes and extravagant yardage of materials. In scent, though, you'd wager that Rochas' luscious wartime Femme smelt much more extravagant. L'Air du Temps wasn't even Nina Ricci's first (Cœur Joie came out in 1946), but it was the upstart younger sister; in the 1950s it was to be adorned with that famous Lalique cap comprising two intertwining doves – so terribly awkward, and somewhat painful, to wrench off the bottle, but so iconic of peace and reconciliation.

Everything about L'Air du Temps whispered gentleness. This perfume was certainly not one of those raunchy 1930s scents which screamed illicit sex. Instead, L'Air du Temps was a faithful romantic. Rather than a wink-wink name there was the suggestive, almost untranslatable idea – 'That Which Is Being Most Talked About' or 'The Spirit of the Times' – and it has since become the spirit of a defined 'then', the post-war years. In contrast to the diva-esque Fracas or the

lithe Ma Griffe, L'Air du Temps was a soft, wafting, spicy carnation – with a peppery quality – designed to be discreet and create a subtle aura about the wearer. There is something fuzzy about this one, as though it is best sprayed onto freshly dried hair. It is the Vaseline-smeared camera lens of fragrances in being so flattering and gentle.

Unthreatening, welcoming: L'Air du Temps has somehow become the fragrance that says 'motherly'. Enough people wore it and loved it for it to become stuck on a generation. For baby boomers, children of the fifties and sixties, it is the smell of being tucked up and told night-night while in the darkness the hazed silhouette of mum hovers then plants a kiss on the cheek.

Fracas

BY ROBERT PIGUET, 1948

THE NOIR PERFUME

FEMMES FATALES LOVE THEIR PERFUME. Take Rita Hayworth as the terrifying seductress Gilda in the eponymous 1946 noir movie, a performance described in beautiful portmanteau as 'Bewitchy!' on the studio publicity materials. *Gilda* may be most famous for turning the removal of a pair of gloves into striptease erotica, but I want to talk about her fragrances. The first time we see Gilda, she is being introduced by her husband – a shady casino owner called Ballin Mundson – to his new employee Johnny Farrell. Little does Mundson realise that Gilda and Johnny are old flames. As the two men enter Gilda's boudoir, she appears – tossing her hair and pretending she's never previously met Farrell – in front of an enormous, kidney-shaped vanity. It is at least six feet wide, covered in a gaudy metallic fabric, and on top are what look to be the entire contents of a perfumery.

The dressing table as mission-control deck is a familiar set-up; plenty of starlets, especially from the 1930s onwards, would be snapped at theirs as they morphed into their role using the assembled powder puffs, unguents, lipsticks and atomisers. For Gilda, as one of cinema's most legendary vixens, her beauty 'shrine' is arguably not just about

looking attractive but also speaks to the archetype's stock traits: an ambivalent seductress, inscrutable, a bluffer who puts on one guise and sheds it for another when she gets cornered, aided perhaps by a new bottle of scent. In ancient Rome, the Stoics were concerned about the use of fragrance by women as a mask for seducing men or as a vehicle of deception. The Roman satirist Juvenal talked of women buying scent with adultery in mind, and such fears were still around in the 1940s – and they're here with us today.

Similarly, in crime fiction fragrance is often the thing that gives the perpetrator away, a piece of evidence persistently wafting about the scene – like the broken shard of a cognac glass left clumsily by the culprit – and almost imperceptible. Specifically in film noir, time and again scent gets associated with misdemeanours. 'How could I have known that murder can smell like honeysuckle?' laments a guilty insurance salesman in 1944's *Double Indemnity*, referring to the perfume of his co-conspirator and lover.

The noir writer Raymond Chandler in particular helped shape this association. Let's look at his most famous mystery, *The Big Sleep* from 1939. Detective Philip Marlowe is stealthily checking out a house at night when he realises that something is wrong. In the dark and noiseless room he becomes aware of a 'heavy, cloying perfume', as though an invisible intruder is hiding. 'Then my eyes adjusted themselves more to the darkness and I saw there was something across the floor in front of me.' Hastily switching on the lamp, Marlowe finds himself with company – not a corpse but a drugged-up blonde who means trouble. Carmen Miranda. She's too spaced out to speak, but she doesn't have to because her perfume can talk. It betrays to Marlowe her sleazy shenanigans before she can pull it together to fake a good-girl act.

Yet perfumed clues can also absolve a suspect, as happens in another Raymond Chandler mystery, *The Lady in the Lake* from 1943. Marlowe is hired by the CEO of a fragrance company called Gillerlain to investigate a murder, and as he calls into the headquarters he notices a display of bottles in the foyer, tied with bows and resembling 'little girls at a

dancing class', a hint that perfume will come to be personified. Later, when Marlowe goes to the empty apartment of the prime suspect, local cad Chris Lavery, he smells the 'too emphatic' aroma of chypre scent coming from a handkerchief. The hanky is monogrammed with the initials of Gillerlain employee Miss Fromsett, but she is exonerated because she only wears expensive sandalwood perfume, not this disreputable slush. We never meet Lavery's chypre-loving girl. Instead, we glimpse her sideways through a trinket found in a suburban Pasadena cupboard. Perhaps this shadow of a scent speaks of the anonymity of vast modern cities such as Los Angeles, in which it is all too easy to (almost) disappear.

Strong, 'emphatic', 'cloying': we certainly don't associate femmes fatales with citrus fragrances; rather there is an expectation that drama is what is required here. For this reason, Fracas, the butteriest, most voluminous tuberose ever committed to a bottle, has become one of those legendary late-1940s perfumes, a shorthand for our retrospective idea of the noir temptress, even though hundreds of scents could do the job. With a name that means 'Crash' or 'Din', it had to, really. Fracas was created for couture house Robert Piguet by a perfumer we hear a lot about in the 1940s and 50s: Germaine Cellier. However, unlike Vent Vert – her work of 1946 – Fracas is certainly no sprite. Another of Cellier's famous fragrances from this decade, also for Robert Piguet, was a leather scent called Bandit, deeply green and tarry. Ample Fracas could not be more opposite, with its white flowers squished with juicy peach.

For sure, one of these two perfumes is the black sheep, but which? It depends who you're asking. Fracas won't hold you up at pistol-point like Bandit; it's more likely to kill you with kindness. This scent is a welcome suffocation, one which slowly dizzies the wearer until they've lost their mind and can't think for themselves; until they suddenly realise they're in the boot of a trunk with their hands tied.

The Elegant Fifties
1950–1959

MALE READERS, WHO THUS FAR have been thrown the odd bone, may be wondering if we will continue to encounter just the one token blokes' scent per decade. Be assured, change is afoot. Finally, in the 1950s, the drought is ending. The rains are coming.

In the 1950s, a new generation of young men, men in grey flannel suits and Timex wristwatches, were entering the corporate workforce, suited, booted and with briefcases swinging. Their grooming routines were starting to get a little more elaborate, and the buzz of Remington shavers could be heard across the suburbs. Naturally, a good after-shave was the finishing touch. When Benny Southstreet in *Guys and Dolls* sings about good-for-nothing slobs entering gainful employment and dousing themselves with Vitalis and Barbasol, he is referencing scalp-treatment and shaving-foam brands whose marketing dollars have ensured their place in a chap's bathroom cabinet and instant recognition.

But which men? This, after all, was the age of advertising and its carefully segmented consumer groups. In the 1950s, billings from the main creative agencies in America more than quadrupled, from $1.3 billion to $6 billion, as they helped brands to define and shape their target demographics. Once there had been fragrances for high society and others for 'the general populace'. Now the growth of the middle classes, spurred in some countries by post-war prosperity (though not, alas, in Britain, which in the early 1950s was still dragging itself

out of rationing), meant that fragrance was on the way to being a serious, mass-market cash cow, especially if segments of the hitherto neglected male population could be cultivated into habitual users. This was particularly vital given that supply was now outstripping demand, and new customers were needed.

The fragrance industry did not yet have its own version of Marlboro Man, the cowboy role model created by Leo Burnett in 1954 to promote filtered cigarettes, traditionally perceived as feminine, as being suitable for a chap. However, aftershaves were beginning to target audiences based on their life stage or role, whether that be the company man aiming for a promotion or the wooer in want of a wife. There was a general effort to build Father's Day as a shopping event, with shaving-care adverts soon featuring young children giving daddy a bottle of cologne to show how much they loved him. Above all came an attempt to imbue this product, which otherwise risked rejection for being too feminine, with the main traits of conservative, middle-of-the-road masculinity: strength, prosperity, productivity, heterosexuality. Some aftershaves were promoted through celebrity endorsements, with various sports stars being wheeled in – Mennen got a grinning champion golfer called Sam Snead to appear in flat cap, in which he promised that their product kept him '"One-Up" on Perspiration Odor!' Such 'authority' advertisements suffered an eventual backlash, however; they were felt to be overbearing and to be taking agency away from an audience of middle-managers already worried that they were simply cogs in the machine.

In the decade which saw the birth and rise of TV advertising, it was notable that only men's fragrances were promoted using this medium. Shulton's Old Spice was one of the few that could afford the media spend. These ads tended to focus on the unique selling proposition, another fifties innovation designed to communicate benefits through a (sometimes all-too) memorable jingle or phrase. Aftershaves could be promoted using this USP technique because their primary benefits, as we found in the 1930s, weren't generally about scent but its effect. Old Spice's TV ad from 1957 featured a sea shanty and some

jaunty animated sailors and mermaids, before moving into a laborious demonstration of the morning shave. The demo guy is shown aggressively rubbing Old Spice into his face, precariously close to the eyes.

In this brave new format, nobody quite knew how to bring to life a perfume. An illustration of this comes from Revlon, who were pioneers in television and developed their own sponsored variety show in 1959 called *The Big Party*, hosted by Rock Hudson and set as though at a swanky domestic cocktail bash. Interspersed between the celebrity interviews, musical performances and comic banter were product demos to help female viewers find out what cosmetics to buy for *their* next big party. Revlon had no problem flogging their brightly coloured lipsticks on black-and-white screens, evoking a product's qualities with crushed ice, bowls of plastic fruit covered in snow, or a beauty in a hammock wearing the shade in question. But they never attempted to sell their perfume. It was as though scent had been caught out by the new possibilities and needed a few years to sit and ponder.

There was another way, outside of advertising, that fragrances could reach the masses, something absolutely timely for the age of convenience. In the 1930s we encountered nips, those disposable Lucite vials of perfume samples. Two decades on came their successor: the Perfumatic vending machine. Found in over ten thousand sites across the USA by 1953, or 'wherever there's a woman', including at movie theatres, gas stations, bars and restaurant chains, the Perfumatic offered four 'greatest hits' perfumes in cologne strength – typically Yardley's English Lavender, N°5, Tabu and Tweed. After sliding in ten cents, customers would hold their wrist against a nozzle and a single application would be sprayed directly onto the skin. This was perfume on the go, cheap and accessible. And noticeably, not one of the core fragrances was a fifties perfume, as if it were time to slow down on the new launches and enjoy the beauty of an archive of classics, some of which were now forty years old.

Did the Perfumatic, with its affordable hit of fragrance, entice teenage girls who were out on a date with a boy? Perhaps, but a striking omission, especially in the latter part of the decade, was that amid

a burgeoning youth culture of rock 'n' roll, and Elvis Presley's gyrating hips, perfume houses still weren't confidently developing perfumes specifically for younger wearers, let alone reflecting the modern design aesthetics of the atomic age. If we flick back to the 1910s and 20s and see how much perfumes were leading the charge and tapping in to the zeitgeist, and then turn back here, we can see that by the 1950s fragrance was following, not leading.

Once a symbol of emancipation, scent now risked being seen as the prop of the pretty housewife beautifying herself for her husband. From *The Economist* in 1956: 'The ordinary woman persists in the belief that in marriage one ounce of perfume is worth a peck of legal rights, and her dreams of power still feature the femme fatale rather than the administrative grade of the Civil Service.'

Fragrance was in danger of growing stale, a part of a woman's chattels rather than an expression of her liberation, and only in the 1960s would this contract start to be rewritten.

Wind Song

BY PRINCE MATCHABELLI, 1952

THE PRINCE CHARMING PERFUME

THIS IS NOT THE FIRST time that Prince Georges V. Matchabelli has appeared on these pages. He was last spotted in the 1920s, inviting women to embark upon his perfume-profiling extravaganza and talking of borscht colognes. And now, in the 1950s, he's back. Or at least, his spirit is. The Prince himself died just shy of fifty in 1935, only two years after divorcing his love and co-founder Princess Norina. A year later, his company was sold, and then sold on again in 1941 to Vicks Chemical Company (it was to be passed on once more in 1958 to Chesebrough-Ponds, which later became Unilever).

By 1952 the brand was in the final throes of its transformation from small outfit to one of the biggest mass-market players in the industry, from a bespoke service for minor royals to a range offering every woman, even those with modest means, the chance to feel like a princess. Even if nobody knew or remembered the real Prince Matchabelli, what mattered was that he was royalty, a figurehead with a similar role to Count d'Orsay of 1923's Le Dandy, someone who might help customers find their own Prince Charming. There was something endearingly twee about the Matchabelli line. With perfumes housed in

colourful, crown-shaped bottles, it had the once-upon-a-time feel of Disney's *Cinderella*, and the copy read as if it might be spoken by one of the helpful mice with a helium-high cute voice: '[Prince Matchabelli] created individual scents to dramatize the personalities of many notable women throughout the world. And, so well-known did these perfumes become, that he soon made his pleasure his business.'

How to introduce Wind Song? The name is a problem, as it sounds like a euphemism for flatulence. The fragrance itself is – of course – nothing of the sort. It's a retro delight, a spicy floral with bergamot, carnation and coriander that's a little like a budget version of L'Air du Temps. It is pungently soapy, as though the scent keeps feeling the need to wash up after itself.

Very much at home in the canon of the late 1940s and 50s, Wind Song quickly outsold the other Matchabelli offerings via an ingenious marketing campaign, which featured photographs of handsome young fellows – corporate Prince Charmings – who stared directly at the viewer, as if they knew what she looked like without her dress on. Cheesy though it might have been, this was an unusual campaign, and it had traction. Instead of using an image of an idealised beautiful woman to stage the sell, it invited women to experience the tease of being desired, a strategy already much more prevalent with men's shaving products and their pin-up model campaigns.

The premise was so successful that it was used right into the 1970s, transitioning into a television spot complete with a perniciously unforgettable folksy lyric that eclipsed the perfume and became its own pop-culture phenomenon. Would Matchabelli, not the best-looking of princes according to surviving photographs, have ever believed that years after his death he would be reincarnated as a bevy of dreamboat male models singing winsome ballads?

Jolie Madame

BY BALMAIN, 1953

THE UPTOWN PERFUME

A VISIT TO THE 1950s begins with a pause of remembrance for all the hats and gloves that once walked the streets – may they rest in peace. Looking back on fashion photography of a half-century ago, we become aware of just how much has changed in terms of social presentation and realise that, quite possibly, we have lost a handy little accessory or two. After all, any old tat can look regal if you add a pillbox hat. This was the decade when chore gloves for housework came with embroidered butterflies and had pompoms dangling off them.

Short, opera or suit? In duchess satin or cotton, pig-skin or doeskin, crushed or uncrushed fabric? And in lilac, blue, pale pink or the newest buttercup yellow? These were just some of the dizzying considerations for glove-buyers of the 1950s. They were even offered etiquette guides as aids, including this one from the brand Paris: 'When lunching in a restaurant, a lady removes her coat but keeps on her hat and gloves, removing her gloves when seated at the table.' And: 'Bracelets may be worn over long gloves, but *never* rings.'

For the epitome of good glove wear, we can turn to Bronwen Pugh, the model and muse of fashion designer Pierre Balmain, who was

later to become Viscountess Astor. Bronwen had a fabulous, slightly haughty manner, as though she might slap you across the cheek with her glove if you gave her too much trouble. In one of her most famous photoshoots from 1957, she stands in a Paris street in her black cocktail dress, cream leather gloves and furry turban. 'Snazzy' would be the word to describe her stance and expression. In the background, some dowdy onlookers stare at her rather disapprovingly in a 'who does she think she is?' kind of way. They are all in their heaviest fur coats, so perhaps it is freezing cold, but Bronwen is too cool to care. In Pierre Balmain's own words:

> She walked with long, easy strides, her arms motionless against her sides. In her big, light-coloured eyes there was a complete absence of expression and ignorance of what was happening around her. She had a habit of slightly disarranging her hair as she entered the salon, giving herself a nonchalant air that is a sign of supreme English elegance.

The mainstream sartorial mood of the 1950s, exemplified by Pugh and her fierce elegance and finesse, helped to sustain a particular style of perfumery, which is where Jolie Madame, created by perfumer Germaine Cellier for Balmain, sashayed in.

Jolie Madame – this pretty woman – is grace in a bottle. Ostensibly it is a leather perfume, but whereas its contemporaries in the leather family such as Cabochard by Grès (1959) or Bandit by Robert Piguet (1947) have a ferrous inkiness to their smell, Jolie Madame is butter-soft; fruity and yielding like a pear. This perfume is tremendously accommodating and flexible. It is not the most audacious of choices but just the thing to wear when out and about in town, day in, day out. When we revisit Balmain's deceptively simple fashion designs of the fifties, his cocktail dresses are certainly special, but his most remembered looks are those of his daywear and in particular his simple sheath dresses, cocooned in an incredible coat and worn always with that pair of short leather gloves and a hat. His models, including

Bronwen, were often photographed outdoors in the city streets, sometimes holding onto a lamp-post, peering into a flower cart or just marching through Paris with purpose. Jolie Madame is this in a smell, even if only from historical juxtaposition. You could do worse than chuck out all those gimmicky perfumes and replace them with Jolie Madame; it is that versatile.

Pierre Balmain was the first to admit that many of his perfumes were slow to shift, but Jolie Madame was, exceptionally, such a hit that when he introduced his clothing collections to the American market, he named them after the fragrance. In his memoir he wrote that retaining this trademark brought the risk of his house being thought of as static, a relic of the fifties. But then he added that 'to justify her title, a Jolie Madame has to move with the times'. And still today, a pair of leather gloves, a swab of lipstick and a canny spray of perfume will lift the sartorial spirits, even if the pillbox hat is no longer in play.

Youth Dew

BY ESTÉE LAUDER, 1953

THE SUBURBIA PERFUME

IF FAMILY TREES COULD BE scratch 'n' sniff affairs, millions of them would be scented with the grande dame that is Estée Lauder's Youth Dew. *Everybody* seems to have had an aunt who wore this molasses-coloured elixir, or remembers sighting the scent in a bathroom, so prevalent was the perfume from its release in 1953 through to the 1980s (and it still sells today). It must hold the trophy for being one of the most nostalgic perfumes in living memory.

Blanket coverage combined with memorability make for a perfume classic, and it's safe to say that Youth Dew is a tattoo for the nose: once smelt, it lingers indelibly in the brain. Lovers of Youth Dew remember fondly the day of their first sniff, while haters spend their lives running away from the faintest whiff. What is this potent and divisive aroma? The closest quotidian parallel is actually cola, that symbol of fifties Americana, of hanging out with pals at soda fountains for fun times after class, as epitomised in *Back to the Future* by the pistachio-hued Lou's Café of Hill Valley in 1955. In Youth Dew's day, the Soda Pop Board of America promoted cola to mothers, telling them that if their babies started drinking it early enough, they would have fewer problems

fitting in with their peers in the difficult years before adolescence. They might also have fewer teeth.

Like Coca-Cola, Youth Dew came to saturate middle-class 'modernist' America and to define it, a demographic with a healthy disposable income and a love of fragrances from home-grown beauty queens. In 1953, Evyan's White Shoulders, Arden's Blue Grass and Helena Rubinstein's Heaven Sent were already established and popular, and Arden and Rubinstein themselves were busy criss-crossing the country, purveying anti-ageing cold creams and the perfect shade of pink lipstick. But it was the fledgling entrepreneur Estée Lauder who understood that if she wanted her products in every home, she must make them much more affordable. She had picked up her trade while helping at an uncle's beauty business and now she pushed in earnest her sampling and innovative gift-with-purchase initiatives. Lauder also knew an enticing, if fanciful, name when she saw one. Inspired by the relaxation ritual of bathing, Youth Dew was launched by Lauder not as a spray perfume but as a bath oil that doubled as a skin scent.

Youth Dew became one of many new consumer products that were making their way into open-plan ranch homes across 1950s America. In the all-important fitted kitchens of these identikit 'bungalow belts' could be found shining Electrolux refrigerators, Hotpoint stoves and Sunbeam Mixmasters, while the cupboards housed time-saving convenience foods, from Jell-O to Borden's drums of pre-grated cheese. Behind the sliding screen, in the lounge, a GE Black-Daylite television would be the pride of those households that could afford the latest gizmo, while upstairs the bedroom furniture was likely to have come from Bassett.

Compared with other personal-care products such as Palmolive or Caryl Richards Happy Hair, Youth Dew was certainly a luxury treat, but it quickly achieved the same ivy-like colonisation as those other familiar items. Such successes are often denigrated (Youth Dew prompted jealous cries of 'vulgar' from Elizabeth Arden), as popularity naturally dents a product's exclusivity, but we have touchstones such as Youth Dew to thank for connecting generations, for becoming little

portals of collective nostalgia. If all smells were niche and worn by only a few, there would be no shared heartland to return to.

While the now-retro Frigidaires sit behind glass screens in design museums, Youth Dew breathes yet. The scent enjoys only a limited fanbase beyond the older clientele who have remained loyal throughout, and may, once the rememberers are no more, disappear. Until then, it is here, a relic of the 1950s, but for ever young.

Noa Noa

BY HELENA RUBINSTEIN, 1953

THE COCKTAIL-PARTY PERFUME

The denizens of the great concrete jungle foregather at
a thousand water holes at dusk – in a dimming light
they look better to each other – and begin the night
pattern of life and death in the big city forest.

HAL BOYLE

IF EVER LIFE FEELS DRAB, play some exotica music from the twentieth-century composer Les Baxter. Pious Monday nights at home can be transformed with one or two tracks from his breakout record, 1951's *Ritual of the Savage*. 'Love Dance', 'Busy Port' and 'Kinkajou', all of which make magnificent use of the bongo drum, will have the listener hallucinating that their front room has morphed into a faux South Seas paradise, complete with monkey cries, a totem pole and some plastic palm trees.

Stop by at a cocktail party in the 1950s, and before long you would have heard Baxter's music and perhaps used its rhythms to shimmy away from the dullard next to you and over to someone more interesting. It was the unofficial soundtrack of the scene and offered

auditory set-dressing for the domestic stage – plus a little sprinkle of globe-trotting kudos. Your hosts, meanwhile, would be at the cocktail trolley, mixing frozen daiquiris with ceremonial razzmatazz, then dispensing them to their guests along with cheese-and-devilled-ham pinwheels. With all the noise and the crush of bodies, the conversation would have to be snappy, ideally focusing on one of 'the 5 Ds', as decreed by tastemaker and managing editor of *Harper's* magazine, Russell Lynes: 'Dress, Domiciles, Domestics, Descendants and Disease'. Maybe a heated debate on Nabokov's *Lolita* would follow, later on in proceedings.

With so many birds of paradise packed into an apartment, all in their most glamorous cocktail dresses, we can imagine smelling a glorious cymbal clash of different perfumes, from the reliable classics to recent on-trend releases such as Quadrille by the designer Balenciaga, Ode by Guerlain or Jolie Madame by Balmain. That which commands particular attention at our fifties cocktail party is Noa Noa by Helena Rubinstein: Les Baxter's music in a bottle. Noa Noa was inspired by the artist Paul Gauguin's portraits of Tahitian women, which in the late 1940s had been exhibited prominently in commemoration of the centenary of his birth and may well have piqued the beauty magnate's imagination. The name of her new perfume referenced the Tahitian word for 'fragrant', which had been the title of Gauguin's journal (later suspected to be at least part fantasy) about his time on the South Sea islands. Describing the women he encountered, he wrote that 'a mingled perfume, half animal, half vegetable emanated from them; the perfume smelled of their blood and of the gardenias – tiare – which they wore in their hair'.

Rubinstein's perfume was, faithfully, full of spicy tiare (a type of gardenia that grows in Tahiti) and housed in a bamboo-shaped bottle. With shades of Jean Patou's Colony fragrance, it brought the siren scent of Gauguin's Tahitian women to the middle classes of America, complete with, in the house's words, 'their flower-framed faces, love-shaped lips and inscrutable eyes'. The most immediate way of describing the aroma of the tiare flower is through those exotic

shimmer oils sold to holidaymakers, which are to be stroked on in between beach and evening drinks to make the skin glisten with gold. They usher in the evening's adventures with their aroma of baking biscuits and freshly smashed coconut.

So powerful and penetrating was Rubinstein's beauty empire by the 1950s that she was able to orchestrate single-handedly an entire lifestyle trend around her new perfume. Alongside Noa Noa came a flamingo-coloured Gauguin Pink lipstick, which Rubinstein designed to match fashion's newest bead jewellery, and a range of summery dresses from American designer Carolyn Schnurer covered in Gauguin-esque Polynesian patterns.

Such clever planning meant that Noa Noa parachuted itself right into the craze for 'exotica' centred on the Pacific Islands. Rodgers and Hammerstein's *South Pacific* had been playing to packed audiences since 1949, becoming the second-longest-running musical ever on Broadway. Themed cocktail parties were so popular in New York that in 1955 a company called Orchids of Hawaii began offering mail-order kits containing such edibles as 'toasted coconut chips, canned poi and passion fruit juice' and party-starting accessories like 'paper leis, records of Hawaiian music, invitation notes and small bottles of a perfume made from island flowers'. Canny Rubinstein, of course, had got there first.

White Fire

BY GROSSMITH, 1954

THE PROVINCIAL PERFUME

'YOU MEET THE NICEST PEOPLE when you wear White Fire,' pledged Grossmith in 1954, when announcing their new female fragrance.

There is something terribly proper about British perfumes of the mid-century, arriving as the nation attempted to reinvent itself and find a modern voice through such initiatives as 1951's Festival of Britain. English perfume houses, once patronised by high society and royalty (not to mention being the envy of the French, who looked to London for inspiration when formulating their belle époque scents), were in the post-war years getting dowdy. The conflict had given the country a hammering; Grossmith's headquarters for one had been destroyed in a bombing raid, and when they emerged from the ashes they were behind the times. French perfumes were racy and American ones *moderne*. But British fragrances were becoming tamer, in tune with the general mood of post-war austerity and continued rationing. Was White Fire possibly a little derivative too, similar in name to Revlon's pizzazzy 1952 lipstick, Fire and Ice?

This is not to say that White Fire was irrelevant. On home soil it was one of the decade's bestsellers, alongside the likes of Goya's Black

Rose of 1955. Offerings such as these brought well-constructed and keenly priced perfumes to the nation's women via their local department stores and chemists. Rather than attempting to find a unique style, Grossmith and Goya talked about how 'French' their fragrances were, this being the hallmark of quality. There was nothing particularly exciting about them – the word parochial comes to mind – but, endearingly, they did promise that one might meet a very nice, respectable man when wearing them. It was all very 'tea with the vicar'.

White Fire was advertised extensively in the weekly *Woman's Own* magazine (Grossmith were no longer taking out pages in upmarket publications such as *Tatler*), which at that time was very keen on knitting patterns and offering young women dating tips so that they might avoid ending up as spinsters. White Fire was a very nice fragrance after the floral, aldehydic style. It smelt of lemon icing and grated soap: brittle and with a froideur that might just melt if you played your cards right.

There is something in White Fire's mood which reminds me of Ealing Studios' *Genevieve* from the previous year, 1953. This comedy road movie follows two well-to-do young couples taking part in the London to Brighton Veteran Car Run. Amid various arguments and breakdowns, there is a brilliant scene in which, having cancelled their hotel room in Brighton, husband and wife Alan and Wendy must stay in a run-down boarding house, complete with springy bed, no hot water, draconian rules and trains thundering past outside. The very glamorous Wendy, who always wears good lipstick and nice dresses, lies on the bed and, instead of bursting into tears, starts laughing. White Fire is no dowdy boarding-house perfume, but it is a fragrance of keeping up standards during austerity, of striving to stay smart in trying circumstances.

White Fire, once as prevalent as Bisto gravy, eventually disappeared. While it may not be *our* defining perfume of the 1950s, for many who actually lived through that decade, it absolutely was. Beware the tunnel vision of retrospection.

Pino Silvestre

BY MASSIMO VIDAL, 1955

THE AIR-FRESH PERFUME

ONE OF THE MAIN HAZARDS of travel by minicab is the headache that ensues from falling prey to a driver's addiction to car air fresheners. They sometimes hang off the rear-view mirror like a cluster of haemorrhoids, each one emitting terrible pulses of fragrance.

Vehicle air fresheners have sold in their billions and for that alone deserve a swift mention here as holding a historically important scent in their own right. The hanging paper ones (made of similar material to beer coasters) were an invention of the 1950s, a decade in which car ownership in Britain grew by a dramatic 250 per cent and became a household 'right'. Cars began to transform the way cities were designed, from built-in garages in the home to out-of-town shopping malls. In those heady days, cars were about more than getting around; they were a leisure pursuit, especially for those fortunate enough to stretch out in their Cadillac at the drive-in cinema. The origins of McDonalds were in serving gourmet meals to middle-class families out on a weekend picnic.

The first of the beer-coaster car air fresheners remains the most iconic: Little Trees. These nuggets of pine-freshness substituted the

invigorating aroma of the forest for the less palatable odours of petrol fumes and stale cigarette smoke. Little Trees were invented by a scientist called Julius Sämann, who as a Jew had fled to America from Switzerland prior to the Second World War. One day in 1952 his milkman mentioned that the smell of spoiled milk plagued him, and Sämann, who'd spent some years extracting aromatic oils from pine needles in Canada, began working on a new kind of paper porous enough to retain a fragrance for weeks. He filed the patent in 1954. Initially the products were to be shaped like pin-ups, but in the end he went for evergreens and a manufacturing company, the Car-Freshner Corporation, was set up in Watertown. Those trees started swinging from their hangtags until a whole forest became the pride of drivers. So distinctive and lucrative has been this design – as recognisable around the world as the golden arches – that woe betide any other firm that tries to re-create it. Several lawsuits have been launched by the corporation since 2002, including one against a company who made an air freshener in the shape of an aircraft, thought by the complainants to be similar in shape to a fir tree.

Being careful, therefore, not to suggest any direct link with tree-shaped air fresheners, we can imagine nonetheless that the aroma of pine needles must have been wafting about in the 1950s. Over in Italy, the Venetian firm of Vidal were finishing off their new evergreen aftershave, Pino Silvestre. It was so instantly appealing in its freshness, and in its entire lack of ambiguity, that this back-to-nature smell, positively elemental, became a classic affordable fragrance. Pino Silvestre is still around today, and comes in a green pinecone-shaped bottle, with a brown plastic lid. It's cute and satisfyingly moulded, like something you might find inside a Sylvanian Family windmill.

Once you get past the novelty factor, Pino Silvestre's evergreen, amber smell is seriously appealing, but to appreciate it we need to override the potential association with toilet bleach and upgrade the scent from worker-drone status to something more special. There is a particularity about pine that sets it apart from other smells. Is it the zing and cooling green? The connotations of being well away from

the city? That sense of being able to set aside our daily cares and silly worries amid the invigoration of altitude and the crackle of cones underfoot? John Cheever put it well in his short story from 1961, 'The Chimera', in which an unhappily married man living in the suburbs begins to hallucinate a new lover who comes to him in conjunction with a most specific scent: 'Then a sudden wind sprang up, a rain wind, and the smell of a deep forest – although there are no forests in my part of the world – mushroomed among the yards. The smell excited me, and I remembered what it was like to feel young and happy.'

Diorissimo

BY CHRISTIAN DIOR, 1956

THE PEDESTAL PERFUME

This is the way I want to live,
Toil not, spin neither.
Diorissimo is like me – almost all lily.
Colour me pretty as a picture.
'*VOGUE*'S PERFUME COLORING BOOK'

ONE OF THE MOST STRESSFUL shopping experiences for a man is having to choose a perfume for his wife or girlfriend. Come Christmas Eve, the beauty counters throng with Desperate Dans looking panicked. Some will have been exposed to the latest Chanel Nº5 advert so many times, they'll call out '5! 5!' as though in a fit of Tourette's, only to be flummoxed by the ensuing question from the sales manager: 'Parfum or eau de toilette, sir?' Other men will ask, 'What's new and similar to that Marc Jacobs? I think she wore that. Once.'

This annual tradition can be traced back to the 1950s, by which point perfume was, as we have seen, an established treat for women (at the right price). In the post-war consumer boom, it was the ideal present for executive men to buy their beloved wives – much less

bank-busting than Tiffany diamonds. The American comedian George Gobel sent up the experience in his sketch 'How to Take Command at the Perfume Counter': 'you know who "they" are. "They" are the ladies in the black dresses who stand behind the counters in the stores waiting to sell you "Violent Affair", "Abandon", "One Utter Night" and the rest of those brews.'

Hapless George gets the full works: impenetrable French accents, eyebrow raising, nail rapping, sighing, even assistants deserting the counter. It was a lucky man who managed to bypass this type of experience, for in the 1950s, perfume-buying guides were rife. The editor of one such set of FAQs, published in American *Vogue* in 1958 for readers to casually leave open for their husbands to discover, clearly put some thought into the question 'How do we make this something men will actually read?' The answer was to make it a parody of a financial newspaper. Full of Dow-Jones-style charts, the 'Perfume Investment Guide for Men' talked of the 'un-risky venture', the 'transaction', and the 'dividend'. Rather than overwhelm with endless options, these articles filleted the market so as to represent only 'Hall of Fame' fragrances, which seems to have brought a consolidation of the market. With a certain restraint, the established classics were represented: N° 5, Shalimar, Arpège, Tweed and Joy. New perfumes had to be very noteworthy indeed to make the cut. Guerlain's Ode garnered a few mentions, and so did Diorissimo, which had been given an 'event' launch, including full-page newspaper advertisements depicting a pricey Baccarat bottle with filigree gold flowers sprouting from the lid – the equivalent of today's J'Adore spreads with Charlize Theron.

Diorissimo is one of the most famous of Christian Dior's perfumes, particularly for invoking an accurate representation of the elusive lily of the valley, a scent which cannot be extracted naturally. Diorissimo is one of those quintessential spring aromas, as gauzy as chiffon and poised between soap and sap. It is a smell complementary to sprouting bulbs, wet grass in the morning and the tweeting of birds. This scent is what you might call pretty and wholesome, not saucy *at all*, and a perfect correlation to Dior's clothing, which was about modest,

appealingly feminine lines. A key look of 1955 was a green skirt suit with carefully nipped-in waist, complete with a sprig of lily of the valley by the lapel. By the mid-1950s, the New Look had been superseded by Dior's A-Line, then the H-Line, then the Z-Line, each of which was pored over by the press, keen to predict what was going to happen to everyone's waist and bosom. Looks were modelled by Dior's seven 'Les Girls', a much-envied coterie who were flown around the world to deliver modelling presentations, a proto version of the supermodel line-up of the 1990s. Christian Dior, too, garnered his fair share of envious speculation. Referred to as 'the Norman gentleman', he could work the metropolis when required but loved nothing more than his simple set-up in Fontainebleau, which revolved around cultivating fruit trees, making raspberry liqueur and treading through his favourite lilies of the valley in the woods.

Diorissimo is the pedestal perfume, a scent which worships women and which just needs a bit of raucous behaviour on the part of the wearer to mess up the perfect hair and put a rip in that A-line skirt. Think Grace Kelly, the quintessential Hitchcock blonde, who – it turns out – had a bit of a thing for a saucy tumble in the back of a car.

Hypnotique

BY MAX FACTOR, 1958

THE CHARM-OFFENSIVE PERFUME

IN *THE BEST OF EVERYTHING*, Rona Jaffe's novel about young women of the 1950s breaking into the world of work, Barbara Lemont, assistant beauty editor on *America's Woman* magazine, is asked by a Madison Avenue ad man whether he should place a commercial in her magazine on behalf of his client, Wonderful perfume. Barbara deters him. Though she herself, as a young working girl, wears Wonderful and would 'spend practically my last cent on cosmetics and perfume', the young housewives and mothers who lug their prams along the grocery aisles are far too harassed, tired and poor to afford luxury fragrances. 'They buy cologne in the drugstore,' she advises him, and if they're lucky, might get scent as a Christmas present from their husband, 'but more often a big appliance like a washing machine'.

Barbara's analysis shows us how the world of beauty was changing to cater for women on a budget – the very ones who over in Britain might have been attracted by the offerings of Grossmith and Goya. We can see this demographic in the pages of *Charm*, a 1950s American lifestyle magazine 'for women who work' that carried features such as 'You and Your Paycheck', 'Who Gets the TV Jobs?' and 'Cooking in

a Closet Kitchen'. Pervading the magazine was a feeling of managed spending, of having disposable income but needing to judiciously watch the dollars and cents so as to avoid losing everything for which one had worked so hard. *Charm* was an apt name, for the endgame was still eventually to marry, not to become managing director. In one feature on perfume, the magazine suggested that while during the day women might wear fragrance to please themselves, 'the fragrance we use at night we should use for others, to make a warm and loving mood, to complete us as women in our ancient role'.

Max Factor's 1958 spicy success story, Hypnotique, was one of these perfumes for the *Charm* reader: mysterious and inviting, yet available in pharmacy chains everywhere. It was propelled into the big time after becoming one of five recommended scents in Helen Gurley Brown's 1962 *Sex and the Single Girl*, a lifestyle bible which expounded on much of what was implied in Rona Jaffe's novel and which sold an astonishing two million copies in its first fortnight in print. *Sex and the Single Girl* famously encouraged women to embrace the liberation of not settling down – for now – and to enjoy the experience of seeing a few guys before angling for a husband. Alongside Brown's tips on dining out, getting in touch with one's sexuality and conversing with men came her advice to saturate cotton wads with perfume and hide them in the bra: 'Remember, if *you* can't smell it, probably *he* can't smell it either so you're being wastefully stingy.'

We can see this positioning of scent as a weapon of entrapment in the campaigns for Hypnotique, in which the bottle was dangled in front of the eyes and waved back and forth like a metronome with the command to 'make him concentrate...concentrate...concentrate on you'.

Hypnotique's spellbinding conceit was no chance idea but firmly rooted in one of the most peculiar crazes of the 1950s. Six years earlier, a housewife known as Ruth Simmons had been hypnotised by a local businessman and therapist called Morey Bernstein. As she lay on his couch, a flickering candle passing in front of her face, Ruth started to speak in the register of an Irish woman called Bridey Murphy, who

had died in a fall.

An elated Bernstein wrote up the story in a book, *The Search for Bridey Murphy*, which became a number-one bestseller and launched regression mania. Living rooms were temporarily turned into hypnosis parlours. Invitations to 'Come As You Were' fancy-dress parties abounded (and highlighted humanity's hubris – did anyone go as a street-sweeper?) and songs with titles like 'Do You Believe in Reincarnation?' could be heard everywhere. Scientists were pulled into debates to discuss the credibility of various reincarnation claims, including from a woman who felt she had once been a horse. Had the magnificent creations of Ruth Simmons and her imitators become an imaginative outlet for those usually preoccupied with the day-to-day chores of home-making? Was there something in the timing of the hypnosis fad, so enticing and sensational to a cohort of women with plenty of time to fret about the meaning of their lives as they embarked on another round of ironing?

As the stirrings of female liberation slowly gathered pace through the 1950s, perfumes such as Hypnotique offered a way of acknowledging and harnessing a woman's potential and power; by the same count, however, they were directed at the woman 'who was born to enchant men', still identifying that as her ultimate raison d'être.

After Hypnotique had been out for a few years, Max Factor released it in a pack with a Sophisti-Cat, a little figurine of a black cat with a pearl necklace and eyes made from rhinestones, designed to sit on a shelf. The cat, symbol of spinsterhood, had been reborn as the feline version of the ultimate single girl about town: *Breakfast at Tiffany's'* Holly Golightly. With small steps, we move forward...

Tabac Original

BY MÄURER & WIRTZ, 1959

THE JUST-FOR-MEN PERFUME

ADVENTURE MAGAZINES OF THE 1950S are such a treat to browse. Selling over ten million copies a month at their height, and with names like *Rugged Men*, *Man to Man* and *All Man*, they found a loyal readership among American white-collar workers and ex-servicemen, many of whom would have been experiencing status anxiety in the post-war culture (specifically, what's become known as 'breadwinner syndrome') and, in some cases, post-traumatic stress disorder.

These pulpy rags, the print equivalent of a B-movie caper, brought a tasty monthly hit of salaciousness to the suburbs. Their illustrated covers are gloriously lurid and typically feature a topless man fending off attacking animals, from giant hippos to otters and, curiously, turtles. Inside, the 'real-life' stories are grubbily addictive, with plenty of rescue-mission tales about saving a bombshell babe who's been kidnapped by sadistic, sex-crazed Nazis. Sometimes the babes themselves are the dangerous ones, and the rescuer gets trapped in a world of nymphomaniacs, as with 'Passion Ship of Desire-Haunted Women' or 'Man-Hungry Hussy of She-Devil Island'.

There is some suggestion that these magazines' stock cast of

cowboys, pirates and Indiana Jones types started to bleed beyond the page to influence the way men presented themselves in real life. In 1949 a Michigan-based style columnist, Clint Dunathan, bemoaned the influx of colourful neckties in the vein of the swarthy adventurer, which he felt fashion designers were pushing at men to make them 'strong, vigorous, and even lusty – at least in appearance'. Those selling aftershaves and shaving creams were of course encouraging this, their products being 'reminiscent of a first baseman's glove and a day at the race track, old saddles and the shower room at the gymnasium'. Dunathan was concerned that smell was being used to help metro-politan men impersonate the lumberjack type, diverting them into some fantasy world remote from their day-to-day lives. They 'want to look like they had just stepped out of an adventure story, still reeking with the sweat and blood of battle'. His summation of these kinds of aromas? 'An afternoon on horseback behind the hounds.'

We can certainly say that use of scent, or shall we say the 'blood of battle', was on the up among men in the 1950s. A feature from 1949 entitled 'The Perfumed Age', and directed at female readers of *Britannia and Eve*, announced that 'men have invaded the nice-smell market as women have invaded the cigarette market'. The report was careful to identify these 'nice smells' not as perfumes but rather as aromatics that had been incorporated into other products, with the suggestion of an intended subliminal effect. 'Shaving-soap, after-shaving lotions, talcum, toothpaste, hair lotions, toilet soap, mouth-wash – is given a carefully and cunningly-designed odour, which the purveyors know, or believe, will attract the male user.'

In the 1950s, the bathroom sink became very definitely the domain of the male (as surely as the dressing table was reserved for women). The burgeoning variety of grooming preparations expanded to include electronic razors from Schick and Remington, and an exciting new innovation: aerosol foams. Yet this makes the quest to identify dedi-cated mass-market male fragrances (as opposed to soaps or lotions) tricky. At the tail end of the 1940s had come new masculine leather scents, such as King's Men and English Leather, which gave that

saddleback effect described so vividly by the Michigan columnist. Then there was a slump, with little happening for the next decade. Nada. But in 1959 Tabac Original by Mäurer & Wirtz finally arrived; with that classic soapy whiff now associated with old-fashioned barbershops and shaving foam, it continued the heritage of the fougère (fern) fragrance type, first available in the 1880s.

Tabac is the string vest of aftershaves: deeply uncool yet clinging on for dear life in certain quarters. It is a busy old scent, and once the initial trumpet of aldehydes clears, it cosies down to something extremely multifaceted, with lavender, sandalwood and tobacco, and a whack of florals. Now this is what a hot face flannel should smell like. Previously, affordable fragrance had largely been acceptable when incorporated in products that were seen to be working on razor burn or nicks – they had to be *doing* something, not just smelling pleasant. Now, with the likes of Tabac, aftershaves could finally smell pleasant for their own sake, even if they still needed to be tied to the morning routine and offer that pleasure-meets-pain of the alcohol sting.

By the end of the 1950s, the mass-market separation of male and female scents as beefcake versus cheesecake was complete. Men now wanted to be told what to smell like – and what they wanted to smell like was a man, a man from the adventure magazines, covered in dirt and scratches, with a sweaty face following great exertion. Their women, meanwhile, even when being attacked in a swamp by giant otters, were high glamour, with perfect feline eyeliner, crimson red lips and pert boobs.

Vétiver

BY GUERLAIN, 1959

THE GENTLEMANLY PERFUME

VETIVER PERFUMES ARE LIKE BUSES, and never more so than in the late 1950s, when three came along at once: Carven's first in 1957, followed in 1959 by Guerlain and Givenchy playing catch-up. And hallelujah that they did. Finally, fine fragrance for men was waking from its nuclear winter.

There had, of course, been all the mass-market scented shaving foams, and the aftershaves, but dedicated 'fragrances' at the luxury end took a while to get going, and the shift was subtle at that – a bit like the segue in clothing from the loose-fitting Ivy League styles of the earlier 1950s to the sharper, leaner, Continental cut (think Cary Grant in *North by Northwest*) of 1958 and 59. The surge in popularity of lifestyle magazines for men, such as *Esquire*, helped create a market of wealthy, discerning consumers looking for something a little more select than Old Spice. And in the middle of the decade came a flurry of prominently labelled 'pour homme' or 'pour monsieur' scents from the likes of Chanel, Givenchy and Coty; these were usually a token one per house, each being absolutely blatant about its masculine attributes, to prevent the embarrassment of a chap accidentally picking up a girly product.

Vetiver, or khus-khus, is a grass native to India that has numerous agricultural uses, including helping hold soil together to prevent erosion, and providing animal feed. It was brought to America's Gulf states via the East Indies before the Civil War, where it became popular among plantation owners. It is the roots of the vetiver plant that are used in perfumery; indeed they are one of its most widely used materials. Up until the early twentieth century, vetiver was imported from Réunion, Haiti and Java and was readily available by the bunch. Householders would lay the roots in cupboards to fragrance their linen, or grind the powder to make oriental sachet perfumes.

With such a heritage, vetiver was certainly not a novel ingredient in these fifties fragrances, but it was newly appropriated as masculine. It is as though, in trying to fence off some territory for the guys, anything remotely woody was grabbed and de-feminised. There is nothing particularly manly about vetiver, aside from being told it is so, to which end all female readers are encouraged to have a go with Guerlain's Vétiver. Since its release, the Guerlain version has become the most famous of the three main vetivers, designed, according to the house, with reference to the smell of a gardener complete with soil under his fingernails. This truly is a marvel of a scent, one to whip out after overdosing on Fracas, when you're in need of something steadying. On a practical level, Guerlain's Vetiver is, to my mind, one of the best of the antiemetics, better even than ginger, and part of the hangover toolkit, alongside toast with Marmite and copious cups of tea. Vetiver has a really chewy smell. It is often described using terms like wood, liquorice, smoke and amber. In this scent its greenness is brought out with bergamot, its aromatic qualities with nutmeg and coriander, and its sweet smokiness with tobacco. The overall effect is like walking from the cold into a room where the fire was lit last night but crackled out hours ago, leaving only its smell behind, hanging in the air.

The Swinging Sixties
1960–1969

LIGHTEN UP! THE FRAGRANCE INDUSTRY certainly does in the 1960s. If, to generalise, the 1940s is melodrama, and the 1950s a fine romance, then the 1960s is a caper, with a fragrant Pink Panther somewhere in shot.

It's a jolt of a change. We are talking here, initially, about the visual campaigns for some of the classic fragrances from the 1920s and 30s. They behave as if they've entered the beauty pageant for one last try, only to realise that their ballgown looks hideously out of date; sprinting backstage for a rummage in the wardrobe department, they re-emerge, out of breath and in a miniskirt and patent boots. We see it with Caron's Fleurs de Rocaille, which in 1962 was still employing the classic glamour imagery and then in 1963 diverted into a psychedelic font plus flower child with daisies in her hair and white eye shadow. The next year brought a dramatic change in tone, when the house, or their ad agency's copywriters, asked with a massive wink if any girl could say no to a handsome man who owned a Ferrari, had a Côte d'Azur villa and who bought her a bottle of Fleurs de Rocaille? The answer? Feebly. Very feebly.

Then, in 1964, Coty encouraged us to buy Emeraude: 'You're only young once, *or twice!*'

Even if some of the humour is a little try-hard and tired from our vantage point, it is quite refreshing to see a product usually so po-faced relax a little, like the sudden rash of colourful Pucci prints in this

decade. The verbal tone moved from trusted advisor (the dominant 1950s register) to being in cahoots with a whisky-breathed wicked uncle who elbows you in the ribs when he comes up with a new punch line.

The contents of Emeraude and Fleurs de Rocaille were largely the same as before (perhaps making substitutions for some of the very expensive natural materials originally used) and so, for the first time in these pages, we encounter two very different presentations of the same perfume. Are both true to the scent? Can Fleurs de Rocaille be exhibited afresh for the next generation as current: yesterday's ingénue becomes tomorrow's gamine?

Even as some long-standing perfumes were searching for the fountain of eternal youth, others were making a virtue of their age. Their strategy for weathering the storm of newer upstarts was to establish themselves as the one constant in a woman's life. Shalimar, now nearly forty years old, managed to do it with wit in 1964, reaching out to faithful wearers as well as to young women looking for a 'go-to' in fragrance. Since 1926 women may, said Guerlain, have revolutionised their hairdos, hats, shoes, shapes, noses and even their husbands. And yet Shalimar remained. While Shalimar was reclaiming her territory, new perfumes certainly did enter stage left. Some, from fashion houses Balmain, Balenciaga and Givenchy, stayed classic, with an Audrey Hepburn-esque catflick-eyeliner twist, while others – such as Calandre by Paco Rabanne, Zen by Shiseido (both coming up) and Futur by Robert Piguet – were moving with the times and looking towards the space age or to a cleaner aesthetic. Then there was the influence of Swinging London, and the emerging cool of Carnaby Street (still half bombed-out from the war) and the Kings Road. Street-fashion brands such as Mary Quant had it sussed, bringing out pacy, fun, young smells – Quant updated a concept popular in the 1950s by releasing a duo of scents called AM and PM for work and play. And Yardley quickly came up with Oh! de London to take this energy over to America. Overall, however, the British fragrance industry, now looking tired, was in no fit state to capitalise on all the attention focused on our shores.

Indeed, it could be said that the fragrance industry as a whole, so tied to glamour and elegance, to floor-length gowns and neatly painted lips, was not quite ready to respond to the social changes sweeping the Western world and would not have been credible even had it tried. Instead, one of the biggest scent successes of the decade came from the counter-cultural grassroots, utterly outside the mainstream: the anti-perfume that was patchouli oil.

It is certainly not the case in the 1960s that fragrance was becoming irrelevant; there were some fantastic releases during the decade, especially for men. These offered the connoisseur of fine whisky, tobacco and wines (with the disposable income to afford them) an aftershave or cologne to match; Eau Sauvage from Christian Dior comes to mind. At the mass-market end, however, that hint of comedy/irony being tried out among the heritage brands manifested itself as raucous laughter among drugstore lines. Fragrance was starting to be parodied, and was even parodying itself, especially now that the conventions of the product were well enough understood to be subverted. We will find this out in entries to come, in the hirsute Brut by Fabergé and in Hai Karate with its accompanying self-defence manual for the ladies. The problem comes in deciphering whether or not the humour was *always* intended.

Centaur from 1967 was one such example. It was marketed as a massage cologne, alcohol-free for sensitive skin. In the advert, which resembles a still from the 1963 film *Jason and the Argonauts*, a babe in a toga with her nipples just about covered tends to the shoulders of a much older, Pan-like man. The bottle looks like an ancient inkwell. Centaur tells readers to rub the stuff into our loins in order to transmit a 'virile message' in intimate moments: namely, 'half man, half beast, all male!' It's a tongue-in-cheek sell that works, just about. The brand is taking the mickey, but knows that some of us will buy into the idea anyway.

Bal à Versailles

BY JEAN DESPREZ, 1962

THE MAXIMALIST PERFUME

ANYONE TEMPTED TO TRY Bal à Versailles must first summon the heraldic trumpeters and demand that a master of ceremonies with red sash and monocle hurry round a ballroom crying, 'Make way! Make way for Her Royal Excellency!'

'Blimey. What's in this one?' the reader may enquire. 'What isn't in Bal à Versailles?' might be a more pertinent question. This perfume is as various as the great, packed, stinking, bleating French court itself, before the whole thing imploded. You want opulent? Give this one a whirl, with its swinging chandeliers of orange blossom, mandarin, rosemary, rose, jasmine, cassia, ylang-ylang, tonka, sandalwood, amber, civet, vanilla, and the rest of the retinue; allegedly there are hundreds of ingredients in the formula. Bal à Versailles is indeed so generous, so full, that to wear it is a little like surrendering happily into a thick afternoon doze under a hot sun.

Bal à Versailles came from the house of Jean Desprez, which had been hitting glamorous, very French fragrances out of the park since the 1930s. This new perfume was something of a late renaissance for the brand, a dense, luscious oriental in the old, pre-war style; indeed,

Desprez had been responsible for one of the greats of the 1920s, Crêpe de Chine. His new sixties triumph took its wearers time-travelling to that fantasy eighteenth-century court as described in *Les Liaisons dangereuses*: plenty of fan flirting, deflowerings and heart-shaped facial gems (to cover the pox). The trippy experience that is 1968's *Chitty Chitty Bang Bang* comes to mind, in particular the scenes set in the Royal Palace of Vulgaria, in which the Baron and Baroness Bomburst, absurdly dressed and drowning in diamonds, sing in sickly baby-talk to each other.

Best of all, King of Pop Michael Jackson is said to have worn this most excessive of perfumes. We have had this confirmed by the house of Desprez itself (sold and now run from Miami). They have entered into the spirit of sharing by quoting his make-up artist, while acknowledging, and this should be repeated here, that such statements do not amount to an endorsement: 'Michael treated the bottles of this scent like gold. He was always so thrilled to have it. He loved the big fancy bottle, and he liked to carry the tiny little bottles in his pocket...He was wearing BAV in the last weeks of his life.' Well, it wasn't quite the Court of Versailles, but Jackson's Neverland Ranch, complete with its elephant, Patrick the orangutan, dodgem cars and drive-in cinema, wasn't far off.

Brut

BY FABERGÉ, 1964

THE NEANDERTHAL PERFUME

When Men's faces are drawn with resemblance to some other
Animals, the Italians call it, to be drawn in Caricatura.

THOMAS BROWNE, *CHRISTIAN MORALS*

THIS IS IT. OF THE hundred scents, Brut is the one made flesh in the popular imagination. It is known, around the world – even by those who never wear fragrance and think it's a waste of time – as the personification of a certain version of masculinity. This identity has been promulgated through pop culture by stand-up comedians, satirists, and sitcoms. There is no room for ambiguity with Brut. The pot's been baked in the kiln and you can either admire it or smash it.

'Oh, you great big beautiful Brut,' went Fabergé's confident gambit for their new fougère aftershave – an expression of desire which could almost be the opening line for a film featuring a housewife and a plumber. We can understand Brut (and this will be revision, not news for most of you) by zooming in on the chest area. The polyester shirt is splayed open, buttons popping off everywhere. We can't see any skin because this man is really hirsute and his forest has a slightly

oily, matted quality, equal to his jumbo sideburns. Duck out of the way quickly because he's now beating his chest and his medallion's about to ricochet off and hit you in the eye. Wafts of deliciously dirty-smelling nitro musks waft up, along with lavender and sebum. It looks as though he'd like you to come back to his cave for some hubba hubba. And by total contrast, let it be raised that in the 1970s, Brut was a trendy sauce for school girls, just as Le Dandy had appealed to the fashionable young gals of the 1920s.

But why Brut? What is it about this particular fragrance that has so gripped the popular imagination? It is, perhaps, the utter absence of nuance? Now that we're in the 1960s, we can forget the wife kissing her husband as he leaves for work, delighting in the aromatic wafts coming from his freshly nicked cheeks; Brut, released from the prudish straightjacket of the previous decade, goes straight to the bedroom to become the aromatic accompaniment of the mating cry. And, God forbid, lest society should worry that all this sexuality was non-mainstream, Fabergé positioned their aftershave definitively as a product for the 'masculine man'. They sponsored a number of sports-men, notably boxers and football players, athletes at the peak of their performance, in an era which was obsessed with testosterone – the hormonal embodiment of aggression, libido, motivation and strength. The joy is that these heterosexual promotions could also be seen as homoerotic, especially by the 1970s when adverts had footballer Kevin Keegan romping about in the shower with boxer Henry Cooper, and motorcycle champion Barry Sheene rubbing it into his nipples, splash-ing it on 'all over!'

When Brut was released from its cage in 1964, it was only just possible to quantify a man's testosterone levels through blood samples and therefore to know if he was 'below par' on this essential elixir of life. Men could get a testosterone shot from their doctor, and the sports world was in the golden age of Dianabol and other anabolic steroids, inspired by the muscular prowess of the Soviet delegation at the 1954 World Weightlifting Championships. Alongside this desire to pump up the capacity of the body there came a strange overlap with the

Human Potential Movement, which asserted that we use only 10 per cent of our minds and must strive for greater self-actualisation. Brut, arguably, is one of our most famous symbols for the self-actualised man, bursting with testosterone, but such a scent might also hint at the disturbing concept of the hormone made liquid.

We can see a parody of 'primal aftershave' in 'Going Ape', an episode of TV sitcom *Bewitched* from 1968. When everyone's favourite nose-twitching witch, Samantha, turns a stray chimpanzee into a man, all hell breaks loose. Her husband Darrin, responsible for a new commercial for a men's aftershave brand, spots the handsome human and declares him to be the face they've been looking for. The primate is coaxed into a series of photo opportunities. He may look the model of respectability, but inside he's still all ape, and when asked in one shot to pose with a golf club he instead starts smashing up the set, clambers up the walls and, beating his chest, makes chimp noises at the horrified crew.

Zen

BY SHISEIDO, 1964

THE JAPONICA PERFUME

There was never a time when the world began,
because it goes round and round like a circle, and
there is no place on a circle where it begins.
ALAN WATTS, *THE BOOK: ON THE TABOO*
AGAINST KNOWING WHO YOU ARE

IT WAS 1964 AND BRUT had some competition. That same year, the
year in which the Olympics were staged in Tokyo, another venomous
green aftershave was launched, this time with a far-out twist. Jade East
came from a company called Swank and was the perfume version of
a plastic rolling boulder in an action film – utterly inauthentic, but
kinda fun. The East-meets-West presentation featured a model in an
apple-coloured turtleneck, a miniskirt and white space-age boots. In
one piece of print, she is holding onto a man and mouthing the words
'Even if he isn't your daddy' – problematic in so many ways.

Orientalism was back, and this time it was being larded with the
Way of Zen, one of the emerging cultural and philosophical interests
of the 1950s and 60s. The mesmerising Alan Watts, a former Anglican

priest from Britain, had been decoding the tenets of Zen Buddhism for Western audiences, delivering a hundred lectures a year at college campuses across the United States, as well as making time for radio slots, books and television appearances. By the 1960s his grassroots activity was translating into mainstream acceptability, and some of his neat expressions appeared in concentrated form in the newspapers, like little bits of biltong upon which readers could work: 'So who are you? That must remain undefined because trying to define yourself is like trying to bite your own teeth.'

Cosmetic products, and in particular fragrance, had long appropriated Eastern aesthetics to sell a beguiling notion of beauty founded in ancient rituals and secrets. Just think of all those Japanese-inflected fragrances of the late nineteenth and early twentieth centuries, whether Grossmith's Hasu-no-Hana (1888), Guerlain's Mitsouko (1919) or Œillet de Japon from Babani (1920). What was different about 1964's Zen was its development by a company that actually originated in Japan, a company that had a history of cross-cultural inspiration.

Shiseido was founded in 1872 by a pharmacist to the Japanese navy, Arinobu Fukuhara. He wanted to run a pharmacy that, instead of being attached to a hospital as was then the protocol in Japan, was a destination in its own right, attracting consumers who were shopping for pleasure. He was very taken by Western beauty culture and borrowed the American custom of installing soda fountains on the shop floor for his first emporium in the smart Ginza district of Tokyo. The company motif depicted camellia flowers in water, in a European, art nouveau style.

Very quickly Shiseido became one of the largest and most famous companies in Japan, spurred on by the success of their whitening face powder, Eudermine skin-softening lotion (note the Ancient Greek-sounding, not Japanese name), and the first toothpaste in the country. They successfully floated on the stock market in 1927. Even as American firms like Revlon and Helena Rubinstein tried to get a piece of the Japanese market in the mid-century, Shiseido held on to their number-one position. They were finally tempted to expand into

overseas subsidiaries: if Helena's going to try and grab your yen, you might as well go and grab a bit of her dollar.

Shiseido – like Japan itself – did not have a strong body perfume heritage. Their fragrances for the home market to date, such as 1917's Hanatsubaki, had been delicate, based around the idea of the camellia, to accommodate preferences for soft aromas. Zen, a green, rosy incense, which smells uncannily like Granny Smith apples, was therefore created specifically for Western markets as a distillation of Japanese beauty culture. Its point of difference was its muted amplification: a quiet perfume to sell notions of tranquillity, loftiness and purity. While other brands were shouting 'Buy me! Buy me!' Shiseido whispered to its customers, turning beauty once more into a considered ritual. The Zen bottle, black and rounded and decorated with what appeared to be hand-painted golden camellias, was sold on Shiseido counters by visiting beauty consultants dressed in kimonos. It was a tactile objet d'art, a thing of beauty not a million miles from Poiret's oriental perfume bottles from fifty years previously.

The Way of Zen, Shiseido style, evolved over the years to reflect whatever the zeitgeist understood the term to mean. In the 1990s it went sci-fi, when the company relaunched the scent in packaging that looked as though it could have been designed by Apple, with the fragrance itself containing a rose extract based on flowers grown in a space shuttle. Finally, in 2007, came another reincarnation, in a gold, cubed bottle inspired by the Japanese tea-ceremony. The 1964 version is now sold as Zen Original; Zen is a way of being, and in perfume, there are many ways of being Zen.

Pretty Peach

BY AVON, 1965

MY FIRST PERFUME

AVON'S PRETTY PEACH RANGE WAS a tantrum-activator. So perfectly conceived were these scented products – cologne bottles with squeezy plastic peaches for lids, soaps which sliced open to reveal bonus kernel-shaped soaps inside, fragrant creams hidden in plastic wicker baskets of peaches – that placid eight-year-old girls would morph into puce-faced Veruca Salts in an instant: 'Mummy, Mummy, but I want it NOW. I've wanted it ALL MY LIFE.'

Even some adults would twitch with nostalgic yearning when shown the goods, for Avon, the first to market perfume explicitly for children, knew instinctively how to enter the imaginary worlds of small girls. It was about more than aping the grown-ups by having a version of mummy's dressing-up ritual. It was about more, even, than the fairy-tale woodland illustrations on the pots of Beauty Dust. This was about the joy of the concealed compartment or lockable diary, in being old enough to hold that secret, and in possessing something touched by enchantment, half prosaic but with unexpected delights within. For all we knew, inside that Pretty Peach soap kernel we might find Roald Dahl's James having tea with Miss Spider and the Centipede.

The provision of the hidden cache played on that conceit of the disguised fantasy world so mesmerising in classic children's literature: the secret garden concealed behind a locked door or the gnarled old oak tree as passage to the Land of Goodies in Enid Blyton's 'Faraway Tree' stories. Such delights were almost, and only almost, made tangible through toys, which re-created them in miniature form. In its design conventions, Pretty Peach helped pave the way for later blockbuster toys of the 1970s and 80s, like Keypers, the family of psychedelic swans, rabbits and snails that opened up to look after your most treasured possessions. Or Clarks' Magic Steps shoes, gleaming in black patent and sold with a key to access hidden pictures set in the heel. Polly Pockets were the most riveting of all, holding a whole palace or home within a dinky, lilac-coloured plastic heart.

These products, all of them, belonged to that exciting era of petro-chemical plastics, of vinyl dolls' heads and Lego bricks fashioned from cellulose acetate, which made it possible for toy giants such as Mattel to manufacture intricate play worlds for even the most modest of pocket moneys.

Funnily enough, for all its immaturity, the Pretty Peach collection most puts one in mind of the absurdist 1930s bottle designs of Elsa Schiaparelli, redirected at an audience who truly would appreciate their whimsy. Another example of a children's perfume from the 60s took this to a slightly more nightmarish level. Mattel's Kiddle Kologne featured dolls dressed up as flowers trapped inside the bottle, with scented contents to match: apple blossom or rosebud, all straightfor-ward soliflores (single-note florals).

Perfume for children can so easily be inappropriate by introducing the vanity regime too soon. Pretty Peach, however, had it just right: a treasure to be cherished for a few short months in childhood until, in later years, the neophyte perfume wearer, finally, could get really serious about their hobby.

Oh! de London

BY YARDLEY, 1965

THE GROOVY PERFUME

ONE OF THE GREAT PLEASURES in being a Brit is the ability to squirm at and criticise Hollywood films' attempts to 'do' the English country-side, the Scottish Highlands or London. Extra points if a character is as poor as a church mouse and yet can somehow afford a townhouse in Chelsea, with a view of Big Ben, that's also a minute's walk from the Tate. Nonetheless, there is, at least for me, a pride in knowing that your country is deemed worthy for cultural export, even if that's by way of a whirling dervish of butlers, secret agents and Dalmatians.

Never has Britain been so cool as it was in those few short years at the end of the 1960s. Across the world was projected a London lifestyle experienced by just a few but made immortal through Antonioni's film *Blow-Up*, which took viewers into the shuddering studio inhabited by a hubristic fashion photographer and his doe-eyed models. London very quickly became an exportable commodity, expressing a quirkiness and coltishness that brands were desperate to latch on to. Just two years prior to their new perfume's launch, Yardley had been all about ball-gowns and handbags, centred upon a smart Bond Street address. Now, newly owned by British American Tobacco, they'd raced across Oxford

Circus to get a piece of the Carnaby Street action. Out went twinsets and pearls, and in came geometric patterns and Jean Shrimpton in dolly lashes – at least for the American market, the intended audience for this take on London.

As part of this mid-sixties transition from floral bouquets to flower power came new brightly coloured cosmetics, hilariously including lipsticks which doubled as whistles to lure over the boys. Kooky spelling was a-go-go (a Luv Dust perfumed powder mitt, anyone?). Cups of tea and dartboards, strangely, made appearances in ads, as if to play up the British miscellany as featured on the album cover of *Sgt. Pepper's Lonely Hearts Club Band*. Yardley's perfume, perfectly positioned to encapsulate the flirty, frisky 'London Look' (a phrase they trademarked), was Oh! de London, a light and informal camomile fragrance that celebrated being young and free. 'Oh! Silly curls. Oh! Pout. Oh! Rapture,' said the not entirely sensical adverts. For only $3, girls in the US desperate to make it to England for just one glimpse of Paul McCartney could splash it on and feel hooked into Twiggy's street style.

Yardley's new strategy paid off – for a while. Very quickly, however, the youthful customers got bored and moved on to the next new fad, or grew up and wanted a lady's perfume (Ô de Lancôme of 1969 would be a neat progression from Oh! de London). Yardley eventually returned to their lavender roots, until, in 2014, a new perfume popped up from the house: Jade, inspired by the perfumes and styles of the 1960s.

Eau Sauvage

BY CHRISTIAN DIOR, 1966

THE PLAYBOY PERFUME

IT IS, ON OCCASION, POSSIBLE to develop a crush on a cartoon character. I will admit to an early infatuation with Disney's fox incarnation of Robin Hood from the 1970s. His true love, fox Maid Marian, didn't do too badly with the boys either (coming a close second to Jessica Rabbit). If we hasten away from the dubious world of animated adult animals and back to the terra firma of humans, we come to one of the most fanciable illustrated men in history: Mr Eau Sauvage.

This fellow is nameless, all the better for being objectified, and as hot as pen and ink can be. He was the creation of Italian-French artist René Gruau, who produced some of the most original and memorable commercial fashion illustrations of the twentieth century, particularly through his long-standing relationship with the house of Christian Dior. Even before electric fans came along to give movement to models' hair in photographic shoots, Gruau was pumping life into his drawings – giving clothes and the figures that wore them energy and above all wit. Many of Gruau's women, even as they wear terrifyingly expensive haute couture, have their head thrown back and mouth chirrupping with delight, looking as if they've just spotted their favourite person

walking towards them. Gruau's best work, though, came when he was advertising perfumes. Selling an outfit is challenging enough, but at least there is a tangible item to animate. Representing a scent, even with the clues of packaging, is much harder as the concept and personality suggested by the aroma must be spun into a personification. Yet Mr Eau Sauvage, the crowning glory of Gruau's fragrance work, is so alive as to actually be someone you would like to date, which I suppose is the point: buy this scent for your boyfriend and the flair might rub off.

Admittedly, on a very bad day, you could look at the Eau Sauvage adverts and see a narcissistic himbo. He's got a buff body and he likes his terry towelling, appearing most often in a white dressing gown and slippers (hairy legs on show), or naked with a towel thrown over his shoulder (nothing to see, ladies; he walks sideways and that towel is conveniently placed). The raunchiest image shows him shaving naked in the bathroom, with a tiny bit of bottom on show as the viewer peeps in.

This is a man padding about at home, for there is an air of post-shower relaxation and the tinkling of vermouth and ice in a glass, rather than a rushed morning routine. Gruau's illustrations of a metropolitan man, perhaps attached, perhaps a bachelor, perfectly encapsulated the scent of Eau Sauvage. Formulated by the minimalist perfumer Edmond Roudnitska, it was a clever twist on the eau de cologne: a mossy citrus splash lifted through the use of a molecule present in jasmine flowers called Hedione (or methyl dihydrojasmonate), which illuminated the composition to brilliance. Eau Sauvage is secure in its own skin; it knows it's got the A game but doesn't need to go on about it. Strangely, unlike many female scents from earlier in the twentieth century, which quickly become 'old', Eau Sauvage has been worn now by three generations without ever seeming past it or too 'dad-like'; many men whose fathers wore this scent have no qualms about inheriting it for themselves.

The seeming effortlessness of Roudnitska and Gruau's work here belies the social changes that made it possible. Selling scent to men

had, as we have seen, hitherto relied on a few laboured persuasion techniques. Gruau got rid of all of this – the endless marketing copy, the adoring wife pecking her husband on the cheek, the cheesy slogans – and showed a man, usually alone, in his element. Eau Sauvage tells little but implies much. As a snapshot of social history he is a pertinent figure. In her account of post-war masculinity, *'Playboy' and the Making of the Good Life in Modern America*, historian Elizabeth Fraterrigo charts the role played by Hugh Hefner's empire, from his magazine to his clubs and penthouses, in presenting young, affluent men with an alternative way to live, one ultimately built on extending the years of 'freedom' prior to marriage. Rather than paying off that new-build suburban home and having the old ball-and-chain nagging at you all hours of the day, this was about pleasure-seeking, in and out of the bedroom. And no self-respecting playboy could truly express his tastes and impress his latest squeeze if he didn't have his own luxurious bachelor pad filled with abstract art, jazz records and up-to-date hi-fi equipment. Away from the entertaining space, the bathroom was of supreme importance, reclaimed as a manly grooming lair. One of *Playboy*'s lifestyle features, 'The Man in his Bath' from 1957, emphasised the need for titanic, plush bath towels (reminiscent of those large red and black boxes of Kleenex for Men tissues) and the all-important voluminous terry robe, to don when emerging from a long soak in an oversized tub.

The Eau Sauvage man is more than a Hefneresque cliché, however. He probably gets all the girls anyway, but that's not why he loves the scent. He wears it for himself, out of the social limelight, and enjoys nothing more than an evening pottering about in his sheepskin slippers.

Aramis

BY ESTÉE LAUDER, 1966

THE URBANE PERFUME

ARAMIS WAS AN ALL-AMERICAN FRAGRANCE from Estée Lauder, designed for suave executive men and named after a character in *The Three Musketeers*. A popular Christmas gift from wives to husbands, sold in gift packs bearing such jetsetter names as 'The Emissary Set' and 'The Diplomat', Aramis became so popular, so aspirational, that it inspired the pilot for a spy series, from which the following scene derives (though it should be said now that this sitcom is entirely imaginary).

THE SCENE: *a dazzlingly new skyscraper office block somewhere in uptown Manhattan. To a medley of instrumental woodwind, we see a yellow taxi pull up outside. A tall man in his mid-thirties hops out without paying, and enters the lobby through a set of revolving doors. He obliviously lets in a pigeon and the doorman, flustered, starts batting the bird away with his hat, revealing a toupée underneath. We see the tall man in close-up. Handsome, he wears a black turtleneck jumper underneath his tweed suit. His sideburns are bold and well groomed. His bronzer is apparent. His behind is pert.*

This is DICK BISHOP, otherwise known as AGENT ARAMIS.

ARAMIS crosses the lobby and gets in the elevator, where he slips the

bellboy a dollar bill and gestures for him to leave. The doors slide closed. He turns to the main panel and, taking a mini screwdriver from his jacket pocket, gets to work removing a metal pane in just four seconds. One bead of sweat is visible on his forehead. Underneath the panel is a very large red button to a concealed floor. ARAMIS presses the button and ascends with some speed. The conspicuous bulge in his right trouser pocket is his bottle of cologne, which he mists over his hair and strokes pensively over his chin.

The elevator doors ping and open. ARAMIS finds himself in a plush, executive office with Kandinksys on the wood-panelled walls.

A young lady sidles over, offering him a document to sign. Her beehive is higher than a kite. This is JACKIE STARLING, secretary to AGENT KNIGHT, Director of the CIA's secret intelligence programme, Checkmate.

JACKIE: Dick, why do you always have to cause so much trouble? I just had to buzz down and pay off that driver. Here I am, trying to be mad at you, and I can't because you smell so darn good.

ARAMIS: Think nothing of it, Jackie.

ARAMIS quickly signs and pushes the paperwork back at JACKIE – which she is not expecting. The pen clatters to the floor.

JACKIE: Now look what you've done. A fountain pen, too.

JACKIE bends over to pick up the pen, revealing the top of her silk stockings. ARAMIS raises one eyebrow and holds it there for the camera. Satisfied with the view, he strides over to a pair of heavy double doors and knocks.

KNIGHT [*from within*]: Come in.

ARAMIS makes as if to enter, then turns around to where JACKIE is standing, cross, her dress covered in fountain-pen ink.

ARAMIS [*to JACKIE*]: Friday. 6 p.m. The Carlton. Wear pink.

Before JACKIE can reply or look annoyed, ARAMIS has disappeared inside the room.

JACKIE [*sighing and smiling*]: Oh, Dick.

The scene: AGENT KNIGHT's office, black leather furniture and a Tibetan rug on the wall. AGENT KNIGHT is an older man, smart, with bushy eyebrows, a pocket handkerchief and slicked-back grey hair. He stands at his desk, a view of the city behind him. He is pouring two tumblers of Scotch.

KNIGHT [*passing over a glass*]: Aramis, you're just the man I need.

God, you smell good.

ARAMIS: Think nothing of it, Knight.

KNIGHT [*gesturing to a leather sofa*]: Sit down, sit down.

ARAMIS turns to lower his rear. He notices a tortoise resting on a cushion and munching on a piece of cucumber. His eyebrows rise once more.

KNIGHT: That's Buzzby. Don't mind him. He keeps me company. Plus he's bugged. A surveillance chip in his little brain. Didn't feel a thing, did you, Buzzby? He likes people and I'm sure he'll get to like you, because you're taking him to Switzerland.

ARAMIS: Isn't this plan full of holes?

KNIGHT: And much more. Now look, quit joking around. I'm sending you there, to Lugano. The Chess Olympiad starts next week and there are a lot of people attending who we need to know about. In particular, this man. Boris Korlakov. Know him?

AGENT KNIGHT slips a black-and-white surveillance photo to ARAMIS.

ARAMIS: You mean the Russian Rook? Sure I know him. Been ferrying arms across the border to Siberia for some grand project. Hides tiny consignments of plutonium in his chess pieces.

KNIGHT: I'm glad you've got the basics. Your mission is to find out what this man's up to. I need places, names, dates, or, God help us, we'll have a nuclear war on our hands. I'm setting you up as a chess champion so you can go up against him, take out his radioactive chess pieces and switch in some dummies. Ever played?

ARAMIS: I had a Chutes and Ladders set as a boy.

KNIGHT: You've got five days to become a master. Buzzby's shell holds a tiny computer that knows every possible combination of moves; these will be relayed to you via a secret earpiece. He'll be with you at all times. Now, you're going to need support.

KNIGHT, who in this time has got through three Scotches, pours another. He takes the tumbler over to his desk and, using a tiny key, opens a hidden drawer. Inside is a bottle of Aramis by Lauder, in its familiar walnut-wood-effect box. KNIGHT walks over to ARAMIS and hands him the scent.

KNIGHT: It's your usual. A disarming yet reassuring blend of bergamot, cinnamon, vetiver, moss and amber. Oh, and with a

soupçon of sandalwood.

ARAMIS [*opening the bottle and about to spray*]: How romantic. Thank you, Knight.

KNIGHT [*putting his hand forward in a halting motion*]: Stop! You don't know what you've got there. This is no ordinary bottle. It's been doctored – has, shall we say, certain additives, which when inhaled produce an intense wooziness and shut down the logic chambers of the brain. I need you to wear this when you're playing the Rook, so he can't work out what's going on. Otherwise he'll figure you out, and you're dead. As will we all be when the nukes come. I'll give you an antidote so it doesn't affect you. Whatever happens, do not spray until you're playing him. Catastrophe could ensue otherwise. Put it away, there's a good boy.

ARAMIS: I'll try to be careful.

KNIGHT: We'll need you back here on Wednesday for final preparations. If you come out of this alive, be nice to Jackie. She adores you, and we need her for morale.

ARAMIS *takes one last gulp of Scotch, pats Buzzby on the shell and exits the room. He is about to stride straight over to the elevator but, raising one eyebrow, takes out his new bottle of cologne and mists it around his head, then walks over to JACKIE, who looks at him disapprovingly.*

ARAMIS: Wednesday, 11 a.m. I'll be here to collect Buzzby and some chess pieces. Then I'm taking you to lunch.

JACKIE: Sure, Agent Aramis. Right after I've got this ink out of my dress, which is never going to happen. I even called my mother and she says it's pretty much ruined. (*Suddenly looking faint*) Boy, you sure are a card. (*Woozier*) I'll put that in Mr Knight's diary. (*Slurring her speech while gesturing for him to leave*) And I must say… (*Hiccupping*)…you're the man of my dreams. (*Slumping*) You really are the model of masculinity. (*Eyes fluttering*) I adore you, Dick. Don't ever forget that.

JACKIE *passes out gently at her reception desk. DICK takes her pulse and, satisfied she is alive, raises an eyebrow, straightens his jacket and strides out of the office towards the elevator. Woodwind music to fadeout.*

Hai Karate

BY PFIZER, 1967

THE SELF-DEFENCE FRAGRANCE

HAI KARATE MARKS THE MOMENT when farce took over. Launched in 1967 with the slogan 'Be careful how you use it', this budget cologne was a work of marketing genius. A proto-Lynx, riding on the wave of kung-fu movies starring martial artist Bruce Lee, it promised young men, with their spots and self-esteem issues, that patting on this stinging lotion would make girls go absolutely crazy.

Hai Karate's campaign even used comic violence to dramatise its irresistible qualities, employing a *Carry On*-style sense of humour. Every bottle of Hai Karate came with a diagrammatic instruction manual intended to help the wearer when accosted by randy females. First he must break free of her grip while 'springing from the knees'. Then come the moves: 'Get her in a good, tight half nelson and shock her back to reality with a stern warning such as "Watch it, sister."'

The accompanying television commercials would never be made now. They borrowed a Clark Kent conceit, in which a bespectacled nerd, having applied his Hai Karate, was attacked by nurses, librarians or orange-pickers – all gorgeous, wearing onesies and hysterically horny. Even after having been slapped, still they run towards him, in

227

a style evocative of a *Benny Hill* run-around. Thrilled with the success of their genius idea, the Hai Karate team released a promotional LP called *The Sounds of Self-Defence.*

And who was behind the scent? Pfizer, who thirty years later were to give the world Viagra. All that can be said is, it worked, in a massive way. The aftershave itself is, these days, one that usually prompts a groan from people as they hear the name. But it is the kind of groan that says, 'I'm mad, me. I used to have that Hai Karate!' For, despite the embarrassment now, they weren't going to say no to a bevy of women in work attire flinging themselves at their manly scented bodies.

Patchouli Oil

THE WANDERLUST PERFUME

OH, SCHISMATIC AROMA OF PATCHOULI. We all know of it, have all experienced it (if you haven't, get thee to a tarot shop, and buy some quartz while you're there). Depending on your generation and personal history, it is either the smell of a mouldy, ratty Afghan coat sweating in an old plastic bag dumped in a damp flat, or it is the smell of freedom, of nomadic adventures and sexy times. Hey, it could even be the smell of sexy times *on* a mouldy Afghan coat.

It is very difficult to point to any one of this group of 1960s fragrances – which encompasses patchouli, musks and other aromatic oils – as exemplifying the Hippie Stink tradition. The very allure of these perfumes was in their unbrandedness and their presentation in little brown glass bottles with squiffily applied labels, put together in some makeshift premises or, even better, imported from Nepal or Kashmir.

Patchouli oil plays a pivotal role in the history of fragrance. It speaks of a sea-change for the young people of the 1960s, who, in their 'nagging urge to rebel against the dead middle of the twentieth century' (as described by writer Jenny Diski), wanted a complete break

229

from their parents' way of living, which included fancy dressing-table perfumes with all their bourgeois conformism. If you identified yourself as a Freak, you wouldn't be seen dead with a bottle of Rochas Femme or Soir de Paris, just as you'd steer clear of little skirt suits, pearls and coral lipstick.

Patchouli oil was the perfume that pretended it wasn't. Unlike those 'stuffy' Diors and Guerlains that were made from a long list of ingredients, this was a natural product, which meant untampered with by humans (allegedly) and therefore authentic – straight from the earth. With its wine-dregs smell, patchouli, a close relation of mint, is suggestive of gnarly plant roots and worms wriggling around in dehydrating soil. Admittedly, scent played only a peripheral role in the counter-cultural movement compared with, say, drugs or the sexual revolution. But the vogue for patchouli speaks of the importance of 'real aromas' for those reacting against the ideal of the nuclear family with its suburban house, fitted kitchen and convenience foods. As the writer Annie Gottlieb puts it in her remembrance of the 1960s, *Do You Believe in Magic?*, 'Children of Lysol, Listerine, and Wonder Bread, we were starved for texture, taste, and smell.'

The implication here is that America and Western Europe were olfactorily sterile, having been town-planned and sanitised to the point of blandness. This was a world of carpet cleaners, detergents and deodorant sprays indoors, and of street cleaners and garbage trucks whisking away rot and decay outdoors. Where was the aroma of unwashed bodies and human sweat? And what had the conveyor belt of comforts screened out from our experience of being alive?

Wanderlust, and the use of psychotropics, tapped into this urge to rediscover sensory stimulation. By the late 1960s, thousands of youngsters, inspired by the Beatles' trip to India, had got themselves a passport, packed a rucksack with Aldous Huxley paperbacks and jumped on a Magic Bus heading for Delhi or Kathmandu. The Hippie Trail has now become one enormous tourism cliché, but push aside the ganja hunting and stories of getting by on a handful of rupees a day (before wiring home to get more money from Daddy) and you have

a fascinating tale of the need for muck. Gottlieb again: 'We wanted baptismal immersion in the film of dust, the press of flesh. Even dirt was spice to us; a world that *smelled* was as much of a revelation as a world that starved or meditated.'

Intermingled with the wafts of human waste, incense, jasmine, henna, exotic foods and rot that these trippers encountered would have been local fragrance traditions, patchouli among them. The dried leaves had long been exported to the West, packed in with fine cashmere shawls to ward off moths, but now patchouli had broken free from its Victorian associations and was ready to become a talismanic symbol of free love. Legends abound that the oil's true role was to cover up (or enhance) the smell of pot, but it was more than that. Nearly thirty years before the launch of CK One, patchouli was a passing-around fragrance, something that could be shared between men and women and which enhanced the smell of sweaty, lusty bodies. Though phero-mones and the olfactory aspects of human attraction were not yet widely understood, the smell of patchouli was already perceived as complementary to our own odours, stimulating desire. It even picked up the names 'love oil' and 'attraction oil'.

Such products, quickly broadening into 'love soap', 'love spray' and 'lover incense', permeated the rash of new herbal and head shops, where one could also get a bong and some Robert Crumb comics. Head shops were usually found in college towns, while the major cities hosted bigger meccas, like the infamous, now defunct, Kens-ington Market in London, and the East Village in Manhattan, which by 1969 was chock-a-block with emporia such as the India Religious Store, the Essex Street Market and Rendon's West Indies Botanical Garden. These joints sold aromatic bits and bobs such as ambergris, ginseng root (a friend to sexual energy) and, more alarmingly, turtle organ. 'Pete's Spice and Everything Nice' offered convenient vials of pre-ground nutmeg for sub-LSD hallucinogenic experiences. One of the most illustrious places to get scent products was Kiehl's pharmacy on Third Avenue, in business since 1851 and from the 1960s hugely hip because of its phenomenal range of dried herbs, available by weight,

echoing the burgeoning trend for wholefoods. Kiehl's was famous for its perfume oils, including, of course, patchouli, and Original Musk Oil, which they maintained was first made in the 1920s by a Russian prince, to be rediscovered in a vat in their basement. As we are by now well aware, the fragrance industry does adore its Russian princes.

One positive aspect of the patchouli craze was that it revived male interest in scent, long confined to the down-low. The not-so-good outcome of wearing the sniggeringly nicknamed 'trog oil' was that these chaps were now seen as an affront to public decency. The *New Scientist* even reported on the phenomenon of what it called 'aromatic males', specifically the tribulations of a Wolverhampton-based theatre designer 'who complained to the local Citizens' Advice Bureau about being refused service in a cafe because the management objected to his Indian patchouli-flavoured aftershave lotion'. According to the proprietors, 'customers started complaining', so they 'had to spray everywhere with air freshener'.

By the mid-1970s the 'love oil' fragrance family was on the slide. The cultural gods of the hippie era were suddenly all grown up, had cut their hair and were tuning in to the more sophisticated fragrances available to the budding consumer. Still, the narrative of musk fragrance would one day be taken over by big business, after an entrepreneur popped into Kiehl's pharmacy, but you will have to turn to the following decade to discover how.

Calandre

BY PACO RABANNE, 1969

THE FUTURISTIC PERFUME

ONE OF THE DEFINING FRAGRANCES of the 1960s is best uttered in a French accent, untranslated. Calandre, pronounced *callon-dra*, is such a beguiling word, but in English it means 'Radiator Grille'. At least the radiators in question are not those in our buildings, but the sexy metallic fronts of prestige cars: symbols of speed and the march of modernity.

As Spanish designer Paco Rabanne's first fragrance, everything about Calandre had to be new. Formerly a jewellery man with a thing for metal, Rabanne had only been showing catwalk collections for three years and was already the most controversial figure in fashion. For his first show, '23 Unwearable Dresses in Contemporary Materials', he had actually managed to make clothes constructed from aluminium and plastics feel slinky and graceful on the skin, not lacerating.

The visual freakiness of women encased in chain mail got Rabanne the gig of designing the costumes for *Barbarella* in 1968, and so the world discovered the joys of Jane Fonda wearing metal boob plates. In most of the press shots she is, inexplicably, lying on her side with one leg in the air, already practising the Legs, Bums and Tums exercises of her future career.

233

Calandre's name was certainly fresh, and the monolithic bottle was strikingly original, resembling the mysterious totem in Stanley Kubrick's *2001: A Space Odyssey*. The perfume itself was adventurous and worked in some just-available synthetics including Evernyl (also known as methyl atratate, this resembled natural oakmoss) and rose oxides to create a commercial take on the idea of futuristic odours; the result was a metallic floral with a gleaming sheen, not dissimilar to Yves Saint Laurent's forthcoming Rive Gauche of 1971.

But what was also unusual about Calandre was its backstory, which industry veteran Michael Edwards discovered when talking with Rabanne's fragrance collaborator, Marcel Carles, as told in his 1996 book *Perfume Legends*. When briefing the creative team, Paco Rabanne spun a tale to get them started: 'A rich young man arrives in his E-type Jaguar to pick up his girlfriend. Imagine the scent of fast air, speed and leather seats…He takes the girl for a ride along the seaside…He stops in a forest…there he makes love to her on the bonnet of the car.' Bless the perfumer, who must have been writing furious notes and wondering how on earth to translate car bonnet into a wearable fragrance.

In the 1960s, this kind of storyboarding was unusual in the fragrance industry but typical of Rabanne's unorthodox ways. As a synoptic approach, it had most in common with the avant-garde concept album, which in 1969 was starting to emerge in popular music. The Who were being feted for Pete Townshend's rock opera about a deaf, dumb and blind boy, Tommy, which endured as a classic for the precise reason that each song stood up on its own merits; it was immaterial that the listener had no inkling of the overriding theme and wondered what on earth Uncle Ernie's sinister holiday camp was about. As a concept perfume, Calandre too held a complex set of motifs, but these were sublimated to the greater service of creating something about which people would say, 'That's really unusual. I'll take a bottle.' Happily, it is not at all necessary to be a fan of the design aesthetics of Rolls-Royce radiator grilles in order to enjoy Calandre – once the future, yet now, in retrospect, quintessentially of its time.

The Spangly Seventies
1970–1979

IN THE SUMMER OF 1975, thousands of people paused before they went for a paddle in the sea, and began hallucinating shark fins on the horizon. This was no regular galeophobia (word of the day: fear of sharks) but the fallout from watching Steven Spielberg's new film, *Jaws*. *Jaws*, which was followed by *Star Wars*, *Superman* and *Rocky*, came to define the blockbuster movie: escapist thrills, insane promotional spend, blanket distribution and a high-grossing box office.

Why talk about *Jaws* in a perfume book? There is not, thankfully, a shark-themed scent coming up (although probably one exists), but we are entering the decade of blockbuster perfumes. 'Go big or go home' was the mantra for a decade flickering between discoballs and dreariness, an era of shimmering flared jumpsuits in flammable polyester and the fantasy of Ziggy Stardust. In an increasingly global playground, the stakes were getting ever higher and the risk of failure more acute, but if millions could be persuaded to buy your perfume, the spoils were prodigious.

Throughout the 1960s, the fragrance industry had been quietly reshaped. As those corporations most successful at cashing in on post-war prosperity grew, they became hungry and started buying out smaller beauty brands and fragrance houses. Max Factor took over Corday in 1961; in 1963 Caron was acquired by investors after becoming a publicly traded company, and Yardley went to British American Tobacco. Sometimes buyouts work, when a brand is carefully nurtured

by its new owners, but what can also happen in fragrance, and with many other luxury products, is that ranges start to be tinkered with to save on cost (perhaps a tweak of a formula, or a packaging redesign) and then get reduced in price to reach the lucrative mass market. By 1969 it was estimated that only four of the fifteen big French houses were still under French ownership, and a backlash against this trend meant that when in 1971 the American company Helena Rubinstein attempted to purchase Rochas (makers of Femme from 1944), the move was halted.

Once part of a conglomerate, however, perfume brands had ready access to wider distribution: new countries, new outlets and new customers. As the companies expanded, so did the retailers. In the UK, Boots – the high-street pharmacist – was taking one in every three pounds spent on beauty. Duty Free, first introduced in the 1960s, was becoming another huge channel for fragrance sales and helped increase international exposure. There were a few murmurs of protest. In 1971, a women's lib group based at New York's Columbia University made the news when they said they'd successfully re-created Joy for $3 an ounce instead of $63, using Henley's *20th Century Book of Formulas, Processes and Trade Secrets*. Their complaint was not that fragrance was oppressive to women, but that corporates were making huge margins on each bottle sold and should be exposed for their 'unconscionable profiteering'. When brands are visibly spending huge amounts of money on advertising, as was the case throughout the 1970s (though, to be fair, Joy was actually quite modest in this respect), it is inevitable that questions will be raised about the value of the liquid inside, in relation to its promotion.

And there certainly was a lot of noise being made about new perfumes, with massive launch events and PR hype, big-budget television campaigns, and enormous billboards. In the 1950s, fragrance companies didn't really *do* television, but by the 1970s they were pulling out all the stops with full song-and-dance productions, though admittedly these were less glossy and art-directed than today's campaigns and more like a slow Monday night at a Weimar cabaret club. The house

of Prince Matchabelli, who we remember from Wind Song, were promoting another of their perfumes, Aviance, with a wife in a pinny doing a very tame striptease and flinging away her tea towel to get ready for the evening's delights. Still feeling their way around the medium, companies sometimes got it very, very wrong.

Quite possibly the most disturbing advertisement ever, let alone for a perfume, was for Love's Baby Soft in 1975. In wanting to convey the scent's particular character, someone decided it would be a good idea to have lullabies playing while a grown woman seductively licked a lollypop as if in the nursery. The voiceover? Let's just say it talked about the irresistible, cuddly scent of innocence. What's especially upsetting is that the product came from Dana, that once-great firm behind Tabu, a wonderfully opulent fragrance of 1932, now sliding from greatness into, well, whatever this was all about.

Aberrations aside, what recurs in many of the new fragrances from this decade is an effort to accommodate the changing roles of women. It would be going too far to say that a scent can be innately feminist, or smell of liberation, but there was a certain pace to many new scents, as if perfumers had found a middle ground between the classical fragrances of the early twentieth century and the run-wild patchoulis. There were beautiful, vivid and bitter green perfumes like Pheromone by Marilyn Miglin (ignore the dreadful name), Jean-Louis Scherrer's signature scent, and Chanel's N°19. There were the smouldering bonkbuster orientals, all clustered around the end of the decade, such as Opium, Cinnabar and Magie Noire. And there were pacy, motivating, sparkly chypres, such as Diorella and Cristalle.

Many fragrances of the 1970s used a material called Hedione, which was first dosed substantially back in the 1960s with Eau Sauvage. Smelling of very little on its own, hedione acted in conjunction with other materials like a bicycle pump, injecting air into perfumes and helping to create a sense of energy and space. These next-gen smells, and the advertising campaigns that promoted them, were referencing the changing profile of their potential customers, who were no longer the leisured rich of cocktail soirées and lunch parties but busy women

juggling work, motherhood and romance. Yves Saint Laurent's Rive Gauche especially tied itself to the play for independence.

In aligning themselves with the feminist agenda, fragrances risked doing so crudely, through 'you can have it all' platitudes, but on the whole their hearts were in the right place. Fragrance was back in step with the times, more affordable than ever and a treat for the masses who were now filling music stadiums across the land. After all, these seventies scents – sniffed everywhere, worn globally – were as rousing and feel-good as a rock anthem.

Rive Gauche

BY YVES SAINT LAURENT, 1971

THE MULTITASKING PERFUME

IN THE LATE 1970S, PERFUME brand Charles of the Ritz released a scent called Enjoli, which defined itself as 'the eight-hour perfume for the twenty-four-hour woman'. Promoted with the Peggy Lee song 'I'm a Woman', in which the singer takes us through her various guises, from busy worker to home cook, Enjoli threatened to demolish in one swoop the glamour of fragrance by actually featuring someone wielding a bacon pan on camera. It was one of the last in show of a subset of launches that were hoping to appeal to the capable seventies woman who was trying to raise her kids, earn a living and have a semblance of a social life. Enjoli was to be her accomplice through all this plate-spinning, lasting out the day, and as suitable worn with a kitchen apron as with a silk negligee.

If we are to find the original fragrance for the multitasking woman, we need to rewind a few years to 1971 when Yves Saint Laurent's Rive Gauche ('Left Bank') came along, determined to be 'nothing like the past'. Rive Gauche was for sassy young women going at ninety miles per hour, and it sold back to them a more amped up, fantastical version of their own lives. Actress Faye Dunaway, then role model for

239

countless twenty-somethings, exemplified the Rive Gauche woman. As Vicki Anderson in 1968's *The Thomas Crown Affair*, she made being an insurance investigator sexy and, while scoping an art crime, had an affair with the lead suspect. In *Network*, produced a few years later, she played an unscrupulous TV executive with a killer wardrobe (and an endless roster of satin dressing gowns), who barked at her terrified underlings, 'I want ideas from you people.'

In intent, Rive Gauche was complementary to its fashion sister, Diane von Furstenberg's jersey wrap-dress, which promised high glamour for daytime with a wash-and-go practicality. In contrast to more traditional dressing-table fragrances, whose amber liquid glinted from within dainty glass bottles, Rive Gauche came in a jaunty aluminium can – idiot-proof and ideal for being chucked in a handbag along with the car keys and wallet. The racy blue-and-black-striped bottle meant it could be spotted in the bag amongst all the old receipts and grabbed for touch-ups throughout the day. The can's mechanism encouraged great whooshes of application, enveloping the body in a fine mist, and women were even exhorted to spray it up and down their legs, which must have solicited strange looks in offices, not to mention coughing fits brought on by that aerated honeysuckle-rose aroma.

Rive Gauche was huge for Yves Saint Laurent, and as the seventies progressed its momentum seemed only to build, allowing eventually for a big-budget, girl-in-a-fast-car advert with its own jingle about having fun, heading onto the open road solo, and not giving a hoot about marriage.

Yet this rather obvious stall-setting-out was by now unnecessary, for the matured Rive Gauche was already being enjoyed as a classic on its own terms, separate from its original rationale. Besides, with Enjoli and all the other copycats, wasn't this independent woman shtick a bit laboured now? And so, with Rive Gauche selling on repeat purchase to loyalists, Saint Laurent eventually turned their attention to marketing a very different sort of fragrance, in which languor, not Lamborghinis, was the name of the game; Opium, to which we will turn in a little while.

Aromatics Elixir

BY CLINIQUE, 1971

THE HOLISTIC PERFUME

AROMATICS ELIXIR WAS ONE OF the first mainstream fragrances to acknowledge the anti-perfume patchouli movement of the 1960s. Looking as though it came out of a Chinese medicine cabinet, this plush product sits rather incongruously against Clinique's stark lab-coat image, and on first release in 1971 the scent was sold quietly, under the counter. Until, that is, Clinique needed to boost interest in their brand ten years later, whereupon they commenced the reverse-psychology trick of taking out full magazine pages promoting it as an underground movement: 'Aromatics Elixir never conformed. Needed no fanfare. It's the only self-made perfume success.'

Fanfare-free it may have been, but Clinique certainly knew how to position their original fragrance. This potpourri of a perfume has patchouli as its star (of course), together with a rose heart and a crown of herbs, including chamomile and sage (for a 'Scarborough Fair' moment). Aromatics Elixir projects like a diva hitting a key change. Though detractors often accuse it of having a sour, cat-wee effect, supporters love it for being completely distinctive and like nothing else available. The company, aware that they had a tiger on their hands,

officially recommended wearers to spray once and walk into the cloud. As many as five sprays and you can forget human contact.

Most cleverly, Clinique described Aromatics Elixir as 'perfume and something far beyond', its botanical ingredients touted as having effects that went further than those of everyday fragrances. *Vogue* excitedly reported the release in its feature 'Scent with Intent':

> They chose orange flower because it's soothing, sandalwood and chamomile for a clean-clean feeling, civet and jasmine for basic, come-hither pow. Not to mention skin-softening ylang-ylang and oakmoss, and a rose meant to be exceptionally freshening. So special is the resulting elixir they don't even call it perfume.

That the language here was a little fuzzy reflects the then-nascent state of aromatherapy, a practice which in the early seventies was breaking through into English-speaking countries, thanks to the work of Jean Valnet (who coined the term) and Austrian biochemist Marguerite Maury, who in the 1960s made popular the topical use of essential oils as part of massage therapy. Aromatherapy was intriguing the population but was still some way from gaining mainstream recognition, lumped together with new-age herbalism and macrobiotic and organic diets. But the drum of the 'you are what you eat' message was spreading into cosmetics and personal care, fuelled by concerns about the source of ingredients in beauty products, and the emergence of the natural movement. Four years after the launch of Aromatics Elixir, Britain would see the opening of the first branch of The Body Shop, while in America, Horst Rechelbacher was developing Aveda, with its focus on wellness through herbal botanicals.

In so far as a fragrance can be thoughtful, Aromatics Elixir is out there as something rather special and has, through the years, become personified into quite a complex individual. She is independently minded, rooted, mature, free-thinking, controversial, confident in her position, and doesn't give a monkey's if somebody hates her. If this isn't more than a perfume, then what is?

N°19

THE INEFFABLE PERFUME

N°19 ENJOYS A CERTAIN NOTORIETY in my parents' household. In the 1970s it was one of my mum's favourite perfumes. She loved it, wore it all the time. Until one day in 1980, when she and my dad were out house-hunting. The memo about having coffee brewing to entice prospective buyers clearly hadn't yet got around, because as soon as they entered one property they were hit with the odour of boiled cabbage. On the stove was a vast pan of the stuff, already very well cooked. As they viewed the rooms, the smell got stronger and stronger, until they felt so sick they had to abort the tour and get out into the fresh air. Two days later, on went the N°19, at which point both of them recoiled and said, 'God, it's that cabbage smell.'

From that moment, the perfume was retired from active service.

Hastily, it must be said that N°19 does not smell of cabbages. What happened here was an unfortunate juxtaposition, which later brought a phantom of that unmistakable sulphuric whiff. This was possibly supported by a couple of facets in N°19's composition, particularly galbanum, an aromatic resin which smells green, and in concentration like garbage, and orris from the rhizome of the iris, which can come

243

across as starchy and vegetal, even carroty.

N°19 was released in 1971, just after Gabrielle Chanel's death, and was the first new perfume for the company following a sixteen-year hiatus. Pour Monsieur had been the last scent to come out, in 1955, and the 1940s had been very quiet too, testament to the enduring appeal of Chanel's early jazz-age roster. The latest fragrance had been Gabrielle's personal scent and was named after the date of her birthday, the 19th of August. Gabrielle was obsessed with numerology, and from a cursory look at the symbolism of 19 you could infer that as 1 stands for new beginnings and 9 endings, the number holds within itself two different identities.

N°19 marked a younger, more vibrant style for Chanel – reinforced by Cristalle in 1974 – which the brand sought to personify through the words 'witty', 'outspoken', 'interesting' and 'confident'. They were looking to carve for the fragrance a more idiosyncratic feminine identity than the usual sexpot or romance suggestions. N°19, though, has never been a big seller for the brand. It instead sits quietly for a small band of devotees who adore it. N°19 rather defies being categorised, and trying to give it an identity is a tricky business. Owing to its cut-stem, green opening (most noticeable in the eau de toilette in comparison to the richer parfum), it is sometimes described as being teeth-chatteringly cool, aloof or frigid; Luca Turin and Tania Sanchez, in their seminal work of fragrance criticism, *Perfumes: The A–Z Guide*, equate N°19 with the lean and mean 'wire mother' of infant attachment theory, set in binary opposition to the softer, more cuddly 'cloth mother.' But such an interpretation could easily jar with the experiences of the wearer who finds these very same facets of fragrance friendly, far from the cut of the scalpel.

There is a sense of friction at the heart of this perfume which makes it endlessly fascinating. Some fragrances are ahead of their time. With this one, even getting on for a half-century after its debut, you have to wonder whether we're ready for it yet. Is this smell familiar enough, or too strange? For N°19 is like being in a garden where what we see in front of us doesn't match up with what we feel in the air: a joyous glut of summer flowers under a thin winter sun.

Musk Oil

BY JŌVAN, 1972

THE LOVE-MAKING PERFUME

HOW TO BEGIN A PRECIS of Jōvan's Musk Oil? This big-budget version of the previous decade's anti-commercial hippie musks was brought out by a salesman from Revlon called Barry Shipp. Shipp had bought one of the oils he had spied at Kiehl's Greenwich Village shop, wrapped trendily in brown paper bags, and then patented his own version of a synthetic musk blend. He found a business partner, Bernard Mitchell, who had a background in manufacturing lamps, and in 1972 they began producing their fragrance in Chicago, a city with little fragrance heritage. This mattered not, and in fact worked to the scent's advantage, helping to characterise it as a democratic love potion, though they still felt the brand name needed a macron (the 'ō' in Jōvan) for a bit of European pizazz.

With the shameless assertion that a little dab of this was the secret to having a roll around in a cave atop animal pelts, complete with a panther guarding the entrance, Jōvan made Shipp and Mitchell's fortunes, and after seven years the company was sold to Beecham for a staggering $85 million. This fragrance was of course not the first to suggest that smell is sex, but the newly liberated era made it

possible to blare out the fact in neon flashing lights. Unlike the trend for hippie musk oils, this was global, mainstream, suburban sensuality, and it coincided perfectly with the release of the forever-mocked love manual *The Joy of Sex*. Its rollerball tip meant that the wearer had to stroke their skin to get the oil on, almost in rhythm to Barry White's fleshy love ballads, immediately making the application the first stage of foreplay.

Jōvan spent millions on television slots showing close-ups of bodies being stripped and culminating in a shot of a pool of oil rippling outwards. What could that be analogous to, we wonder? Whether Shipp and Mitchell were ever challenged as to the materials in their oil, or its uniquely sexy properties, we will never know. But compared to modern-day pheromone perfumes, Jōvan's claims are perfectly quaint, if groan-worthy. In one magazine spread, featuring a group of topless men grinning in a locker room, a 'Mr B. van Sickle' is quoted, while doing up his flies, as saying, 'It hasn't put more women in my life. But it sure has put more life into my women.' Mr J. Hart, an attorney who resembles Charles Bronson, tells us, 'My secretary used to call me Mr Hart. Now she just calls me.' There is even a Mr J. Fink, whose occupation is described as 'swinger'.

Though sold as raw passion, in its soft floralcy this musk oil was really more like the post-coital cuddle, invoking that soft-focus longing induced by the cheesy crooners of the era – David Essex and Barry Manilow for sure, but above all Demis Roussos. You can imagine the Greek singer, rotund in his kaftan, piling on the scent before looming in front of the Vaseline-tinted camera lens (his comb-over billowing in the wind) to wail 'Forever and Ever', over and over and over again. You might also imagine Beverly in *Abigail's Party* rolling it on prior to her monthly nuit d'amour with husband Tone, with crudités to start.

Good news: Jōvan Musk Oil is still available to anyone keen enough to hunt it down, so readers can decide for themselves whether this is one to apply to get into the groove.

Diorella

BY CHRISTIAN DIOR, 1972

THE JOIE-DE-VIVRE PERFUME

IT MAKES A GOOD NAME for a girl, does Diorella. The kind of girl about whom the Kinks might have written a song. Following Christian Dior's formula of christening their scents to suggest different facets of the Dior persona – Diorissimo, Diorama and Dioressence – in 1972 Diorella became the next generation's mademoiselle. Diorella, a fresh peach chypre created by Edmond Roudnitska, the maker of Rochas Femme and Dior's Eau Sauvage, has none of the porcelain delicacy of Diorissimo (discussed in the 1950s chapter), or the boudoir indolence of 1949's Dioressence. Instead, it is the olfactory equivalent of one those rare mornings when you wake up naturally and perfectly, eager to get going: the curtains are swooshed open, the shower is on, and fresh air gushes through the open window. Not that this is an annoyingly perky perfume; it is more that Diorella's scent is full of the pleasures of being alive and enjoying the moment. Roudnitska was brilliant at fruity notes and no other perfumer has come close to his luscious, never cloying treatment. Diorella's peach savour sometimes comes across with the metallic wiring of green mango, or the watery, boozy quality of very ripe melon. It is unusual and absolutely delicious.

247

Even as Diorella first appeared in stores, it was recognised as a new kind of perfume which seemed to chime with other sartorial innovations. Barbara Hulanicki's brilliant London clothing and life-style bazaar Biba was starting to offer brown lipsticks and tawny eye shadows, delighting the Biba girls bored with the samey prettiness of corals and pinks. And the skinny, bobbed models in miniskirts had been replaced by glossy, long-haired brunette celebrities – Bianca Jagger, Jaclyn Smith, Ali MacGraw and Kate Jackson – taking big strides in white pant suits.

Vogue described Diorella as 'Breezy. Unaffected. Elegant, but relaxed about it. Deliciously feminine, without shouting the obvious,' which hints that by the 1970s the fragrance industry was assured enough to shift into casual wear, and had the creativity and range of synthetic materials to do so without just producing a traditional cologne. Diorella's sisters, all with the same high energy, and moussey with lemon and honeysuckle, were 1969's Ô de Lancôme and 1974's Cristalle by Chanel. They were from top French houses and, though far from the grungy world of patchouli oil or the cheap charm of upcoming scents such as Revlon's Charlie, they did suggest that for those in their twenties and thirties desirous of a prestigious perfume, it was time for a change in mood. Lancôme's Ô in both name and smell is a sob of delight, an interjection, and Diorella's first advertisements featured a giant exclamation mark, which could be read vertically as 'I-o', or 'io', the Latin for 'joy'.

Diorella is still with us, even though, along with Diorissimo and Diorama, it's usually hidden away behind the more recent house offerings. Over forty years on and it smells as modern as any of them.

Charlie

BY REVLON, 1973

THE DISCO PERFUME

CHARLES REVSON, FOUNDER OF REVLON Cosmetics, loved to rile people. A terrifying figure to have as boss, he once said of his business, charmingly: 'You got to keep tight at the ass. The day we get soft, we'll go down fast,' and would hold to account staff who so much as dropped a paperclip in the bin. This was a man who managed to infuriate the grandes dames of the beauty industry throughout his fifty-year career, most notably Elizabeth Arden, who referred to him as 'That Man'. Well, you should never waste a good idea, so Charles named his first aftershave…'That Man'.

As much of a controlling tyrant as Revson was, as a brand Revlon was so good at getting people to covet their range that re-reading some of their archive of print adverts makes me twitch as I type. They were masters of reverse psychology. Fire and Ice, a red lipstick, was sold on a series of questions to ascertain whether magazine readers were wild enough to wear it. Only those who answered yes to eight of the fifteen ('Do sables excite you, even on other women?') were deemed worthy of this bold colour.

When Charlie came out in 1973, Revson was nearing the end of his

249

life, yet still keen to get one up on his rivals, which naturally would involve lending his own name to a perfume. He had always been an expert at anticipating what his customers might want next, whether that be matching nail varnish and lipsticks or fragranced face-powders with a nostalgic nod to those fin-de-siècle Parma violets. When it came to producing his most famous fragrance, Charles and his team could see before him a new generation of sparky young women, who, yes, wanted perfume, but who were not prepared to fork out a week's salary on a bottle. Charlie was a floral aldehydic fragrance that offered a more than passable alternative to the likes of Chanel Nº5 – at a fraction of the price. It was as cheap and cheerful as a pair of spangly flares at the disco, where it was all about copying the steps from *Saturday Night Fever*. Charlie was unashamedly populist and mass-market, with all the glorious cheese factor of the Bee Gees.

In their commercials for Charlie, Revlon emphasised its affordability by speaking directly to their audience in the second person, as though in an intimate tête-à-tête. Perhaps this conflates the cultural influences, but it was almost as though the voice of Charlie the perfume was the very same man as Charlie of the Angels. Flattering the nascent 'Charlie-girls' with smooth assurances, the advert tapped into their aspirations ('You want more out of life, more out of love, more out of yourself.') before suggesting that Charlie was now here to help with its 'gorgeous sexy-young smell.' The buddy-buddy intimacy might all seem rather patronising now.

Revlon also signed up actress Shelley Hack to front a new television spot. In a masterclass of seamless editing, the camera follows Shelley, in her satin onesie, as she very clearly sprays Charlie on her neck (most of it goes on her cheek and nearly in her eye), gets out of her pink car and manages a hybrid move that is part stride, part spin, into a cocktail bar. There she keeps spinning but also shakes her hair around constantly, to remind us that perfume is emanating from her at all times (the overall skit was so famous as to be spoofed on the Donny & Marie Show, in which a hapless Charlie-esque imitator gets stuck in the car, tears her trousers and knocks over a table). The

accompanying soundtrack from cabaret musician Bobby Short was as persistent as the theme-tunes to *The Waltons* and *Little House on the Prairie*. It wriggled into the brain and wouldn't let go until, on the next trip to the pharmacy, you slipped a bottle of Charlie into your basket along with the tights and hair dye. Like Mateus Rosé, which in the same decade helped to democratise wine and is now seen as a guilty pleasure, Charlie is still there for those who wish to find it, ready to start up again with a spin as soon as you open the bottle.

Babe

BY FABERGÉ, 1976

THE PROM-NIGHT PERFUME

THERE IS A COUPLE. THEY are young, in love, and in black tie. They may be in their twenties, but then again, they could be fresh from the high-school prom, where they were homecoming king and queen of all they surveyed, a preppier but still cool version of *Grease*'s Danny and Sandy. They clink coupe glasses of champagne; on reflection, it is probably Babycham. Whatever they are drinking, it is sloshing about everywhere, because the couple are squished into a giant black rubber ring, like something out of a demonic theme-park ride. They are heading down a raging river, with alarming velocity, towards a terrifying waterfall. If they have wet bottoms, their faces do not reveal it. Given that the current leads the rubber ring straight under a rickety-looking bridge, their love is looking precarious.

This was the 1977 promotional campaign for Babe by Fabergé (they of the notorious Brut), a raspberry-scented cologne that contained '118 essences'. Fabergé had just signed up Ernest Hemingway's granddaughter, Margaux, in what was then a record-breaking million-dollar deal. She would front one of the biggest ever American fragrance launches, which would see her take on an exhausting schedule of

events (as well as those white-water rapids). Margaux, named after the wine, was captivating, partly owing to her family ties, and partly for her golden-girl looks and athletic, six-foot frame. She was also deeply troubled and soon to descend into a very dark, Studio 54-related pit. But as the face of Babe she represented a Californian brand of health and wholesome living that was utterly desirable for the scent's teenage audience.

If Charlie was for the hard-working but party-loving woman without wads of cash, Babe (clearly a direct competitor) was for her little sister, now ready to move on from the beginner's eroticism of *Forever* by Judy Blume. Babe took out a huge presence in *Cosmopolitan* magazine, then under the editorship of *Sex and the Single Girl*'s Helen Gurley Brown who had mastered the art of, shall we say, zingy cover lines. Just two from March 1977: 'Why Nice Guys Finish Last – a Woman's Need for a Man Who Dominates, Protects, and Occasionally Mistreats Her!' and 'How to Handle an Obscene Phonecall (Don't Hang Up!)'. Babe, marketed at the impulsive reader prepared to try any product featured in the *Cosmo* bible, was as addictive as the magazine's stories. Having tracked down an old bottle, I can confirm that it outclasses many of today's juvenile juices; after all, sometimes plastic jewellery is what you want to wear.

Despite its brash name, which appeared on the bottle in the same typeface as the title for the upcoming stage-school film *Fame*, Babe was really a sweetly earnest scent. Margaux's rubber-ring river ride – hopefully inspiring a few similarly adventurous first-date activities among her fans – supposedly represented the twists and turns of fortune, through which she would always be accompanied by her Babe cologne and her one true love: 'You're the babe I wanna journey through life with' went the perfume's song.

Opium

BY YVES SAINT LAURENT, 1978

THE ME PERFUME

IT IS DIFFICULT TO THINK of a perfume that has caused quite as much Mary Whitehousian outrage as Opium, uproar which continued as recently as the year 2000 when the brand received over seven hundred complaints about advertisements showing Sophie Dahl posed in nude ecstasy. Originally brought out in the late seventies by the pulse of 'C'est chic', Yves Saint Laurent, Opium is cannonball of hot, tingling spices and dry, crackling woods that shoots into your nostrils.

What first set Opium on its path of wickedness was a carefully constructed image straight out of Narcotics Anonymous, bolstered by the excesses of its promotional activities. Andy Warhol famously regretted being out of town for Opium's coming-out party, for which the New York display ship *Peking* was got up like an opium barge and stuffed with eight hundred guests (twice as many as should have embarked). These included author Truman Capote as captain, enter-tainments industry mogul David Geffen, Cher in perm mode, and fashion editor Diana Vreeland. The notorious club Studio 54 hosted the after-party, a fiesta of peacocking at which Opium's model Jerry Hall and Saint Laurent held court.

It is Hall's print adverts for Opium that reveal most about the fragrance's relationship with its era. Inspect any other perfume spread from the decade and the model is nearly always looking directly into the camera, into the eyes of a man or at a flower. Hall, on the other hand, is sprawled across a divan in a gold lamé Halston gown, like something out of 1930s Shanghai, and she's on the nod. In some photographs her eyes are fluttering closed; in another she is staring in glazed fashion at a fascinating spot on the ceiling. The viewer, in the position of voyeur, is being courted very discreetly by the brand.

Just as the oriental fragrances of the belle époque had promised the wearer a ladder to reverie, Opium, though clearly 'offering' sexual attraction on one level, also brought something of this earlier flavour: a selfish enjoyment of scent, to be bought and worn for solo pleasure. Hence Jerry Hall's disregard for us. Opium is an egotistical perfume, and it mirrored beautifully the self-indulgent tendencies of the era. As Tom Wolfe put it on the cover of *New York* magazine in 1976, this was 'The "Me" Decade', for the experimental drug-taking of the late 1960s had helped widen the preoccupation with the true nature of personal consciousness, and the self-help movement had gone mainstream. Money was tight, but that didn't necessarily matter. For the first time, decadence had been democratised and could be claimed by Mr and Mrs Average as well as by the elite. Individuation might manifest itself as self-sufficiency in the suburbs; it might involve artistic creativity under hallucinogens or visiting a therapist to talk about problems and issues. For the brave in the United States, personal development might also entail a visit to one of Betty Dodson's self-love workshops.

With Opium, the drugs tag was simply the bait. What Yves Saint Laurent was really marketing, with some genius, was perfume as me time: a daily opportunity to get languid and to care sod-all about anything or anyone else.

Magie Noire

BY LANCÔME, 1978

THE WICCAN PERFUME

MAGIE NOIRE WAS ONE OF those perfectly timed fragrance launches that completely cannibalised a certain mood, an interest, which had been building throughout the 1970s, in all things pagan and 'spelly'.

The mainstreaming of counter-cultural ideas that had begun in the 1960s was much in evidence in the subsequent decade: London's Camden Lock was packed with tarot readers setting up shop at weekends for a bit of extra cash (my father has admitted to being one of them, under the name of 'Tireas', an embellished anagram of Aries); Fleetwood Mac's tambourine-clanging singer Stevie Nicks was continually being grilled about whether she was a white witch, a line of questioning that persists to this day; and the 1973 film *The Wicker Man* both sickened and enthralled audiences with its dark tale of village life and pagan bonfire rituals.

Then it got silly. Stephen King's short story 'Children of the Corn' came out, and by the end of the 1970s America was in the middle of a hailstorm of mini-series dramas that nurtured a hysterical interest in fertility cults and neo-paganism. Perhaps one of the most ridiculous was *The Dark Secret of Harvest Home*, about a family who come undone

when they move to a New England village and succumb to Widow Fortune (and her special mead), played by Bette Davis.

The enticing connections between perfume, spells, drugs and incantations were ripe for appropriation. Magie Noire – kindred to Opium – can be procured today, as then, at such mysterious emporia as department stores and is a stonker. It certainly lives up to its name, being a dark, smoky chypre, all incense and autumn mulch, not at all sweet. Were this drinkable like wine, it would be highly tannic. It is one of the most grown-up perfumes around (without being old-lad-yish) and stands alongside Opium as a dark spirit of the decade. In a mystical conceit, the scent was apparently designed to unfold not in a linear progression but in a figure of eight, returning at the end of the day to smell as it did on first spray.

Lancôme had their perfume, they had a name, and they had a slightly naff bottle. Now all they needed was a launch event or two. The party held three years later to mark Magie Noire's entry to the American market was one of the most over-the-top displays ever seen in the name of fragrance, holding its own even against rival Yves Saint Laurent. Building on Magie Noire's 'edgy' image, Lancôme's press team decided to host their party among the tenements of New York's East Village. They turned The Saint, a gay disco, into the setting for a black-tie do for five hundred. The locals had never seen anything like it. One homeless man, watching a fleet of black limousines pull up outside, asked, 'Who died?'

At $300 a head, this launch certainly needed to excite the crowd. Did it work? Fortunately, *New York* magazine sent down a reporter to cover the night's festivities. He put the following to his readers:

> How can you put a price tag on the thrill of being approached by a butler bearing a gigantic floral arrangement at the base of which are hidden ten jumbo tempura shrimp? Consider the flush of excitement that comes from munching on golden caviar heaped on a black-lacquered seashell that is perched atop a gilded galax leaf.

In order to create an atmosphere of intrigue and delight, the fragrance was hardly talked about by Magie Noire's representatives; instead, it was evoked through every other means possible. Everything, but everything, in the building was black and gold, from the outfits of the gypsies who would read the guests' fortunes to the tableware and even the cigarettes. At the night's culmination, a model in the house colours descended from the ceiling: 'photos of the fragrance bottle were projected up on the dome overhead, revolving at increasing speed – like the famous dizzying waltz sequence in *Madame Bovary*'.

So overwhelmed and dazzled were the assembled journalists, buyers and hangers-on that Magie Noire was a huge success. It even made it through the Iron Curtain, where it became one of the most popular black-market perfumes in Soviet Moscow. Out of a puff of smoke and a hall of mirrors came a winning formula which made millions for the brand and helped to defeat communism (who's to say otherwise?). There's got to be magic in that, surely.

Anaïs Anaïs

BY CACHAREL, 1978

THE WISTFUL PERFUME

REMEMBER HOUBIGANT'S ROMANTIC FLORAL PERFUMES of the early twentieth century? Think back to Le Parfum Idéal, which became so associated with the 'it' concept represented by the Gibson Girls. Anaïs Anaïs was this pretty, winsome mood brought back in a 1970s guise – a cellophaned bunch of madonna lilies, hyacinths and carnations, which for many girls probably marked their first gift of flowers to themselves, after their boyfriends failed to arrange a much-hoped-for Interflora delivery.

Where does 'Anaïs' come from; what language is it? Maybe it has something to do with Anaïs Nin or a Persian goddess, but finding meaning was not a priority for fans. Anaïs Anaïs was all about the sound of the words. Whether pronounced 'An-a*y* An-a*y*', or (correctly) as 'An-ai-*ees* An-ai-*ees*', what mattered most was that the name should be uttered whisperingly. Though the whispering, it must be said, does not follow through to the scent. When first sprayed on, it is a bit of a banshee – those flowers do screech, and there is something about the floral mix that puts one in mind of scented sanitary-pad-disposal bags in lilac and pink. The perfume needs a good couple of hours to

bed down, at which point it becomes much more gauzy, seeming to amplify the smell of the skin and taking on a deliciously salty tang.

Anaïs Anaïs was not the most original scent ever, but it was well timed to seem original, for Cacharel steered clear of the perceived zeitgeist, just as, in their fashions, the label had garnered credibility for their women's shirts in nostalgic printed floral fabrics from Liberty of London. The late 1970s was a sea of grown-up orientals à la Opium and Cinnabar, and mass-market teen perfumes at the other extreme. For young women growing out of the likes of Babe and Aqua Manda, Anaïs Anaïs offered an authentically nostalgic world, one inflected with an Edwardian sensibility. Out went bright colours and in came washed-out, cool-toned imagery encompassing old-fashioned photo frames and dusky découpage. Refreshingly, men did not feature in the campaign; this was an all-female affair of sylvan nymphs garlanded with floral crowns. Anaïs Anaïs worked spectacularly, because, for all our attempts at cool, what teenager hasn't at some point wanted one of those sets of silver-plated mirrors and hairbrushes, and to sit at a dressing table in a long white nightgown, glancing through the sash window at the waxing moon?

The pull of this perfume was such that, even now, I feel again the pangs of a fifteen-year-old self who so hoped for Anaïs Anaïs. Thankfully, though I was unable to afford it at the time, today a bottle sits proudly upstairs, albeit lacking a dressing table worthy of this most precious item.

The Egotistical Eighties
1980–1989

ONE OF THE PRIME OGLING opportunities available to older men in Ancient Greece was the gymnasium, where they could check out the straining muscles of young athletes at work. The scene was rendered additionally erotic by the presence of *aryballoi*, small bottles of fragrant olive oil that hung from the belt and could be used to revive aching muscles or protect the skin from dirt.

In Xenophon's *Symposium*, which describes a boozy evening with the philosopher Socrates as a guest of honour, a discussion ensues about perfume, during which Socrates comments, 'sweeter than any perfume else to women is good olive-oil, suggestive of the training-school: sweet if present, and when absent longed for'. Female fragrances were, according to Socrates, far too obvious; athletic oil, with its aromatic subtlety, was superior to the contrived delights of flowers or resins because its odour was inseparable from that of the human body sweating with exertion. Socrates may also have been feeling a little nostalgic: athletic oil was so potent a part of this highly erotic scenario that the memory of it alone was perhaps enough to rekindle desire.

As the twentieth century progresses, fragrance flashes around the body like a laser light show. In the early 1900s wardrobes and lampshades exhaled scent, and if perfume was used around the person it was impregnated in handkerchiefs that could be detached from the body. Then it migrated onto the skin, finding new erogenous zones, from necks to wrists, cleavages and behind the knees. It went onto the

clothes and loved more than anything to invade a fur coat. Perfumes emerged that were meant to complement the body energetically engaged on the tennis court or more languorously wielding a golf club. In the sixties and seventies came the suggestion of writhing naked bodies after a go with Centaur cologne.

And now, in the 1980s, we find ourselves in a contemporary take on Socrates' gym and those sweet-smelling olive oils, albeit less subtle. For with the birth of Kouros from Yves Saint Laurent and Cool Water by Davidoff, both of which feature in our decade, we progress a step further as the beautiful male body comes to the fore, naked, chiselled and waxed. While it's true that not every aftershave becomes associated with topless men, there are more than enough to form a troupe of Chippendales. It is not that surprising, given our over-exposure to straining muscles during the eighties. Many of us watching our televisions and coming across WWF *Championship Wrestling* were gripped by the sight of knots of bulging veins in the most unlikely parts of the body. We may also have vowed to stop eating chocolate Mini Rolls after seeing lifeguards running shirtless along the beach in early episodes of *Baywatch* or admiring some of the new Azzedine Alaïa bodycon fashions coming down the catwalk. Perfume, which had once been about affecting our minds, was starting to be positioned as an agent for physical prowess, and aftershaves were becoming the finishing touch at the end of the gym regimen, or a substitution where the regimen was perhaps lacking. Their exhilarating aromatic properties, particularly in Cool Water, corresponded no longer just to the freshness of a morning shave but to the embers of an endorphin rush after a brutal bout of exercise. Men in suits were still being used to sell scents, but increasingly the tops were off; pecs were vying with black ties to lure the punters.

Like our mousse-infused hairstyles, fragrance grew in volume and became an extension of the body. Infamous shoulder-pad scents – Poison, Paris and Giorgio Beverly Hills – were so powerful they could inflate our 'aura' and announce our presence before we even entered a room, emitting a miasma as potent as the green slime in *Ghostbusters*.

Like the slating of Le Trèfle Incarnat in the early twentieth century, perfume as a product was being discussed as a problem, a pollutant. Poison was undeniably full on, but just as shoulder pads were a reworking of a 1940s fashion, so this scent was not a million miles from Fracas and other 1940s concepts. Was it over-application that so intensified the clouds of fragrance around us? Or was it that we were becoming more sensitive to our personal space as commuter trains got more crowded, offices turned open-plan and we succumbed to the idea of moving around cocooned from both stress and boredom thanks to that great eighties invention, the Walkman?

Certainly popular psychology was encouraging us to tune in to what the body was saying and to be conscious of the effect we had on others. Body language became a preoccupation in this decade, yet another way for us to indulge our fascination with ourselves and to try and control those little tells that might give away our true state of mind in job interviews and on dates. Desmond Morris' *Manwatching* was one of the most well-thumbed texts for anyone caught up in the 'psycho-sensitive' mood, helping us decode whether, if a girl touched her hair too often, she was interested or not. A *New Scientist* feature from 1981 entitled 'Truth and Lies in Body Language' summed up the trend and encouraged readers to turn the tables by observing the observers:

Watch the men chat up the women. Watch them peering at the girls' faces, trying to determine if their pupils are dilating or not. See them making a mental check on whether their legs or arms are crossed; and if so, in what way. Watch as they try to imitate the women's non-verbal signals, as they try to copy their every position to show rapport and togetherness. Watch the women flee.

Mastering our body language offered us a way to better that crucial first impression. The importance of making a striking visual impact in the first seconds of meeting someone was further developed through the international movement that promoted 'having your colours done'.

This was all about understanding whether clothes in spring, summer, autumn or winter hues best suited your personal colouring, founded on colour theory that dated back to the Bauhaus of the 1920s (and that reminds us of the hair-colour perfume profiling of that time) and was reinvented now in *Color Me Beautiful* from Carole Jackson. Wear the right colours and, according to Jackson, 'you become credible and people listen to you, compliment you, hire you and maybe even flirt with you'.

Also fashionable was a man called David Kibbe, proprietor of New York's Metamorphosis Salon, where women could find out about their body-shape archetype – whether Dramatic, Classic, Gamine and so on – and then use that knowledge to buy the clothing best tailored to express this core character. That Hollywood staple *People* magazine sent someone along in 1987 and reported back on the whole experience:

'What is your glove size?' Kibbe, 32, asks a tall brunette slouching nervously against a wall. 'How big are your feet? Now pull your hair back so I can see your face.' He stares, furrows his brow and delivers his judgment. 'Think of yourself,' he purrs, 'as the physical equivalent of the Chrysler Building.'

Better the Chrysler than St Paul's Cathedral.

The scene is thus set for the personal-image industry of the 1980s. Scent, along with colour, shape and gesture, became a part of our non-verbal vocabulary, a statement of intent, which goes some way to explaining why so many perfumes were seen to be emphatic; they needed to be heard. Perfume commercials started to refer to this role. One, for Tweed, declared that, 'Everything you wear says something about the kind of woman you are', before suggesting that theirs would be the obvious choice of perfume. And one of the most fun, brash, brilliantly poppy fragrances of this decade, Ex'cla-ma'tion by Coty (1988), told women to 'make a statement without saying a word'. This fruity perfume, like an apricot low-fat Ski yoghurt, was a cymbal clash of noise. And it heralded a new voice in perfumery, that of Sophia

Grojsman, who was behind many of the most beloved releases of the 1980s and 90s, including Yves Saint Laurent's Paris, Lancôme's Trésor, Karl Lagerfeld's Sun Moon Stars, Elizabeth Taylor's White Diamonds and Calvin Klein's Eternity – not to mention Vanderbilt, which is coming up. Sophia is known for her fuzzy, fug-like take on rose, and many of her eighties perfumes have that foghorn projection we associate with the decade, together with the sense of volume. One way of describing them is that they are like a particularly squidgy cushion. These tactile fragrances extend so far from our bodies that when they come back in and give us a hug, it's as though they have turned into someone else entirely.

Kouros

BY YVES SAINT LAURENT, 1981

THE ACTION-HERO PERFUME

THERE ARE SOME POTENT SCENTS in this world, but Kouros is out there in its own special category. Kouros reeks so much it seems to throb. The masculine yang to Poison's feminine yin, Kouros is one of the great 1980s power sniffs and smells as if cast in titanium. It is more bombastic even than the fictional rock band Spinal Tap.

Kouros developed from a tidy concept, named after the Ancient Greek statues of beautiful young men carved from creamy yet stern white marble. These boys were buff as hell, waiting to be enviously adored. Yves Saint Laurent's scent sought to reference this artistic tradition, so the bottle had a chalky matt finish with a tactile, smoothed-pebble feel, while the aroma was said to be that of a living demigod. Let us see.

Those of you brave enough to wear Kouros will be met with a swoosh of scent upon first spray that's as if the spear-holders of an ancient army are rushing towards you, the horses not far behind. You know not whether to run for your life or roar and charge ahead.

As a smell, Kouros is lavender and spice, or a fougère on steroids, with something of the barbershop in its coriander, leathery tang. After

you've been to work, gone to the gym, showered, had your tea, slept and woken up again, it unfurls into a friendlier honey fragrance. It is actually a work of genius. They say that in a nuclear winter only the cockroaches survive. So too would Kouros.

You can absolutely see the appeal of this kind of fragrance. When Kouros was lobbed into the stores, America was on the verge of a body-building revolution. With the lean and nimble martial arts fighters of the 1970s slowly moving out of fashion, it was time for cinema screens to embrace the oil-slicked, muscled, orange hunks of the *Pumping Iron* fraternity, whose nipples twitched in pursuance of a fight. In 1981 Arnold Schwarzenegger was busy filming *Conan the Barbarian*, while Sylvester Stallone was chucking back the whey powder in readiness for his first Rambo movie. Keep-fit was sweeping the world: Olivia Newton-John's 'Physical' was on the radio, Jane Fonda was continually releasing new aerobics videos and Spandex was, unfortunately for some, a fashionable fabric. A certain segment of the populace seemed to be working on their fire-hydrant kicks and guzzling down meal replacement shakes. The plan? To chisel glutes so hard they could be deployed to cut diamonds.

This quest for physical primacy needed a smell, and that smell was Kouros. It translated the idea of muscle into an aroma, in an incredible feat of symbiosis between the senses. So confident and narcissistic is this scent, you're advised not to put it on unless you're ready to be very much on display.

Giorgio Beverly Hills

BY GIORGIO BEVERLY HILLS, 1981

THE BANNED PERFUME

THE BIG, BAD, LOUD-AND-PROUD PERFUMES of the 1980s invariably find their analogue in shoulder pads. As time advances, these much-maligned sartorial structures become even more monstrous in the remembrance, as if they were the size of banqueting platters or used to crack the chins of bystanders as their wearers moved past them like combine harvesters. Add to this equation jade-green eye shadow, geometrically applied blusher and gold lipstick cases that could double-duty as paperweights and it is no surprise that the aggressive beauty aesthetic of this period has become shorthand for career ambition, relentless networking and 'getting ahead'.

But the truth is that scents like Poison, Paris and of course Giorgio Beverly Hills had to be Godzillas because in the 1980s the consumer marketplace was an overstuffed elevator in which everybody was elbowing and poking each other. One of the only ways to be noticed was to be as instantly memorable as a Cindi Lauper tune. Perhaps the reason we feel there were fewer scents in the past, compared to today's landscape, is because the bolshy ones suffocated all the others; they were in the air, everywhere. To spray on such a perfume was to be

instantly tagged and known as a conspicuous consumer – like carrying a logo-emblazoned bag. And while many people still preferred to own the rare and obscure, there was, as there is now, an appeal in cracking open something famous and joining millions of others wearing the same thing – the feel-good factor of tuning in to the zeitgeist.

Giorgio Beverly Hills, a tuberose and orange-blossom bomb (not a million miles away from its 1985 successor, Poison from Christian Dior) became infamous for its tenacity. It was so strong, some joints banned it. And, would you believe it, even the English periodical *Punch*, which rarely cast its net of wit over the world of perfume, commented on the phenomenon in 1989. In what could be viewed as a shamefully sexist moment, but which nonetheless expresses the allure of prohibition, the magazine opined:

> There are restaurants in New York that have signs up saying 'No Smoking or Giorgio', and I have to admit that it is oddly seductive in rather a crass and obvious way, like those pretty blondes who want to be in *Dallas* who one would quite happily hurl across the nearest Slumberking or fish-crate and ravish, were one not absolutely certain that they would want to 'talk' afterwards.

From where did this perfume come that it should conquer the world?

From the street that conquered the (shopping) world: Rodeo Drive.

The baby of Swiss hotel-manager turned retailer Fred Hayman, Rodeo Drive began its rise to fame in the 1960s with one luxury outlet: Giorgio Beverly Hills, a boutique run by Hayman and his wife Gail and named after Fred's early co-investor, George Grant. The Haymans sold expensive European fashions to California's finest, and they really knew how to put on the glitz; they greeted their wealthy customers by name and sold softly and oh so effectively. To start with, their place was the only destination of note on an otherwise average street, but within a few years, through careful cultivation and clean-up efforts, the Haymans saw more luxury retailers set up store. Rodeo Drive and

its Beverly Hills lifestyle soon became famous globally, eclipsing the down-at-heel reference point *The Beverly Hillbillies* and going on to have a starring role in the 1990 romantic comedy *Pretty Woman*, as the third person in the Gere–Roberts relationship.

After several years of careful research and testing, the Haymans' boutique launched its eponymous fragrance, and it was almost like a tourism campaign from a small principality: 'Visit Rodeo Drive'. The fact was, you did have to visit if you wanted to get the scent. That, or be seduced by one of the fragranced strips carefully placed in *Vogue*, which invited readers to send off a cheque and a form for a bottle in the post.

When it arrived, Giorgio's box bore the sprauncy yellow and white stripes of the shop's awnings, suggestive of sunning yourself in a deck chair or drinking San Pellegrino while nibbling at a tuna niçoise in a Monaco cafe ('but not too much tuna, baby, the mercury levels are so toxic'). Initially, then, Giorgio Beverly Hills was exclusive, with *Orange Coast* magazine, the bible for wealthy Orange County residents, reporting that 'people associate Giorgio with the rich and famous – a group they can aspire to be when wearing the fragrance'. But given that it sold $15,000 dollars' worth in just over a week, it wasn't too long before the perfume became available more widely in department stores. Astonishingly, it was soon bringing in $100 million a year.

Eventually the Giorgio Beverly Hills brand was sold to Avon in 1987, the Haymans' spawn somebody else's business. Fred and Gale, now divorced, each had another go at fragrance, but this time it was cut-throat – and not just because of all that tuberose. Giorgio got his boutique back and came out with a scent called 273 ('Wealthy. Elegant. Wildly seductive.'); Gale set up a new perfume brand called Gale Hayman Beverly Hills. But it was too late. Even the original perfume had slightly fatigued the public, as if they had been eating clotted cream non-stop and suddenly realised that, at least for now, they should revert to plain low-fat yoghurt, more befitting of a good Californian.

White Musk

BY THE BODY SHOP, 1981

THE CLEAN PERFUME

AMONG THE SIMPLE PLEASURES IN life, a sniff of freshly tumble-dried laundry is up there. Since 1969, when the Comfort brand first became available in British supermarkets, the smell of fabric softener has been shorthand for orderliness in the home. Everything else might be an utter disaster zone – mugs cluttering up the sink, unscrapeable pans breeding on the hob and last night's clothes thrown over the hamster cage – but if you've got newly dry, still steaming, clean-smelling sheets, you're OK.

Cleanliness/godliness should really be marked by an absence of smell, but given the dearth of kicks available in the puritanical world of chores, we need an aroma to reward us, whether it's our knickers or our armpits that we're washing. An odourless sock is iffy: who knows if we remembered to put it in the machine. But a kitchen that smells of Granny Smith apples or Lemon Delight is a triumphant warzone wherein these sprightly scents have helped us vanquish bacteria and E. coli.

The fragrance of clean clothes additionally evokes the properties of the textiles themselves – strokeable, touchable and fuzzy, an interpretation through odour of the perfect woollen jumper.

This is where musk comes in.

Keep up, because we are most definitely leaving behind the animalic party of secretions and excretions. We are also moving on from the 1970s and raunchily promoted musks like Jōvan's Musk Oil. That most dirrrty of materials is, in the 1980s, cleaning up its act. Or rather, with such a wide palette of synthetic musk molecules now available, the public understanding of its aroma spectrum is stretching all the way from grubby to gleaming.

The Body Shop's White Musk found its fanbase predominantly, though not exclusively, among schoolgirls. The company, headed by the zany and irrepressible Anita Roddick, was politically right-on, especially with regards to animal rights – essential for the budding vegetarian. They had exotic products for hair and body, some of which smelt of bananas, and were early into the lip-balm game with their pots of delicious kiwi and strawberry gunk. The option to 'curate' a clingfilm-wrapped gift basket of assorted goodies in-store was irresistible, and you could pad it out with raffia straw to make it an acceptable present for a classmate even when filled meagrely with three bath pearls, a small soap shaped like a penguin and a mini bottle of Satsuma bubbles.

The prime real estate in any Body Shop was the round, free-standing table around which girls could gather to test the perfume range, like a coven around a cauldron. Many of the fragrances found favour but, sadly, cannot be given a fuller account here; they include sweaty Dewberry (a colleague of 1990s entrant, Impulse O_2), exotic Ananya and a lickable Vanilla. These were the scents which taught a generation what the hell an eau de toilette or perfume oil was about, and White Musk, a blend of materials focused on synthetic, cruelty-free musk, was the bestseller of the range, attractive in its safe sophistication. It really is such a clever smell for being so finely balanced and holding together apparent opposites: safe and comforting, with an edge of sexiness; creamy yet powdery; quiet and mewing yet voluminous. White Musk is the idealised version of what skin should smell like, and in this we find an interesting connection with laundry.

In the middle of the twentieth century, just as the market for domestic laundry products was booming, certain musk molecules were discovered to be perfect in fabric conditioners, clinging beautifully to clothing even when rinsed and so enabling a longer-lasting scent.

What's more, these materials – some of which go by the Star Trek-esque names of Velvione, Galaxolide and Tonalid – were getting cheaper and cheaper; a huge 7000 tons of musk was produced in 1988. The more they became included in household products, the more we associated their aromas with functional notions of cleanliness and with soft pastel colours like lilac, eau de nil and baby pink. It should also be noted that as many as half of us are anosmic to (unable to smell) some musk molecules, so they often appear in a blend in case we can't detect one of them.

Clean-smelling clothes are satisfying, redolent of new starts, and while The Body Shop's White Musk is more subtle than the scent of fabric softener, there is, in its reassuring smell, something of simple beginnings: the world of crisp new notebooks or a properly made bed. Any woman reading this who re-samples their old ally will be reminded, strikingly, of a time of school uniforms, rolled-up skirts, homework, pencil cases and going home with your mates on the bus; the perfect summation of the day-to-day, which seemed so boring at the time, but which now, in its easy, responsibility-free mundanity... seems most attractive.

Drakkar Noir

BY GUY LAROCHE, 1982

THE YUPPIE PERFUME

ON HEARING ABOUT THIS BOOK, an original bottle of Drakkar Noir, a herb and leather stalwart of the 1980s, got in touch. Initially reluctant to open up publicly about his story – for the downward trajectory of this aftershave has been somewhat traumatic – Drakkar Noir was eventually persuaded to talk. His words are reproduced here in full:

It all started in the early eighties. As I came into this world, 'Hungry Like the Wolf' was playing on the radio and, you know, things were looking good. I got a fancy name: Drakkar Noir – something to do with Viking ships. People told me I was 'unadulterated man' and I made an entrance into the fragrance halls of uptown department stores – the kinds of places where guys in fancy suits come in especially to pick you up. That made me feel nice. Very nice.

They showed me round Manhattan and I was feeling like the luckiest guy alive. I got to see a few deals, play a few squash games at La Raquette, hang out in some exclusive night spots. Danceteria's not bad; the doorman made sure I got to sit next to Sade once. She was classy. And, man, the restaurants. We even got a table at

Lutèce, though sushi's more my style. What went on later in the evening, well, let's just say the ladies went wild, and though my man took the credit, it was me they wanted.

Then I got a little too famous. A little over-exposed. My price tag came down and I worried that a crash was coming. I was used to hanging out with the platinum wristwatches. Now it was a younger crowd. They abused me, over-applying, using me up in a few short weeks. I had to bear witness to their attempts at dating. Their orthodontics. Their synthetic fabrics. Their ineffectual grappling with body hair. They didn't have any money, these youngsters, so Sancerre was off the table and it was hello, Bud Light. I wonder even now what the hell I did to deserve this; I was starting to get sick of the smell of myself.

Then I got sold, to an outfit which didn't understand me. You get used to being tossed about, neglected, spending too much time in freezing warehouses. Next thing you know, you're in a drugstore and they've put you in the bargain bin with all the other losers. People come by and they laugh at you, mock you. Now and then, someone picks you up and they gawp and they say, 'Oh my Gawd, Brian, do you remember when you used to wear this on date night? And me in Elizabeth Arden?' You're held for a few seconds. You catch a look at Brian's beer gut out the corner of your lid. You hope they might take you home so you can hang out with the toothpaste tube. But then you're thrown back into the bin, or even worse, onto the bottom shelf, where the spiders set up shop.

I like to think I had a decent run, a shot at life. Others? They got liquidated, put on a shipping container and never came back. Once day, if I survive this game, I'll tell the grandkids everything and they'll shake their heads and they'll say, 'We never knew, Pop, we just never knew.'

Vanderbilt

BY GLORIA VANDERBILT, 1982

THE CELEBRITY PERFUME

IN THE PERFUME WORLD, THERE most definitely exists a BC and an AC: the eras before and after celebrity scents. After the flurry of fragrances associated with dancing girls in the earliest decades of the century, such releases became rare, exotic birds. They were the domain of a few very select divas, women who had earned the right to license their names and push their products upon us. One of the earliest was Brigitte Bardot's perfume, La Madrague, from 1970, and in the 1980s came Sophia by Sophia Loren and Cher's Uninhibited. Fictional characters also occasionally got a look-in. Charles of the Ritz bought the rights to release Forever Krystle and Carrington, named after characters from the gloriously over-the-top soap opera *Dynasty*. The most glittering was Elizabeth Taylor's White Diamonds of 1991, inspired by her jewellery-hoarding, bling-bling tendencies, and which has made over a billion dollars in sales. Yet our gaze must turn away from Liz's sparkler and focus instead on an earlier celebrity scent from the eighties, the one that really set the shooting star in motion: Vanderbilt.

Gloria Vanderbilt, born in 1924 to one of the most famous families in American history, is the woman who turned being a socialite into

a lucrative profession; the WASP who kept her sting. Gloria, with her colourful, heiress's life, has been a celebrity of sorts for aeons, not always for reasons of her choosing. As a child, she found herself at the centre of the infamous 'poor little rich girl' custody trial, which ended with her mother being forced to hand Gloria over to her Aunt Gertrude (Vanderbilt's enormous $5 million inherited fortune having raised the stakes rather high).

Gloria has had a portmanteau career, as an artist, journalist and author, but her name has been her greatest asset and the building of Brand Vanderbilt her main activity. Aside from fish tanks and maybe lawnmowers, there are few consumer goods that have not been released as a Gloria Vanderbilt range; products have included designer scarves, a frozen tofu dessert, booze, bed linen, jewellery and, famously, very tight jeans. However, she really went to town on perfume, launching eight in total, from the original in 1982 to 2004's Little Gloria (though that record has since been beaten by several other celebrities, including Celine Dion and her *sixteen* fragrances).

Gloria's insignia is the socialite symbol of the swan, which brands all her products. It became the motif of her original scent, which was titled simply 'Vanderbilt'. Created by Sophia Grojsman, one of the most high-profile perfumers from the eighties onwards, Vanderbilt is a pastel dream with a sweet smoky plastic smell redolent of dolls' heads; it belongs to the 'patisserie and romance' perfume category we first saw in the 1940s with Chantilly. Vanderbilt's storyboard idea was a woman staring intensely at, and then caressing, her lover by a lake, after which they both turn into swans and form a heart with their necks. Slightly schmaltzy, yes, although Vanderbilt's genius was to offer everyday romance to perfume enthusiasts who might not have been able to afford department-store scents but who wanted something a little more serious than the emerging crew of young teen fragrances. It is one of my favourites, and even though wearing Vanderbilt everyday might be a stretch, for the price it's one of the biggest bargains in perfume.

Salvador Dali for Women

BY SALVADOR DALÍ, 1983

THE ART PERFUME

AND LIKE BUSES, HERE COMES another celebrity perfume. Would you believe that Salvador Dalí has – in life and posthumously – put his name to fifty fragrances, with more still coming out each year? That is serious output. As well as Dalissime, Dalilight and Dali Wild, there is Dalimania, which aptly describes what has been happening with this fragrance range. While at first glimpse it might seem peculiar that an artist, even a polymath such as he, should have been behind one of the most prolific perfume brands of the century, on reflection it makes perfect sense. When perfume is venerated as a portal to obscured memories and a key to the unconscious mind, who better than the most famous surrealist of all to dabble in the Edward Lear-ish world of the fragrance industry?

We can say that Dalí was nuts about perfume in so far as he was nuts about an awful lot of things. In the 1930s he partnered with fashion designer extraordinaire Elsa Schiaparelli (of Shocking fame) to create whimsical fragrance concepts and bottle designs, including Le Roy Soleil of 1947, whose bottle emerged, like Botticelli's Venus, from a golden scallop shell.

'Oh if only I could perfume myself with the odor of that ram that passed every morning!' recounted Dalí, writing of his first years as an artist in his memoir from 1942, *The Secret Life of Salvador Dalí*. Delighting in the 'dominant genital note' of the animals near his beachside house, Dalí made his first Pan-like perfume experiments long before he worked with Schiaparelli. He wanted to create a scent that would accompany a swimwear costume, for which he had dyed his armpit hair blue. The composition began with fish glue dissolved in boiling water. Dalí then added goat manure and stirred it into a paste; once it had jelled, he tipped in a bottle of aspic oil. No sooner had he smeared this all over his body then Dalí spied out of his window Gala, a married woman he was very keen to seduce. He immediately realised that he looked utterly 'savage' and tried to scrub off his goat stench. She later became his wife – either because of or in spite of the smell.

Then, during the Second World War, in the same year his book was published, came another fragrant folly, which Dalí invited a photographer to witness; it would demonstrate 'the secret of the subconscious-automatic nature of his art'. Lying on a couch with his pencils and brushes to hand, Dalí summoned his assistant to press perfumed compresses over his eyes. Dalí fell asleep and, while under the influence of these olfactive suggestions, his imagination got to work. On waking, off came the compresses and Dalí began sketching furiously on a canvas placed by his bedside. The journalist in attendance, responding to something that looked like a Christmas tree, wrote: 'Are these scarecrows? No. They are drawings induced by the particular scent on Dalí's eyelids. Patchouli, would you say, or something of Guerlain?' The exact perfumes used were not named, but it could be that this stunt was linked to Schiaparelli's Sleeping fragrance (designed to provoke interesting dreams), or at least that Dalí was working in the same imaginative space.

Whether he ever practised this ritual for his next perfume-related commission is for the reader to decide. In 1946, mega-corp Shulton – of Old Spice fame – approached Dalí, wanting to involve him in the promotion of their new female fragrance, Desert Flower. When we

think how famous Dalí was for his desert landscapes, which had come to represent the subconscious mind, the logic for this becomes clear – not that Desert Flower smelt anything like an actual desert. Shulton asked Dalí to paint three new works inspired by the fragrance, which became known as the *Trilogy of the Desert*: *Mirage, Oasis* and *The Invisible Lovers*. There is something delicious in the idea of Dalí having Desert Flower dribbled onto his eyeballs for inspiration.

It was not until 1983, just six years before his death, that Dalí actually licensed his name – to the company Cofinluxe – for a perfume. This came in a bottle shaped like the lips in his *Apparition of the Face of Aphrodite of Knidos*. Thankfully, it was not made by Dalí himself using fish glue but by pro perfumer Alberto Morillas. Dali for Women became one of the major successes of the decade. It feels complementary to those other 'black and gold' perfumes of the 1980s – Paloma Picasso, and Estée Lauder's rose chypre, Knowing – which speak of cocktail parties full of women in black velvet puffball dresses with matching hair scrunchies. The beauty of this husky diva fragrance is that while it is an oriental, it feels as though it's taking you on a whole tour through perfumery, from aldehydes to green, via florals and spices. Veering away from the cloying, there is something very mature about Salvador Dali for Women, a grownup-ness which has not come to the fore in many fragrance releases since. Best of all, somewhere in this perfume, sneaking through via the sweet decay of a heady jasmine note and all those earthy resins, comes a good old sizzle of manure.

Poison

BY CHRISTIAN DIOR, 1985

THE POLLUTANT PERFUME

MID-EIGHTIES MAINSTREAM HOLLYWOOD LOVED COVERING the workplace. It especially loved the revamped New York fairy tale that saw the lowly secretary make it onto the board against the odds and get off with the company vice president. Our heroine would invariably be shown racing out of the subway in her white trainers and then hobbling along the street as she got in to her stilettos ready for the revolving doors of her office block.

For every screen treatment of a woman fighting to get to the top, there was another which zoomed in on the post-Happy Ever After moment, in which the female boss at the pinnacle of her career had become a heartless bitch or lost soul, in need of a lesson about real values. *Baby Boom* from 1987, for example, tells the story of a tough management consultant, played by Diane Keaton, retreating from the boardroom to Vermont, where she makes gourmet baby food, rediscovers herself and falls in love with a kind vet. In 1988's *Big*, it is toy-company executive Susan who, burned out by the end of her twenties, needs a boy-turned-man in the form of Tom Hanks to remind her about joy, fun and the pleasures of bouncing on trampolines.

To establish just how bitchy they were pre-makeover, these divas resorted to a number of easy-to-interpret shorthand gestures. One such was the overt waving about of a perfume bottle – especially effective if it was an atomiser with a squeezy bulb. In *Indiana Jones and the Temple of Doom* (set in the 1930s), spoiled Shanghai club singer Willie is put through a few testing situations, such as being covered in insects and having to ride a stinky elephant through the jungle when she'd rather be back in her dressing room in a silk gown. To make the situation more bearable, she pours half a bottle of perfume on the elephant's head ('expensive stuff'). *Overboard*'s catty heiress Joanna (played by Goldie Hawn), whose yacht has ended up in the hicksville harbour town of Elk Snout, sprays perfume in a cloud around the grubby carpenter who's been called in to build her a luxury shoe closet. And in 1988's *Working Girl*, the domineering and unlikeable director Katharine Parker, played by Sigourney Weaver, drowns herself in Shalimar as she plans to get back together with Harrison Ford's nice guy, Jack Trainer (he has other ideas). Perfume in these scenarios is the bedfellow of long, sharp, red-varnished nails – ostentatious and aggressive.

It is intriguing, if we refer back to the banning of Giorgio Beverly Hills from certain restaurants, that in the 1980s overt use of the decade's mega-perfumes started to be viewed as pernicious, construed as the wearer inflicting themselves on others – bullying them, even – by extending the throw of their shadow through smell.

A new sort of politesse in the use of scent was emerging; in the same way that it was thought inappropriate to apply a full face of make-up on public transport, abundant spraying of perfume in public was becoming vulgar. Even *New Scientist* chipped in, aggrieved by the 'gaseous anarchy' that the jangle of different fragrances was creating within the office environment. Their suggestion? To emulate 'one aspect of the war on tobacco – the widespread acceptance of smoke-free zones, on both aesthetic and health grounds', because 'your freedom to swing your fist ends where my nose begins'.

Poison was among the most wicked of aggressors in this supposed war of the perfumes. It marked a radically new direction for Parfums

Christian Dior, quite different from the pared-down elegance of Edmond Roudnitska's fragrances such as Diorissimo and Diorella, and may have been a response to the provocations of Opium, from rival Yves Saint Laurent, and Coco, by Chanel. Created by perfumer Edouard Fléchier, Poison is a burning, psychotropic pastille of tuberose, this time with ripe plums and incense so as to be like something from a sacrificial rite, all swooning flowers and braziers. It's wonderfully in your face with its bling, as though Liberace has come straight off the table from his latest facelift in a sequinned operating gown, ready to play his white piano even as the anaesthetic wears off. But while the smell is, admittedly, not subtle, Poison was singled out more because of its prominence than because it was *particularly* offensive. Dior spent $40 million dollars launching this scent globally, and it took on the profile of a viral contagion, becoming the most identifiable example of perfume excess; one suspects, however, that such notoriety can only have helped Dior's public relations campaign. After all, at the time of writing there are four versions, from Tendre Poison to Hypnotic Poison (the current bestseller). Choose your poison carefully.

Obsession

BY CALVIN KLEIN, 1985

THE EROTIC PERFUME

'WHAT DOES IT ALL MEAN?' was the question which greeted the debut of Calvin Klein's Obsession in 1985; a fair query, and one with which this book is going to grapple. This marked the moment when the erotic tableau of the contemporary fragrance launch was first met with a puzzled expression. Without the precedent set by this perfume and another Calvin Klein release, Escape, we wouldn't have the stock narrative we have today, in which two strangers, battling against a wind machine, come together and writhe about in the middle of an industrial corridor, as though trapped on the set of *The Crystal Maze* but still making the best of it.

There was no ambiguity about the sex in Obsession; its originating force and the man behind the brand, Calvin Klein, was already in-famous. He'd been heralded by *Time* magazine as 'America's undisputed pacesetter in turning out erotic ads and commercials', most notably with a fifteen-year-old Brooke Shields in a pair of white pants saying, 'You want to know what comes between me and my Calvins? Nothing.'

Instead of the 'making love on the rug' soft-core crooning of Jōvan Musk Oil – consummation in a bottle – Obsession was hard-core

foreplay to the sound of a quickening pulse: all desire, no climax. That would come once you'd been persuaded to buy a bottle, orgasms ringing at the tills. Many a Valentine's night in the eighties was conducted to the checklist of oysters, new red lingerie, Obsession, a box of Milk Tray for afters and maybe a pirate copy of sexy movie *9½ Weeks* – if you were lucky. The print campaign, shot by Richard Avedon, featured three naked men and a naked woman offering her finger to be sucked; it was designed to titillate, the rationale being that extreme strategies were required if you wanted to attract attention within the pages of already overstuffed glossy magazines. It was hinted that Obsession was no polite 'fragrance' but a primitive animal 'smell' (indeed, two smells, given there was both a 'pour homme' and a 'pour femme' version, like his and hers dressing gowns). In reality, perfumer Jean Guichard (later to compose LouLou) had concocted an oriental scent in the grand tradition dating back to Shalimar, with amber and nibble-me vanilla to lure someone in for a love bite. This was first of all faithful to the canon, dating back to the 1920s, of what we think seduction should smell like.

Avedon's screen advertisements, however, were less instantly legible. There were four of them, and each featured the same beautiful woman pursued by a different lover, uttering lines such as, 'The whispers at my bedside, her arms, her mouth, her amber hair and oh, the smell of it.' Then there were the Salvador Dalí dreamscapes with giant chessboards, somebody lopping the petals off a flower, and Penrose staircases, all with jerky jump-cuts that left the viewer clueless as to what was meant to be happening. This quirky art direction no doubt was intended to invoke Obsession's subliminal power, working merrily on the unconscious through emotion, not reason. Journalists pored over the campaign, getting knotted up even as they tried to untangle the narrative thread:

Call it the flirt's dilemma: independence is possible without loneliness only so long as all the people you reject will continue to want you. The ad plays not on independence but on the insecurity

and loneliness that independence has wrought. The pitch is New-speak: the only way to real independence is through unquestioning approval by others; the key to autonomy is an ever greater subjugation to other people's opinions.

Headache, anyone? What this writer from the *Boston Phoenix* seems to be getting at is the irony that a message about female empowerment is inviting women to use perfume – that prop of the fifties housewife – in order to get what she wants. Was fragrance anti-feminist because, while gutsy women had replaced the submissive housewives, all that had really changed was the outfit, and the message was still about attracting a mate?

Of course feminists can love fragrance – there's nothing problematic about a nice smell. Yet there is a legitimate argument here: that the selling of perfume had not quite caught up with the sexual revolution to accommodate more nuanced motivations for wearing scent other than sex or being 'independent' in the bluntest of terms.

Obsession seemed fresh at the time because it took a classic conceit (wear this and he'll want to sleep with you) and did a striptease on it. It took the narrative to its explicit endgame: clinging, sweaty nudes. The same record, copied by others who followed Klein's daring of 1985, has been playing ever since and many feel it's a broken one.

Should we clamour for a sea-change in the way we are sold our scents? Less of the nonsense. Fewer couples thrashing about in a corridor. Sex, but on our own terms. Is it that really, no matter what we might say otherwise, we still buy perfume in the hope of a frisson, even if the encounter is strictly between us and a beautiful smell?

LouLou

BY CACHAREL, 1987

THE REFLECTIVE PERFUME

LouLou is a perfume which once held a queenly power. She had a decade-long rule but now is in exile from the main shelves, usurped by younger pretenders. In her glory days she inspired faithful devotion and wretched desire among her subjects, summoning girls from neighbouring kingdoms to attend to her in the beauty hall, where they would gaze at her awe-inspiring form. They would vow – getting ten good sprays from the tester bottle while nobody was watching – that one day, if that Saturday job at Wimpy panned out, they would hand over a couple of crisp notes to the sales assistant and whisk their LouLou home.

LouLou is a clever one. It is in appearance the ultimate 1980s trashy mascot, in a plastic-fantastic bottle as blue as the decade's eye shadow and with clashing red lid. Think the MacGuffin from an episode of *ThunderCats* or *He-Man* and you'll not be far off. Or a prop from an early Madonna video: those years of the Minnie Mouse hair bows, ripped lace crop-tops and fingerless gloves.

Then comes the smell, which at 2000 calories a sniff almost resembles those wonderful desserts only frozen-food conglomerates know

how to conjure. We are talking Wall's Vienetta ice cream blended with Black Forest gateau and finished with a thudding spoonful of Pillsbury's raw chocolate-chip cookie dough. The fragrance does indeed provide the instant hit of eating cake mix straight from the bowl.

LouLou, though, is stranger than she might first appear. The perfume house at Cacharel had already worked out the perfect formula for marketing to teens with Anaïs Anaïs; with LouLou they moved from the ethereal watercolour world to something more shadowy and vampish. The perfume was named after the famous early-film actress Louise 'Lulu' Brooks. Two years after her death, Cacharel mounted a silent tribute to her in which she was resurrected by a young model, bob haired and with dark bow-lips. In LouLou's television slot, mock-Louise, clad in a trench coat and beret, is filmed by a crew on a dark streetscape film set, evocative of an early German expressionist movie. Gabriel Fauré's *Pavane* plays in the background. 'Louise' gets off the soundstage, past the TV monitors, and escapes into her dressing room. She takes off her coat and, finally unwinding, hears a knock at the door. 'C'est moi,' she says, looking straight at us through her dressing-table mirror, surrounded by old black-and-white photos of Louise Brooks.

That deceptively simple slogan – 'It's me' – is one of the cleverest used to sell the dream that is fragrance. 'C'est moi' is the bottle of perfume calling out like an old friend. It is the actress in the advert, telling us she is Brooks, or at least urging us to believe the illusion of her performance. It is us, the wearers of LouLou, repeating the mantra that this perfume encapsulates us – the perfect expression of our identity, or the identity we hope to channel by wearing the scent. LouLou, at first glance so brash, turns out to have hidden depths. If White Musk is the sweet-sixteen perfume of the John Hughes movie, then LouLou is more introspective, the one we can imagine being beloved by fans of the film *Labyrinth* (1986), in which teen heroine Sarah, with her vivid imagination and loner tendencies, makes her way into Jim Henson's fantasy puppet world and keeps bumping into David Bowie in his shiny leggings.

So we turn back to LouLou for a rethink and notice that the bottle is referencing the aesthetic of vintage flacons from the early twentieth century. We might spot a smokiness to the perfume that puts us in mind of classic French powdery perfumes such as Guerlain's L'Heure Bleue (with a little less subtlety but at a fraction of the price). LouLou was really the first mainstream fragrance to pause the race towards the new and the next in favour of being reflective. In 1987, the fragrance industry was well overdue a look back at its heritage, and LouLou's makers found the ghosts, Louise included, and brought them back in a new body. Her buyers were thrilled – an emerging generation of young women desperate to fall in love with perfume and adoring of LouLou's contradictions: a brazen, flashy exterior hiding an old, sentimental heart.

Cool Water

BY DAVIDOFF, 1988

THE TOPLESS PERFUME

IF HELEN OF TROY WAS the face that launched a thousand ships, Adam Perry was the body that sold five million posters. It is unlikely you know his name. Hunks don't need them. He was that topless model sensitively holding an adorable new-born baby in 1987's 'L'Enfant' poster, which kept the tills of print shop Athena ringing for a good few years back in the eighties.

Athena Man brought together two irresistible qualities. He was soulful, and he had good pecs. Sensitive and paternal; a blue jeans babe in the James Dean mould; a man for modern times. Was he a tragic widower whose wife had died in childbirth? A single father just trying to bring up a child in the only way he knew how? A male midwife who preferred to work nearly nude? The possibilities were dreamy.

Athena Man's brother was Mr Cool Water, the soulful surfer dude from 1988 who still gets reincarnated every few years in the guise of a not-quite-A-list actor. Cool Water Man has only one job to do: dive into the ocean and do the butterfly stroke for a bit. Like the Cadbury's Flake Girl, who must show just how crumbly chocolate can be, his

task is unvarying, dedicated to protecting the precious turf (and surf)

of Davidoff's fragrance: namely, that spraying on this aftershave is the most refreshing experience imaginable, the essence of all things marine. Whatever happens, no imposter brand must come along and trump Cool Water, therefore its bottle is of the bluest azure, so blue it could summon Poseidon to combat a drought. Its aroma, that of a fougère dropped in a bucket of ice, brings together tooth-chattering cool mint and volatile ozonic notes to convey the rush of the crashing waves. The model must be visibly sweating before he gets into the sea, to emphasise the cold embrace of his swim. In these attributes, Cool Water won without challenge a war still being fought among lager brands desperate to be seen as the more thirst-quenching beverage.

The most important message conveyed by Cool Water is that reward comes after hard work. Cool Water Man is not some layabout beach bum necking beer on a deckchair and wading in for a go on the banana inflatable. His developed pecs, the contours of which are visible from satellites, spasm so much, we can almost discern a Morse code. These bad-boys are clearly the result of discipline, and Cool Water is the earned payoff for having waxed the surfboard or run up and down the coast on lifeguard duty. The genius in this positioning is that by buying a bottle, wearers get to skip the tough bit and go straight to the dive. Or they can do twenty half-hearted laps in the local leisure centre and feel like a stud muffin in the changing room afterwards.

In its gift of the elemental aquatic, Cool Water offered 1980s man one other piece of relief: the ability to wear and talk about aftershave without being seen as a little *too* enthused and therefore emasculated. Cool Water can be summed up in one simple, effective, descriptive word – *refreshing* – which, in the language of pleasure, is the perfect intermediary between sanitation, utility and frivolous delight.

The Naughty Nineties
1990–1999

THIS IS IT, THE FINAL decade, the one that scarcely needs an introduction. We began in 1900 with perfumes barely remembered, let alone available today, and we end with ten that, without exception, can still be sniffed, bought and enjoyed. These are perfumes that readers are likely to know well, to have something to say about, and must be introduced together with those feel-good lyrics so popular in nineties pop, in which everyone's got to rock their body, reach for the stars, throw their hands up in the air, and get down now.

This decade, at least in this account, is about the pains of youth. Throughout the century, perfume has continually shouted about its 'newness', but during the nineties the teenagers really stole the show. First came the precocious purchasing of some of the new adult perfumes on the scene, intended for grown women yet as likely to be sniffed on a sixteen-year-old. Among them were Elizabeth Arden's Sunflowers; Christian Dior's Dune, which smelt like a lover throwing her unwanted bouquet into the ocean; and the heavy hitter that is Rochas' Byzance, very Kristin Scott Thomas in *Four Weddings and a Funeral*. In Escape, which bore an uncanny resemblence to Midori and lemonade, Calvin Klein decided to follow up on what happened after the steamy tryst that was Obsession, with a fragrance for clubbing and no-strings sex. For Monday morning back at work, Chanel brought out Allure and Estée Lauder Pleasures, timeless florals for corporate offices at which one doesn't want to cause offence.

Then came the fragrances more specifically targeted at younger wearers, acknowledging their insecurities and desperation to be on the pulse in the same way that the right sportswear was *essential*; scents that echoed the growth in dedicated teen media like 'young adult' fiction, movies and television shows.

The Versace jeans may have been fake and from the local market, but the scents were all real, and just about affordable. They were particularly appealing for their diner-chic presentation, coming in a cola bottle, housed in a tin (the baked-beans look was used in another nineties hit pairing: Jean Paul Gaultier's Classique, for women, with his Le Male for the guys). The joy was in choosing which colour: maybe Red Jeans, or Baby Blue, or Yellow – or all of them, for the stamp-collector types. As we will see, the preppy alternative was Tommy Girl and Boy. Sixth-formers could go for CK One, while the younger ones were starting off with O_2 and Lynx, to the distress of their even younger siblings trying to get some oxygen.

Teenagers are both easy to sell to (their push points can be obvious) and, once recruited, notoriously disloyal, should they get the remotest inkling that something might be on the way out, so this chapter must duck and dive to stay current with the latest fads. One way the fragrance industry managed to keep up, and take some of the risk out of a big launch, was through the use of the gas chromatograph, a machine first used in the 1960s that analyses a fragrance and gives a reading on its molecular composition, enabling rival firms to make a copy. Once Tommy Girl was outselling everything else for young girls, another brand could say to a perfume firm: we want something that happens to smell just like that, but not *exactly*. Out could come another Tommy Girl-esque number within a matter of months. GC machines were not new to the nineties, but they were increasingly relied upon, giving the impression that new perfume clones were popping up as frequently as manufactured pop stars.

Those who felt far too old to be watching television phenomenon *My So-Called Life* had other outlets. Certainly in England, the 1990s marked the beginning of a middle-class food revolution that was

preoccupied with speciality ingredients from Italy: balsamic vinegar, single-estate olive oils, sundried tomatoes, capers and, of course, polenta. Slowly this began to affect fragrances too, which went back to the idea of the special ingredient inspired by a small handful of natural smells rather than a complex-sounding formula with a mood-based name. One of the most famous was Lime Basil and Mandarin (1999) from the London florist and facialist Jo Malone; this offers pleasure both in its scent, which is the sort of thing you would want steaming out of a hot iron onto a white shirt, and in being able to identify on the nose each of its constituent parts. Aided by the label, we can *read* the perfume, rather than be confounded by its complexity. Guerlain's Aqua Allegoria Herba Fresca from 1999, radically different from their usual style, also brought this reward, as did the endless pots of green-tea perfumes, which started with Bulgari's Eau Parfumée au Thé Vert in 1992.

These fragrances all shared a perennial simplicity, which alongside the roaring success of the original Issey Miyakes and the unisex style of CK One and offspring (anyone remember Gap Heaven?), has led to a summation of the 1990s as a 'clean' decade, as though everyone was seeking clarity in reaction to the heavy eighties. Of course, the picture was more nuanced, and one of the problems in defining a decade through one style of perfume is that it leaves out everything that didn't quite fit. In fact, a glance through other fragrances of the time reveals that there were plenty of 'big' scents, such as Hypnotic Poison, Tocade, Safari, 24 Faubourg and the spiced rice-pudding that is Kenzo Jungle L'Elephant.

What this speaks of – this labelling of the nineties as clean and unisex and the eighties as corporate, a labelling of which these very pages have been culpable – is a desire to understand our youth through smell, to be able to say it in a sentence, so that we can finally put it to bed, leave the Tommy Girl behind and move on to the next perfumed delight.

Joop! Homme

BY JOOP!, 1989

THE BOYBAND PERFUME

A REVELATION, ONLY JUST REALISED: Joop! is actually pronounced as 'yope'. It hardly seems possible.

Joop! may not have the kudos of an Eau Sauvage or a Dior Homme, but it is a critical fragrance in this history. Promoted by a German fashion brand just as we were about to embark on a new decade and inspired by the optimism following the collapse of the Berlin Wall, this was one of the very first global releases to liberate boys from the dictat that they should only wear aftershaves with 'manly' aromas, ergo citrus fruits, ferns and marines. Joop!, instead, was all about the vanilla and honey. Carry out a blind test and many people would assume this to be a young women's perfume, for it provokes immediate associations with the likes of Candy, and Slush Puppy.

This onetime favourite of late teenagers is as sticky smelling as the floors of the town centre clubs in which it was worn. It quickly became one of the primary 'lads' night out' smells of the nineties, as inevitable as hearing 'Come on Eileen' at 3 a.m. just before the managers turned on all the lights and everyone realised they looked as rough and bleary as hell. Joop! personified is a seventeen-year-old

with gel-coated undercut hair. He's tucked his fake ID into the pocket of his Fred Perry polo shirt, and is looking forward to necking some novelty bomb shots later on, all to the soundtrack of European techno.

Gloriously, Joop!'s magenta bottle – the pinkest since Schiaparelli's Shocking – is as rainbow-brite as an alcopop and would have blended in perfectly with those rows of scarily hued Bacardi Breezer and Reef which used to be on a '5 for £5' offer at the pub. For really special nights, Joop! wearers might even upgrade to a round of celebratory Goldschlägers.

This might sound a little disparaging, but this is overwhelmingly compensated for by an affectionate, cosy feeling towards it now that enough time has passed to reappraise this once inescapable smell. Joop! was very much on the same wavelength as the manufactured boybands of the early 1990s. The brand's poster models had the same oiled pecs as these teenyboppers, not to mention an equivalent positioning: there is both an emphatic suggestion of the hetero-normative, yet also a strong homoerotic subtext and appeal to the gay club scene, with which Joop! (and of course the hunky sailor that was 1995's Le Mâle by Jean Paul Gautier) was hugely popular. When the likes of New Kids on the Block, East 17 and Take That broke into the mainstream, it felt like they, and their freshly waxed chests, had taken over the music charts in the fashion of a military coup and were settling in for the long haul. Take That's rendition of 'It Only Takes a Minute' felt more like a year, and East 17's 'Stay Another Day' caused some to beg: 'OK, one more day, but then will you stop singing?' Who would have thought, then, that having vowed never to listen to these gyrating songsters ever again, this entry would inevitably have to be written to the tune of 'Never Forget' as Take That, albeit reduced in number, storm venues across the nation once more. Joop!, too, is with us, and while its six-pack may have gone slightly to seed, it's still persuading men to embrace, without embarrassment, the irresistible smell of 'pink' while out with the boys.

Angel

BY THIERRY MUGLER, 1992

THE RED-CARPET PERFUME

Be not forgetful to entertain strangers: for thereby
some have entertained angels unawares.

HEBREWS 13:2

IT'S SATURDAY NIGHT...THE HAIRDRYERS are at full blast and bronzing pearls are spilling out all over the bed, which means it is time to meet Thierry Mugler's Angel, the 'getting ready' perfume of the 1990s. Angel is what went over the sequinned halter-neck top as a substitute for a coat on a Big Night Out in deepest winter, the finishing flourish to mark the transition from mortal to Cosmic Girl.

Angel came out in 1992. It was a slow burner, peaking in the later years of the decade. Such patience in mass-market launches is unheard of now, with fragrances getting just a few weeks to prove themselves on the shelves before industry bods start motioning their hands in front of their necks and whispering, 'Cut!'

Angel's ascent mirrored the economic recovery. As recession gave way to the 'no more boom and bust' years of millennial prosperity, Generation X-ers began spending their rising incomes on cheap stuff.

High-street retailers took advantage of low import costs and labour in the Far East to turn around multiple collections a season, stimulating the notion of disposable fashion: get an outfit for the weekend and then chuck it out and buy another one.

With Dolly Parton's '9 to 5' seeming quaint in the face of an increasingly Protestant work ethic of long hours and faltering lunch breaks, the adage of 'living for the weekend' (and, by extension, the misty glory of two weeks in the sun every summer) became positively sacred. Friday and Saturday nights, both in their preparation and in their experience, were to be grasped, and every possibility of pulling exploited to the full. Down in the mega-clubs came unifying dance routines, including Whigfield's 'Saturday Night' and Los del Rio's Spanish song 'Macarena', which involved the kind of moves that etch themselves indelibly on the most primitive parts of the brain, an update of line-dancing involving slow hip-circling, jumping 90 degrees and slapping the bum. There was, of course, the additional social glue that came from downing Ecstasy or alcohol, and as many synonyms for drunkenness as there were mixers for Smirnoff vodka: wasted, wasticated, trolleyed, hammered, legless, plastered and tanked.

Rewind a few hours, before the mascara got smudged and the club toilets messy (smelling of sick mixed with Angel, Jean Paul Gaultier, or Versace Blonde), and Saturday nights were – indeed still are – all about becoming the most glamorous-looking version of yourself. Standards were high and we have to remember that, while perfected beauty had long been fed to us as an ideal, it was the 1990s that brought the concept of the supermodel, athletic and glossy, to wider public consciousness through 'the Trinity', aka Christy Turlington, Linda Evangelista and Naomi Campbell. Later in the decade, other models were invited into these hallowed ranks, including Heidi Klum, who was one of the early Victoria's Secret Angels, strutting the catwalk in lingerie and angel wings.

Hollywood, like fashion, was also cranking up its image machine. It was the 1990s which spawned professional red-carpet stylists tasked with calling in shortlists of dresses, jewellery and make-up entourages

so as not to leave it to the stars to make a tasteful impression at the big awards ceremonies. Graydon Carter's appointment as editor of *Vanity Fair* in 1992, hot on the heels of Demi Moore's naked pregnancy shoot, ushered in a new era of ultra-slick covers photographed by Annie Leibovitz and featuring the latest crop of starlets. If the photographs didn't come out flawless, it didn't matter, because there was now Photoshop, which made it so easy to cover the star's spots and slim down her thighs. Back in the real world, everyone could practise a little 'enhancement' of their own thanks to the Wonderbra, as advertised by Eva Herzigová's infamous, car-crash-causing 'Hello Boys' billboards.

Angel, a real diva of a perfume (who might refuse all the M&Ms placed in her trailer except the blue ones), seemed to anticipate this hyper-real aesthetic. This celestially inspired scent really is an unearthly experience. Even readers who absolutely detest Angel should go and have another sniff. It is absolutely bonkers. The sniffer is lured in with the promise of candy, but having started chewing in delight, they realise there's something iffy in this chocolate bar and spit it out, only to be tempted to have another bite. The reel-you-in-then-slap-you effect was famously created through a balance of ethyl maltol, with its gourmand candyfloss smell, and discordant, earthy, sour patchouli, an idea which was utterly original at the time. Angel is no earthly beauty but a disturbing, otherworldly presence. 'Beware of Angels. Good ones. Bad ones' went Mugler's original strapline, and indeed we have no idea whether this perfume, this poisoned cocoa powder, is our guardian angel or a demon. Subsequent releases from Mugler, particularly Alien, demonstrate the house's continuing dedication to strange, dystopian beauty, their own take on the Fritz Lang aesthetic.

Angel was originally fronted by model Jerry Hall (who lounged around, not on a couch as in her Opium appearances, but on an intergalactic sand dune), and recently her daughter, model Georgia May Jagger, took up the mantle as the new ambassador for the perfume. The light of beauty passes from one generation to the next, never ageing, never diminishing. Angels are immortal, and judging by the continued success of Mugler's first fragrance, so is their perfume.

L'Eau d'Issey and
L'Eau d'Issey Pour Homme

BY ISSEY MIYAKE, 1992 AND 1994

THE SPRING-CLEAN PERFUMES

HOW TIMES HAD CHANGED. BACK in the 1920s bathing in champagne was the last word in decadence. By the late eighties, rumour had it that Michael Jackson bathed in Evian, and celebrity hairdressers were telling the magazines that really the final rinse should be in mineral water to give the best shine. Between 1990 and 2005 sales of bottled water quadrupled and we kept on loading up the car boot with multi-packs, even while thrilling in the revelation that Evian is 'naive' spelt backwards.

How on earth did those mini green bottles of Perrier usurp vodka to became the last word in aperitif-cool circa 1991? That nebulous word 'detox' had started doing the rounds; perhaps that had something to do with it.

L'Eau d'Issey, which came in versions both male and female, is often cited as the detox perfume, an antidote to the scent excesses of the 1980s (not that they ever went away, cough, Angel). The designer Issey Miyake famously hated perfume, hated being accosted by it on an aeroplane, and wanted something that smelt like water falling on clean skin. Thankfully, instead of pouring Perrier into a perfume bottle,

301

team Miyake, which included the perfumer Jacques Cavallier from Swiss firm Firmenich, set about creating the impression of a waterfall spraying onto flowers, bits of sticking-out tree branch and rocks. It's the right kind of smell for the Apple look – in fact, picture Steve Jobs in one of his Issey Miyake polo-necks and you could imagine him in L'Eau d'Issey Pour Homme. Or a young professional couple in a very tidy flat, with their his 'n' hers Isseys next to the sonic toothbrushes.

Many other accessories of nineties minimalism – the erratically adopted stuff that Edina from *Ab Fab* might have bought on impulse – have been packed away in the attic or put on eBay: Prada nylon bags, futons, and books about turning the lounge into a feng shui paradise. Yet Issey Miyake's perfumes continue to sell, managing to transcend their moment. That's because they're so good. If ever one feels perfumed-out, and I'll admit, it's possible, Issey is the reset button.

Hanging out with the crew of CK One, Acqua di Gio and Cool Water, Issey Miyake is a scent of brilliant tenacity despite being light as a bubble. It offers a thirst-quenching evocation of watery fruits (melon for women; yuzu for men), together with dry timber, and is famous, in part, because of its bold use of the molecule Calone – which on its own (and to reiterate: not detectable as such in the perfume) is reminiscent of a raw, quivering, platter of shellfish.

There is something so appealing in the idea of oxygenated water, of the imagined scent of purity, and L'Eau d'Issey, a little like Jo Malone's Lime Basil and Mandarin, was an utter relief for those who never thought they'd find a suitable perfume or were suffocating from too much Joop! It won many fans in humid climates, who just needed a little olfactory air conditioning, the reassuring mirage of a cold plunge-pool close to hand.

Sunflowers

BY ELIZABETH ARDEN, 1993

THE FAMILY PERFUME

SUNFLOWERS IS THE CANARY-YELLOW PERFUME with a glutinous-looking texture. It is in purgatory right now as a Mother's Day offering, hideously unfashionable and in danger, on bad days, of making you feel as though you're being beaten up by a bunch of freesias. Yet it simply must be included as one of the quintessential 1990s 'contentment' perfumes.

Sunflowers wasn't the flashiest launch of the decade – it was no Angel – but it was different: an aquatic citrus that cleverly blended the smell of old-fashioned lemonade with melon and peach.

Like Clinique's Happy, Estée Lauder's Pleasures and Calvin Klein's Eternity, Sunflowers avoided the usual sex-and-power-trip territory and focused instead on being feel-good; the alprazolam of perfumes. Sunflowers gives off the vibe of having been designed for 'women in their prime' – in other words, she's got three lazy teenage boys and is desperate to remember the last time she necked a bottle of wine and danced to Lionel Richie. Of course, like many releases of the decade, it gathered up more than its target market: Sunflowers was also popular with teenage girls.

While at least the territory was novel (for perfume), offering a detour into a different, middle-of-the-road story, many of these perfumed paeans to family life were *slightly* romanticised. Instead of revolving round a screaming toddler who's just shoved a Lego brick up their nostril, the world depicted in Sunflowers was more about twirling your adorable mini-me on the beach while wearing matching tutus; or, as with Calvin Klein's Eternity, frolicking in the sand dunes with your ridiculously handsome hubby while the children go off to inspect a rock-pool.

Impulse O$_2$

BY UNILEVER, 1993

THE SCHOOL-CRAZE PERFUME

READERS WILL BY NOW HAVE spotted that our century of scent presents not only the finest of fragrances but also those more humble in artistic intent, important because to a certain generation or tribe they behaved as vital mood music; the soundtrack to their growing up. Impulse O$_2$ admittedly is a curious inclusion and as a body spray just about qualifies. Many will not know of it, but it is a personal favourite, and I'll wager that any British woman born between 1979 and 1987 will yelp when they see its tale told here.

O$_2$ was an entry-level fragrance, a crop-top in smell form that came out of nowhere to grow into an atomic mushroom of a craze. Anyone hoping to deconstruct the puzzling viral spread of school-based trends would do well to turn to Louisa May Alcott's *Little Women* and the description of brat-sister Amy's obsession with pickled limes:

> Why, you see, the girls are always buying them, and unless you want to be thought mean, you must do it too. It's nothing but limes now, for everyone is sucking them in their desks in school time, and trading them off for pencils, bead rings, paper dolls, or

something else, at recess. If one girl likes another, she gives her a lime. If she's mad with her, she eats one before her face, and doesn't offer even a suck. They treat by turns, and I've had ever so many but haven't returned them, and I ought for they are debts of honour, you know.

Though the novel was first published in 1868, the reaction of young female readers to this passage will have changed very little since. First, they will wonder what the hell a pickled lime is. Is it similar to a preserved lemon? A sherbet Dip-Dab? A euphemism? And then, still unclear as to the answer, they will experience a desperation, a hysterical desire, to try one.

Fervour in schoolgirls is always difficult to unpick. There is peer pressure, yes, which holds a powerful grip, but in the case of Impulse, why was O_2 the one that flew, of all the myriad alternatives in their body-spray collection? One clue is colour; indeed, with all the tubes lined up on the shelf in shades of pink, purple, yellow, green, and yet another stab at purple, shopping for body sprays was an early exercise in cross-sensory translation between sight and scent. We learned here that the pink one smelt soft but a bit babylike, while the blue one had a slightly unappealingly sporty aroma.

O_2 was in a tantalising acid-lime tube and smelt like pear-flavoured Jelly Bellies. Its juicy, reviving aura helped propel it into P.E. changing rooms, where, after a traumatic hour of netball or gymnastics, it took on the role of emergency provision: showers were either non-existent or communal (thus needing to be avoided), meaning that O_2 was the best, the only way to hide body odour and stay fresh. In its ubiquity, it quickly became wrapped up with prepubescent fears about changing bodies: 'Is an AA cup really too small for a bra and will it provoke mockery?' 'Can someone hear me rip off my sanitary pad in the toilets?' And, most feared of all: 'What if I write the word "pubic" instead of "public" in my homework by accident?' The more these paranoias circulated in the mind, the more O_2 would be sprayed, becoming a tornado of vapour. So much of the stuff was used in the 1990s that

British water reservoirs must have smelt like synthetic orchard fruits.

For the merry band of original wearers, coming across somebody who also had a can is an almost Masonic experience; former O_2 ownership becomes the catalyst for a friendship for life, or at least a conversation about other shared reference points from one's youth, which cluster around the scent like fat (plastic) jewels. With O_2, the accompanying shopping list would include Global Hypercolor T-shirts, Slap-On Bracelets, Adidas trousers, Trolls, Dummy Jewellery (with all its choking hazards) and Forever Friends memorabilia. If none of this is familiar to you, you had to be there. (Or, more accurately, you had a lucky escape, because no one should wear Lycra cycling shorts with a body leotard.)

CK One

BY CALVIN KLEIN, 1994

THE GRUNGE PERFUME

HANDS UP: WHO OWNED A pair of Calvin Klein boxers in the 1990s (or stole their boyfriend's)? Are they still in a drawer somewhere, the colour of a leaden morning sky, waiting to feature in a washing powder advert? Be not ashamed, for the power of Calvin over the populace was still strong in this decade – and CK One was replacing Obsession as his new holy water. A sprinkling of this unisex scent, with its ascetic, industrial-design presentation, offered the prospect of joining a tribe, one in which androgynous twenty-somethings in black, white and grey stood about, arms crossed, staring at each other, or gesticulating as though arguing about something important – such as why they had to wear those horrendous, arm-exposing spaghetti-strap vests. It was a grungier version of *Friends*, or so CK One's effortless-looking magazine spreads, featuring Kate Moss and other waif-like models of the mid-nineties, would have us believe. Doing nothing had never seemed so vital; in essence their poses were very similar to those of after-school teenagers, hanging about at bus shelters, but with added credibility. Like the cast of *Beverly Hills, 90210*, they were pushing thirty while pretending to be youngsters.

Although the scent bottle itself never featured in the campaigns, the intimation was that these models were all sharing a flacon of CK One between them in the same way they might pass about the (very similar-looking) bottle of Absolut vodka, or go in for a bit of partner-swapping within the group. Just like the couple in the gum adverts splitting a stick of Wrigley's Spearmint on a Greyhound bus, it was cool to share this zesty, nutmeggy brew, to embrace through early fragrance experimentation one's inner androgyny. For girls it was de rigueur to ignore the spray nozzle that came with a bottle and use the screw cap instead, allowing you to pat on the scent like a guy would.

CK One was, after all, the aspirational, gateway smell for the mid-to-late adolescent finally leaving behind the mood swings and keen *not* to be found watching *Clarissa Explains it All* and other borderline young-adult television programmes. It was definitely a bottle to show off on one's bedroom shelf, while also implying that the owner had more important things to care about than stupid perfume. In stark contrast to the patrons of fashion-house fragrances of the earlier twentieth century, a large tranche of CK One's wearers were unlikely to be able to afford Calvin Klein dresses, but rather would be found in Gap, stocking up on branded hoodies to wear with home-cut denim miniskirts. Their idol, who of course would have a bottle of CK One, was Jared Leto in *My So-Called Life* – his hair and lumberjack grunge clothing interchangeable with those of Claire Danes' Angela, just as they might nick each other's scent, if they'd hurry up and get together.

For all this gentle ribbing, CK One was brilliant and clever; along with L'Eau d'Issey, it brought the hesperidic style back from the vaults and gave the easy-breezy style of perfumery something new to say. Everyone had become so accustomed to the division of 'pour homme' and 'pour femme' that a 'pour both' perfume seemed daring and terribly modern – just as, four years earlier, that other design icon of the 1990s, Philippe Starck's lemon squeezer, had got everyone very excited about what could be done with a citrus fruit, as though kitchen implements had never existed before.

CK One, once a self-conscious outlier, is now a classic. Many of its original wearers still have a bit left hanging out in a drawer somewhere, which might get the odd outing on hot days but which otherwise goes unworn for the fear that they are now perhaps a little too old for this eternal cool kid, still slightly in thrall to its confidence and swagger.

Lynx Africa

BY LYNX/AXE 1995

THE PUBESCENT-BOY PERFUME

LYNX AFRICA (OR AXE AFRICA, as it is known in many countries) remains the pre-eminent fragrance appetiser for millions of teenage boys. Since the 1990s, as the world's largest toiletry brand for men, Lynx has reframed the cheeky suggestion first raised by Hai Karate, that with some of their product under your pits, the girls will come. But it has also managed that tightrope position of acknowledging that these claims might just be fantastical, with tongue firmly in cheek. They may be deodorants, but Lynx's fragrances are big business and are taken very seriously indeed, developed by some of the most experienced perfumers in the industry. The names, too, are totemic and make spraying the armpits an epic procedure: Tempest, Atlantis, Apollo and, of course, Africa. Let us go on a safari to meet a typical wearer:

And now we find ourselves in a small room somewhere in the northern hemisphere.

It is late morning, but the sun is unable to penetrate through the thick, undrawn curtains. We must therefore watch closely and patiently for our elusive subject, aided by our night-vision lens.

There, under the duvet, a stirring.

Suddenly, a leg pokes out, offering us our first glimpse of a teen-age human male. Slowly, over a period of several hours, he emerges, shown here using a time-lapse camera. The process of disentangling himself from the bed is a long one and fraught with risk.

Finally, he stands, stretches and makes ready for the short day ahead. A shower first, perhaps. But no. The male hesitates, and beats a hasty retreat from the bathroom. Instead, he reaches for an aerosol can from among his possessions.

Lynx Africa.

The young male can use as much as a can per week. Sniffing his underarms, he sprays round and around, over and over again, until covered in a patina of aroma. Some will be ingested, but it is not harmful and can only help his cause.

Soon, the room is thick with Lynx. As he opens the door, a wailing is heard from nearby. It is his sister, who has unwittingly inhaled some of the smell. The boy now leaves the house.

His aim today: to secure the interest of a female, and for this he must make his way to the nearest settlement. On the bus, passengers wince. Their olfactory systems cannot accommodate the Africa, for it is not intended for them. Finally, he arrives at his destination, a busy bowling alley. Passersby are stunned by the Africa and clear a path for him as he lopes towards his peer-group.

This is the critical moment, where it will quickly become clear whether his efforts have paid off.

He is unlucky. The females sniff the air, grimace and walk away. Alone once more, he sighs, inaudibly, and goes to fetch some bowling shoes while reassessing the lie of the land.

But wait. There, ten feet away, is another.

He doesn't see her, but she is advancing towards him. She speaks. He turns and quickly gesticulates. They have a conversation – a critical first step which may well herald something more.

Out of the grip of defeat comes a new beginning. The day has been a triumph. Hope…is restored.

Tommy Girl

BY TOMMY HILFIGER, 1996

THE PREPPY PERFUME

IN THE 1990S THERE WAS a certain haircare advert that blazed out from television sets for months. Promoting Salon Selectives' new flexihold hairspray, it included the immortal line 'Like you just stepped out of the saloooooooooon' and turned hair-swishing into an Olympic sport. In total contrast to the very 'done' set styles of the eighties, hair was now about the wash-and-go dream, with the ideal look combining honeyed highlights, gentle layering and waterfall straightness. The mistress of perfect hair (namely Cher in the 1995 film *Clueless*) was the girl who could rake her fingers through her mane as a flirtatious gesture. Attempting this move with less than perfect, grease-free locks was dangerous as one's hand could easily get trapped within the knots. Such flirty, flippy hair – which for those aiming for the gold medal meant getting 'the Rachel', as sported by Jennifer Aniston in *Friends* – seemed to lack artifice, but, as ever with natural looks, could take hours to perfect. Nineties neutral make-up also made itself out to be easy but actually required a quintuplet of brown eye shadows, MAC's Spice lip liner and a consignment of all-in-one powder foundation plus a crusty sponge.

Fluency in achieving salon-straight hair was, particularly in this decade, an important part of east coast America's preppy dream. This sophisticated teen culture was worlds away from the trashy goofiness of John Hughes' movies or the melancholy of *My So-Called Life*. Preppy teens were aspirational, not through being overtly glamorous but by nailing casual wear. This meant polo shirts and chinos for the boys and, well, almost the same for girls, but with some mini-kilts thrown in for good measure. These idealised teenagers never had spots. They would always have access to good sports facilities. They were either in the final throes of high school or attending neo-classical-campus colleges, where they would be in a sorority. Donna Tartt's cult novel *The Secret History* from 1992 was prep culture gone murderous, with a dash of Greek Studies, while the TV series *Dawson's Creek*, which ran from 1998 to 2003, offered the perfect middle-class version of preppy teendom, full of unrealistically articulate sixteen-year-olds. Dawson, asking Joey whether they are still friends, elicits from her: 'It's called social evolution, Dawson. What's strong enough flourishes and what doesn't we look at behind glass cases in science museums.'

OK, Joey, time to loosen up and have an underage drink.

Led by the designers Ralph Lauren and Tommy Hilfiger, the nineties incarnation of preppy culture became a hugely successful global export. It was the US of A writ as a Massachusetts lullaby of equestrian culture, baseball caps and blazers – with just enough urban and street references to feel relevant. Ralph Lauren's polo shirts, with their jockey insignia, were a runaway success for offering one of the key attractions of the style: looking smartly turned out without appearing to have made an effort. More than that, for many teens the Red, White and Blue appeal of Ralph and Tommy's wares came from their particular expression of togetherness. Their intensely art-directed campaigns depicted happy, sitcom-ready groups of friends hanging out on a lawn with an East Hampton beach house behind them, harmonious in their gilets and rolled-up jeans.

Ralph Lauren was the first to make the transition into fragrance, and who can forget his myriad Polos, from the original Green version

in 1978 through to Red, Blue, Black, then Double Black? Tommy Hilfiger came along later, with 1994's Tommy, which sought to capitalise on Brand All-America by showcasing various aromas that could be found across the States, from Kentucky Bluegrass to Cottonwood and Red Maple. Tommy was popular and no doubt many readers will have encountered it. Tommy Girl, however, was even more so, and became the perfect scent expression of preppiness. It may not have been as bleeding-edge hip as CK One, but Tommy Girl shared something of its clarity, starting with the pure-looking transparent liquid in a bottle with gleaming silver cap. The scent, blending green tea with lemon, was fresh and discreet, making unintentional over-application difficult (though not impossible). This was ideal for girls who tended to worry continually about what they were conveying to others through their dress, language and mannerisms. Tommy Girl was a smell that went well with brilliant white shirts, freshly brushed teeth and nicely clipped nails.

Buying a bottle of Tommy Girl was not necessarily about copying the cool girls or entering a popularity contest. It offered something far more satisfying. This pared-down, crisp, youthful scent gave instant order. Her wearers may have suffered from hair lank with too much Frizz-Ease. They may have walked around fully aware that their too-orange concealer was drawing attention to the acne on their chin. They were perhaps frowning because their new Kickers shoes were already looking scruffy and second-rate. Even though, deep down, they knew the teen perfection of Dawson, Joey, Pacey and Jen was a fantasy and that life is not a photoshoot, with a spray of easy-breezy Tommy Girl, at least they could smell sorted out.

'Genuine Gucci'

c. 1996

THE COUNTERFEIT PERFUME

Oxford Street, London's premier shopping destination, can always be relied upon for extra-curricular features. There are the novelty Christmas lights, which by 2020 will probably be mounted sometime in March for the coming December. These illuminate the centipede of clapping Hare Krishnas who wend their way up and down the street and manage to provoke a twinge of guilt in some of the thousands of shoppers laden with bags full of cheap clothes. Said shoppers are invariably less sympathetic to the freelance megaphone preachers clogging the entrance to the tube and preventing them from picking up a newspaper for the journey home.

Wander down towards the less salubrious end, near Tottenham Court Road, and you'll likely find that one of the vacant shops has been commandeered by a 'perfume' outlet flogging dodgy juice named 'Samantha' or 'Carrie', inspired by the TV show *Sex and the City*; bottles of the stuff will be piled high in bins out back, with business conducted via a soapbox outside. These retailers, forever in closing-down mode, will disappear overnight, only to reopen three days later next door, chucking scent bottles into the crowd once more.

Such displays are nothing compared with Oxford Street's heyday as a counterfeit perfume marketplace in the mid-1990s. And indeed, going further back, the purveying of counterfeit goods was rife in the 1920s, with just one example being the practices of a Mr Louis Goldberg, who was busted for loitering outside theatres and selling dubious concoctions to showgirls. While fake goods always pose a threat to the luxury industries, there were, certainly in Britain, a good few years during which global brands, and specifically their distinctive marques, became highly desirable as part of the patina of conspicuous consumption. News items would report on the problem of school kids dragging their parents into debt thanks to their predilection for the Nike swoosh, Adidas' three stripes, or sweatshirts emblazoned with 'Reebok' or 'CK'. By the end of the 1990s, reaction would come through Naomi Klein's book *No Logo*, a bible for those rankled by branded consumerism.

Initially, brands masterminded their own viral proliferation – the Louis Vuitton insignia escaped from the luggage where it belonged and ventured into all sorts of freaky products; there was also that infamous Burberry check: who before or since has desired a tartan bikini? The officially licensed products came first, quickly regretted by the brand managers, for once interest had been piqued, then came the fakes; these were effortlessly easy to pass off when all the equity in the product was held in the logo – a simple piece of graphic design replicable on sunglasses, watches, sportswear and handbags. As long as the interlocking letters looked real, who cared about the rest? Perfume, which, to a large extent is about the cachet of the box and bottle, was particularly ripe for the counterfeiting, especially now that Calvin Klein, a brand which had perpetuated logo monomania through its underwear, was so in fashion with CK One and CK Be.

Perfume hawkers began to pepper the streets, their modus operandi being a small trestle table perched next to the bins. These stands were operated by characters like something out of Dickens; dozens of bottles would be spilled onto the table, quickly lined up and with tester bottles on hand. From nowhere would emerge a crowd baying

for fragrance, nearly all of them part of the criminal gang and paid to be there to entice gullible tourists over. The scent in the sample bottles would usually be real, but those actually purchased certainly didn't contain real perfume. Various horror stories went around as to the liquid contents, which ran the full gamut of toxicity, from tap water to pond water to arsenic. One analysis found wee inside.

It was nonetheless thrilling to observe the workings of the counterfeit perfume sellers from the safe shelter of the nearest bus stop: not only their classic sales patter – 'Fell off the back of a lorry on the motorway', which makes one wonder about all these vehicles positively spewing products onto our roads – but the cat-and-mouse games they would play with the police. These gangs knew all the undercover coppers and as soon as one was spotted, they would pack up their gear and scuttle off towards Marble Arch at remarkable speed, only to reappear half an hour later with everything neatly laid out once more. Just as many people took the gamble and bought pirate VHS tapes, misguidedly assuming the quality couldn't be that poor, so it was tempting to buy a bottle of counterfeit scent to see just how bad its contents could be.

These Del Boys were never going to seriously thwart the profits of Gucci et al, although they did apparently dent annual turnover by 5 per cent; rather, it was an embarrassment to have the counterfeit traders set up so brazenly, in plain sight, just down the way from Selfridges, and to be giving the street a bad name. A war on this blight was announced, in the way that mayors talk of getting rid of urban pigeons. It targeted stallholders, through an aggressive clean-up operation, as well as their suppliers, the dodgy factories housed in semi-rural homes and farmhouses in Huddersfield and Nottingham; and it worked, up to a point.

The scourge of Oxford Street may have been tamed, but the real action has moved from our streets to the even murkier domain of the online seller. If tempted to buy a bottle of your favourite via an auction marketplace, be very careful indeed. Especially if the word 'genuine' appears in the sales copy.

Dirt

BY DEMETER FRAGRANCE LIBRARY, 1996

THE UN-PERFUME

LOAMY, DAMP AND GRAVELLY: DIRT smells exactly as you'd think it would. Like many of Demeter's scents, which include Grass, Laundromat and Snow, it is an evocation of a prosaic smell, something we encounter and take for granted every day, translated into a fragrance.

One of Demeter's first perfumes, and created by contrary founder-perfumer Christopher Brosius, Dirt is an interesting reverberation of the 1960's patchouli movement, repurposed for the 1990s indie-coffee-shop scene. In the sixties, patchouli offered the smell of dirt in reaction to narrow suburban conformity; in the nineties, Dirt was a response to the impersonality of global prestige fragrances. Both were about reclaiming individuality with all its kinks. Rather than buying into the luxury corporation's idea of what a twenty-five-year-old woman would want to smell like, Dirt offered a refreshing new concept: the fragrance of something personally meaningful to the wearer; nostalgia in a bottle. This might be freshly cut grass, sawdust or plastic tinsel – as explored in some of Demeter's other releases. The irony is that Demeter did this by plundering the banal; or, to put it another way, we think we are particularly quirky in adoring the smell of turpentine

319

but, as it turns out, so do millions of other people.

Wearing Dirt is a wonderfully strange experience. It can be enjoyed in a meditative, solitary fashion or as a day-to-day perfume, although it is particularly fun worn with a ballgown, as though you have just chucked the contents of a wheelbarrow over your finery. Once the iconoclasm of the experience is done with, we can start to appreciate Dirt for being an interesting, lovely smell, rather than simply 1996's pretentious, hipster flavour of the month. Beautiful in its own right, Dirt forces us to unlearn everything we've been told in the past hundred years about what perfume *should* smell like and about how it *should* make us feel. Why not spray on the aroma of freshly raked and watered soil? Why not have a scent whose name is not an emotive concept but a mundane common noun, allowing us to supply the meaning? Demeter's offerings work the other way round too, by reframing aromas we think we know; their 1997 Gin & Tonic revealing that this drink is indeed highly fragrant, an alternative take on the traditional herb-and-citrus scent.

Dirt certainly didn't threaten the orthodoxy or topple the world of fragrance as we know it. The superhighway carried on as always, but Demeter built a new path to give us the scenic route should we ever feel the need to experience the journey from a different vantage point.

Since Dirt's appearance in 1996 the fragrance industry has increasingly promoted the wizardry of nature-identical and even industrial smells. With the help of a technology called Headspace, which identifies the aroma present in the air around a particular object, a perfumer can now use the appropriate fragrance molecules to re-create the smell of a vat of petrol, body odour, or the fragrance exuded by a flower. Back in 1900 we were being sold violet perfumes made using synthetic ionones – a flower made flesh; now we can take apart the olfactory phenomena of our post-industrial cities and have them put together again, trapped within a bottle, just in case anyone in a hundred years should ask, 'What did life smell like when you were young?'

A New Century

As Y2K DREW NEAR AND the world tried to imagine what life would be like once the Millennium Bug had brought down our entire infrastructure, the final major fragrance launch of the old century arrived: J'Adore from Christian Dior. Appropriately for such a year, this was an immersion in liquid gold, a perfume suitable for the biggest New Year's Eve party ever, which quickly became Dior's house scent, their Christmas perfume to rival Chanel N°5. Fronted latterly by a flaxen-haired Charlize Theron, striding dramatically onto the catwalk though a pair of very large double doors, J'Adore is still a big seller, and one of those perfumes we might still reasonably expect to smell on a Saturday evening, if some kind of perfume bingo game were on the cards.

Even though it might sometimes seem as if there are too many perfumes available these days (not like 'back then'); that you could travel the world and never sniff the same scent twice; and that nothing quite holds the times together in the way that Giorgio did during the eighties, they are doing pretty well, the newer crop. There is, for example, the 'playing-hard-to-get, independent lady' Coco Mademoiselle, which arrived two years after J'Adore, a reworking of Chanel's Calvados-infused fruitcake of an oriental perfume, Coco of 1984. Its success spawned the 'fruitchouli' (fruit meets patchouli) category, in which now sit more perfumes than brides at a Moonie wedding. There is the shell-pink and shy musk of Narciso Rodriguez, as versatile and inevitable as those nude-coloured shoes that suddenly appeared everywhere. There has been Flowerbomb from Viktor & Rolf, which blooms on the wrist as if the skin were a hot metal radiator. And there has been

1 Million and Lady Million from Paco Rabanne, which look like over-sized gold teeth from a gangster movie. These sparky, fun juices invite a girl to banter with a guy, to click her fingers to get what she wants, whether that's a fast car, a diamond ring or proper respect. At the time of writing, Lancôme's La Vie Est Belle is one of the bestsellers, a cross between Thierry Mugler's Angel and a Mimosa cocktail (that's Buck's Fizz to you and me).

The unifying factor behind many contemporary fragrances is sugar. We are in the midst of a candy crush and though we are told sugar is a drug and must be avoided, it can't hurt us to smell a bit of Prada's Candy, can it? Even the bottles are confections, especially those from Marc Jacobs. Once upon a 1910, the most desirable perfumes were those in unusually shaped bottles with special hand-tied trimmings and eye-catching boxes. Marc Jacobs' wares, especially Daisy and Lola, now give the same effect on an industrially produced scale, with their stick-on rubberised petals, faux pearls and trinkets. Jacobs' boxes are oversized to fit in all the extras, and in their advertising campaigns the models stand in a field of daisies holding aloft giant inflated dummy bottles, as big as Godzilla. It is as though in order to assert its rele-vance as a purchase, scent has to reach all four corners of the screen or page. There are the big narratives, too: advertising films which seem to last for half an hour and which provide variants on the classic love story. These often have high production values, devastatingly beautiful scenery, music as dramatic as any build-up to a *Lord of the Rings* battle scene, and dubious scripts. Even the cats are big: fragrance brands love to feature a leopard or cheetah slinking about as the intimate sidekick of the Glamazon.

Then there are the biggest perfume touts of them all: the celebri-ties. As we well know, fervent curiosity about the beauty products used by the rich and famous is nothing new, and nor are dedicated celebrity scents. It can be tantalising to find out what the likes of Katharine Hepburn or Cary Grant used to wear, as if it is possible to divine some-thing otherwise hidden through their choice of perfume. One striking example of this comes from 1949, in an incident which heralded a

shift in the relationship between the press and the royal family. Princess Margaret, then the biggest style icon among the Windsors, was on holiday in Capri. While she was out and about, a journalist broke into her hotel suite and reported back that she owned a bottle of Tweed by Lenthéric. *The Times* newspaper was affronted by the incident, calling it 'a peep show'. That it was, and one which probably did very well for Lenthéric. Marilyn Monroe, long dead, continues to shift product through her informal association with N°5.

What has changed in the new millennium is the average age of both subject and object. When Jennifer Lopez extended her personal brand, J. Lo, to Glow perfume in 2002, it was seen as a wholesale refresh of the celebrity fragrance, breathing new relevance into the genre. Then came the avalanche: first Sarah Jessica Parker, then Britney, Kate Moss, the Kardashians, Kylie, Lady Gaga, Rihanna, Nicki Minaj, Beyoncé and Taylor Swift, along with some unlikely candidates like Kerry Katona. The churn rate seems to be as fierce as it is for newly released songs. After barely five months, it's time for the new fruity floral to usurp the old, which in interviews the star will proclaim is their favourite of the range, alongside all the other favourites. An alternative is the ambassadorship, which is so essential that a celebrity isn't A-list until they've put their face to a bottle and stood in front of a wind machine in its promotional service.

The latest turn has been for boybands to launch one – or ten – perfumes for their female fans. Sometimes they have smelt it before the press launch – a sign of true dedication to their craft. Justin Bieber's bottles have a similar packaging style to Marc Jacobs': flowery grenades of true love. One Direction's are preoccupied with pronouns to make the fan feel a part of their world. First came Our Moment, then That Moment, then You & I. We can only pray for No Moment.

It is easy to become despondent about fragrance when these wares shove themselves into our faces, but to redress the balance, a few considerations. Firstly, the perfumers working on these scents are sometimes the very same individuals put to work on all the other fragrances, including expensive ones. While the cost of a celebrity scent

is going to be pretty low, some of them aren't bad, and again we have to wonder how quickly in a blind testing we could identify a £14.99 Kylie perfume against something three times as pricey. If you love Britney's Fantasy, as many do, go for it. We can also see sleb scents as the smell equivalent of the celebrity memoir. They might not win any literary prizes, but they'll sell a few and help get money in the coffers to support more experimental work.

And there is an awful lot more going on to interest the perfume lover, who need only ignore the Beliebers, if they so choose. In complete contrast to the products of manufactured talent entities, one of the big stories since 2000 has been the rise of what is called 'niche' or even 'arthouse' perfumery. This refers, albeit inexactly, to fragrances that reach a small, specific cohort, are sold in a limited number of outlets, and which by virtue of their size can afford to take creative risks unfeasible elsewhere; they therefore claim to have an authenticity that is lacking in, say, I don't know, a perfume from a sixteen-year-old boy.

Niche was born in the 1970s. As we cast our minds back to the musk oils, the Babes and the Opiums, one new player not referred to in that decade, but whose influence grew slowly over subsequent years, was the chemist and perfumer Jean Laporte. Jean founded a company called L'Artisan Parfumeur in 1976 to revive the heritage of crafted, fine French fragrance, focused on the product and with minimal promotional spend. Compared with everything else going on that decade, L'Artisan was the one room of creaking wooden floorboards in a house of seventies shag-pile rugs. Their early fragrances marked a return to the nineteenth-century approach, taking inspiration and names from a single material, whether tuberose or sandalwood. What L'Artisan did so cleverly was to reset these old-hat, yawn-inducing aromas using the best materials they could get their hands on, so that they seemed fresh and interesting again. Their Vanilia, for example, took that most overlooked, anodyne smell and showed how smoky and complex it could be. With Mûre et Musc, there was that musk scent most typical of the decade but with a squidge of juicy blackberry. In a nod to fragrance's heritage in scented objects, L'Artisan developed amber-infused wooden

balls and silk sachets, little treasures like something from *The Box of Delights*. They were joined by Diptyque, a company founded by a small group of friends in Paris with a penchant for Anglo history; they, more than anyone else, sparked our current mania for £40-plus scented candles that line up like marionettes on mantelpieces and promise to make our sofas smell better than we do. There was also Annick Goutal, who became known in the 1980s for her eponymous range, particularly Eau d'Hadrien, an orange and bergamot which appealed to those who thought they didn't like perfume.

L'Artisan carried on quietly for years, not seeking the oxygen of publicity. It was only around the year 2000 that niche became a recognised entity within fragrance, its rise corresponding with and fuelled by the growth of the internet, which provided fertile ground for non-traditional conversations and critiquing on this most specialist of subject areas. For the first time ever came proper peer-to-peer fragrance appreciation. For those desperate for something more than the usual glossy magazine coverage of five green perfume bottles photographed on crushed ice, there were reviews, directories, blogs, discussion boards, histories and swap services, and the emergence of an audience desperate to learn about fragrance and open to esoterica, who could be serviced by tiny brands.

One of the first modern expressions of niche as we know it came from Éditions de Parfums Frédéric Malle, which has established a rigorous set of values in order to bind together its very broad roster of talents and styles – styles that for most fragrance brands would not make sense as a collection. Frédéric Malle decided that all the bottles would look the same, that there would be limited suggestion of gender appropriateness, and that each perfume would be identified not just by name but by perfumer, to acknowledge the work of those who usually beaver away unseen. These perfumers could for once experiment unconstrained by marketing briefs or budgets; they could indulge their curiosity and stretch their talents, free to play with perfume's heritage, to make the strange wearable, to get to grips with a conundrum, such as how to make a wintery eau de cologne.

The one unifying factor was commitment to excellence and beauty, nothing else (try Portrait of a Lady for size), which makes the Malle line endlessly interesting, full of variety.

After Malle came more and, given that the sands shift quickly even within a matter of months, you can bet that there now is, or will soon be, a fragrance brand for any interest, any peccadillo. Some invite us to sniff the unsniffable, making us wonder how the original idea was born: Blood Concept riffs on the idea of different blood types – certainly a development of the hair-type perfumes; Nu_Be presents a different bottle for each element of the Big Bang. Today there are scents inspired by the highly personal unfolding of a real-life love affair (from Jul et Mad) and those which, in a reinvention of the nineteenth-century Jockey Club colognes, invite the wearer to feel part of a particular sort of elitist club, whether for yachting types or golfers (Xerjoff JTC). If we require our scents to transport us back in time, there is ample choice. How about the world of Slavic fairy tales, brought to life through The Vagabond Prince; or the court personalities of the past, through Parfums d'Empire; or even a specific moment such as, in Fleur de Louis from Arquiste, the first meeting between Louis XIV and his bride Maria Theresa on the Isle of Pheasants in June 1660? Even the process can be the point – some perfume brands' entire output is about the story of a collaboration, most notably that of Olfactive Studio, which issues perfumers with a piece of work by a photographer and then invites the customer to play a part in the interpretative process.

Through niche has come the return of animalic perfumes, which, following the glory days of those devilish fur perfumes of the 1920s and 30s, became largely absent from the mainstream. This perhaps reflects our tendency to oscillate between the stripper and the prude. Or rather, we don't mind sexy perfumes as long as the sheets are clean. Forced underground, the scent of the body has come out to play dirty: some perfumes have become notorious, to the delight of serious perfume lovers, for wheezing the aroma of crotch and pit, as with Absolue Pour le Soir from Maison Francis Kurkdjian, and Muscs Koublai Khan from Serge Lutens. They'll even evoke semen, as in État

Libre d'Orange's infamous Sécrétions Magnifiques, which, along with penis-shaped straws, can be reliably guaranteed to get a hen party going. Not only do these test the boundaries of what can be considered to be perfume, they also acknowledge its most standard function: to help people get laid.

That question: what can be considered to be fragrance? This has been challenged on various fronts, including by 'antiperfumes', which, instead of creative formulations and blends, offer a single molecule in a bottle. The most famous are Iso E Super, and a set of amber molecules that often go by the names of Ambrox or Ambroxan. Many people cannot smell the former at all, are anosmic to the material, which gives these perfumes the added kudos of having an inner circle who *can* detect them. A proprietary form of Iso E Super is the solitary aromatic material in Geza Schoen's Molecule 01, and in Not a Perfume by Juliette Has a Gun. It doesn't smell of much at all on the strip and needs the skin for its odour, or more accurately its 'texture', to reveal itself. Iso E Super can be elusive and its very appeal lies in enhancing the smell of the skin underneath, sometimes bringing out a saltiness, other times a metallic scent, a sweatiness or a dryness like a wooden sauna. We all like to think we're special and unique, for which reason Molecule 01 – which seemingly smells different on everyone – is the perfume of the ego, of me me me. Even though there is less laboured creative work here, and you might feel that this scent is therefore a case of the emperor's new clothes, what it demonstrates is that in smell a formulation can be ever so simple, as little as one or two molecules, yet it will still seem complex, as though it contains a seething mass of materials. Our noses cannot necessarily tell the difference.

So many stories, so many quirks, hooks and baits. This is precisely why niche is so appealing. Instead of just talking about perfume by season, as something for day or for night, as a floral or a citrus, or in reference to a worn-out archetype, the creators of niche fragrances offer different narratives for thinking about our sense of smell, a form of intellectual enquiry. No longer are we passive wearers buying something beautiful. We can be an armchair traveller, inquisitive about

places and cultures; we can learn about materials, get geeky on a molecule; we can have a conversation with the person who made it, or listen to a piece of music related to the final scent. We live, today, in a perfume fairground with a ride for every persuasion, whether play-it-safe or daredevil.

Is it too much? Are we getting sick on all the candyfloss? Each sniff of a new fragrance can be as laden with expectation as if our eyes were about to glimpse an entirely new colour. The more perfumes we buy to chime with the timbre of our moods, the more our moods fragment, giving birth to new, more nuanced states which none of our existing fragrances can quite match. And so the binge goes on. Not to mention the mounting cost, for how is the fragrance fan to meet the desire for variety without facing bankruptcy? In recent years another layer of retail has been built in to support addiction, introducing a twenty-first-century version of the nip. These are perfume-decanting services. They offer as little as a quarter of a millilitre, from thousands of scents, for pick 'n' mix sampling at home, so that fifty perfumes can be experienced, each for a couple of days. Perhaps one or two of them will later be bought as a full bottle, or perhaps none, if the thrill is in the short-lived affair.

It is just as well such innovations exist, because perfume is getting more expensive, noticeably so. Some of the prices would make even Poiret's eyeballs bleed. In particular, there is a subset of perfumes designed to appeal to oligarchs, and the international super-rich from the Middle East – the latter being crucial to the continued health of the fragrance industry for their cultural tradition of paying more for their olfactory pleasures and for getting through shedloads of the stuff, so that a bottle might last a week at best.

Costing upwards of £5000 per Limited Edition bottle, encrusted with crystal gems and nestled in satin, and incorporating some of the most scarce and expensive materials, some of these fragrances mark a spiritual return to the court perfumes of the nineteenth century – available only to a tiny coterie. They're reminiscent of that millennial dining trend whereby restaurants would come up with the

most expensive possible version of a fast food, such as a wagyu beef burger that had been stuffed with a slab of foie gras and dusted with a snow of white truffle. The couture argument just doesn't quite wash. A bespoke gown, beaded by hand, represents hundreds of hours of work. A perfume costing £50,000? Perhaps, but unlikely.

Those scents with price tags that truly reflect the cost of their ingredients may include oud, a material customary in fragrances of the Middle East. Oud, or agar, comes from *Aquilaria* and *Gyrinops* trees found in south-east Asia, which produce an aromatic substance as defence against a fungal invasion. When neat, natural oud can smell like stilton cheese; when diluted and incorporated into a perfume, it smells like getting lost inside a cello. It is hideously expensive but can be simulated synthetically and has filtered through into the mainstream – oud fragrances keep on coming, eye-rollingly so, though for haters of the sweet stuff they offer welcome relief.

For a long time, all this niche activity seemed a separate entity from the mainstream: for the specialist only. Then the luxury brands began supplementing their core offerings with new lines of exclusive scents for connoisseurs, mining obscure reference points within their archives and making them available at only a handful of department stores and boutiques around the world. In 2015, something changed when Estée Lauder purchased Éditions de Parfums Frédéric Malle and another feted range, Le Labo. Niche, once the preserve of the trendier department stores and independent retailers, is being fused with the operational machines behind some of the biggest companies in the industry. Will their more unusual lines go mainstream, flooding retail outlets? Or is fragmentation the future: instead of the few mega-launches of previous decades, will there be a more diverse set of low-key releases, individually selling less but en masse presenting something a little more substantial? Fragrance could fracture into thousands of micro-brands, as numerous as the craft breweries or coffee companies we are becoming accustomed to, as diverse as the wine trade. Or perhaps the industry will just cave in on itself? But then, people always want to smell nice, don't they?

*

Throughout our century, perfumes have eluded our grasp like so many eels. They know not, nor care not, whether they are works of art or creatures of commerce, important or trivial, literary or trashy, earthy or ethereal. Some perfumes are fossils of their age – a snapshot of a moment in time – and as such are liable to obsolescence. Some of the scents presented here are already on the slow slide to obscurity, and a few are unlikely to be smelt ever again. But many of them aren't done with yet; their biographies and histories are still in progress. They are living, breathing entities that move with the times and with us, finding lucky new owners to adore them. Every perfume has a thousand stories, and most of them will never be heard because they are your own private stories.

This is the thing about perfume: it won't sit still for the photographer, be locked down or captured in a single image. For most of us, a particular fragrance will always offer much more than smell alone – it will summon a mirage of something or someone we thought was lost and the sudden, surprising revival of exactly what it was to feel like us, all those years ago when life was different. Back then: when we wore that old, wonderful favourite.

Acknowledgements

I would like to thank, starting from the beginning...

My parents, Jackie and William, and my sister, Suz, for all their love and support.

Nikki Shaill, for friendship and imagination.

Denis Nichols, Niels Kelsted, Christine Hocking and Ian Patterson, for getting me to think.

The English girls: Clare, Esther, Natalie.

Dan, especially for when I'd email bits of chapters to you while you were working and for not going away until you'd read them and laughed at the right bits. And, of course, Janine, Michael, Sarah, Rachel.

Lolo Chambovet, and Liat Chen, Freya Coote and Heather Pistor from Mothership, without whom the events, and this book, would never have happened.

Those who offered so much support when I was starting out: Claire Hawksley, Shelly and the gang at Les Senteurs, and Grant Osborne.

Amanda Gore and Sarah Sternberg, for coming out to help at my nights pretty much every month at the beginning.

Everyone who has come along to an event over the last few years. It's been a pleasure to get to know you and to talk scent.

For geeking out on olfaction with me: Jo Barratt.

The perfume crew: Fiona Cooke, Nick Gilbert, Callum Langston-Bolt, Laurin Taylor, Angela and Kate Flanders, Mai-Vi Ferraro, Eva Carlo, Suzy Nightingale, Jo Jacobius, Lisa Hipgrave, Julie Young, Karen Gilbert, Pia Long, Sarah McCartney, Liz Moores, Luke Stephens, Louise Woollam, Rachael Rayment, Emily Maben, Kate Williams, John Bailey, Dariush Alavi, Jason Waterworth, Jo Fairley, Catherine Mitchell, Liam Moore, Zoe Cook, Caroline Neville, Michael Donovan, Stephan Matthews and

ACKNOWLEDGEMENTS

Nicola Barr, my marvellous, wickedly funny literary agent at Greene & Heaton who tracked me down scarily quickly, and Sarah Rigby and Jocasta Hamilton at Hutchinson, especially Sarah for editing my work with such wit and grace.

All those at the libraries – especially the guy who didn't bat an eyelid when I accidentally ordered a load of porn – The British Library, The New York Public Library (and Karen and Danny for having me stay and feeding me cheese and wine) and Luci Gosling at the very special Mary Evans Picture Library, together with Bernie and Shenda. And all at the world's perfume mecca, the Osmothèque, whose founder Jean Kerléo was so helpful when we met.

For sharing their stories with me: Judy Mead, Renee Linder, Vera Gorman, Sir John Hegarty, Angelica Coshland's mum, Suzanne Perlman, the Grossmith family, the Yardley team.

My dear friends, especially Laura Baynton for reading so much of the book as it was written and offering continual cheer.

Lucy Ridout for her stellar copy-editing, Alice Brett for proof-reading and Lindsay Nash and Raquel Leis Allion for their beautiful text and jacket designs.

Cynthia Kittler for agreeing to illustrate the book (thank you) and with what humour!

Philippa Cotton, Alexandra Young and Phil Brown in the Hutchinson publicity, marketing and production teams.

And with special thanks to James Craven, dear friend and mentor, without whom none of this would be here.

Notes and Select Bibliography

The Bountiful Belle Époque: 1900–1909

Bayer, Patricia, and Waller, Mark, *The Art of René Lalique*, Book Sales, 1996.

Coleman, Elizabeth Ann, *The Opulent Era: Fashions of Worth, Doucet and Pingat*, Thames & Hudson, 1989.

Hattersley, Roy, *The Edwardians: Biography of the Edwardian Age*, Abacus, 2006.

Ledger, Sally, and Luckhurst, Roger (eds), *The Fin de Siècle: A Reader in Cultural History*, Oxford University Press, 2000.

Mesch, Rachel, *Having It All in the Belle Epoque: How French Women's Magazines Invented the Modern Woman*, Stanford University Press, 2013.

INTRODUCTION

On Gosnell's hot-air balloons, see: John Gosnell, *Through the Fragrant Years: A History of the House of Gosnell*, Gosnell (John) and Co., 1947.

On Rimmel's perfumed products, see: Eugene Rimmel, *Rimmel's Perfume Vaporizer for Diffusing the Fragrance of Flowers in Apartments, Ball Rooms etc.*, [1865?]; Eugene Rimmel, *Recollections of the Paris Exhibition of 1867*, Chapman and Hall, 1868.

On Piesse & Lubin's fountain finger rings, see: Edward McDermott, *The International Exhibition 1862: The Illustrated Catalogue of the Industrial Department, Volume 1: British Division 1*, Cambridge University Press, 2014.

On sewing-bee clubs making scented sachets, see: 'A Christmas of Perfumes and Sachets', *Chicago Daily Tribune*, 20 December 1903.

A detailed entry on the use of ionones in perfumery can be found, at: http://perfumeshrine.blogspot.co.uk/2011/02/perfumery-materials-violet-violet-leaf.html, accessed 6 May 2015.

'hundreds of women and children, in their picturesque national costumes...': 'The Poetry of Perfume', *Vogue*, American edition, 1906.

LE PARFUM IDÉAL

On Charles Dana Gibson and the Gibson Girls, see: http://www.loc.gov/exhibits/gibson-girls-america/index.html, accessed 24 April 2015.

On the 1900 Exposition Universelle, see: Alexander C.T. Geppert, *Fleeting Cities: Imperial Expositions in Fin-de-Siècle Europe*, Palgrave, 2010; *Guide-commode indicateur de l'Exposition universelle'de 1900*, L. Joly [1900?]; Richard D. Mandell, *Paris 1900: The World's Great Fair*, University of Toronto Press, 1967; Melanie Paquette Widmann, *212 Days – The Paris Exposition of 1900*, CTG Publishing, 2013.

'The very thought of that golden lady on the label...': 'Beauty Business', *Vogue*, American edition, November 1934.

LE TRÈFLE INCARNAT

On the difficulties of dating this perfume, see: http://www.mimifroufrou. com/scentedsalamander/2010/03/the_popularity_of_clover_aroma.html, accessed 11 May 2015.

On late-Victorian etiquette and social mores, see: Gertrude Elizabeth Blood, *Etiquette of Good Society*, Cassell and Co., 1893; Lady Troubridge, *The Book of Etiquette*, The World's Work Ltd, 1913.

On the popularity of Amyl Salicylate and Le Trèfle Incarnat, see: *The Spatula Magazine*, Volume 16, 1909; *The National Druggist*, Volume 38, 1908.

'I got a burst of louder, madder music...': Berta Ruck, *Miss Million's Maid: A Romance of Love and Fortune*, Hutchinson & Co., 1915.

'Above all the frangipani and patchouli and opoponax and trèfle incarnat...': Compton Mackenzie, *Carnival*, Martin Secker, 1912.

'You don't know Trèfle Incarnat?...': Agnes Castle, *Diamonds Cut Paste*, John Murray, 1909.

CLIMAX

For general history on the Sears, Roebuck catalogue in American culture, see: David L. Cohn, *The Good Old Days: A History of American Morals and Manners as Seen Through the Sears, Roebuck Catalogs 1905 to the Present*, Simon and Schuster, 1940.

For historic catalogues of Sears, Roebuck and Co., 1896–1900, see: http:// search.ancestry.co.uk/search/db.aspx?dbid=1670, accessed 28 April 2015.

On the impact of the American railways, see: Richard Saunders, *Merging Lines: American Railroads, 1900–1970*, 2nd edn, Northern Illinois University Press, 2001.

MOUCHOIR DE MONSIEUR

Print depicting 'An Exquisite Alias Dandy in Distress', [1819?], courtesy of the Lewis Walpole Library: http://images.library.yale.edu/walpoleweb/ oneitem.asp?imageId=lwlpr12017, accessed 28 April 2015.

L'ORIGAN

On the history of department stores, see: Robert Hendrickson, *The Grand Emporiums: The Illustrated History of America's Great Department Stores*, Stein and Day, c. 1979; Jan Whitaker, *The Department Store: History, Design, Display*, Thames & Hudson, 2011; Lindy Woodhead, *Shopping, Seduction & Mr Selfridge*, Profile, 2012.

Reference to perfumed fountain, in: Émile Zola, *Au Bonheur des Dames*, Charpentier, 1883.

On the story of François Coty and his fragrance business, see: Roulhac B. Toledano and Elizabeth Z. Coty, *François Coty: Fragrance, Power, Money*, Pelican, 2009.

Early advertisement for Coty fragrances in the United States, in: *The Salt Lake Herald*, 16 March 1905.

On Coty's legacy, see: http://graindemusc.blogspot.co.uk/2008/08/coty-lorigan-lheure-bleue-without-blues.html, accessed 6 May 2015.

SHEM-EL-NESSIM

On orientalism in consumer commerce, see: William Leach, *Land of Desire: Merchants, Power, and the Rise of a New American Culture*, Vintage, 1994.

'Many women love sweetness...': Virginia Lea, 'Sweet Odors', *Vogue*, American edition, June 1899.

For editions of *Physical Culture* magazine, see: http://libx.bsu.edu/cdm/search/collection/PhyCul, accessed 28 April 2015.

'crooked-backed, stooping, too fat unless too lean...': Bernarr Macfadden, *The Virile Powers of Superb Manhood: How Developed, How Lost, How Regained*, Physical Culture Publishing, 1900.

POMPEIA

On continued popular interest in Pompeii, see: Judith Harris, *Pompeii Awakened: A Story of Rediscovery*, I.B. Tauris, 2007; Ingrid D. Rowland, *From Pompeii: The Afterlife of a Roman Town*, The Belknap Press of Harvard University Press, 2014.

On the discovery of L.T. Piver products on the steamer SS *Republic*, see: http://odysseysvirtualmuseum.com/categories/SS-Republic/Artifacts/Bottles/Cosmetics/?sort=featured&page=1, accessed 7 May 2015.

On hoodoo tradition, see: Katrina Hazzard-Donald, *Mojo Workin': The Old African American Hoodoo System*, University of Illinois Press, 2013.

For examples of Pompeia used in hoodoo ritual, see: Ray T. Malbrough, *Hoodoo Mysteries: Folk Magic, Mysticism & Rituals*, Llewellyn Publications, 2003; Kenaz Filan, *Vodou Money Magic: The Way to Prosperity through the Blessings of the Lwa*, Destiny Books, 2010.

AMERICAN IDEAL

For historic catalogues of the California Perfume Company, see the Avon Historical Archive at the Hagley Library, at: http://digital.hagley.org/cdm/search/collection/p15017coll20, accessed 28 April 2015.

PEAU D'ESPAGNE

On nineteenth-century Peau d'Espagne recipes, see: G.W. Septimus Piesse, *The Art of Perfumery and Methods of Obtaining the Odors of Plants*, Lindsay and Blakiston, 1857.

'it is said by some, probably with a certain degree of truth...': Havelock Ellis, *Studies in the Psychology of Sex: Sexual Selection in Man*, 1927.

For an analysis of Peau d'Espagne in decadent poetry, see: Catherine Maxwell, 'Scents and Sensibility: The Fragrance of Decadence', Jason David Hall and Alex Murray (eds.), *Decadent Poetics: Literature and Form at the British Fin de Siècle*, Palgrave Macmillan, 2013.

'there was no decent perfume to be got in that Gibraltar only that cheap peau dEspagne that faded and left a stink on you...': James Joyce, *Ulysses*, Sylvia Beach, 1922.

'the familiar blended odors of soaked lemon peel, flat beer, and peau d'Espagne': O. Henry, 'Past One at Rooney's', *Strictly Business: More Stories of the Four Million*, Doubleday, Page & Co., 1910.

The Theatrical Teens: 1910–1919

Adlington, Lucy, *Great War Fashion: Tales from the History Wardrobe*, The History Press, 2013.

Doyle, Peter, *First World War Britain: 1914–1919*, Shire, 2012.

Gosling, Lucinda, *Great War Britain: The First World War at Home*, The History Press, 2014.

Nicholson, Virginia, *Among the Bohemians: Experiments in Living 1900–1939*, Viking, 2002.

Nicholson, Virginia, *The Great Silence*, John Murray, 2010.

INTRODUCTION

On the intravenous use of fragrance, see: 'Perfume Now Injected', *New York Times*, 1 October 1912.

On the Ballets Russes inspiring fragrances, see: Davinia Caddy, *The Ballets Russes and Beyond: Music and Dance in Belle-Époque Paris*, Cambridge University Press, 2012.

On fragrance in the theatre, see: 'Inspiring an Actress to Act by Giving Her a Perfume "Jag"', *The Washington Herald*, 23 May 1915; '"Perfume Jag" Is Aid to Acting', *Oakland Tribune*, 16 May 1915.

NARCISSE NOIR

'elaborate intimacy with various Continental salons and watering-places...': in George Jean Nathan, *The House of Satan*, Alfred A. Knopf, 1926.

For the judgement on Caron's attempt to protect the intellectual property of Narcisse Noir, see: *Caron Corporation v. Conde, Limited*, New York Supreme Court, 213 N.Y. Supp. 785.

For sample reportage on court action involving Narcisse Noir, see: *Patent and Trademark Review*, Volume 23, 1923; *The Business Law Journal*, Volume 8, 1926; *The Trade-mark Reporter*, Volume 17, 1927.

SPECIAL Nº 127

For a fragrance advertisement mentioning aristocratic patrons, see: *La Belle Assemblée*, 1 December 1812.

POINSETTIA

For general history of the Gaiety Girls, see: http://www.vam.ac.uk/users/node/9009, accessed 28 April 2015.

On the New Gaiety Theatre and its shows, see: http://www.arthurlloyd. co.uk/GaietyTheatreLondon.htm, accessed 28 April 2015.

'What charms they possess...', 'A very pretty crêpe de chine mantle...' and other quotes from a review of *Peggy* at the Gaiety Theatre in 1911, *The Play Pictorial*, Volume XVIII, Number 107.

'I am surprised that a perfume of such rare charm...': Olive May quote in Poinsettia advertisement, *Illustrated Sporting and Dramatic News*, Volume 76, 1912.

'the beating of a heart and the swish of lasso...': from Leslie Stuart, 'The Lass with the Lasso' in *Peggy*, 1911.

NUIT DE CHINE

On Paul Poiret and his fragrances, see: Harold Koda and Andrew Bolton, *Poiret*, Yale University Press, 2007; Paul Poiret, *King of Fashion: The Autobiography of Paul Poiret*, trans. Stephen Haden Guest, V&A Publishing, 2009.

'The outline indicates a limited area...' and 'Is she fairy, goddess, or vestal?': 'An Alchemist in Perfumes', *Vogue*, American edition, 1 August 1916.

For the 1002 Nights Ball, see: Aleksandr Vasil'ev, *Beauty in Exile: The Artists, Models, and Nobility who Fled the Russian Revolution and Influenced the World of Fashion*, Harry N. Adams, 2000.

'He covered the whole garden with a silken canopy…' and subsequent account of meeting Paul Poiret, in: Robert Forrest Wilson, *Paris on Parade*, Bobbs-Merrill, 1925.

'I sleep on the grass, and I smell the verdure…': Anne Archbald, 'The Vanity Box', *Theatre Magazine*, December 1922.

ESS VIOTTO

For accounts of women working in the First World War, see: Susan R. Grayzel, *Women's Identities at War: Gender, Motherhood, and Politics in Britain and France during the First World War*, University of North Carolina Press, 1999; Deborah Thom, *Nice Girls and Rude Girls: Women Workers in World War I*, I.B. Tauris, 1998.

'Are your hands White, Soft and Beautiful…': Bronnley advertisement for Ess Viotto, featured in *The Sketch*, Volume 90, 1915.

ENGLISH LAVENDER

'There are some typically English things…': *The Sketch*, 7 April 1915.

'In a ride by rail from West Croydon to Sutton…': 'The Lavender Country', *The Farmer's Magazine*, July 1872.

'We had considered, and we continue to consider, Eau de Cologne indispensable…': *The Sketch*, 13 December 1916.

LE BOUQUET PRÉFÉRÉ DE L'IMPÉRATRICE

For an overview of Soviet perfumes, see: http://www.realussr.com/ussr/soviet-brands-the-scent-of-communism-part-1-of-2/, accessed 28 April 2015; Susan E. Reid, 'Gender and the Destalinisation of Consumer Taste in the Soviet Union Under Khrushchev' in Emma Casey and Lydia Martens (eds), *Gender and Consumption: Domestic Cultures and the Commercialisation of Everyday Life*, Ashgate, 2007.

'what would happen if all our cakes and pastries were to take on the aroma of "Red Moscow"?': Elena Skrjabina, *After Leningrad: A Diary of Survival During World War II*, Southern Illinois University Press, 1978.

For an outline of *kulturnost* in Soviet culture, see: Oleg Kharkhordin, 'Reveal and Dissimulate: A Genealogy of Private Life in Soviet Russia' in Jeff Weintraub and Krishan Kumar (eds), *Public and Private in Thought and Practice: Perspectives on a Grand Dichotomy*, University of Chicago Press, 1997.

'characteristically Russian, sweet and cloying…': 'Perfume Commemorates Joint Space Mission', *Lakeland Ledger*, 16 July 1975.

LE FRUIT DÉFENDU

For more on the early silent-film production of *Snow White*, see: Robert K. Klepper, *Silent Films, 1877–1996: A Critical Guide to 646 Movies*, McFarland, 1999.

CHYPRE

On François Coty and his fragrance business, see: Roulhac B. Toledano and Elizabeth Z. Coty, *François Coty: Fragrance, Power, Money*, Pelican, 2009.

MITSOUKO

On the history of Guerlain fragrances, see: Colette Fellous, *Guerlain*, Denoël, 1987.
In-depth coverage of Guerlain's range can be found at http://www. monsieur-guerlain.com, accessed 28 April 2015.

The Roaring Twenties: 1920–1929

Anonymous, *Meditations of a Flapper. By One*, Dranes, 1922.
Brogan, Hugh, *The Penguin History of the United States of America*, 2nd edn, Penguin, 2001.
Gorman, Daniel, *The Emergence of International Society in the 1920s*, Cambridge University Press, 2012.
Marshik, Celia (ed.), *The Cambridge Companion to Modernist Culture*, Cambridge University Press, 2014.
Miller, Nathan, *New World Coming: The 1920s and the Making of Modern America*, DaCapo Press, 2004.
Moore, Lucy, *Anything Goes: A Biography of the Roaring Twenties*, Atlantic, 2009.
Peretti, Burton W., *Nightclub City: Politics and Amusement in Manhattan*, University of Pennsylvania Press, 2007.
Taylor, D.J., *Bright Young People: The Rise and Fall of a Generation 1918–1940*, Vintage, 2008.

INTRODUCTION

Account of schoolgirls ingesting perfume from 'Oppose Perfume Eaters', *New York Times*, 29 January 1924.
'Once a woman has become accustomed to the use of perfumes and toilet preparations…': 'Perfume and Toilet Goods Trades on Solid Basis', *The American Perfumer and Essential Oil Review*, March 1921.

On trade responses to the Volstead Act, see: 'A National Menace', *The American Perfumer and Essential Oil Review*, June 1921.

'revealing at its top the face and figure of Dorothy Neville...': 'Mi Lady's Perfumes', *Variety*, March 1927.

'familiar with common perfumes like Coty and Houbigant...': Stefan Zweig, *The Post Office Girl*, trans. Joel Rotenberg, Sort Of Books, 2009.

'Stay here and don't make any noise...': '$20,000 Perfume on Truck is Stolen', *New York Times*, 26 November 1927.

'You cannot illustrate the products you sell...': Howard S. Neiman, 'The Psychology of Trademarks', *The American Perfumer and Essential Oil Review*, May 1921.

HABANITA

'We only know ABDULLA's best, so cheered and braced...': Abdulla cigarette advertisement can be viewed, at: http://tomboystyle.blogspot.co.uk/2014/06/moment-abdulla-advertisements-of-1920s.html, accessed 10 May 2015.

On the popularisation of cigarettes, see Allan M. Brandt, *The Cigarette Century: The Rise, Fall, and Deadly Persistence of the Product that Defined America*, Basic Books, 2007; Francesca Middleton, *Women, Smoking and the Popular Imagination of the 1920s: From Squalor to Glamour*, University of London, 2002.

Nº 5

For a full history of Chanel Nº 5, see: Tilar J. Mazzeo, *The Secret of Chanel Nº 5: The Intimate History of the World's Most Famous Perfume*, HarperCollins, 2010.

For biographical accounts of Gabrielle Chanel, see: Lisa Chaney, *Chanel: An Intimate Life*, Penguin, 2012; Axel Madsen, *Coco Chanel: A Biography*, Bloomsbury, 2009; Paul Morand, *The Allure of Chanel*, trans. Euan Cameron, Pushkin Press, 2008; Justine Picardie, *Coco Chanel: The Legend and the Life*, Harper, 2013; Hal Vaughan, *Sleeping with the Enemy: Coco Chanel's Secret War*, Vintage, 2012.

'Grab your partner one an' all...': Fred W. Longshaw and Richard E. Thompson, 'At the Christmas Ball', performed by Bessie Smith, *Preachin' the Blues*, 1925.

NUIT DE NOËL

'This winter, New Yorkers have been trying to prove...': 'New York Heeds the Call of Fancy Dress, *Vogue*, American edition, April 15 1922.

On the history of champagne see: Serena Sutcliffe, *A Celebration of Champagne*, Mitchell Beazley, 1988.

On Edward VII's proclivity for champagne baths, see: Jane Ridley, *Bertie: A Life of Edward VII*, Chatto & Windus, 2012.

For an overview of Prohibition in the United States, see: Edward Behr, *Prohibition: Thirteen Years That Changed America*, Skyhorse Publishing, 2011; Daniel Okrent, *Last Call: The Rise and Fall of Prohibition*, Scribner Book Company, 2011.

On Earl Carroll's reputation for racy shows, see: 'Earl Carroll Producer', *The Milwaukee Sentinel*, 1 November 1926.

'any man, even a minister…': 'News of "Wild Party" Starts Investigation', *Modesto News Herald*, 25 February 1926.

On court proceedings relating to the prosecution of Earl Carroll, see: http://law.justia.com/cases/federal/appellate-courts/F2/16/951/1481403/, accessed 11 May 2015.

For accounts of Earl Carroll's trial and prison sentence, see: 'Earl Carroll on Trial for Perjury in Bathtub Case', *The Montreal Gazette*, 21 May 1926; 'Earl Carroll Will Start for Prison on April 12', *The Pittsburgh Press*, 4 April 1927.

'Three be the things I shall never attain…': Dorothy Parker, 'Inventory Poem', *Enough Rope Poems*, Bony & Liveright, 1926.

'Mirrors and lights to dazzle them, jazz to excite them…': Robert Forrest Wilson, *Paris on Parade*, Bobbs-Merrill, 1925.

LE DANDY

'a perfumed pest with a silky beard…': Oliver Herford, *The Deb's Dictionary*, Methuen & Co., 1932.

An overview of Dandyism in the 1920s can be found in: Catherine R. Mintler, 'From Aesthete to Gangster: The Dandy Figure in the Novels of F. Scott Fitzgerald', *The F. Scott Fitzgerald Review*, Volume 8, 2010.

On jazz musician Lesley Hutchinson's link with Chanel N°5, see: Charlotte Breese, *Hutch*, Bloomsbury, 1999.

For a biography of Stephen Tennant, see: Philip Hoare, *Serious Pleasures: Life of Stephen Tennant*, Penguin, 1992.

Interview with Stephen Tennant's great-nephew, including reference to Worth fragrances: Rebecca Wallersteiner, 'The Brightest Young Thing', *The Lady*, 30 November 2001.

On the revival of the D'Orsay name as fragrance house in the twentieth century, see: http://fr.wikipedia.org/wiki/D'Orsay_(maison_de_parfum), accessed 11 May 2015; Nick Groom, *The New Perfume Handbook*, 2nd edn, Blackie Academic and Professional, 1997.

'Worthy of Him. Worthy of You.': D'Orsay advertisement for Le Dandy, featured in *Vogue*, American edition, 13 October 1930.

GARDENIA

For trade accounts of gardenia's increasing popularity in perfumes and beauty-counter displays, see: *Druggists' Circular*, Volume 80, 1936; *Perfumery and Essential Oil Record*, Volume 28, 1937.

'enveloping...filling...stifling...': Aldous Huxley, *Point Counter Point*, Doubleday, Doran and Co., 1928.

AMOUR AMOUR; QUE SAIS-JE?; ADIEU SAGESSE

'The most difficult woman always...' and 'For this one – this slim, fragile little woman...': 'The Cult of the Nose', *Vogue*, American edition, 15 May 1925.

'strong, pungent scents have a depressing effect upon the golden-haired...': 'Perfumes and Personality', *Arts and Decoration*, June 1925.

TUTANKHAMON PHARAOH SCENT

For a comprehensive account of Egyptomania, see: Bob Brier, *Egyptomania: Our Three Thousand Year Obsession with the Land of the Pharaohs*, Palgrave Macmillan, 2013.

'Nubian slaves lead the Queen to her bath...': Dudley S. Corlett, 'The Kohl Pots of Egypt', *Vogue*, American edition, 1 September 1923.

'From father to eldest son in each generation...': Clara E. Laughlin, *So You're Going to the Mediterranean! And if I Were Going with You These Are the Things I'd Invite You to Do*, Houghton Mifflin Company, 1935.

HUILE DE CHALDÉE

For tanning as style statement in the 1920s, see: Alys Eve Weinbaum et al. (eds), *The Modern Girl Around the World: Consumption, Modernity, and Globalization*, Duke University Press, 2008.

Quotations about the Deauville scene taken from: 'Deauville Diversions (Being the Musings of Miranda)', *The Sketch*, 2 August 1922 and 30 August 1922.

ZIBELINE

For statistics on the popularity of furs in this period, see: Carol Dyhouse: 'Skin Deep: The Fall of Fur', *History Today*, 22 February 2012.

On the history of fur clothing, see: Chantal Nadeau, *Fur Nation: From the Beaver to Brigitte Bardot*, Routledge, 2001.

'There was a different scent in the fur department, heavier...': Dodie Smith, *I Capture the Castle*, William Heinemann, 1948.

'among the coats and rubbed her face against them...': C.S. Lewis, *The Lion, The Witch and the Wardrobe*, Geoffrey Bles, 1950.

The Threatening Thirties: 1930–1939

Basinger, Jeanine, *The Star Machine*, Vintage, 2009.

Gardiner, Juliet, *The Thirties: An Intimate History*, HarperPress, 2011.

Horwood, Catherine, *Keeping Up Appearances: Fashion and Class Between the Wars*, The History Press, 2011.

Mcdonald, Paul, *The Star System: Hollywood's Production of Popular Identities*, Columbia University Press, 2001.

Pugh, Martin, *We Danced All Night: A Social History of Britain Between the Wars*, Vintage, 2009.

INTRODUCTION

On perfume used in psychological therapy, see: 'Nightmare Routed by Music, Perfume', *New York Times*, 17 May 1935.

Revillon advertisement, in: *Time*, 17 May 1937.

'Marcel Rochas is doing one that is wonderfully smart...': 'Beauty Notes from Paris', *Harper's Bazaar*, UK edition, March 1937.

On the debutante lifestyle, see: Anne de Courcy, *1939: The Last Season*, Weidenfeld & Nicolson, 2012; Lucinda Gosling, *Debutantes and the London Season*, Shire Publications, 2013.

'chypre, which used in former days...': *The Queen*, c. 1936 (issue unknown).

'We can see little masked ladies, looking out of moonlit windows...': Edith Sitwell, *Harper's Bazaar*, UK edition, c. 1936 (issue unknown).

SKIN BRACER

'Feel its ice-cool, stimulating tingle...': Mennen advertisement for Skin Bracer, featured in *LIFE*, 8 October 1945.

For an account of the product's use in the Korean War, see: Robert W. Black, *A Ranger Born: A Memoir of Combat and Valor from Korea to Vietnam*, Random House Publishing Group, 2007.

SCANDAL

On perfume dispensers, see: Kerry Segrave, *Vending Machines: An American Social History*, McFarland & Co., 2002.

On Guerlain's legal pursuit of perfume re-bottling, see: https://casetext.com/case/guerlain-inc-v-woolworth-co-1, accessed 11 May 2015.

VOL DE NUIT

On early flight, see: Tom D. Crouch, *Wings: A History of Aviation from Kites to the Space Age*, Norton, 2004.

For the novel which inspired Guerlain's fragrance, see: Antoine de Saint-Exupéry, *Vol de Nuit*, Gallimard, 1931.

'Tipped...in indecision...': Elizabeth Bowen, *To the North*, Penguin, 1932.

TWEED

For a history of Harris Tweed, see: Francis G. Thompson, *Harris Tweed: The Story of a Hebridean Industry*, A.M. Kelley, 1968.

'because pungent lichens and herb roots, peat smoke, fire and water are used...': 'Rustic Cloth Goes to Night Clubs', *LIFE*, 17 October 1939.

BLUE GRASS

On Elizabeth Arden's business, including an account of Blue Grass being used in the horse stables, see: Lindy Woodhead, *War Paint, Madame Helena Rubinstein and Miss Elizabeth Arden: Their Lives, Their Times, Their Rivalry*, Virago, 2012.

For the design of the Maine Chance spa, see: Victoria Sherrow, *For Appearance' Sake: The Historical Encyclopedia of Good Looks, Beauty, and Grooming*, The Oryx Press, 2001.

'reached such a nervous pitch in the last few years...': 'Getting Away From It All', *Vogue*, American edition, 15 May 1933.

'In the midst of Sybaritic surroundings...' and 'You see the lake gleaming down the hill...': 'Give Yourself the Maine Chance', *Vogue*, American edition, 15 April 1937.

FLEURS DE ROCAILLE

'depicting squalor, sordidness and depravity...': Caron Corporation v. R.K.O. Radio Pictures, Inc., 28 N.Y.S. 2d 1020 (N.Y. App. Div. 1941).

For coverage of Caron's legal action against R.K.O. for placement of Fleurs de Rocaille in *Primrose Path*, see: *Variety*, 27 March 1940.

SHOCKING

On Elsa Schiaparelli, her life and her fashion house, see: Elsa Schiaparelli, *Shocking Life: The Autobiography of Elsa Schiaparelli*, J.J. Dent & Sons Ltd, 1954; Patricia Volk, *The Art of Being a Woman: My Mother, Schiaparelli, and Me*, Hutchinson, 2013; Judith Watt, *Vogue on: Elsa Schiaparelli*, Quadrille, 2012.

'Has she not the air of a young demon who tempts women...': Jean Cocteau, 'From Worth to Alix', *Harper's Bazaar*, March 1937.

OLD SPICE

For the history of Shulton and Old Spice collectibles, see: http://www.
oldspicecollectibles.com/, accessed 29 April 2015.

COLONY

For an account of Jean Patou's perfume cocktail bar, see http://
jeanpatouperfumes.blogspot.co.uk/2013/07/cocktail-by-jean-patou-c1931.
html, accessed 29 April 2015.

'It is the inevitable reaction to the English fog...': Mrs James Rodney,
'To and Fro', *Harpers Bazaar*, January 1937.

'You can credit them convincingly...': Peter Fleming, 'Cameras Over Cathay',
Harper's Bazaar, June 1937.

ALPONA

On the history of skiing and ski resorts, see: Roland Huntford, *Two Planks
and a Passion*, Bloomsbury Continuum, 2013.

Ski fashions of the 1930s depicted in: Jenny De Gex, *The Art of Skiing: Vintage
Posters from the Golden Age of Winter Sport*, Universe, 2006.

For the story of Sun Valley, Idaho, see: E. John B. Allen, *From Skisport to
Skiing: One Hundred Years of an American Sport, 1840–1940*, University of
Massachusetts Press, 1993; Wendolyn Holland, *Sun Valley: An Extraordinary
History*, The Idaho Press, 1998; Van Gordon Sauter, *The Sun Valley Story*,
Mandala Media LLC, 2011.

The Insubordinate Forties: 1940–1949

Calder, Angus, *The People's War: Britain, 1939–45*, Jonathan Cape, 1969.

Dillon, Steven, *Wolf-Women and Phantom Ladies: Female Desire in 1940s US
Culture*, State University of New York, 2015.

Dirix, Emmanuelle, *1940s Fashion: The Definitive Sourcebook*, Carlton Books,
2014.

Rose, Sonya O., *Which People's War?: National Identity and Citizenship in Wartime
Britain, 1939–1945*, Oxford University Press, 2003.

Summers, Julie, *Fashion on the Ration: Style in the Second World War*, Profile,
2015.

Veillon, Dominique, *Fashion Under the Occupation*, trans. Miriam Kochan,
Berg, 2002.

INTRODUCTION

'The scent is still fresh, isn't it?...': Daphne du Maurier, *Rebecca*, Victor Gollancz, 1938.

'cut as softly as tempered steel into what could have been the fug of a sickbay...': Eric Baume, 'Perfume', *Britannia and Eve* magazine, October 1943.

CHANTILLY

On romance fiction, see: Jennifer McKnight-Trontz, *The Look of Love: The Art of the Romance Novel*, Princeton Architectural Press, 2002; Tania Modleski, *Loving with a Vengeance: Mass-Produced Fantasies for Women*, 2nd edn, Routledge, 2007.

DRI-PERFUME

On black-market trading and smuggling, see: 'Lifetime Perfume Proved Short-Lived', *New York Times*, 21 November 1944.

Q&A feature on perfume shortages, in: 'Perfume???', *Vogue*, American edition, November 1942.

On rising demand for fragrances in the United States, see: 'Shoppers Here Breaking Sales Records, With All Types of Goods in Heavy Demand', *New York Times*, 16 December 1944.

For negotiations on relieving blockades, see: 'Release is Sought of Perfume Bases', *New York Times*, 9 June 1941.

'A tale is told of vast supplies of jasmin extract stored at Casablanca...': Martha Parker, 'Beauty: New Perfumes', *New York Times*, 28 February 1943.

On attempts to cultivate naturals in the United States, see: 'U.S. Is Developing Oils For Perfume', *New York Times*, 11 April 1942.

For the growth in sachet scents, see: 'Powder Perfumes Gain in Popularity', *New York Times*, 31 May 1944; 'Dry Perfume', *Tide: The Newsmagazine of Advertising and Marketing*, 15 August 1944.

FEMME

For an account of Femme's creation, see: Michael Edwards, *Perfume Legends: French Feminine Fragrances*, Michael Edwards & Co., 1996.

On Rochas' atelier in the post-war years, see: Alice K. Perkins, *Paris Couturiers and Milliners*, Fairchild Publications, 1949.

WHITE SHOULDERS

'The whiteness of the glazed observatory...': Herman De Bachelle Seebold, *Old Louisiana Plantation Homes and Family Trees*, Pelican Press, 1941.

Tennessee Williams, *A Streetcar Named Desire*, New Directions, 1947.

BLACK SATIN

'they have attacked potential customers by spraying perfume wholesale into city streets…' and for the story of Granville and Swartout, see: Percy Knauth, 'How to Sell a Smell', *LIFE*, 4 December 1950.

On Angelique's perfume-spraying car, see: Bett Adams, 'Black Satin's Coming!' *The Miami News*, 2 February 1952.

On Swartout's move to the Virgin Islands, see: 'Swartouts Retire to V.I.', *Sunday Herald*, 29 September 1957.

On the injunction placed on the firm by the Securities and Exchange Commission, see: 'Took Whiff of Stock: SEC Got on Scent of Perfume Maker', *Sunday Herald*, 3 May 1959.

OH!

Claude Marsan's promotional strategies are detailed in: 'Speaking of Pictures…Frenchman Demonstrates Correct Way to Make Love', *LIFE*, 20 January 1947.

For some lively reader letters prompted by their feature on Claude Marsan, see: *LIFE*, 10 February 1947.

For a report on men allegedly 'calling' for Claude Marsan to leave their town, see: 'Texans World's Worst Lovers? Unwed Frenchman Says We Are', *El Paso Herald-Post*, 29 August 1947.

For an account of Claude Marsan's arrest, see: 'Police Disrupt Love Class, Hold Teacher', *The Salt Lake Tribune*, 21 November 1948.

'portions of your performance were so lewd and obscene…': '"Expert" Asserts Love is Relative', *The Monroe News-Star*, 4 February 1949.

'I am aggrieved in my heart…', Claude Marsan's response to the verdict: 'Letters to the Editors', *LIFE*, 21 February 1949.

ST JOHNS BAY RUM

A corporate history of Bay Rum can be found at: http://www.stjohnsbayrum. com/pages/three-generations-of-st-johns-bay-rum, accessed 1 May 2015.

For opinions on the impact of Prohibition on the export of Bay Rum, see: 'West Indies Welcome Rum Trade Revival', *The Literary Digest*, 17 February 1934; Ray Lyman Wilbur and William Atherton Du Puy, *Conservation in the Department of the Interior*, United States Government Printing Office, 1931; *Modification or Repeal of National Prohibition: Hearings, Seventy-Second Congress, First Session*, 2 Volumes, US Government Print Office, 1932.

Webb's distinctive Bay Rum packaging was eventually protected in 1962 after a ruling against a competitor. See: *The Virgin Islands Daily News*, 3 July 1962.

MA GRIFFE

For contemporary discourse about young people and emergent teenage cultures, see: Maureen Daly (ed.), *Profile of Youth: By Members of the Staff of the Ladies' Home Journal*, Lippincott, 1951.

L'AIR DU TEMPS

'A tenth muse, called Osme, Greek for perfume...': Virginia Pope, 'New Perfume has Impressive Debut', *New York Times*, 28 March 1945.
On the construction of L'Air du Temps and its influence on subsequent fragrances, see: Robert R. Calkin and J. Stephan Jellinek, *Perfumery: Practice and Principles*, John Wiley & Sons, 1994.

FRACAS

On the femme fatale in noir cinema, see: Julie Grossman, *Rethinking the Femme Fatale in Film Noir: Ready for Her Close-Up*, Palgrave Macmillan, 2009; William Luhr, *Film Noir*, Wiley-Blackwell, 2012; Alain Silver et al. (eds), *Film Noir: The Encyclopedia*, 4th edn, Gerald Duckworth & Co., 2010.
'How could I have known...': line quoted from Billy Wilder (director), Billy Wilder and Raymond Chandler (screenplay), *Double Indemnity*, Paramount Pictures, 1944.
For fragrance in the Phillip Marlowe mysteries, see: Raymond Chandler, *The Big Sleep*, Alfred A. Knopf, 1939; Raymond Chandler, *The Lady in the Lake*, Alfred A. Knopf, 1943.

The Elegant Fifties: 1950–1959

Abrams, Nathan, and Hughes, Julie, *Containing America: Cultural Production and Consumption in 50s America*, Bloomsbury Academic, 2005.
Jones, Darryl et al. (eds), *It Came from the 1950s! Popular Culture, Popular Anxieties*, Palgrave Macmillan, 2011.
Mort, Frank, *Capital Affairs: London and the Making of the Permissive Society*, Yale University Press, 2010.
Palmer, Alexandra, *Couture and Commerce: The Transatlantic Fashion Trade in the 1950s*, University of British Columbia Press, 2001.
Reed, Paula, *Fifty Fashion Looks that Changed the 1950s*, Conran, 2012.
Spigel, Lynn, *Welcome to the Dreamhouse: Popular Media and Postwar Suburbs*, Duke University Press, 2001.

INTRODUCTION

On the growth in advertising spend, see: http://adage.com/article/adage-encyclopedia/history-1950s/98701/, accessed 2 May 2015.

'The ordinary woman persists in the belief…': *The Economist*, 21 April 1956, cited in Elizabeth Wilson, *Women and the Welfare State*, Routledge, 2002.

WIND SONG

'He created individual scents to dramatize…': advertisement for Prince Matchabelli fragrances, featured in *Spokane Daily Chronicle*, 20 December 1957.

JOLIE MADAME

'When lunching in a restaurant, a lady removes her coat…': 'Glove Etiquette, compliments of Paris Gloves', at: http://www.retrowaste.com/1950s/fashion-in-the-1950s/1950s-gloves-etiquette-styles-trends-pictures/, accessed 2 May 2015.

'She walked with long, easy strides, her arms motionless…' and 'to justify her title…': Pierre Balmain, *My Years and Seasons*, Cassell, 1964.

YOUTH DEW

On the growth of the suburbs in 1950s America, see: Dianne Harris, *Second Suburb: Levittown, Pennsylvania*, University of Pittsburgh Press, 2010.

On home conveniences of the 1950s, see: Diane Boucher, *The 1950s American Home*, Shire, 2013; Kathryn Ferry, *The 1950s Kitchen*, Shire, 2011.

NOA NOA

'The denizens of the great concrete jungle…': Hal Boyle, 'Big City Cocktail Party Great Place for Study of Animal Life!', *Moberly Monitor-Index*, 26 September 1953.

For an analysis of Les Baxter and trends in music, see: Philip Hayward, *Widening the Horizon: Exoticism in Post-War Popular Music*, John Libbey Publishing, 1997.

For cocktail-party etiquette, see: Joseph Russell Lynes, *A Surfeit of Honey: On Contemporary American Manners and Customs*, Harper, 1957.

'a mingled perfume, half animal, half vegetable': Paul Gauguin, *Noa Noa: The Tahitian Journal*, trans. O.F. Theis, Nicholas L. Brown, 1919.

'their flower-framed faces…': Helen Rubinstein advertisement for Noa Noa, featured in *Vogue*, American edition, 15 November 1954.

'toasted coconut chips, canned poi…': June Owen, 'New Party Service Features Everything That's Hawaiian, *New York Times*, 9 June 1955.

WHITE FIRE

On British social history of the 1950s, see: David Kynaston, *Family Britain, 1951–57 (Tales of a New Jerusalem)*, Bloomsbury, 2010; Virginia Nicholson, *Perfect Wives in Ideal Homes: The Story of Women in the 1950s*, Viking, 2015.

PINO SYLVESTRE

On the rise in car ownership in Britain, see: http://www.vads.ac.uk/learning/designingbritain/html/crd_cultrev.html, accessed 2 May 2015.

For the story of Julius Sämann, see: Hilary Greenbaum and Dana Rubinstein, 'Who Made Those Little Trees Air Fresheners?', *New York Times Magazine*, 2 March 2012.

On Car-Freshner's legal action against competitors, see: http://www.worldipreview.com/article/norway-court-rules-in-air-freshener-case, accessed 11 May 2015.

'Then a sudden wind sprang up, a rain wind...': John Cheever, 'The Chimera', *The New Yorker*, 1 July 1961.

DIORISSIMO

'This is the way I want to live...': '*Vogue*'s Perfume Coloring Book', *Vogue*, American edition, 15 November 1962.

'You know who "they" are...': George Gobel, 'How to Take Command at the Perfume Counter', *Vogue*, American edition, December 1957.

Perfume-buying tips for husbands from: 'Perfume Investment Guide for Men', *Vogue*, American edition, December 1958.

On the life of Christian Dior, see: Marie France Pochna, *Christian Dior: The Man Who Made the World Look New*, Arcade Publishing, 1996.

HYPNOTIQUE

Rona Jaffe, *The Best of Everything*, Simon & Schuster, 1958.

'the fragrance we use at night we should use for others...': Catherine Finerty, 'Different Women After Five. Fragrance Is What They Remember You By', *Charm*, October 1954.

'Remember, if *you* can't smell it, probably *he* can't smell it...': Helen Gurley Brown, *Sex and the Single Girl*, B. Geis Associates, 1962.

'make him concentrate...': Max Factor advertisement for Hypnotique, c.1960, at: http://www.parfumo.net/Perfumes/Max-Factor/Hypnotique, accessed 13 July 2015.

'born to enchant men...': Max Factor advertisement for Hypnotique, featured in *The Raleigh Register*, 3 November 1958.

On the Bridey Murphy phenomenon, see: Herbert Brean, 'Bridey Murphy Puts Nation in a Hypnotizzy', *LIFE*, 19 March 1956.

On the art and conventions of adventure magazines, see: Max Allan Collins et al., *Men's Adventure Magazines in Postwar America: The Rich Oberg Collection*, Taschen, 2008; Adam Parfrey, *It's a Man's World: Men's Adventure Magazines – The Postwar Pulps*, Feral House, 2002.

For a wider survey of masculinity, see: David M. Earle, *All Man!: Hemingway, 1950s Men's Magazines, and the Masculine Persona*, Kent State University Press, 2009.

'strong, vigorous, and even lusty – at least in appearance...': Clint Dunathan, 'Good Evening', *The Escanaba Daily Press*, 11 April 1949.

'men have invaded the nice-smell market...': C. Patrick Thompson, 'The Perfumed Age', *Britannia and Eve*, March 1949.

The Swinging Sixties: 1960–1969

Boyreau, Jacques, *The Male Mystique: Men's Magazine Ads of the 1960s and '70s*, Chronicle Books, 2004.

Cracknell, Andrew, *The Real Mad Men: The Renegades of Madison Avenue and the Golden Age of Advertising*, Running Press, 2012.

Evans, Paul, *The 1960s Home*, Shire Publishing, 2010.

Forbes, Evelyn, *Hairdressing and Beauty as a Career*, B.T. Batsford, 1961.

Holdeman, Angie, *'It's a Man's, Man's, Man's World': Popular Figures and Masculine Identities in 1960s America*, California State University, 2007.

Miles, Barry: *London Calling: A Countercultural History of London Since 1945*, Atlantic Books, 2010.

Ogilvy, David, *Confessions of an Advertising Man*, Mayflower Books, 1966.

INTRODUCTION

'Feebly. Very feebly': Caron advertisement for Fleurs de Rocaille, 1963, at: http://file.vintageadbrowser.com/6r3ishbrn9ii80.jpg/, accessed 19 May 2015.

'You're only young once, *or twice!*': Coty advertisement for Emeraude, 1964, at: http://file.vintageadbrowser.com/udosht2m067au5.jpg/, accessed 19 May 2015.

'virile message...half man, half beast, all male!': Century Creations advertisement for Centaur Cologne, 1967, at: http://vintage-ads.livejournal.com/3698754.html, accessed 13 July 2015.

BAL À VERSAILLES

Michael Jackson's alleged use of the scent, at: http://www.jeandesprez.com/balaversaillesexclusive.html, accessed 3 May 2015.

BRUT

'When Men's faces are drawn with resemblance to some other Animals...': Thomas Browne, *Christian Morals – With the Life of the Author*, Read Books, 2008.

'Oh, you great big beautiful Brut...': Fabergé advertisement for Brut, 1960s, at: http://brutaftershave.blogspot.co.uk, accessed 13 July 2015.

'all over': Fabergé advertisement for Brut 33, c.1976, at: https://www.youtube.com/watch?v=C5tLfiu7an4, accessed 15 July 2015.

On the performance-enhancing use of testosterone, see: John M. Hoberman and Charles E. Yesalis, 'The History of Synthetic Testosterone', *Scientific American*, February 1995.

On theories of the brain and and the Human Potential movement, see: http://www.theatlantic.com/technology/archive/2014/07/you-already-use-way-way-more-than-10-percent-of-your-brain/374520/, accessed 12 May 2015.

ZEN

'There was never a time when the world began...': Alan Watts, *The Book: On the Taboo Against Knowing Who You Are*, Souvenir Press, 2009.

'Even if he isn't your daddy': Regency Cosmetics advertisement for Jade East, featured in *Ebony*, June 1969.

'So who are you? That must remain undefined...': 'Watts on Zen', *LIFE*, 21 April 1961.

The corporate history of Shiseido, in: Geoffrey Jones, *Beauty Imagined: A History of the Global Beauty Industry*, Oxford University Press, 2011.

PRETTY PEACH

On toys in the mid-twentieth century, see: Stephen Kline, *Out of the Garden: Toys, TV, and Children's Culture in the Age of Marketing*, Verso Books, 1995; M.G. Lord, *Forever Barbie: The Unauthorized Biography of a Real Doll*, William Morrow, 1994.

OH! DE LONDON

On 1960s London, see: David Johnson and Roger Dunkley, *Gear Guide, 1967: Hip-Pocket Guide to Britain's Swinging Carnaby Street Fashion Scene*, Atlas, 1967; Rainer Metzger, *London in the Sixties*, Thames & Hudson, 2012.

'Oh! Silly curls...': Yardley advertisement for Oh! de London, 1960s, at: http://www.parfumo.net/Perfumes/Yardley/Oh_de_London, accessed 13 July 2015.

EAU SAUVAGE

For sample Eau Sauvage advertisements, see: http://www.hprints.com/search/Eau-Sauvage-Christian-Dior/, accessed 12 May 2015.

On bachelor lifestyles in post-war America, see: Elizabeth Fraterrigo, *'Playboy' and the Making of the Good Life in Modern America*, Oxford University Press, 2009; Bill Osgerby, *Playboys in Paradise: Masculinity, Youth and Leisure-Style in Modern America*, Bloomsbury Academic, 2001.

On bathrooms and grooming, see: David Grayson, 'The Man in his Bath', *Playboy*, July 1957.

HAI KARATE

'spring from the knees...'Get her in a good, tight half nelson...': Chas. Prizer & Co. advertisement for Hai Karate, featured in *LIFE*, 6 October 1967.

PATCHOULI OIL

'nagging urge to rebel against the dead middle...': Jenny Diski, *The Sixties*, Profile Books, 2010.

'Children of Lysol, Listerine, and Wonder Bread...' and 'We wanted baptismal immersion in the film of dust, the press of flesh...': Annie Gottlieb, *Do You Believe in Magic?: The Second Coming of the 60's Generation*, Times Books, 1987.

On travelling to India in the 1960s, see: Rory MacLean, *Magic Bus: On the Hippie Trail from Istanbul to India*, Penguin, 2008.

'who complained to the local Citizens' Advice Bureau about being refused service...': 'The Last Word on...Aromatic Males', *New Scientist*, 1 May 1974.

CALANDRE

For Paco Rabanne's fashions, see: Jean Clemmer and Paco Rabanne, *Nues*, Éditions Pierre Belfond, 1969.

Account of Calandre's creation, from: Michael Edwards, *Perfume Legends: French Feminine Fragrances*, Michael Edwards & Co., 1996.

The Spangly Seventies: 1970–1979

Dirix, Emmanuelle, *1970s Fashion: The Definitive Sourcebook*, Goodman-Fiell, 2014.

Kaufman, Will, *American Culture in the 1970s*, Edinburgh University Press, 2009.

Sandbrook, Dominic, *State of Emergency: The Way We Were: Britain, 1970–1974*, Penguin, 2011.

Sandbrook, Dominic, *Seasons in the Sun: The Battle for Britain, 1974–1979*, Penguin, 2013.

Schulman, Bruce J., *The Seventies: The Great Shift in American Culture, Society, and Politics*, Da Capo Press, 2001.

Shepherd, Janet, and Shepherd, John, *1970s Britain*, Shire Publications, 2012.

INTRODUCTION

On the blockbuster Hollywood movie, see: Tom Shone, *Blockbuster: How the Jaws and Jedi Generation Turned Hollywood into a Boom-Town*, Simon & Schuster, 2004.

On Boots' share of the British beauty market, see: Geoffrey Jones, *Beauty Imagined: A History of the Global Beauty Industry*, Oxford University Press, 2010.

On the women's liberation movement's foray into perfume-blending, see: Kay Marsh, 'The Scent-agon Papers', *The Daily Herald*, 18 August 1971.

RIVE GAUCHE

On changing female roles and identities in television and advertising, see: Sherrie A. Inness (ed.), *Disco Divas: Women and Popular Culture in the 1970s*, University of Pennsylvania Press, 2003.

AROMATICS ELIXIR

'They chose orange flower because it's soothing…': 'Scent with Intent', *Vogue*, American edition, December 1971.

For the popularisation of aromatherapy in Britain, see: J. Bensouilah, 'The History and Development of Modern-British Aromatherapy', *The International Journal of Aromatherapy*, Volume 15, Issue 3, 2005; Robert Tisserand, *The Art of Aromatherapy*, C.W. Daniel Co., 1977.

Nº 19

Turin, Luca, and Sanchez, Tania, *Perfumes: The A–Z Guide*, Profile, 2008.

MUSK OIL

On ballads and denigrated music of the 1970s, see: Mitchell Morris, *The Persistence of Sentiment: Display and Feeling in Popular Music of the 1970s*, University of California Press, 2013.

Life of Barry Shipp from his obituary, at: http://articles.chicagotribune.
com/1999-09-08/news/9909080032_1_mr-shipp-fragrance-sold/,
accessed 12 May 2015.
Jōvan advertisement for Musk Oil, featured in *Ebony*, December 1975.

DIORELLA

On the influence of Biba, see: Barbara Hulanicki, *From A to BIBA*, Hutchinson
& Co., 1983; Barbara Hulanicki, *The Biba Years: 1963–1975*, V&A Publishing,
2014.
'Breezy. Unaffected. Elegant, but relaxed about it…': 'Fall Fashions in
Fragrance', *Vogue*, American edition, September 1973.

CHARLIE

'You got to keep tight at the ass…': Andrew P. Tobias, *Fire and Ice: The Story of
Charles Revson, the Man Who Built the Revlon Empire*, William Morrow & Co.,
1976.
'Do sables excite you…': Revlon advertisement for Fire and Ice lipstick,
featured in *LIFE*, 10 November 1952.
'You want more out of life…' and 'gorgeous sexy-young smell': Revlon
advertisement for Charlie, featured in *Pittsburgh Post-Gazette*, 26 March
1973.
On the influence of disco culture, see: Alan Jones and Jussi Kantonen,
Saturday Night Forever: The Story of Disco, Mainstream Publishing, 1999;
Peter Shapiro, *Turn the Beat Around: The Rise and Fall of Disco*, Faber &
Faber, 2009.

BABE

On representations of adolescence and the 1970s youth market, see: Patrick
E. Jamieson and Daniel Romer (eds), *The Changing Portrayal of Adolescents
in the Media Since 1950*, Oxford University Press, 2008.
'You're the babe…': Fabergé advertisement for Babe, 1977, at: https://www.
youtube.com/watch?rqQJCIChgA, accessed 13 July 2015.

OPIUM

On Sophie Dahl's controversial modelling campaign for Opium, see: http://
news.bbc.co.uk/1/hi/uk/1077165.stm/, accessed 12 May 2015.
On consumer cultures of the 1970s, see: Sam Binkley, *Getting Loose: Lifestyle
Consumption in the 1970s*, Duke University Press, 2007.
On Yves Saint Laurent's styles, see: Patricia Mears and Emma McClendon,
Yves Saint Laurent + Halston: Fashioning the '70s, Yale University Press, 2015.

For the influence and culture of Studio 54, see: Anthony Haden-Guest, *The Last Party: Studio 54, Disco, and the Culture of the Night*, William Morrow, 1997.

On the 'Me' Decade, see: Tom Wolfe, 'The "Me" Decade and the Third Great Awakening', *New York Magazine*, 23 August 1976.

MAGIE NOIRE

'How can you put a price tag on the thrill of being approached by a butler...': Henry Post, 'Going Baroque', *New York Magazine*, 29 June 1981.

On hedonism and party culture of the 1970s, see: Robert Hofler, *Party Animals: A Hollywood Tale of Sex, Drugs, and Rock 'n' Roll Starring the Fabulous Allan Carr*, Da Capo Press, 2010.

The Egotistical Eighties: 1980–1989

Turner, Alwyn W., *Rejoice! Rejoice!: Britain in the 1980s*, Aurum Press, 2010.

Rose, George, *Hollywood, Beverly Hills, and Other Perversities: Pop Culture of the 1970s and 1980s*, Ten Speed Press, 2008.

Evans, Peter William, and Deleyto, Celestino, *Terms of Endearment: Hollywood Romantic Comedy of the 80s and 90s*, Edinburgh University Press, 1990.

Honeycutt, Kirk, *John Hughes: A Life in Film*, Race Point Publishing, 2015.

Sivulka, Juliann, *Soap, Sex, and Cigarettes: A Cultural History of American Advertising*, Cengage Learning, 2011.

INTRODUCTION

'sweeter than any perfume else to women is good olive-oil...': Xenophon, *The Symposium*, trans. H.G. Dakyns, featured in: *The Complete Xenophon Anthology*, Bybliotech, 2012.

Morris, Desmond, *Manwatching: A Field Guide to Human Behavior*, Harry N. Abrams, 1979.

'Watch the men chat up the women. Watch them peering at the girls' faces...': Geoffrie W. Beattie, 'Truth and Lies in Body Language', *New Scientist*, 22 October 1981.

'you become credible and people listen to you...': Carole Jackson, *Color Me Beautiful*, Ballantine Books, 1985.

'"What is your glove size?" Kibbe, 32, asks a tall brunette...': Kim Hubbard, 'Even If You Look Like the Pentagon, Make-over Man David Kibbe Claims He Can Bring Out the Beauty Within', *People*, 26 October 1987.

'Everything you wear...': Lentheric advertisement for Tweed, 1980s, at: https://youtube.com/watch?v=47Gm_NjTWB0, accessed 15 July 2015.

'make a statement…': Coty advertisement for Ex'cla-ma'tion, featured in *Santa Cruz Sentinel*, 18 December 1989.

KOUROS

On 1980s action movies, see: Harvey O'Brien, *Action Movies: The Cinema of Striking Back*, Columbia University Press, 2012.

GIORGIO BEVERLY HILLS

'There are restaurants in New York that have signs up…': 'Bargepole', *Punch*, Volume 296, 21 April 1989.

On the life of Fred Hayman, see: Rose Apodaca, *Fred Hayman: The Extraordinary Difference – The Story of Rodeo Drive, Hollywood Glamour and the Showman Who Sold it All*, A+R Projects, 2011.

'people associate Giorgio with the rich and famous…': Rita Mercs, 'A Fuming Battle', *Orange Coast Magazine*, February 1989.

'Wealthy, Elegant. Wildly seductive.': Fred Hayman advertisement for 273, featured in *Sarasota Herald Tribune*, 17 September 1990.

WHITE MUSK

On the use of fragrance in laundry care, see: J.K. Funesti, 'Perfumery Applications: Functional Products', in P.M. Muller and D. Lamparsky (eds), *Perfumes: Art, Science and Technology*, Blackie Academic & Professional, 1994.

DRAKKAR NOIR

On yuppie 'culture', see: Marissa Piesman and Marilee Hartley, *The Yuppie Handbook: The State-of-the Art Manual for Young Urban Professionals*, Pocket Books, 1984.

VANDERBILT

On the life of Gloria Vanderbilt, see: Clarice Stasz, *The Vanderbilt Women: Dynasty of Wealth, Glamour, and Tragedy*, Excel Press, 1999; Gloria Vanderbilt, *It Seemed Important at the Time: A Romance Memoir*, Simon & Schuster, 2004.

SALVADOR DALI FOR WOMEN

'Oh if only I could perfume myself with the odor of that ram…': Salvador Dalí, *The Secret Life of Salvador Dalí*, Dial Press, 1942.

'the secret of the subconscious-automatic nature of his art' and 'Are these scarecrows? No…': 'We take off our hat to Salvador Dalí for showing

357

us how scented dreams are the stuff of which surrealism is made',
The Sketch, 20 May 1942.

POISON

On the depiction of women in Hollywood films of the 1980s, see: Marsha
McCreadie, *The Casting Couch and Other Front Row Seats: Women in Films of
the 1970s and 1980s*, Praeger, 1990.
'one aspect of the war on tobacco – the widespread acceptance of smoke-
free zones...': Dan Greenberg, 'What's your poison?', *New Scientist*, 18
September 1986.

OBSESSION

'America's undisputed pacesetter in turning out erotic ads and commer-
cials...': *Time* magazine quote featured in: Genevieve Buck, 'Erotic Ads
Ensure That Nothin' Comes Between Calvin and Controversy', *Chicago
Tribune*, 15 January 1986.
On Calvin Klein's fashion house, see: Steven Gaines and Sharon Churcher,
Obsession: The Lives and Times of Calvin Klein, Carol Publishing Group, 1994.
'Call it the flirt's dilemma: independence is possible without loneliness ...':
Charles Bloche, 'Message in a Bottle: The Marketing of Calvin Klein's
Obsession', *The Boston Phoenix*, 4 June 1985.

COOL WATER

For the story of the Athena *L'Enfant* poster, see: http://www.independent.
co.uk/news/uk/this-britain/the-curse-of-man-and-baby-athena-and-the-
birth-of-a-legend-432331.html, accessed 5 May 2015.

The Naughty Nineties: 1990–1999

Austin, Joe, and Willard, Michael Nevin (eds), *Generations of Youth: Youth
Cultures and History in Twentieth-Century America*, New York University
Press, 1998.
Birnbach, Lisa, *The Official Preppy Handbook*, Workman Publishing, 1980.
Crewe, Ben, *Representing Men: Cultural Production and Producers in the Men's
Magazine Market*, Berg, 2003.
Gough-Yates, Anna, *Understanding Women's Magazines: Publishing, Markets and
Readerships in Late-Twentieth Century Britain*, Routledge, 2002.
Jackson, Peter et al., *Making Sense of Men's Magazines*, Blackwell Publishers,
2001.
Jones, Mark et al. (eds), *Fake?: The Art of Deception*, University of California
Press, 1990.

Klein, Naomi, *No Logo: Taking Aim at the Brand Bullies*, Picador, 1999.

Massoni, Kelley, *Fashioning Teenagers: A Cultural History of 'Seventeen' Magazine*, Left Coast Press, 2010.

Moore, Ryan, *Sells Like Teen Spirit: Music, Youth, and Social Crisis*, New York University Press, 2009.

Turner, Alwyn W.: *A Classless Society: Britain in the 1990s*, Aurum Press, 2013.

L'EAU D'ISSEY AND L'EAU D'ISSEY POUR HOMME

On the growth of the mineral water market in the 1980s and 90s, see: Bernice Kanner, 'On the Water Front', *New York Magazine*, 9 May 1988.

IMPULSE O₂

'Why, you see, the girls are always buying them...': Louisa May Alcott, *Little Women*, Roberts Brothers, 1868.

TOMMY GIRL

'It's called social evolution, Dawson...': line quoted from Steve Miner (director), Jon Harmon Feldman (writer), 'Carnal Knowledge', *Dawson's Creek*, Episode 103, 10 February 1998.

'GENUINE GUCCI'

On counterfeit operations in Britain in the 1990s, see: http://www.independent.co.uk/news/hot-on-the-scent-of-the-calvin-klein-fakers-1265505.html, accessed 5 May 2015; Glenda Cooper, 'On the Scent of the Fake Products...Which Devalue the Real Thing', *Independent*, 27 June 1997.

A New Century

'a peep show...': 'Princess Margaret Goes in Swimming and British Press Has a Crisis', *LIFE*, 16 May 1949.

Further Reading

Aftel, Mandy, *Essence & Alchemy: A Book of Perfume*, Gibbs Smith, 2001.

Alavi, Dariush, *Le Snob: Perfume*, Hardie Grant Books, 2012.

Anon., *Fragrance and Fashion*, Silverdale Books, 2000.

Beaulieu, Denyse, *The Perfume Lover: A Personal History of Scent*, Collins, 2012.

Daly Goggin, Maureen, and Fowkes Tobin, Beth (eds), *Material Women, 1750–1950: Consuming Desires and Collecting Practices*, Ashgate, 2009.

Drobnick, Jim, *The Smell Culture Reader*, Berg, 2006.

Dyhouse, Carol, *Glamour: Women, History, Feminism*, Zed Books, 2011.

Edwards, Michael, *Perfume Legends: French Feminine Fragrances*, Michael Edwards & Co., 1996.

Gilbert, Avery, *What the Nose Knows*, Crown Publishers, 2008.

Groom, Nigel, *The New Perfume Handbook*, 2nd edn, Blackie Academic & Professional, 1997.

Herman, Barbara, *Scent & Subversion: Decoding a Century of Provocative Perfume*, Lyons Press, 2013.

Humble, Nicola, *The Feminine Middlebrow Novel, 1920s to 1950s: Class, Domesticity, and Bohemianism*, Oxford University Press, 2001.

Johnson, Jacqueline, *Classic Perfume Advertising, 1920–1970*, Schiffer Publishing, 2007.

Jones, Geoffrey, *Beauty Imagined: A History of the Global Beauty Industry*, Oxford University Press, 2010.

Marsh, Madeleine, *Compacts and Cosmetics: Beauty from Victorian Times to the Present Day*, Remember When, 2009.

Marwick, Arthur, *A History of Human Beauty*, Bloomsbury Academic, 2007.

Miller, Judith, *Perfume Bottles*, Dorling Kindersley, 2006.

Morris, Edwin T., *Fragrance: The Story of Perfume from Cleopatra to Chanel*, Charles Scribner's Sons, 1984.

Ohloff, Günther et al., *Scent and Chemistry: The Molecular World of Odors*, Wiley, 2011.

Rosen, Marc, *Glamour Icons: Perfume Bottle Design*, Antique Collectors' Club, 2011.

Sell, C.S., *The Chemistry of Fragrances: From Perfumer to Consumer*, 2nd edn, Royal Society of Chemistry, 2006.

Stamelman, Richard, *Perfume: Joy, Scandal, Sin – A Cultural History of Fragrance from 1750 to the Present*, Rizzoli, 2006.

Thompson, C.J.S., *The Mystery and Lure of Perfume*, Kessinger Publishing, 2010.

Turin, Luca, and Sanchez, Tania, *Perfumes: The A–Z Guide*, Profile Books, 2008.

Watson, Peter, *A Terrible Beauty: A Cultural History of the Twentieth Century: The People and Ideas that Shaped the Modern Mind*, Weidenfeld & Nicholson, 2000.

Williams, Tessa, *Cult Perfumes: The World's Most Exclusive Perfumeries*, Merrell, 2013.

Wyman, Margaret Woodney, *Perfume in Pictures*, Sterling Publishing Co., 1968.

For general referencing I am indebted to:
http://www.basenotes.net
http://www.fragrantica.com
http://www.perfumeintelligence.co.uk
(all accessed 6 May 2015)

For commentary on vintage fragrances I have referred to:
http://www.cleopatrasboudoir.blogspot.com
http://www.thevintageperfumevault.blogspot.com
http://www.yesterdaysperfume.com
(all accessed 6 May 2015)

I also generally follow a plethora of fragrance blogs, including:
http://www.boisdejasmin.com
http://www.glasspetalsmoke.blogspot.com
http://www.kafkaesqueblog.com
https://lessenteurs.wordpress.com
http://www.nstperfume.com
http://www.perfumeposse.com
http://www.perfumeprojects.com
http://www.perfumeshrine.blogspot.com
(all accessed 6 May 2015)

Index